CU00670467

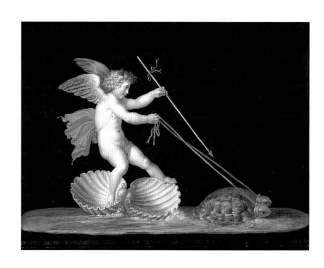

THE SHELL

INGRID THOMAS

THE SHELL

A World of Decoration and Ornament

With 526 illustrations, 507 in colour

Thames & Hudson

CONTENTS

For Finn, admirable and beloved son,
and in memory of my Mother, who first
showed me the beauty of shells.

PAGE 1 *Cupid being led by Tortoises*, 1812,
by Michelangelo Maestri (died *c*. 1812).
PAGE 2 *Linda*, 2003, by Ingrid Thomas.
THESE PAGES, LEFT TO RIGHT Giant Knobbed
Cerith (*Cerithium nodulosum*); St James's Scallop
(*Pecten maximus jacobaeus*); (below) Common
Paper Nautilus (*Argonauta argo*); Spotted Tun
(*Tonna dolium*); Spiny Bonnet (*Galeodea
echinophora*); Great Ribbed Cockle
(*Cardium costatum*).
PAGE 7 (Above) Japanese Wonder Shell
(*Thatcheria mirabilis*); (below) Distaff
Spindle (*Fusinus colus*).

Any copy of this book issued by the publisher as a
paperback is sold subject to the condition that it shall
not by way of trade or otherwise be lent, resold, hired
out or otherwise circulated without the publisher's prior
consent in any form of binding or cover other than that
in which it is published and without a similar condition
including these words being imposed on a
subsequent purchaser.

First published in the United Kingdom in 2007
by Thames & Hudson Ltd, 181A High Holborn,
London WC1V 7QX

www.thamesandhudson.com

© 2007 Ingrid Thomas
www.theshell.co.uk

All Rights Reserved. No part of this publication may be
reproduced or transmitted in any form or by any means, electronic
or mechanical, including photocopy, recording or any other
information storage and retrieval system, without prior permission
in writing from the publisher.

British Library Cataloguing-in-Publication Data
A catalogue record for this book is available
from the British Library

ISBN 978-0-500-51357-6

Printed and bound in Singapore by CS Graphics

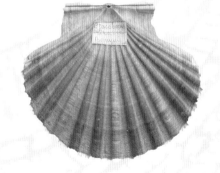

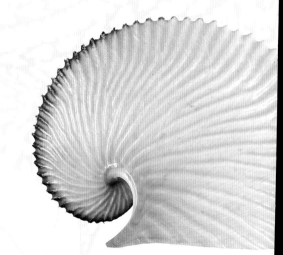

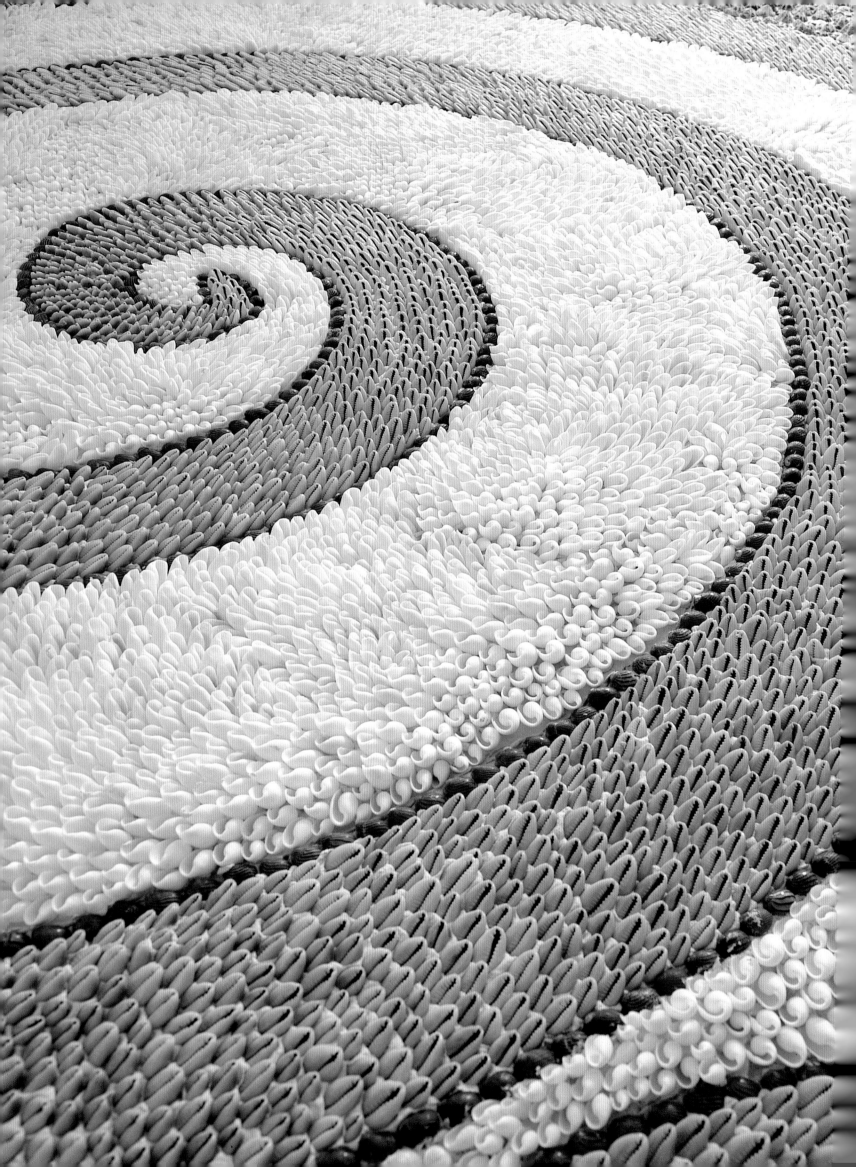

THE BEAUTIFUL SHELL

Shells form a felicitous group, and the sight of them may inspire lofty ideas as to form, in architects, sculptors, and even in painters.

Edmé François Gersaint, French shell trader, 1736

To the human eye, shells are small objects of great beauty. Their myriad shapes, textures and colours defy the imagination, and many people regard them as works of art in their own right. Yet in the natural world there is no deliberate investment in making shells beautiful. Unlike birds, whose fine plumage has evolved to attract the opposite sex, molluscs are guileless. They are simply genetically programmed to build their shells as the best forms of protection available to them. Camouflage may be a factor in some cases, and possibly – although scientists are uncertain – even some form of communication, but beauty does not come into the equation.

To those of us who are drawn to them, however, shells rank as sublime creations; their beauty is like nothing else, and its accidental quality only adds to their appeal. Anybody who can reach a seashore may find shells and be enthralled by them. They are irresistible to adults and children alike, and there are no national boundaries that limit the pleasure they can give.

Artists and craftsmen since time immemorial have found inspiration in the archetypal beauty of shells, and have sought to capture its essence in every creative form. Shells have been portrayed by painters in every genre. They have decorated buildings, furniture and costume. Jewellers may thread them on a simple cord, mount them in gold, or surround them with gemstones. Sculptors cast them in bronze, and chisel their forms in stone. Their shapes have been moulded in the finest bone china; their designs woven into silk fabric. There are no art forms in which shells have not featured. This book pays tribute to the aesthetic shell, and celebrates the wealth of creativity that it has inspired.

OPPOSITE Shell spiral wall in a cliff-top retreat in southwest England, 2006, by Blott Kerr-Wilson (b. 1962), North Wales. Kerr-Wilson is the most innovative shell artist working today. To create this magnificent spiral, inspired by the 'music' and movement of the waves on the beach below, she used only three species of shell: Gold-ringer Cowries (*Cypraea annulus*), white Bubble shells (*Bulla* sp.), and small dark Nerites (from the family *Neritidae*). Several thousand shells were needed to complete the piece.

INTRODUCTION

WHAT IS A SHELL?

My heart is like a rainbow shell
That paddles in a halcyon sea;

Christina Rossetti, 'A Birthday', 1861

The sea surrenders her treasure of shells, and they lie on the shore, each one a small gem. Their shapes and colours enchant us, and we pick them up because they are irresistible. Most of us have one or two cherished shells that we found on a holiday beach and wanted to keep, as a beautiful and permanent souvenir of the sea. But what exactly are we looking at when we admire a shell?

To the mollusc, the animal that creates it, a shell is essential to life. It is the equivalent of our human skeleton, though the mollusc builds its skeleton on the outside of its body, while ours is internal. A mollusc (from the Latin word *mollis*, meaning soft) is an invertebrate animal, without a backbone, and its body parts are soft and vulnerable. By secreting a supply of calcium carbonate, it ingeniously protects its body by enveloping it in a rigid structure which we call its shell. It does not discard this shell and replace it with a larger one as it grows, but lives in the same supportive outer casing, enlarging it as it matures. When it dies, the body separates, and the empty shell may be washed up by the tide onto a beach somewhere. But of course not all shells end up on our shores: countless numbers remain on the ocean bed, or are crushed by the waves.

Molluscs come from an enormous family, second only in number to that of insects. In fact they are one of the most successful animal families on earth, and were among the first to appear, over 500 million years ago. Today there are approximately 100,000 different species of shelled molluscs, and new ones are being discovered all the time. They are found in every part of the world, from the highest mountains to the ocean depths; they live on land and in freshwater lakes and rivers, but the majority of them dwell in the great oceans. The largest shell in the world is the Giant Clam (*Tridacna gigas*), which can reach nearly 1.5 m (5 ft) in length. The smallest shell found to date is said to be a tiny sea-snail, *Ammonicera rota*, measuring just 0.5 mm (1/50 in.) in diameter.

This book almost exclusively features marine shells, because with few exceptions, it is seashells that have provided the inspiration for artistic

expression and influenced human culture. It will concentrate principally on the two largest classes of mollusc: gastropods, or univalves, which produce many familiar species of spirally coiled shells, such as Cowries, Conches and Cone shells; and bivalves, whose shells consist of two hinged parts, for example Oysters, Clams, Mussels and Scallops. Scientific names are provided in brackets after the common names. The standard English-language reference *Compendium of Seashells* by Abbott and Dance (see Bibliography, page 251) has been used as the source for common names, although it is important to note that these often vary from country to country, even within a common language. For a more in-depth discussion of the classification and naming of shells, see pages 227–30. The Illustrated Glossary, pages 238–46, features photographs and key facts on the individual shells mentioned throughout this book.

SHELLS AND PEOPLE

But there are other beaches to explore. There are more shells to find. This is only the beginning.
Anne Morrow Lindbergh, *Gift from the Sea*, 1955

The most enduring and the most captivating of nature's legacies, shells have mattered to humankind throughout history. We have always wanted to keep them, use them, and appreciate them, not only for their intrinsic beauty, but for a magical quality that transcends the aesthetic and lifts them into a realm of symbolic, even religious importance.

The relationship between people and shells began in prehistoric times out of necessity. The contents of shells were first and foremost a source of food. Molluscs provided early human beings with vital nourishment, and were among the first sources of protein people were able to obtain. Prehistoric middens containing enormous piles of empty shells have been discovered by archaeologists in coastal areas across the world, evidence of the importance of shell-food in the evolution of human society. This source of protein was reliable the whole year round, and was obtained by means of the simplest technology. A stick, or even a pair of hands, were all that was needed to prise shells from rocks, or dig them out of the sand.

It was not long, in evolutionary terms, before humans began to use shells as self-decoration. They became the earliest form of jewelry, long before glass, metal or pottery beads were invented. Certain shells also made perfect tools and weapons, and they were even useful as trumpets

that could project sound further than the human voice. As the earliest societies became gradually more complex, so shells grew in importance. With the emergence of magic and religion, there developed the need for symbols that could protect people from dangerous forces and bring good fortune. The resemblance of shells to parts of the human body led them to be endowed them with spiritual powers, and they became essential amulets and fetishes. Their shapes and marine origins gave them status as sacred objects that were held in awe and veneration. In many parts of the world shells were paid mankind's highest compliment by being used as his most treasured commodity: money. But perhaps above all, the shell has provided inspiration for artistic expression. Artists and craftsmen all over the world have delighted in its beauty, and translated that quality into timeless works of art.

The shell has been of historical and cultural significance since the earliest evolution of human beings, and even to this day, it plays a part in the daily life of many people all over the world.

THE USEFUL SHELL

But why not one turn more?

Paul Valéry, *L'Homme et la Coquille*, 1937

Shells can be put to countless uses, and there seems to be no end to human ingenuity when it comes to adapting them for practical purposes. Some groups of shells lend themselves perfectly by the nature of their shape and substance. They are impermeable, many are as smooth as porcelain, and they will withstand the heat of an oven. Strongly built shells can be drilled with holes, filed down to a fine point, or sharpened to a razor finish. Before metal implements arrived on the scene, shells served perfectly well in many parts of the world as domestic containers and utensils, as tools of many trades, and even as weapons.

Inhabitants of the coral islands in the Pacific and Caribbean traditionally depended on shells for their daily survival. The contents of the shells provided communities with a vital source of food, and as there was no stone on thousands of these islands, the empty shells provided the raw material for the manufacture of all tools and weapons. Conches (*Strombus* sp.), Giant Clams (*Tridacna gigas*) and Great Green Turban shells (*Turbo marmoratus*), among other species,

BELOW LEFT An octopus lure from Tahiti, made of wood and at least three different species of Cowrie shells threaded together: Reticulated Cowrie (*Cypraea maculifera*), Tiger Cowrie (*Cypraea tigris*) and Ventral Cowrie (*Cypraea ventriculus*). The octopus's favourite food is Cowrie flesh, so when the fisherman finds a pile of discarded Cowrie shells on the sea bottom he knows there is likely to be an octopus nearby. Lowering the lure, he waits until the octopus emerges from its hiding place and approaches the boat, enabling him to hook and haul it in.

BELOW In the Andaman Islands in the Indian Ocean, a mother feeds her baby from a perfectly suited receptacle: a Chambered Nautilus shell (*Nautilus pompilius*). Readily available shells have a wealth of practical uses and symbolic meanings for this island tribal community, whose ancient culture remains virtually untouched by modernity.

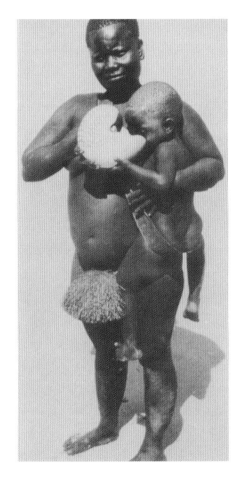

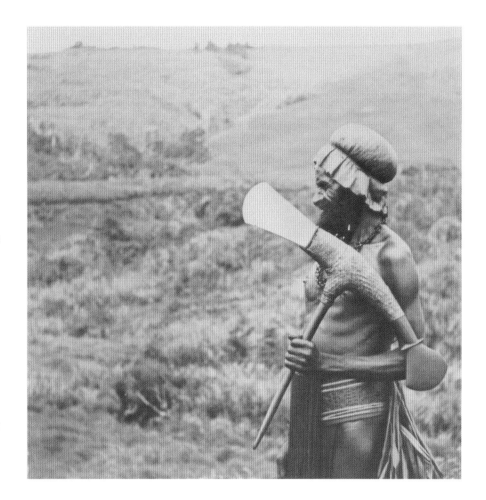

RIGHT A man from the Highlands of New Guinea holds an axe with a shell blade. The only shell large enough to provide such a substantial tool is the Giant Clam (*Tridacna gigas*).

BELOW LEFT Pearl shells make ideal fishhooks, their glinting lustre serving to lure unsuspecting fish. They are widely used in the Pacific islands, where such shells are plentiful. The examples shown here are likely to have been cut from the locally common Black-lipped Pearl Oyster (*Pinctada margaritifera*). Clockwise from the top, they come from: the Marshall Islands, Solomon Islands, California, and Cook Islands.

BELOW CENTRE Baler shells (*Melo* sp.) cut into spoons or ladles by the people of the Philippine Islands. These elegant implements could easily pass for objects created by a modern designer of kitchenware.

BELOW RIGHT This axe has a blade made from a Giant Clam (*Tridacna gigas*), and the decorative wooden handle is carved in the shape of a bird. It was made by the people of Kaniet Island, near New Guinea. Giant Clams are the largest shells in the world, reaching up to 1.5 m (5 ft) across. They are as hard as stone, and make ideal tools and weapons.

were used to produce gouges, pounders, scrapers, fishhooks, chisels, knives and axes, as well as all domestic utensils. The Nautilus shell (*Nautilus* sp.) made a perfect drinking cup or even a small bucket, and large bivalve shells such as Oyster shells (*Ostrea* sp.) and Scallops (*Pecten* sp.) made great ladles, bowls and spoons. The Baler shell (*Melo* sp.) acquired its name because it was traditionally used as an ideal baling tool on small boats and canoes caught in tropical squalls. With its flared opening, it was also a perfect scoop, and is still used in island markets as a measure for sugar, salt and flour.

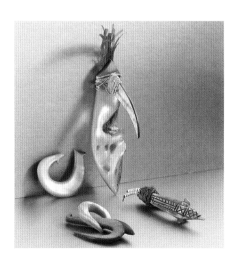

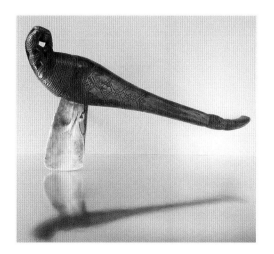

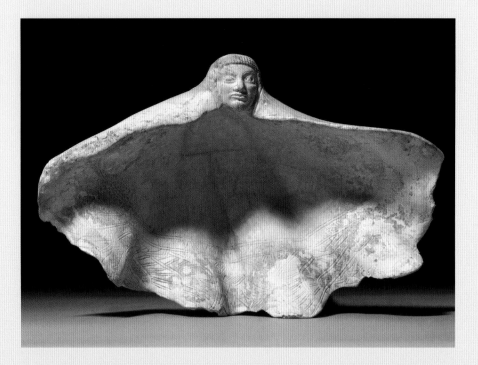

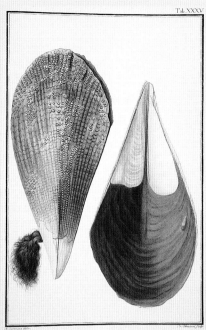

Tab. XXXV

Throughout the Middle East, archaeologists regularly find oil lamps and ancient cosmetic containers made of shells, some of them adorned with beautiful carvings. In both Asia and South America, a pair of closely fitting small bivalve shells such as Clams (*Mactra* sp.) were used as efficient tweezers for pulling out unwanted hair.

One of the most intriguing uses of shells over the centuries is in so-called 'pinna silk'. Many bivalve molluscs spin 'byssus' threads (from the Greek *bussos*, meaning linen) by which they anchor themselves to rocks or into sand on the sea bed. The Noble Pen shell (*Pinna nobilis*), a mollusc that is found only in the Mediterranean, produces a particularly long tuft of silk-like filaments that prevent strong currents uprooting it from its mooring. These threads are a rich, glistening, golden-bronze colour, and are very strong, but so fine that they resemble spun glass. Revered by the Romans, who called the threads the 'silk of the sea', they were the raw material of an exclusive industry that developed in southern Italy thousands of years ago. The shells were fished out of the sea, and their precious threads were converted into the finest yarn that was woven into stockings, gloves, shawls and collars. One shell produced only a single gram of yarn, so

ABOVE LEFT An ancient shell cosmetic container from the Syro-Palestinian area, 700–600 BC. This is a Fluted Giant Clam (*Tridacna squamosa*) which comes from the Pacific and Indian Oceans, as far east as the Red Sea. The umbo or central protrusion has been carved in the form of a woman's head, while the natural form of the shell gives the impression of a windblown cloak draped around her. The border is carved with sphinxes and lotus flowers in a design which can also be seen on textiles depicted in Assyrian carved reliefs.

ABOVE The Noble Pen shell (*Pinna nobilis*). This large shell grows to an average length of 60 cm (2 ft), though some specimens can reach twice that size. It is found only in the Mediterranean. The byssus tufts from which pinna silk is spun are visible in this 18th-century engraving by Giovanni Ottaviani, from an original drawing by Giovanni Casanova.

LEFT A glove knitted from pinna silk. It was owned by Charles Lennox, the 2nd Duke of Richmond (1701–50).

Italian fishermen developed an ingenious method of hauling in the precious Noble Pen shells (*Pinna nobilis*) used to produce pinna silk. They lowered specially adapted long-handled tongs which grabbed the shell and allowed it to be tugged away from its moorings. The byssus threads anchoring the shell to the sand can be seen clearly in this engraving.

several hundred would be needed to provide enough for, say, a shawl. The finished article was so fine that a pair of gloves made of pinna silk could be folded inside a walnut shell, yet they were so strong as to be virtually indestructible. In the Middle Ages, returning crusaders passing through Italy bought these golden garments to take home to their ladies. In 1754, a pair of stockings packed in a tiny box no bigger than a snuff box was presented to Pope Benedict XV, and Queen Victoria is said to have found her sea-silk stockings 'very comfortable'.

Articles made from pinna silk were shown at the London and Paris Exhibitions as late as the 1860s. But sadly, the growth of the silk trade in Europe, coupled with the decline of the population of Noble Pen shells in Mediterranean waters, saw the disappearance of the trade by the early 20th century. However, during research on this book, it was exciting to

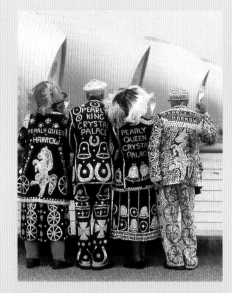

ABOVE The tradition of the Pearly Kings and Queens of London dates back to the 19th century. Born in 1862, London orphan Henry Croft became a road sweeper and rat-catcher in the local markets, where he was befriended by kindly costermongers. These market sellers wore mother-of-pearl buttons sewn onto the seams of their bell-bottomed trousers, jackets, waistcoats and caps, in order to identify themselves in their trade. Henry Croft never forgot the children in the orphanage where he grew up, and regularly took them fruit and other goods that he collected from his friends in the markets. He extended his charitable work, and in order to attract attention as he collected money, he made a suit covered in mother-of-pearl buttons. A tireless fundraiser, he was soon in demand by charitable organizations, so he persuaded his costermonger friends to follow his example. Pearly families soon became a regular sight in London, with one family for each London borough, one for the City of Westminster, and one for the City of London. Today these colourfully dressed, dedicated charity workers attend public events all over the city, and are a familiar part of London life.

ABOVE RIGHT A Saha Indian from the Colombian Andes mixes coca leaves with shell lime in a gourd container. These Indians maintain that chewing coca staves off feelings of

discover that there is at least one craftswoman, living in Sardinia today, who keeps her ancestors' tradition alive, continuing to use their time-honoured methods to produce this strangely beautiful silk of the sea.

We have not stopped using shells, even in today's most economically developed countries, where we are spoiled for choice with a plethora of natural and man-made materials. Mother-of-pearl from various shells is still used on all continents for inlay work, in jewelry and accessories. And most of us will have worn a shirt with mother-of-pearl buttons, though few pause to reflect on their origin on some distant tropical coast.

Modern medicine acknowledges the usefulness of shells, which are rich in calcium, minerals and vitamins. Calcium supplements extracted from Oyster shells (*Ostrea* sp.) are widely sold to help with osteoporosis and arthritic conditions. In parts of Asia, powdered Oyster shell is taken to treat acid indigestion and fatigue, and is also sprinkled over open wounds and boils. Naturopathic remedies include Variously Coloured Abalone shell (*Haliotis diversicolor*) as an aid to vitality, improved eyesight, and as an antispasmodic. In traditional Chinese medicine, Abalone is used 'to nurture the eye and pacify the nervous system'.

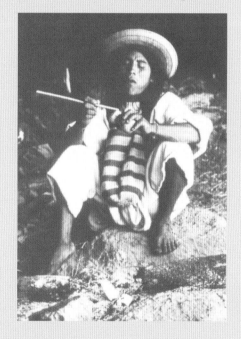

Shell lime, made from ground and sometimes burned shells, has been used as a fertilizer for four thousand years. In many coastal communities it serves as a temper in pottery to prevent shrinkage in firing, or as paint on wooden figures and masks. In some parts of the world shell lime is an ingredient in the manufacture of glue, and a mixture of shell lime and oil is still used to caulk boats. Shells build our roads and houses too. In parts of Africa and North America, where huge quantities of empty shells can be dredged, the crushed shells are used for road-making, and they are also bound with cement and made into building blocks or used as surface rendering. From a tiny spoon or fishhook to the walls of a mansion, for sheer versatility, no other natural material can match the shell.

hunger and cold, enabling them to work longer in the high altitude of the Andes. Recent research suggests that shell lime reacts with the coca leaves to activate the narcotic, and in addition a new chemical is formed that helps the body combat high altitude stress.

SYMBOLS OF STATUS

Who has not heard how Tyrian shells
Enclose the blue, that dye of dyes
Whereof one drop worked miracles,
And coloured liked Astarte's eyes
Raw silk the merchant sells?

Robert Browning, 'Popularity', 1855

Human society likes to recognize status at a glance. Certain kinds of dress and ornament immediately identify a person's place in society; they form a visual language that says something about wealth or marital status, high social rank or political authority. In some societies people wear obvious signs of their status all the time; in others they are reserved for specific occasions. Shells have often been used as part of the vocabulary of this visual language. They may be chosen as decoration simply because they are beautiful objects that lend themselves to adornment. But for some peoples, they mark important rites of passage, and for

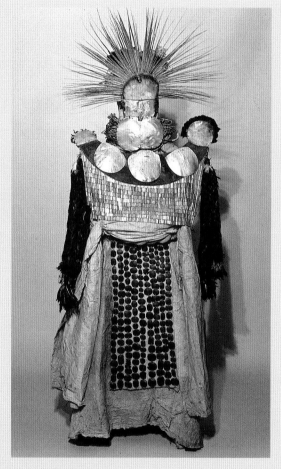

RIGHT Mourner's dress from the Society Islands in French Polynesia. This is probably the actual garment presented to Captain Cook in 1774, which he subsequently donated to the British Museum. It would have been worn by the chief mourner of an important deceased person, either a priest or close relative. He would have carried a long menacing club edged with shark's teeth, and led a procession of mourners through the local area, attacking people, sometimes fatally. This 'reign of terror' could last for up to a month. The main section of the dress is made from barkcloth and feathers. The face mask is made of pearl shell, probably Black-lipped Pearl Oyster (*Pinctada margaritifera*), surmounted by tropical bird feathers. The wooden breast ornament is also decorated with Black-lipped Pearl Oyster shells, and suspended from it is a chest apron of pearl shell slivers.

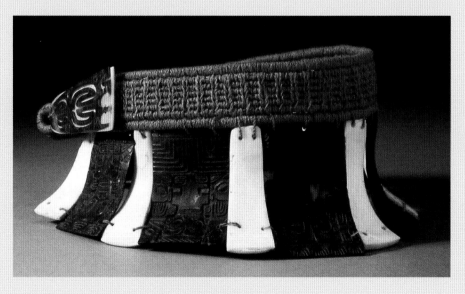

LEFT A headdress (*Pa'e Kaha*) from the Marquesas Islands in French Polynesia, probably 19th century. This was worn only by men as a mark of prestige. It consists of alternating plates of turtle-shell and white Triton shell (*Charonia* sp.). Each plate is connected by coconut fibre string, threaded through drilled holes, to the plaited coconut fibre headband. The turtle-shell plates are carved in low relief with complete and partial human figures, called *tiki*.

15

RIGHT In New Guinea's Sepik River region, Cowries represent valuables. When a man from the Chambri or Iatmul people dies, or when an enemy head is taken in battle, the head is kept until the skin and flesh have disappeared from the skull. A craftsman then models the features of the dead man with a mixture of oil and clay. He paints the face with the patterns the man would have used in his lifetime. On the forehead a band is placed with objects signifying the man's status; a line of opossum fur would indicate an initiated man. In this case, the row of Gold-ringer Cowries (*Cypraea annulus*) indicates that the man was both important and wealthy.

RIGHT A 19th-century shield from the Central Solomon Islands. It is made from plaited cane, overlaid with a putty made from parinarium nut and inset with pieces of Nautilus shell (*Nautilus* sp.). Shields such as this one were probably carried as a sign of prestige by important individuals, but they may also have been exchanged as items of wealth. They are no longer made by the Solomon Islanders, and the few that survive are rare museum pieces.

others, they are indicators of social and political rank. In certain cultures the wearing of shells also signifies a special kind of status: that of the warrior.

One important rite of passage in all societies is marriage. The married state is outwardly signalled by some special form of ornamentation, sometimes worn by both partners, but usually only by the wife. On the borders of Pakistan and Afghanistan, the Kalash women begin to wear headdresses covered with Gold-ringer Cowries (*Cypraea annulus*) from the age of about four, when they are promised in marriage. From that time, they are expected to wear these heavy 3 kg (7 lb) headdresses at all waking moments, even while working in the fields. By contrast, in New Guinea, the Mountain Arapesh people use a shell as a symbol of a woman's married status, but it is worn by the bride only at the marriage ceremony. A green Elephant Tusk shell (*Dentalium elephantinum*) with a red feather is inserted into a hole specially pierced in the tip of the bride's nose.

The people of the Andaman Islands in the Indian Ocean have a different way of doing things. They celebrate life-changing occasions with dance. At initiation rituals, marriages and funerals, the participants remove all their ornaments, taking off their girdles, necklaces and leg bands of Dentalia and Cockle shells (*Dentalium* sp. and *Trachicardium* sp.), and they only replace them when the ceremonies are completed, as a sign that they have now arrived at the next life stage.

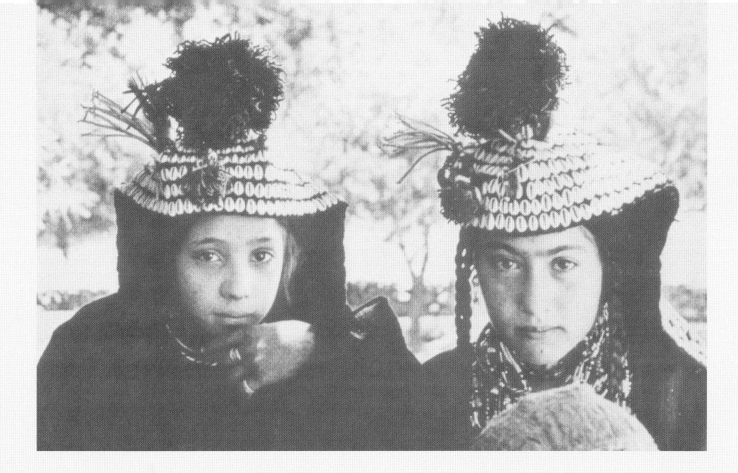

ABOVE These Kalash girls of the Pakistan–Afghanistan border region are wearing woollen headdresses covered in Gold-ringer Cowries (*Cypraea annulus*) as a sign that they are already promised in marriage.

BELOW Found in a grave at Gran Chimu on the coast of Peru, this pre-Columbian bag and pillow survived intact for hundreds of years because of the almost total absence of rain in Peru's coastal desert. Threaded together using hundreds of orange beads shaped from the Pacific Thorny Oyster shell (*Spondylus princeps*), these objects will almost certainly have been buried with their owner as a mark of their great value. The Chimu culture (12th–15th centuries AD) was based in the north of Peru, and was ultimately conquered by the Incas.

RIGHT This bib was also among a treasure of grave items discovered at Gran Chimu in Peru. Precisely who wore it, and on what occasion, remains a mystery, but it must have belonged to a person of great wealth and status. Made from tiny shell beads carved from the highly valued orange Pacific Thorny Oyster (*Spondylus princeps*), the bib also contains green malachite and unidentified purple and white shells. The motifs of human figures and birds are identical to those found in ancient Peruvian textiles.

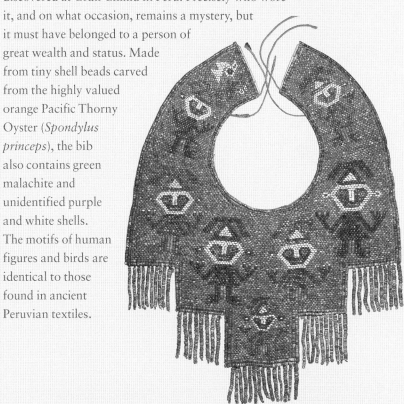

17

BELOW The Kuba king's mask
(*Mwaash a m'booy*), worn during
coronation ceremonies. Covered with
Cowrie shells and beads, it represents
Woot, the mythical creator of all Kuba,
the first king, and the origin of all
fertility. As Woot's direct descendant,
only the king is permitted to wear the
mask, which will be buried with him
when he dies. A new mask will be
created for his successor.

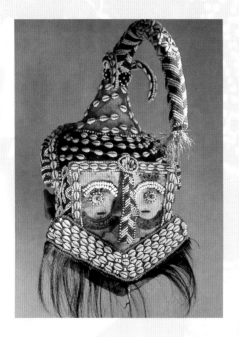

In central Africa, Cowrie shells (*Cypraea* sp.) are symbols of royal authority and power for the Kuba of the Democratic Republic of Congo. The members of the royal lineage are traditionally called *Baapash*, which translates as 'people of the Cowrie shells'. Only descendants of royalty are permitted to wear Cowries, and the position and number of shells worn by each individual signifies political rank. All men of royal descent and their wives may wear Cowrie armbands, but only the highest nobility may wear headdresses and leg bands decorated with them. The king is regarded as divine ruler, and source of all authority, power and fertility. When he dies, his successor's final coronation ritual is to sit on the royal stool, a basket covered with Cowrie shells. The Kuba believe that if anyone not destined to become king were to sit on this stool, he would be struck dead instantly.

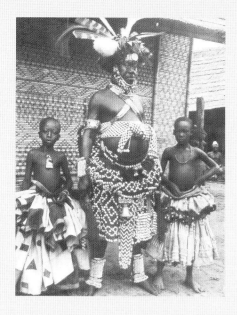
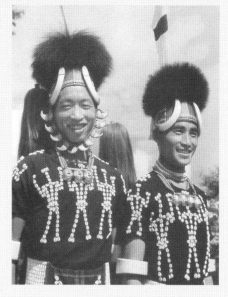

ABOVE AND OPPOSITE A Kuba chief of high nobility, displaying his rank and authority by the considerable number of Cowries he is entitled to wear.

ABOVE CENTRE Chang Naga warriors in ceremonial dress. Their many special ornaments include blouses decorated with Gold-ringer Cowrie shells (*Cypraea annulus*), in a design permitted only to successful head-hunters. Their helmets are made of plaited canework decorated with two wild boar tusks, and topped with a hornbill tail feather, and goat or bear hair. The chin strap on the warrior at the left includes all ten claws of a tiger's front paws. The tiger is held in superstitious awe by the Naga, and only head-takers can wear its claws. The cast-brass trophy-head pendants further show off the wearers' prowess, indicating the number of heads he has taken in battle.

ABOVE RIGHT An Angami Naga warrior from northeastern India demonstrates his hunting prowess by his skirt decorated with rows of Cowrie shells. Traditionally such a skirt was permitted to bear a maximum of four rows; the 19th-century European visitor who drew this portrait exercised artistic licence and exaggerated their number.

Nagaland is a landlocked territory in northeast India, a varied terrain consisting of mountains, narrow valleys and jungles that separate tribe from tribe. The nearest market for shells is 650 kilometres (400 miles) away in Calcutta, where the Naga travel to buy Gold-ringer Cowries (*Cypraea annulus*), imported into India from the Laccadive and Maldive Islands. The prolific use of Cowrie shells to decorate Naga clothing and ornaments carries associations of material wealth, echoes of the time when Cowries constituted the currency of many Indian states. Shells are worn only by the male members of the different Naga tribes, and according to each tribe's particular customs, are invariably linked to military achievement. In the past, inter-tribal wars were a frequent occurrence among the Naga, and the goal for warriors was the taking of enemy heads. The most distinctive Chang Naga ceremonial costume was that of the warrior, and was worn on festive occasions. An elaborate headdress was accompanied by a blouse; if this was decorated with a design of Cowrie shells, it was an instantly visible sign that the warrior had successfully taken heads in battle. In another tribe, the Angami Naga warriors wore their Cowries on skirts in rows, three rows signifying success, and a fourth row being awarded only to warriors of great distinction. Though delightfully, for one particular Naga tribe, there appears to have been an alternative reason for the acquisition of the prestigious fourth row: for them it was not a symbol of martial prowess but communicated to the whole tribe that the man wearing it was successful in love.

A mollusc was responsible for one of the most widespread symbols of prestige that the world has known. Its influence stretched far and wide, and lasted for thousands of years. Indeed its impact is still felt today, though many people are unaware of its ancient origins. Tyrian purple, also called Royal or Imperial Purple, is the colour produced by a dye obtained from several common molluscs, and from the earliest recorded time the use of this purple dye was reserved for people of the highest rank. It still has associations of prestige and power. Although the dye was

TOP Fragment of a brocaded panel, made in 16th-century Brusa, Turkey, during the Ottoman Empire. The dye that coloured the threads which form the fabric's purple ground came from a shell, probably the Purple Dye Murex (*Bolinus brandaris*), abundant in the Mediterranean and Northwest Africa.

ABOVE A detail of a Mexican *pozahuanco* (hip-wrapper) from Oaxaca. The purple dye used on this fabric was extracted from the Wide-mouthed Purpura shell (*Purpura patula pansa*). The other colours were obtained from indigo and cochineal.

first discovered around 1700 BC by the Minoans in Crete, it was the Phoenicians in the cities of Tyre and Sidon (in southern Lebanon today) who produced the high quality dye that was renowned throughout the ancient world, and that contributed substantially to the Phoenicians' pre-eminence in international trade.

There are a number of molluscs in the world containing the basis of purple dye, but two common species were used in the original production of Tyrian purple: Trunculus Murex (*Hexaplex trunculus*), and Purple Dye Murex (*Bolinus brandaris*). The smaller molluscs were crushed whole in their shells, while the larger ones were carefully opened to remove the gland that contained the dye. The resulting mass was simmered in cauldrons for ten days at a time, after which raw fabric was soaked in the clear liquid. It turned purple when exposed to sunlight. The dye was remarkably fast, and fragments of fabric have been discovered hundreds of years later, their colour undimmed by time. It took approximately eight thousand shells to produce just one gram of dye, which accounted for the huge prices commanded by the end product. Tyrian purple fabric was literally worth its weight in gold. The Old Testament records that Moses used it in the furnishing of the Tabernacle and for the vestments of the High Priest. The Egyptians used it to dye the borders of their ships' sails to show the captain's rank. At the battle of Actium in 31 BC, the ship of Cleopatra and Mark Anthony stood out from the rest of the fleet because its great sails were entirely coloured purple. The ancient Greeks depicted their gods dressed in purple, and they reserved the colour for their most eminent statesmen. Roman senators were originally permitted a band of purple on their tunics, but in the first century AD Nero decreed, on pain of death, that only the emperor could wear the colour.

Even now purple is a colour still associated with ceremonial robes worn by royalty, and the vestments of high-ranking members of the Church. Chemical dyes have long since replaced the original method of producing the colour, but in Mexico there are a few Indian groups who still derive purple dye from molluscs in the traditional way. They extract it from local species, the Wide-mouthed Purpura (*Purpura patula pansa*, now protected) and the Columella Purpura (*Purpura columellaris*). There is one very heartening difference, however: these days the mollusc is not killed for its dye, but is only 'milked' of its special dye-making secretion and returned to the sea unharmed.

Heraldry, or armory as it is sometimes called, has long been one of the most distinctive means of communicating status in the Western world. The coat of arms, or armorial bearing, dates back to medieval times in Europe, although its precise origin is still obscure and a matter of debate. At an early stage, heraldry certainly had strong military associations,

when it was essential for identifying individual knights in armour on the battlefield. Some experts argue that the hereditary nature of heraldic arms was a product of the feudal land-tenure system, when a man held land in return for military service. If land and, with it, the right to lead in battle were inherited, it followed that the coat of arms was hereditary too. Whatever the original purpose, the heraldic coat of arms has been the outward sign of the rank of royalty, nobility and families of distinction since the 12th century.

Scallop shells have featured regularly as charges, or symbols, on shields from the 13th century. Known as *escallops* in heraldic terminology, in their early use these shells gave added prestige to the bearer because they signalled a connection with the great pilgrimages to the Holy Land, Rome, or Santiago de Compostela in Spain (see page 26). As one 18th-century poet explained:

> 'The scallop shows a coat of arms
> That, of the bearer's line
> Someone in former days hath been
> To Santiago's shrine.'

Of the thousands of coats of arms adopted by succeeding generations, four or five in every hundred have included the *escallop*. It appears on the arms of Sir Winston Churchill, Diana, Princess of Wales, and the present Pope Benedict XVI. Other shells also feature occasionally, but they are rare, and may be selected simply because they provide a pictorial pun on the name of the owner.

Heraldry, with its precise artistry and quaint terminology, continues to thrive in the 21st century, and new coats of arms are accorded to individuals entitled to own them. But the historic significance of these coveted symbols of status is still best summed up in the words of Alexander Nisbet, who wrote in his *System of Heraldry* published in 1722 that coats of arms 'represent the heroick Achievements of our Ancestors and perpetuate their memory.'

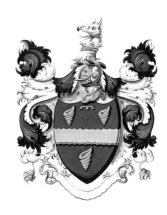

ABOVE The arms of Henry Shelley Esq. of the Bath, 1803. Shells were included here as a pun on the owner's name – in this case, stylized Whelk shells.

BELOW LEFT The arms of John Browne, Sheriff of London in 1472, painted in the time of Queen Elizabeth I. Three stylized Scallop shells feature prominently on the shield.

BELOW CENTRE A modern coat of arms belonging to Sir John Morrice Cairns James, 1976, showing a cross-section of a Nautilus shell (*Nautilus* sp.).

BELOW RIGHT The arms of Sir Thomas Masterman Hardy, 1815, displaying three *escallops*, or Scallop shells.

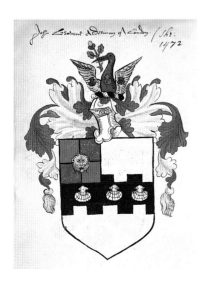

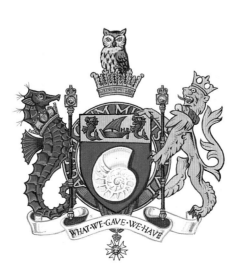

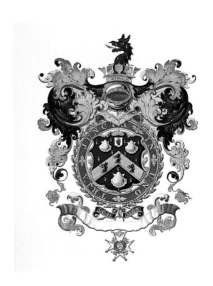

Below centre A ritual fan from the Eleko cult of the Yoruba people in Nigeria. Made of incised brass, it is decorated with Money Cowries (*Cypraea moneta*) dyed pale blue. Cowrie shells are believed to have curative powers, and the function of the fan is to prevent death in children.

Below right An amulet hung with bells and decorated with Money Cowries (*Cypraea moneta*). Among the nomadic people of Turkmenistan, this protects the yurt – the circular tent made of skins – and guards against the evil eye.

Below An Eshu Cult figure made by the Yoruba people of Nigeria. This male figure, carved from dark wood, has hair that begins on the forehead and extends back into a long point, an association with unrestrained energy and sexual aggressiveness. Eshu figures are usually adorned with beads and Cowrie shells (*Cypraea* sp.), but this one, unusually, is covered with Mussel shells from the *Mytelidae* family, which signify wealth and prosperity.

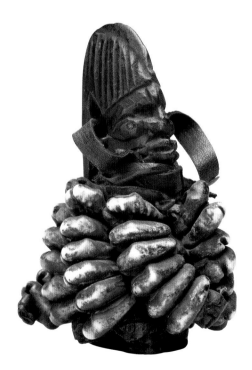

MAGIC AND RELIGION

Give me my scallop shell of quiet,
My staff of faith to walk upon,
My scrip of joy, immortal diet,
My bottle of salvation,
My gown of glory, hope's true gage,
And thus I'll take my pilgrimage.

Sir Walter Raleigh, *The Passionate Man's Pilgrimage*, 1604

What mystery there is in a shell. It appears from the unknown depths of the sea, shrouded in its own secrecy. That very enigmatic quality, coupled with its archetypal beauty, is surely what first prompted humankind to endow a shell with magical qualities, to believe it to be vitally powerful, even a symbol of eternal life.

Above all other shells, the Cowrie (*Cypraea* sp.) has been, and still is, the most important symbol in many cultures; no other object has been so widely venerated. The reason is simple enough. Whatever the particular species, the Cowrie's general form and shape of its underside have always been seen to resemble female genitalia, the essential door through which a precious child enters the world. In the classical Roman world, the Cowrie was called *Concha Venerea*, the shell of Venus. Its scientific name, *Cypraea*, derives from Cyprus, the island where the goddess Aphrodite (the Greek name for Venus) was first worshipped. The Cowrie has been a prime symbol of fertility and abundance since prehistoric times. With such powerful attributes, it is a potent amulet or fetish, believed to bring good fortune and plentiful harvests. Headdresses, garments, jewelry, masks and hunting gear are decorated with Cowries by many ethnically diverse communities, according to their own traditional mythology and convictions. One thing they all have in common, however, is that the magic surrounding the Cowrie is invariably benevolent; the shell is always a force for the good.

As far as we know, the beliefs associated with the Cowrie began around the Red Sea, spread to the eastern Mediterranean and were carried by migrating peoples to almost every part of the world. Cowries have been found in Cro-Magnon graves in France, in prehistoric sites in Germany and England and in

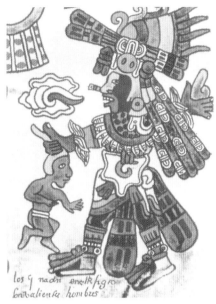

los q̃ nadñ enelR figra
bñ aliente hombres

FAR LEFT Cross-section of a Florida
Horse Conch shell (*Pleuroploca
gigantea*), emblem of the pre-eminent
Aztec god Quetzalcoatl. This was
discovered in the Mexican state of
Veracruz. The perforations suggest
it was hung on an image of the deity,
or it may have been worn by a priest.

LEFT In this painting from the ancient
'book' the *Codex Borbonicus*,
Quetzalcoatl wears a cross-section
of shell as a pectoral ornament that
stretches below his waist, and in front
of his mouth there appears to be a
speech scroll in the form of a Conch
shell, possibly a stylized Florida Horse
Conch (*Pleuroploca gigantea*).

BELOW A shaman in Siberia wearing
a costume decorated with bells and
numerous Cowrie shells (*Cypraea* sp.).
The tinkling bells summon the spirits
of the dead in defence against evil, and
the Cowries bring good fortune.

pre-dynastic Egyptian tombs. In ancient China, at the time when
Cowries served as currency, the shells were also used to protect the dead
in the afterlife. Depending on the rank of the deceased, a specific number
of Cowries were inserted into their mouths before burial, to ensure they
would have money to spend in the next world. In Egypt, mummies
were sometimes given eyes of Cowries to guarantee good eyesight in
the hereafter.

The role of Cowries as magical symbols is not just a thing of the past.
They are still used in parts of the world where people believe in the evil
eye. This belief holds that somebody may unintentionally or even wil-
fully cause harm by looking at another person or animal with either
admiration or envy. Any compliment paid to an individual also immedi-
ately invokes the evil eye, and the victim is sure to suffer some form of
bad luck, or may shortly become ill, and possibly even die. The Cowrie's
perceived resemblance to a human eye makes it an important protective
amulet, and it is still in use as such in parts of Europe, the Middle East,
northern India, and in Latin America.

A shell is one of the few natural objects that can produce musical
sound. By simply cutting the apex off a suitable univalve, or by drilling a
hole along its length, low, sonorous notes can be produced when it is
blown hard enough. As religions developed, the shell trumpet became
one of the most important instruments in temple worship and in tribal
ceremonies. From the second millennium BC, the religious uses of these
instruments spread throughout the world to almost every inhabited area.
Serving as sacred objects, they could summon the deity, and they called
the faithful to worship. They are used today by Shinto priests in Japan,
and in Tibetan Buddhism, in which the Chank shell is one of the Eight
Auspicious Symbols. In many other places where communities hold fast

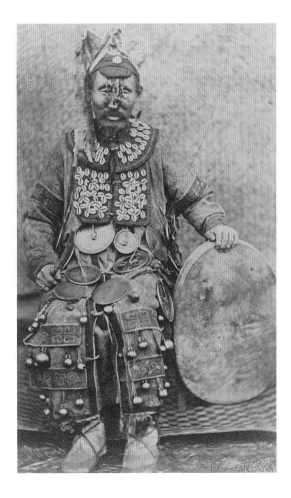

RIGHT A Tibetan monk blows a sacred Chank shell trumpet at a ceremonial occasion. The Indian Chank shell (*Turbinella pyrum*) is one of the Eight Auspicious Symbols of Buddhism, and therefore an object of veneration. This fine example is set in an ornate mount of silver and copper, and inlaid with coral and turquoise. The decorative carvings represent a dragon and other symbolic emblems. Large shell trumpets such as this one produce low, sonorous notes which are sounded as a call to prayer, and during important festivals such as New Year and the Buddha's birthday. The low tone of a large Chank trumpet is believed to carry the prayers of the faithful to the ears of the deity. By contrast, the higher notes produced by smaller shells are considered sad sounds, and are used principally in funeral rituals.

BELOW A statuette of the Hindu god Vishnu, seated on the serpent Sesha, and holding a sacred Indian Chank shell (*Turbinella pyrum*) in one of his four hands.

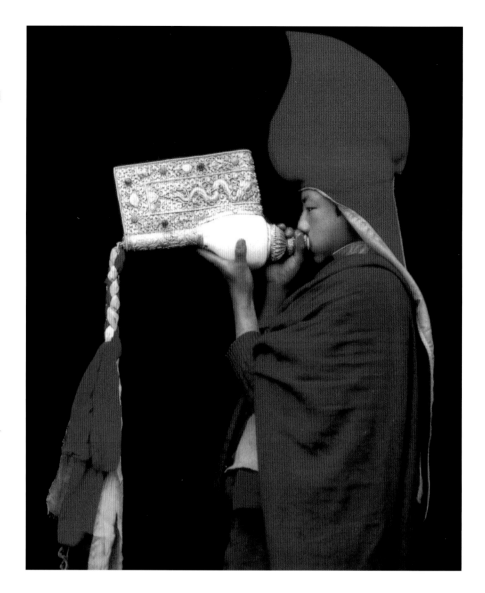

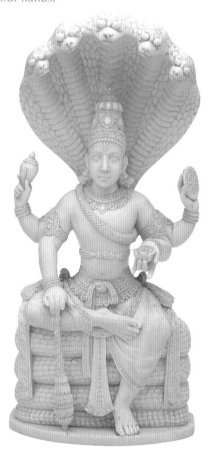

to ancient beliefs, shell trumpets still play an important symbolic and ceremonial role in marriage and funeral rites, and during circumcision and initiation rituals.

In India, the religious and cultural use of a shell goes far beyond that of any other religion. The Indian Chank shell (*Turbinella pyrum*) is a symbol of Vishnu, the preserver of the universe, and one of the three major gods of the Hindu pantheon. Vishnu is usually depicted, in his human form, holding a sacred Chank in one of his four hands. Closer inspection reveals this to be a 'sinistral' shell. Almost all univalves, when viewed from the apex, turn spirally to the right. Very rarely, nature produces a mutation, a shell whose whorls turn anti-clockwise, resulting in a sinistral spiral. It has been estimated that this freak of nature is found only once in every 3.5 million shells, and that no more than between two and three hundred have ever been discovered. When it happens, the shell is regarded as a holy relic, worthy of great veneration, and most of those that have been discovered are the treasured possessions of Hindu temples. A sinistral sacred Chank will typically be mounted in ornately chased and embossed silver or gold: a perfect emblem of purity and most fitting of all offerings to the god.

In the daily liturgy of the Brahmans, a prayer is offered by the priest while he holds a Chank in his hands: 'At the mouth of this shell is the God of the Moon…In this Chank is the chief of the Brahmans. That is why we worship the Sacred Chank. Glory to thee, sacred shell, blessed by all the gods, born in the sea, and formerly held by Vishnu in his hand. We adore the Sacred Chank and meditate upon it. May we be filled with joy!'

As a trumpet, the Chank is used in both religious and domestic rituals. It is blown to call the faithful to worship in the temples, and to summon the deities to the rites to be performed. Its sound is also powerful in driving away evil spirits. As with many musical instruments, each shell has a slightly different 'voice', and the price of a good Chank is determined more by the quality of its sound than by its size. This can be judged by slapping the hand against the blowing aperture. James Hornell, a Scottish marine biologist based in Madras in the early 20th century, wrote extensively on various aspects of folklore and ethnology in India, including the role of the Chank in Hindu life. Describing the sound of the Chank trumpet, he wrote that: 'No tune properly so called can be played, but the tone is capable of much modulation by the lips, and the long drawn notes as they drone clear and mellow on the evening breeze have a haunting charm that clings sweet and seductive in the memory.'

A traditional Hindu marriage in Bengal is not complete without the blessings conferred by the Chank shell. It is used as a libation vessel to pour holy water over the joined hands of the bride and groom. The marriage is not legal until the bride places on her wrist two red lacquered bangles, cut from sections of the shell. They are the equivalent of the wedding ring, and as long as she is married, the wife will never remove these bracelets. Only if her husband dies will she take them off, break them and throw them away.

All Hindu households are likely to have at least one Chank shell in the home, as a safeguard against ill omens and protection in case of danger. Even the Chank dust gathered in the bangle-cutting workshops is valuable. This chalky powder is used as an antacid for complaints of the stomach, and sold as a cosmetic to be mixed with water and used to conceal unsightly pimples. Chank shells are not only sounded at funerals, but sometimes a shell is buried with the corpse. Among the Tamils, a Chank may be buried beneath the foundations of a new house, to ensure good fortune and protect the inhabitants against evil influences. In rural areas, farming families need to protect their livestock, and to that end a shell will often be hung around the neck of a cow or buffalo.

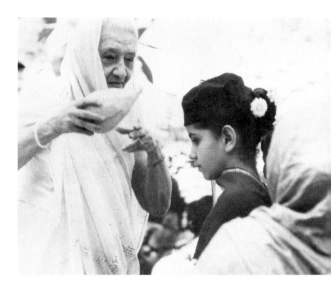

ABOVE An Indian woman pours sacred water from an Indian Chank (*Turbinella pyrum*). The power of the Chank is so great that ordinary water poured into it is believed to be transformed immediately into sacred water.

BELOW A sacred Indian Chank shell (*Turbinella pyrum*) from Bengal. The outer layer has been burned off with acid, and it is carved with intricate representations of Hindu deities.

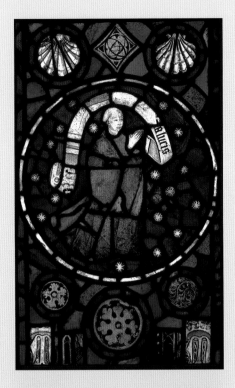

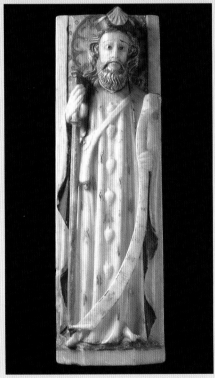

TOP A 15th-century English stained glass panel showing St James the Greater, patron saint of pilgrims. St James's Scallops (*Pecten maximus jacobaeus*) are depicted in the upper roundels, emblem of the saint and of all Christian pilgrims.

ABOVE St James the Greater on a 15th-century English alabaster panel. Carved, painted and gilded, it depicts the bearded saint wearing a hat decorated with a St James's Scallop (*Pecten maximus jacobaeus*).

Christianity has not had much use for shells in its history, with one outstanding exception. The shell which holds a unique place in Roman Catholic iconography is the Scallop, the badge of the pilgrim, and emblem of St James the Apostle, patron saint of pilgrims.

According to some sources, St James the Greater spent a number of years evangelizing in Spain, but on his return to Jerusalem, he was beheaded by Herod Agrippa. A legend of the 8th century tells that James's disciples rescued his remains and brought them by boat back to northwest Spain, where he was buried in Iria (now Padrón). During the next two hundred years, his grave was forgotten, until a hermit received a vision and St James's body was miraculously rediscovered. A church was immediately built on the site, called Campus Stellae, later renamed Santiago (St James) de Compostela. Pilgrimages to the shrine became extremely popular in Medieval Europe, and Santiago de Compostela remains one of the most important destinations for Roman Catholic pilgrims today.

There are plenty of legends purporting to explain how the Scallop became the badge of St James. But despite scholarly research into the question, it remains something of a mystery. It seems most likely that at some point in the Middle Ages, an enterprising salesman brought Scallops into the city of Santiago de Compostela to feed the hungry hordes of pilgrims, and began selling the shells as souvenirs of the pilgrimage. Over time this inspired ever more extravagant tales that associated St James himself with the Scallop shell. The most famous of these tells of a horse and rider emerging from the sea, miraculously covered with the shells. By the 11th century, all portrayals of the saint – statues, paintings and stained glass windows – showed him flanked by images of the Scallop, which has become the quintessential emblem not just of St James but of all Christian pilgrims. The species of Scallop associated with the pilgrim is appropriately named *Pecten maximus jacobaeus*, or St James's Scallop.

WEALTH FROM THE SEA

Why, then the world's mine oyster,
Which I with sword will open.

William Shakespeare, *The Merry Wives of Windsor*, II, ii

It is difficult today to conceive of money in any other form than the familiar banknote and coin. Be it pounds or dollars, euros or yen, cash looks pretty similar wherever we go. We take it for granted that in order to pay for something we will use metal, paper or, these days, the ubiquitous

plastic card. But in the past, in many parts of the world, things were done differently. Until relatively recently, if people wanted to buy food, pay their taxes, or even buy a house, many of them paid in shells. In fact, shells served as currency for nearly four thousand years, and have been used by more people in more places than any coin. That's quite a feat for a discarded little product of nature.

Two species of rather uninspiring Cowrie shells were responsible for providing many regions of the world with their money. Known as Money Cowries (*Cypraea moneta*) and Gold-ringer Cowries (*Cypraea annulus*), these shells fulfilled all the criteria required for currency: they were more or less uniform in shape and size, portable and durable. Most important of all, they were almost impossible to counterfeit. Plentiful in certain locations, but totally absent elsewhere, their value as currency was created when they were transported to lands far away from their source.

Money Cowries are the most abundant members of the Cowrie family. They live in the warm shallow waters of the tropical and subtropical Indo-Pacific, usually under stones and coral, and close enough inshore to be exposed at low tide. It is just as well that they are so common, because when it came to serving as cash, humankind needed astonishing numbers of them. The centre of the Cowrie industry was the Maldive Islands, the Laccadive Islands and Ceylon, and it was from these islands that most of the world's trade in shell money originated.

As far as we know, the first people to have used shells as currency were the Chinese. Stone Age deposits of Cowries have been unearthed far inland, and some authorities believe they may have been in use as early as 2000 BC. They were certainly in wide circulation by 700 BC. In the 13th century AD, Marco Polo observed camel trains loaded with sacks of Cowries crossing the Himalayas on their way to China, and as late as the 14th century, taxes in China were still being paid in Cowries, where millions each year would pour into the Imperial treasury. Even today, the Chinese character for the word 'expensive' resembles a stylized Cowrie.

Although the use of shells as currency began in China, it was not until much later that the career of the Money Cowrie as a 'world currency' was established. Around the 1st century AD, Money Cowries were in circulation in several Indian states, as well as Thailand, Burma and Cambodia. It was also in India that the Cowrie acquired its English name, from the Hindu word *kauri*. In Bengal, for nearly two thousand years, Cowries were the *only* money in circulation, and they did not disappear entirely until the 20th century. One irrefutable report records Cowries as a negotiable currency in Ajmer, Rajasthan, as late as the mid-1970s.

By 850 AD, Arab traders were sending Cowries to northern Africa as ship's ballast, and then transporting them across the Sahara by caravan to

BELOW A pre-Columbian necklace from Peru, made over a thousand years ago. This beautiful necklace, sadly missing one section, was made from pieces of Pacific Thorny Oyster shell (*Spondylus princeps*). These brightly coloured shells and the artifacts created from them were revered valuables in ancient Peru. The limited tools available at the time would have made the grinding and cutting of the shell an extremely time-consuming task, performed by only a few skilled craftsmen. Found in the sea at depths of up to 18 m (60 ft), the shells were difficult to collect, and were available only in remote locations. This necklace was found in Peru's Nazca Valley, over a thousand miles from the southernmost habitat of the Pacific Thorny Oyster in the Gulf of Guayaquil in Ecuador. Similar ornaments have been discovered as far away as the Andes, a testament to their value and the wealth they represented in ancient Peru.

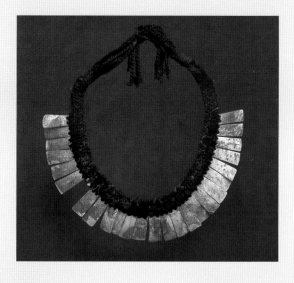

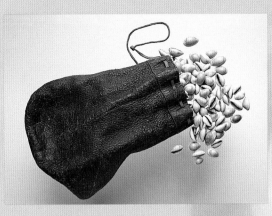

ABOVE An 18th-century merchant's leather purse, complete with the Gold-ringer Cowries (*Cypraea annulus*) he used for trading purposes. This was found in an antique shop in England in 2001, and the delighted buyer paid £130 for it.

BELOW The daughter of American Horse of the Oglala Sioux, wearing a dress covered with Indian-money Tusk shells (*Dentalium pretiosum*) as a sign of wealth.

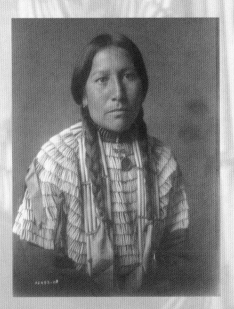

Western Africa, where their rarity gave the shells value and locals were willing to trade them for slaves, ivory, and above all, gold.

Europeans also began to ship Money Cowries into Africa in the 1500s, and the trade spread to many Central and Western African countries. By the 17th century, astronomical numbers of shells were being imported into the continent. Records from the time show that the Dutch trade, from 1669 to 1766, amounted to 4 billion 700 million Cowries. And of course the French, Portuguese and English were all doing the same thing; it is a wonder there were any Money Cowries left in the ocean.

Other facts and figures are revealing. Records from a European traveller in the early 1700s tell us that he saw Arab slave traders weigh out 12,000 pounds of Cowries as payment to an African chief for 600 slaves; that translates as 20 pounds of shells per slave. A fine elephant tusk cost 1,000 shells, and a cow was worth 2,500 shells. In India in the 19th century, a gentleman in Cuttack paid over 16 million Cowries to have his house built. And in the Congo in 1850, one chicken was worth 10 Cowries, and a bride cost 30, but fifty years later, a chicken required 300 Cowries and a bride was worth 3,500.

For four thousand years this small shell had had a giant impact on the world, but times and trade were changing. With prices fluctuating, and inflation rife, by the beginning of the 20th century Cowrie shell money had all but lost its value and ceased to function as a currency.

On the other side of the globe, when the empire of the New World was in its infancy, the small but mighty shell would prove a force to be reckoned with. The first Europeans to arrive on the shores of North America in the 15th century brought with them supplies of Money Cowries to trade with the people of the islands they hoped to find. Those early explorers must have been frustrated to find that the inhabitants of the strange land they discovered already had a shell currency of their own, and the Money Cowries were, for the most part, completely redundant. Here there were already several quite distinct shell currencies which had operated for centuries.

Native Americans used shells as valuables in different ways, according to their own tribal customs and beliefs. On the Pacific coast of North America, including coastal Canada and Alaska, Tusk shells were used as a medium of exchange. Known as Indian-money Tusks (*Dentalium pretiosum*), these small, sturdy white tubes, shaped like miniature elephant tusks, were open at both ends, making them ideal for stringing into necklaces. For currency purposes, the shells were strung in fathom (six feet) lengths. The value of a length varied according to the size and quality of the shells. On average a length held forty shells, and in the

fur-trading regions one of these would buy a fine beaver skin. A length made up of only thirty-nine shells, i.e. bigger ones, was worth double, and one of thirty-eight shells, treble. Tusk shell strings were also used for ritual payment – they could be given as a dowry or as compensation for anything from the smallest loss or injury to a killing.

The most famous North American shell money, however, was 'wampum', which had long been used by the Native American nations. The earliest reference, almost certainly describing the use of wampum, comes from the French explorer Jacques Cartier, who in 1535 wrote in his *Voyages*: 'The most precious article which they [the Hurons] possess in this world is the *esnoguy* which is as white as snow. They procure it from the shells in the river…of which they make a sort of bead which has the same use among them as gold and silver with us, for they consider it the most valuable article in the world. It has the virtue of stopping nose-bleeding for we tried it.'

Wampum consisted of purple and white shell discs, taken from the common Northern Quahog (*Mercenaria mercenaria*) and a Whelk shell (alternatively *Busycon canaliculatum* or *Busycon carica*). These were laboriously ground down into even-sized discs, which were then strung on deer sinew and laced together into handsome belts. Producing the tiny discs was painstaking and hard work, usually done by women, and the value lay in the labour required to create them. Some Indian tribes called the white discs '*Wamp-unp-eeg*', which meant 'strings of white beads', and the more valuable purple discs were called '*su-kahn-hog*'. As these names were too much of a mouthful for the colonists, they simplified matters by lumping all shell money under the shortened name of wampum.

Although it was of great value in Indian society, wampum probably only became a medium of exchange after the explorers arrived. Before then, it had an entirely different function. Native Indians used it as a means of communication. By staining the shells with various colours, and stringing them into belts using complex and often beautiful patterns, tribes were able to keep records and send messages which could register events, transactions and treaties. White beads denoted peaceful and happy occasions; purple beads recorded death, war and disaster. Each collection of belts had its custodian, a tribal historian known as 'the keeper of the wampum', who could read the language of the designs and interpret the events recorded in the belts, long after their original creators were dead and forgotten.

Wampum also took the form of cylindrical Clam shell beads worn round the neck. They had to be as smooth as china, and each bead precisely the same size. The strings were used for ceremonial

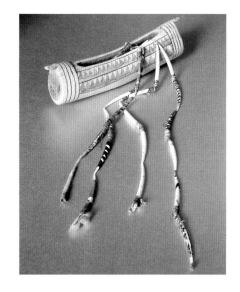

ABOVE To indicate the value attached to their strings of Indian-money Tusk shells (*Dentalium pretiosum*), the Shasta, Yurok, and Hupa Indians of northern California frequently incised the shells with intricate geometric designs. Then they wound tiny pieces of snakeskin around them, and inserted tufts of red woodpecker down or red thread into the holes. The carved elk's antler purse comes from Oregon.

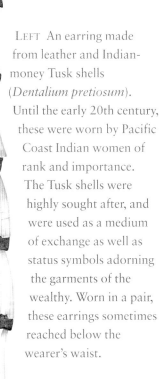

LEFT An earring made from leather and Indian-money Tusk shells (*Dentalium pretiosum*). Until the early 20th century, these were worn by Pacific Coast Indian women of rank and importance. The Tusk shells were highly sought after, and were used as a medium of exchange as well as status symbols adorning the garments of the wealthy. Worn in a pair, these earrings sometimes reached below the wearer's waist.

LEFT For the Chambri people of New Guinea's Sepik River, this necklace made from the Gold-lip Pearl Oyster (*Pinctada maxima*) was the most valuable wealth item, worth twenty Great Green Turban shells (*Turbo marmoratus*). It was used for bridewealth payments, and in ceremonial exchanges.

ABOVE RIGHT A wampum belt, made by the Algonquian people in the 18th century. It probably comes from New Brunswick in southeast Canada. Woven using purple and white shell beads from the Northern Quahog Clam (*Mercenaria mercenaria*) and one of several species of Whelk (*Busycon* sp.), the two colours of this belt act as a mnemonic device, and the design of three rectangles suggests an alliance of three groups in war.

BELOW Waist ornament made of nine sections of the Great Green Turban shell (*Turbo marmoratus*). Until recently, the Tsembaga people of highland New Guinea prized these shells over any other object. They wore them as ornaments on ceremonial occasions and exchanged them for valuable items.

purposes; they were buried with the dead, and were given as gifts. They were also worn by chiefs as an emblem of wealth and prestige, or as a badge of tribal identification. Six strings of wampum could buy a pardon for a crime punishable by death.

Once the settlers began to trade with the Indians, however, the old order changed. Recognizing that the Indians placed the highest value on wampum, the white traders pounced on it as the medium of exchange for goods they wanted, such as skins, furs, and even slaves. Wampum was declared legal tender, and in 1640, the state of Massachusetts fixed the value of wampum beads: four white or two purple equalled a penny. In the early 1700s, even a fare on the Brooklyn ferry could be paid in wampum.

Gradually, over the next hundred years or so, wampum began to decline in value as the Europeans sought ways to counterfeit it, although they struggled to match the patience, skill and speed of the Indian craftsmen and women. Eventually, and inevitably, the British and Dutch colonists imported machinery to mass-produce the shell money, and by the early 1800s it had more or less lost its value. The famous chronicler of Indian life George Catlin wrote in 1832, 'Below the Sioux, and all along the whole of our Western frontier, the different tribes are found loaded and beautifully ornamented with it, which they can now afford to do, for they consider it of little value, as the fur traders have ingeniously introduced a spurious imitation of it, manufactured by steam or otherwise, and sold at so reduced a price as to cheapen and consequently destroy the value and meaning of the original wampum.'

There were, and to a lesser extent still are, a great variety of shell currencies operating in different locations across the world. In the Oceanic islands, over seventy different types of shell money have been identified. Cone shells, Clams, Pearl Oysters, Conches, Nassa shells, Egg shells, Baler shells, Olive shells and Cowries have all exerted their power over island cultures. Many currencies are extremely localized, so that shells which have great purchasing power on one island may be a mere ornament on the next, a status symbol on a third, and of value only for ceremonial payments on the fourth.

For the Baegu people of Malaita Island in the Solomon Islands, shell money remains an essential part of society. Baegu elders, who control the wealth, insist that ritual services must be paid at least partly in strings of tiny coloured shell beads woven into armbands and belts. Even if a quantity of paper currency is amassed by a Baegu,

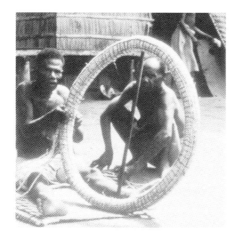

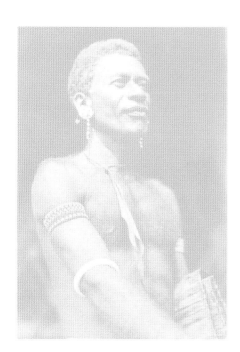

ABOVE A huge coil of Tabu money, in East New Britain, New Guinea. When it is finished, this coil of tiny Camel Mud Nassa shells (*Nassarius camelus*) will probably measure more than a mile, contain many thousands of shells, and be worth a considerable sum to its owner. However, these coils are only a store and display of wealth; the owner cannot use them for everyday purchases. In this form, his coiled Tabu will be displayed at all festivals, but can only be dismantled and distributed at his own funeral.

ABOVE RIGHT A short length of Tabu, the traditional shell currency still used today by the Tolai of East New Britain, in New Guinea. It is made up of pierced Camel Mud Nassa shells (*Nassarius camelus*) threaded onto rattan.

he cannot exchange it for shell valuables, and his traditional shell money, called *tafuliae*, is still used in ceremonial exchanges, as compensation, and in gift-giving.

Perhaps the most interesting of all today's surviving shell currencies is 'Tabu' of East New Britain, one of the islands of New Guinea. Tabu is made using small Camel Mud Nassa shells (*Nassarius camelus*), which are broken in such a way that they can be threaded on to strings of rattan. For the Tolai people living in the Gazelle Peninsula, Tabu represents a way of life, and nowhere else in the world has a money-form so shaped and dominated the lives of its inventors. Despite the availability of the Kina (the official metal currency), the Tolai people remain true to their traditional beliefs and customs concerning the use of Tabu, and this is accepted by government authorities. The Tolai's daily transactions are conducted using Tabu; court fines, council taxes and even school fees can be paid in Tabu, and the first shell money exchange bank opened in the area at the start of the 21st century. More are expected to follow. In 2002, a study by the provincial government found that 'an estimated equivalent of over US$2 million worth of shell money is sitting in family homes throughout the Gazelle Peninsula.' It is not gold, silver or diamonds that represent a standard of value in this society; it is, as it has always been, the modest shell.

LEFT Shell money from Malaita Island in the Solomon Islands. Known locally as *tafuliae*, this consists of tiny beads carved from four different shells, which are threaded and woven into armbands and belts. The red beads, *romu*, are made from the Large Pacific Jewel Box shell (*Chama pacifica*); orange beads, *kee*, from the Half-round Cardita (*Beguina semiorbiculata*); black beads, *kurila*, from the Indo-Pacific Pen shell (*Atrina vexillum*); and the strong white beads, *kakadu*, from the Granular Ark (*Anadara granosa*). Most of the painstaking labour to produce these beads is undertaken by women, and is often their sole source of income.

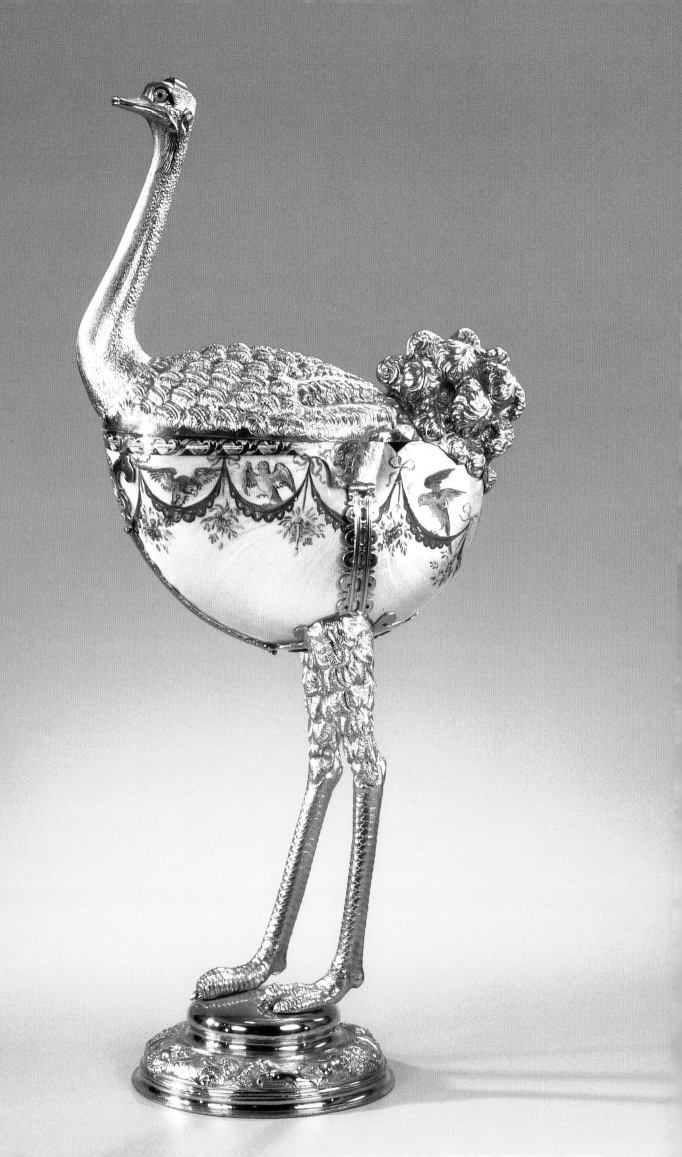

OPPOSITE A Nautilus cup (*Nautilus pompilius*) made in early 17th-century Holland. The shell has been cut to the shape of the ostrich's body, and is painted with floral garlands and birds in flight. The upper part of the body and the legs are silver-gilt, an amethyst has been placed on the head, and the eyes are of ivory. The lid can be removed. This cup would have been placed on the table on special occasions, and possibly even used as a drinking vessel.

BELOW A decorative German drinking vessel in the form of a jewelled partridge, made by Jörg Ruel in Nuremberg around 1600. With feathers formed from carved plaques of mother-of-pearl, and studded with rubies and emeralds, this exquisite object would have been intended purely as a work of art, and would have had pride of place in a princely *Schatzkammer* or Treasury.

CARVED SHELLS

I believe the right question to ask, respecting all ornament, is simply this: Was it done with enjoyment – was the carver happy while he was about it?

John Ruskin, *Seven Lamps of Architecture*, 1849

The art of carving goes back at least 15,000 years, to the time when our early human ancestors took flints and scratched the first primitive signs and symbols into rock. Known as petroglyphs, these markings constituted a new form of communication. Since that time, carvers have chipped, chiselled and engraved symbolic forms and decorative images onto all kinds of materials, marrying nature's gifts with fertile human imagination and skill.

Shells may be limited in scale, but they are an ideal and highly versatile medium for carving. Many shells are strong enough to withstand the pressure of cutting tools, yet soft enough to be obligingly workable. Shells have been carved, incised, pierced and filed into beads, earrings, pendants and bracelets. Shell jewelry has been worn as talisman and fetish, amulet or symbol of wealth. Shells have been painstakingly shaped into tiny pieces of mosaic for delicate inlay work, and master craftsmen have carved intricate relief designs onto larger shells, producing work of sometimes exquisite genius.

The skills of shell carving go back millennia. In the 1920s, archaeologist Leonard Woolley excavated a series of royal tombs of the Sumerian kingdom in the Biblical city of Ur in Babylonia (now Iraq), dating from around 2500 BC. He unearthed a cache of spectacular treasures, including several beautiful ornaments and musical instruments inlaid with shell that testified to the sophistication of this ancient culture. Sumerian craftsmen decorated wooden objects by cutting a design

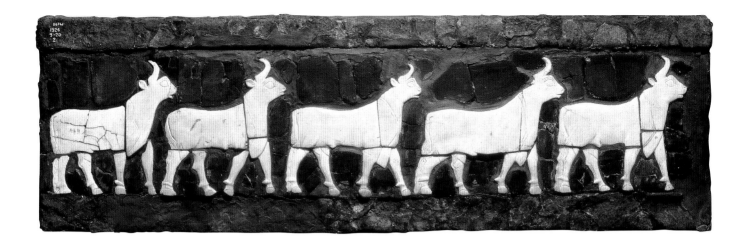

from the shell, cutting the same form out of the wooden setting, then lining the surface, including the setting, with bitumen. Once the shell inlay was inserted, the bitumen hardened to form the background and glue. This method of inlay was practised throughout Asia and Asia Minor up to and beyond the Ottoman period. In a refined form, it is still used by artisans today.

With its lustrous sheen and iridescence, mother-of-pearl is a material unique to shells with no equal as a medium for carving: there are literally thousands of examples of its religious, symbolic and decorative use through the millennia and across the world. It is used as inlay, on jewelry and in a dazzling variety of decorative ways to adorn luxury goods, furniture and architecture. In Muslim countries it radiantly embellishes religious as well as secular buildings, and it is just as beautiful on the prow of a Polynesian canoe as on the handles of a set of silver cutlery. Its versatility and popularity are truly global,

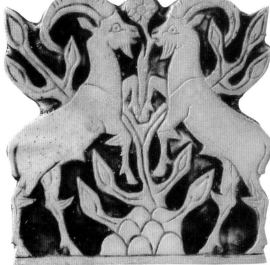

and humankind shows no sign of tiring of it today.

Mother-of-pearl is also known as nacre, a word derived from the Arabic word *naqqarah*, meaning shell; it was not until the 16th century, during the reign of Queen Elizabeth I of England, that it acquired its common English name. It is formed of crystals of calcium carbonate and a protein called conchiolin. These are secreted by the mantle of the mollusc as it lays down the layers of its shell. This nacreous inner layer smoothes the shell itself and defends the mollusc against parasitic organisms and alien intrusion. Its iridescence comes from the crystals from which it is formed, which create prismatic mirrors that split and reflect light. Mother-of-pearl appears in a range of colours, from white to black, and nearly every other colour in between. The colour is determined by three factors: genetic make-up, food and trace metals in the water, and to a lesser extent, depth and salt content of the water.

OPPOSITE ABOVE A frieze from the Temple of Ninhursag, Tell al-'Ubaid, close to the Sumerian city of Ur, *c.* 2600 BC, 22.2 cm (8¾ in.) high. Ninhursag was a mother goddess whose name means 'lady of the steppe land', where cows were put out to pasture. Appropriately, therefore, her temple was decorated with bulls and cows. This panel was made of wood covered with strips of copper secured with copper nails. The main area was coated with bitumen, into which the shell figures were pressed. The bulls were made from one piece of a Giant Clam (*Tridacna* sp.), with the legs and head carved separately.

OPPOSITE BELOW Shell plaque, *c.* 4.5 cm (1¾ in.) square, found in the grave of Queen Pu-abi in the Royal Cemetery at Ur, *c.* 2600–2400 BC. The shell used to carve this scene of two browsing goats may have been a Giant Clam from the *Tridacnidae* family. The carving is believed to have been part of the decoration of a lyre or harp.

THIS PAGE Clockwise from top left: Gold-lip Pearl Oysters (*Pinctada maxima*), Black-lipped Pearl Oyster (*Pinctada margaritifera*), and Commercial Trochus (*Trochus niloticus*). These shells are all harvested for their mother-of-pearl.

Most molluscs are capable of making mother-of-pearl, but only relatively few shells contain it in any quantity. Two of the best-known species are the Black-lipped Pearl Oyster (*Pinctada margaritifera*), found in the Indian and Pacific Oceans as far east as the Persian Gulf and as far west as the Gulf of California; and the Gold-lip Pearl Oyster (*Pinctada maxima*). This second shell, the largest of the Pearl Oysters, has been harvested for more than a hundred years in the South Pacific, and is the mainstay of the Australian, Japanese and Philippine cultured pearl industries, its shell providing the commercial market with high-quality mother-of-pearl. The Akoya Oyster (*Pinctada fucata*), farmed in Japan for its pearls, is also exported worldwide for its mother-of-pearl. Commercial farming in the 20th century has fostered an expansion of certain previously uncommon species, including the Atlantic Pearl Oyster (*Pinctada imbricata*). The La Paz Oyster (*Pinctada mazatlanica*), coming from the waters of Panama and California, is also now cultured and its mother-of-pearl used extensively.

Mother-of-pearl buttons are most frequently made from the robust Commercial Trochus (*Trochus niloticus*), a species abundant in the Indian and Pacific Oceans, where it occurs naturally in some areas and has been artificially introduced in others. And of course the Abalone shell (*Haliotis* sp.) has provided the world for hundreds of years with its radiant colouring, quite different from any other mother-of-pearl shell. Several species of Abalone are traded commercially today, including the Green Abalone (*Haliotis fulgens*) from the Gulf of California, the Rainbow Abalone or Paua (*Haliotis iris*) from New Zealand, and the Red Abalone (*Haliotis rufescens*) which occurs naturally in waters from Oregon to Baja California.

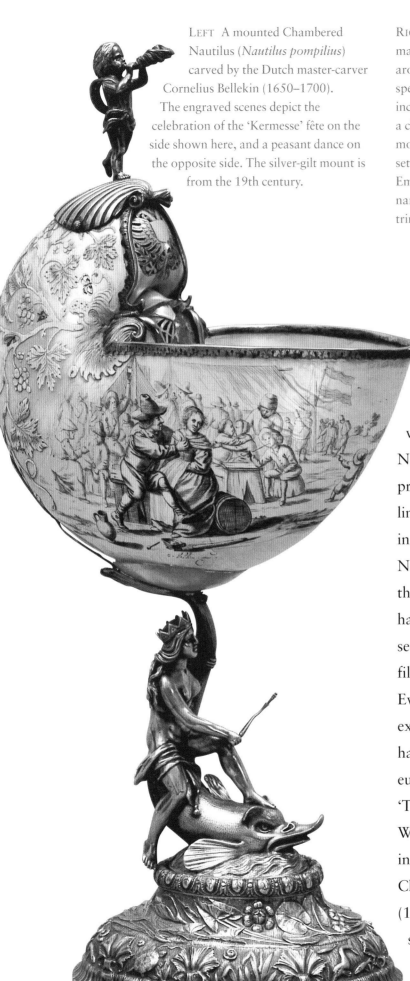

LEFT A mounted Chambered Nautilus (*Nautilus pompilius*) carved by the Dutch master-carver Cornelius Bellekin (1650–1700). The engraved scenes depict the celebration of the 'Kermesse' fête on the side shown here, and a peasant dance on the opposite side. The silver-gilt mount is from the 19th century.

RIGHT A bottle in the form of a pilgrim's flask, made by goldsmith Jörg Ruel in Nuremberg around 1598–1602. Ruel's prolific workshop specialized in drinking vessels that frequently incorporated exotic shells. This bottle on a chain includes unusually large disks of mother-of-pearl on the front and back, set in finely pierced silver-gilt borders. Emeralds embellish the bottle's narrow sides and the central trim on the pearl disk.

If just one mother-of-pearl shell were to be singled out as the greatest source of artistic and poetic inspiration over the centuries, it would surely be the breathtaking Nautilus (*Nautilus* sp.). Once dominating the prehistoric seas of the world, this genus is now limited to fewer than half a dozen species, all found in the southwestern Pacific. The inhabitant of the Nautilus shell is a cephalopod, the class of molluscs that includes the shell-less octopus and squid. It has about ninety tentacles, and lives in the outer section of the shell only, reserving the rest as gas-filled chambers that keep it balanced in midwater. Ever since its introduction to the West by explorers returning from the Pacific, the Nautilus has drawn the admiration of artists and been eulogized by writers. It was the subject of the poem 'The Chambered Nautilus' by American Oliver Wendell Holmes (1809–94), and inspired a passage in the epic poem *Canto General* by Nobel-winning Chilean Pablo Neruda (1904–73). Jules Verne (1828–1905) famously named Captain Nemo's submarine *Nautilus* in his science-fiction adventure novel *20,000 Leagues Under the Sea*.

To European master carvers of the 17th century, the Nautilus was the most fabulous of all shells to decorate. In its natural state, it is creamy white with broad, rusty brown stripes. But underneath this outer layer is hidden brilliant mother-of-pearl; perfect material for the carver. To 'pearlize' the shell, it was soaked in acid for ten to twelve days, after which the external coating could be scoured off. The stripped shell was then polished with diluted alcohol until the beautiful lustre of the mother-of-pearl emerged. After a final rinse in soapy water, the shell was ready for carving. But despite its magnificent size and shape, it was still immensely fragile and liable to shatter, so that not only patience and skill but an extremely delicate touch were required of the carver.

Nautilus shells had been carved by the Chinese long before they reached the West, and the master carvers who emerged in the 17th century were most likely inspired by examples created under the Ming Dynasty during the 15th and 16th centuries. But craftsmanship in Europe, particularly in Holland, now reached new heights of design and detail, most notably in the work of the Bellekin family. Their carved shells were among the objects most coveted by wealthy collectors; they were expensively mounted as cups in silver or gold, and affectionately described as 'ships of pearl'.

The Nautilus was not the only shell to provide the Chinese with its coveted mother-of-pearl. Centuries before the birth of Christ, it was discovered in China that if tiny figures of deities were slipped between the soft mantle and the shell of a living bivalve mollusc, the freshwater Mussel *Cristaria plicata*, the figures soon became coated with a thin layer of mother-of-pearl (see page 38). Small effigies created in this way were taken to the temples and offered to the gods in the hope that they would bestow good fortune upon the donor.

Like jade, mother-of-pearl was for centuries held in high status in Chinese society, and became associated with stories of gods and mythical creatures. It was used in profusion as a decorative inlay on ornaments,

LEFT The Frewen Cup, an English 17th-century engraved Chambered Nautilus shell (*Nautilus pompilius*), depicting other sea shells and fish. The silver-gilt mount has a floral decoration on the base, and the lid bears a man riding on the back of a sea creature or whale, with a chain in its mouth (not shown), allowing the cup to be carried. The maker's mark is John Plummer, from York, and the hallmark is dated 1660–61.

and in more recent times, on Chinese and Korean furniture. Other ancient cultures equally admired the lustrous qualities of mother-of-pearl. Combining a fearsome predilection for war and human sacrifice along with a tradition of fine artistry, the ancient civilizations of Central America have bequeathed a rich legacy of monumental architecture, carvings and artifacts. Among the many treasures from the Maya, Toltec and Aztec cultures discovered by archaeologists are ornamental jewelry, sacrificial items and ceremonial and burial masks inlaid with mother-of-pearl and carved shell. Even the knives used in ritual human slaughter were elaborately decorated and delicately inlaid.

Medieval Europeans were also captivated by mother-of-pearl, and religious ornaments carved from pearl shell were common. During the Renaissance, public demand soared to such a degree that by the 1500s, the supply of shells from the Persian Gulf was more or less exhausted. To replace it, pioneering maritime explorers discovered a new species of pearl oyster in the Pacific. The Black-lipped Pearl Oyster (*Pinctada margaritifera*) fulfilled the growing desire for jewelry and decorative ornaments in mother-of-pearl. Boasting colours that ranged from grey to green, with blue or rose overtones, and larger than any mother-of-pearl shell yet seen, it surpassed the beauty of any of its known counterparts. With the opening of new trade routes throughout the world, particularly to Asia, the Pacific witnessed a rush of European traders keen to profit from its wealth of mother-of-pearl. They acquired it in its natural, uncut state, to bring back to the craftsmen who were flourishing in Holland, Germany, France and Italy. The nobility and the wealthy in Europe also commissioned decorative pieces from India for their cabinets at home. The workshops in Gujarat crafted some of the finest carved shellwork in the world in the 16th–18th centuries.

From the early 18th century, a flourishing trade in mother-of-pearl gaming counters developed between Canton in China and Europe and North America. These flat counters were produced in a variety of shapes, and were carved in China according to the wishes of the commissioning client. Some had simple designs,

ABOVE LEFT From the 1300s, for hundreds of years, the Chinese placed small clay or metal representations of the Buddha or deities between the mantle and shell of the freshwater Mussel *Cristaria plicata*. These figures eventually became covered with a thin layer of mother-of-pearl, and the small effigies were cut out and presented as offerings at temples.

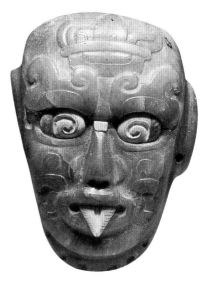

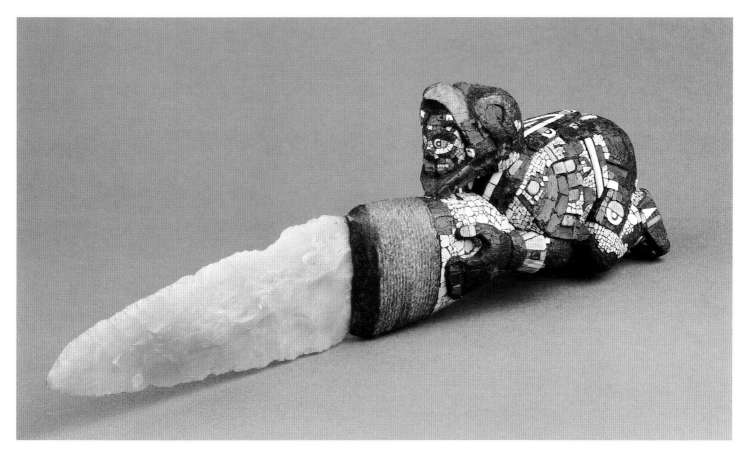

TOP LEFT A pair of 7th–8th century AD Maya earflare ornaments from Guatemala, carved from an unknown species of shell. Despite their small size – 5.7 cm (2¼ in.) high – the carving shows considerable detail, including the flattened profile of the Maya head, and dental modifications. The motif on the forehead is unclear, but it could be an ornament through which a lock of hair is threaded.

TOP RIGHT A Maya mask of the rain god Chaak, Mexico, c. 250–550 AD. It is carved in greenstone, with eyes and tongue of an unidentified white shell and red Pacific Thorny Oyster (*Spondylus princeps*).

ABOVE An Aztec sacrificial knife with mosaic handle from Mexico, 15th–16th centuries AD. The blade is made from chalcedony. The handle, representing an Eagle Knight, one of the Aztec military orders, is in wood inlaid with turquoise, malachite and four different unidentified shells coloured white, pink, purple and orange, as well as mother-of-pearl. These knives were used by Aztec priests to cut out the hearts of live human sacrificial victims.

LEFT AND BELOW Mother-of-pearl gaming counters in a range of shapes popular in Europe and North America in the 18th and 19th centuries. The fish were particularly favoured by ladies who enjoyed competitive card games. In *Pride and Prejudice*, Jane Austen tells us that Lydia 'talked incessantly… of the fish she had lost and the fish she had won.'

OPPOSITE Hand-carved mother-of-pearl buttons from men's costumes of the 18th and 19th centuries. These were probably made in England.

while others were elaborately engraved on one side with scenes of Chinese life, and on the other with the owner's armorial crest or initials. The shapes represented different units, and the value of the counters was decided by participants prior to play. In 1777, in his *Diary of a Country Parson*, Parson Woodforde recorded playing quadrille at one penny per fish, while Sarah, Duchess of Marlborough wrote of playing quadrille for half a crown per fish. Occasionally counters were bought in numbered sets; typically a rectangular or shuttle-shaped counter was valued at one, a circular counter at five, and a square or oval at ten.

The Chinese used the best shell species for the manufacture of gaming counters, in particular the Gold-lip Pearl Oyster (*Pinctada maxima*) which they imported from the Persian Gulf. The removal of the hard outer layer involved an arduous grinding process. The counters were flat and extremely thin, typically 1.3 mm ($\frac{1}{20}$ in.), and designs were shallow carved and engraved. Goat's milk was used to give them a final polish.

In the last two centuries, mother-of-pearl has provided the raw material for an entirely different industry, which at its height employed many thousands of people. In the United States and Europe, mother-of-pearl buttons became highly fashionable in the 19th century. They were used to fasten bodices, boots, gloves and waistcoats, and the fashions of the day often demanded dozens of buttons on each garment. Mechanization allowed production on an industrial scale, and billions of buttons were made. In the US, the German button maker John Boepple (1854–1912) pioneered the use of the shells of freshwater Mussels to make buttons, and in 1889 he opened the first of sixty factories in Iowa on the banks of the Mississippi, from where the Mussels were harvested. The best buttons were made from varieties known locally as Pistolgrip (*Tritogonia verrucosa*), Three-ridge (*Amblema plicata*) and Yellow Sandshell (*Lampsilis teres*). In Birmingham, England, up to 5,000 people were employed making buttons in the 1890s, and in one factory alone, ten million were produced every year.

The mother-of-pearl button industry declined almost to extinction in the 20th century, partly as a consequence of over-fishing of mother-of-pearl shells, but also because imports ceased during the two world wars. The advent of mass-produced cheap plastic substitutes made matters worse. However, the outlook in the 21st century is more positive. The growth of the pearl-farming industry in Asia and the US, and a renewed taste for authenticity, craft and natural materials, have given the mother-of-pearl button a new lease of life, and it is now as popular as it ever was.

A wholly different carved shell tradition also has a rich history of its own. The cameo first made its appearance in Alexandria, Egypt, the city founded by Alexander the Great in 332 BC. In the ancient world, cameos were made not from shell but from precious stone. They were inspired by the introduction from India and Arabia of a very special kind of stone, multi-layered sardonyx. Using carving techniques imported from the Orient, the ancient Greeks found that they could produce very effective relief designs in which one or more strata of the stone provided one or more colours, the light upper layer of the stone standing out boldly against the contrasting darker layer underneath. Favourite subjects for cameo carving were sensuous portraits of gods and goddesses, mythological animals, and historic scenes. Besides sardonyx, a variety of different stones were used: chalcedony, carnelian, agate, and most popularly, onyx.

The art of cameo carving flourished throughout the ancient world, but with the fall of the Roman Empire came a decline in the skills of workmen in all the arts. It was over a thousand years before gem carving and engraving were revived, amid the renewed appetite for learning, luxury and the refinements of life that marked the European Renaissance. So too was the art of cameo carving rediscovered, its finest examples destined for the cabinets of curiosities in which the most sophisticated collectors of the day displayed their exotic treasures (see pages 104–5).

In 16th-century Europe, however, there was a scarcity of layered stone suitable for carving cameos, and other possibilities had to be investigated. This search led to the discovery that some shells offered the necessary layers of different colour. What's more, they were found to be a perfect medium for carving, requiring the simplest of hand tools. Yet their market value matched that of their precious gemstone counterparts. European shells generally were not suitable for cameo carving, so cameoists working in France and Italy relied on shells brought back by traders from the Pacific, Indian Ocean and Caribbean. These shells did not come cheaply, and by the time they had been carved and mounted, only the wealthiest of clients could afford them.

A number of shells were used by the cameoist. The largest shell commonly carved was the Emperor Helmet (*Cassis madagascariensis*), sometimes up to 30 cm (12 in.) or more in length, with a thick outer wall and a dark brown interior. Also known as the Sardonyx shell, it looked like sculpted marble when it was carved. Native to Florida and the Bahamas, this shell was originally thought to come from Madagascar, whence its Latin name. More commonly used in cameo carving was the smaller Bullmouth Helmet (*Cypraecassis rufa*) from East Africa. Measuring around 15 cm (6 in.), this contains layers that vary in colour from pale orange to deep brown. Another shell from the same family was the King Helmet shell (*Cassis tuberosa*) from the Caribbean, with colours of white and brown. Among the Cowries, the most commonly used was the Tiger Cowrie (*Cypraea tigris*) from the Indo-Pacific, with a brown spotted and white external layer, and white middle layer and a brown inner layer. The Panther Cowrie (*Cypraea pantherina*) from the Red Sea had a dark brown and white mottled exterior, a white middle layer and a dark brown inner layer.

Cameos finally found widespread popularity during the neoclassical revival in Europe of the late 18th and 19th centuries, when fashionable taste turned against the ornate Rococo decoration of the first half of the 18th century in favour of the classical 'Empire' style. Cameos, as carvings in relief, were classed almost as miniature sculptures. They provided a perfect vehicle for the revival of classical themes, and flourished as an art form. No longer the exclusive province of collectors and patrons of the arts, cameos were now designed to be worn, and they became fashionable items of jewelry. Emperor Napoleon I chose a crown decorated with cameos for his coronation in December 1804, the Empress Josephine delighted in them, and they were a particular favourite of Queen Victoria, which greatly increased their popularity in England.

By the end of the 19th century, taste had moved on again, this time from the classical to the

Top A shell cameo portrait of Christian IV, King of Denmark, framed in a gold mount. This was made in northern Europe, *c.* 1645.

Centre French cameo depicting Androclus and the Lion, dating from the 16th century. The carving is crude in comparison with later examples, but this piece is important as an early incidence of shell being used in cameo carving. It formerly belonged to the Duc d'Orléans in Paris, 1787.

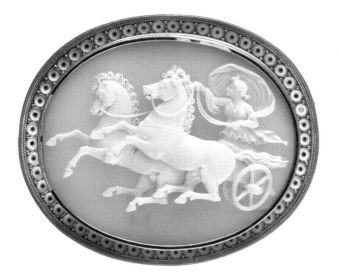

LEFT A 19th-century cameo brooch showing Aurora, the Roman Goddess of Dawn, driving her *biga*, a two-horse chariot. The border motif is made up of twisted wire circles inlaid with white and dark blue enamel.

BELOW A shell commesso of Queen Victoria, made in France in 1851. It shows the young queen with a crown, gold chain and ermine cape. This brooch in the style of a cameo is in fact made from separately carved pieces collaged together and adorned with gold and gems.

new aesthetic of romanticism. But cameos were still produced. Mythological figures continued to be the favourite subjects, but now they were reinterpreted in a more sentimental style, and became decidedly more coy and docile.

The wars of the 20th century brought a decline in the availability of imported raw materials. Suitable shells were hard to come by, and cameos fell out of fashion. Cameo carving became something of a languishing art. It also faced a good deal of competition with the widespread manufacture of ceramic and plastic versions. When the invention of the ultrasound carving machine made possible mass production, a decline in individual artistry was inevitable.

Fortunately there is always a demand for fine jewelry produced by the skilled craftsman. Today, along with a thriving market in antique cameos, there is also a continuing demand for the hand-crafted workmanship of the cameoist. The undisputed world centre of cameo carving is a small town in Italy called Torre del Greco, near Naples, where workshops were first set up in the 18th century. From the ranks of the craftsmen there emerged a new class of artists and engravers,

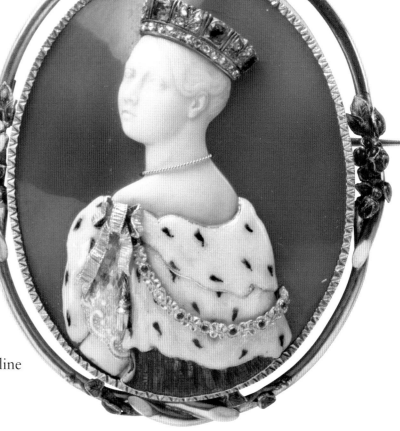

and their supremacy heralded the opening in the town of a school for the manufacture of cameos in 1878. Since that time, Torre del Greco and cameo carving have been intertwined, and out of a population of 100,000, at least 5,000 people are now employed in the cameo carving industry. Here business is still as brisk as it was two hundred years ago.

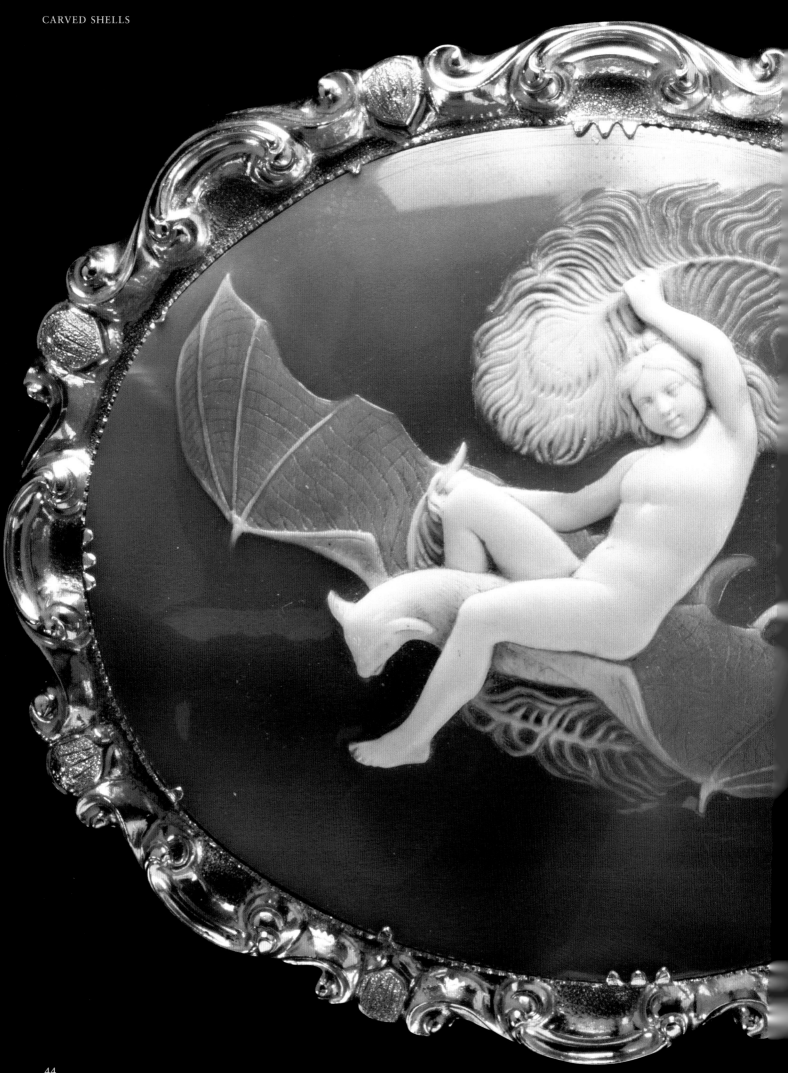

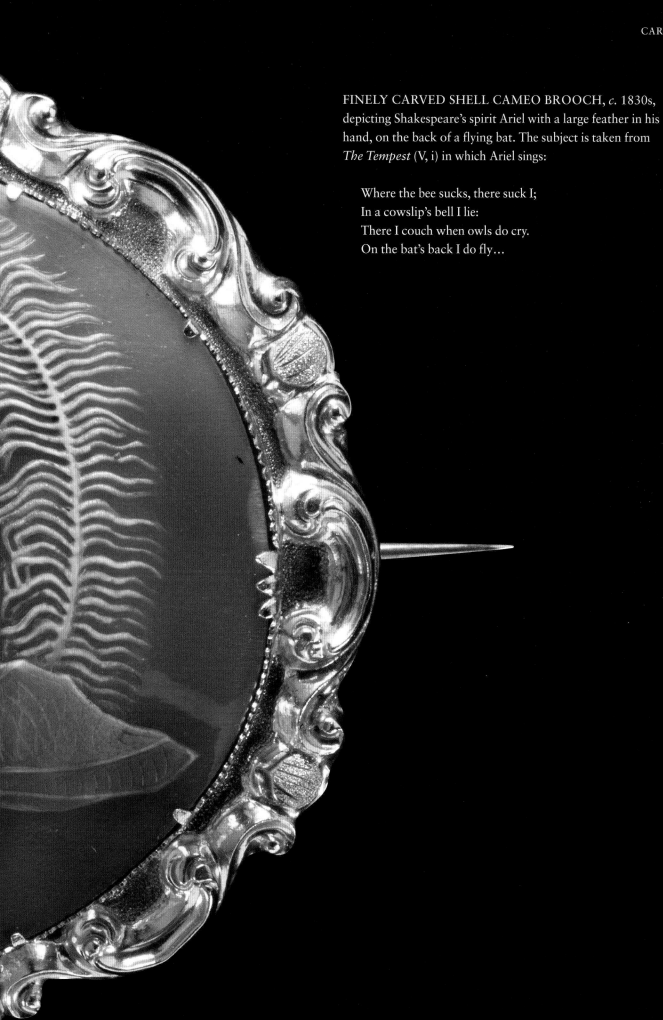

FINELY CARVED SHELL CAMEO BROOCH, *c.* 1830s, depicting Shakespeare's spirit Ariel with a large feather in his hand, on the back of a flying bat. The subject is taken from *The Tempest* (V, i) in which Ariel sings:

Where the bee sucks, there suck I;
In a cowslip's bell I lie:
There I couch when owls do cry.
On the bat's back I do fly…

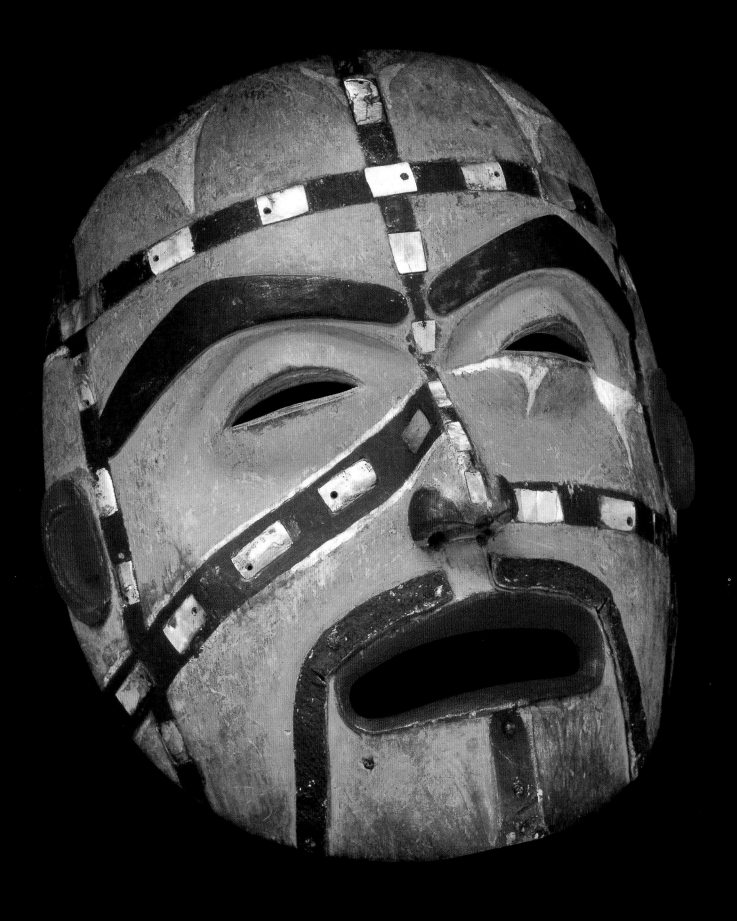

HEILTSUK MASK OF THE MOON portrayed as a
person, from *c.* 1850. The face is decorated with Abalone
(*Haliotis* sp.). The Heiltsuk people have lived for centuries
in what is now the central coast of British Columbia, Canada.
Formerly known as the Bella Bella Indians, they have their
own language and traditions.

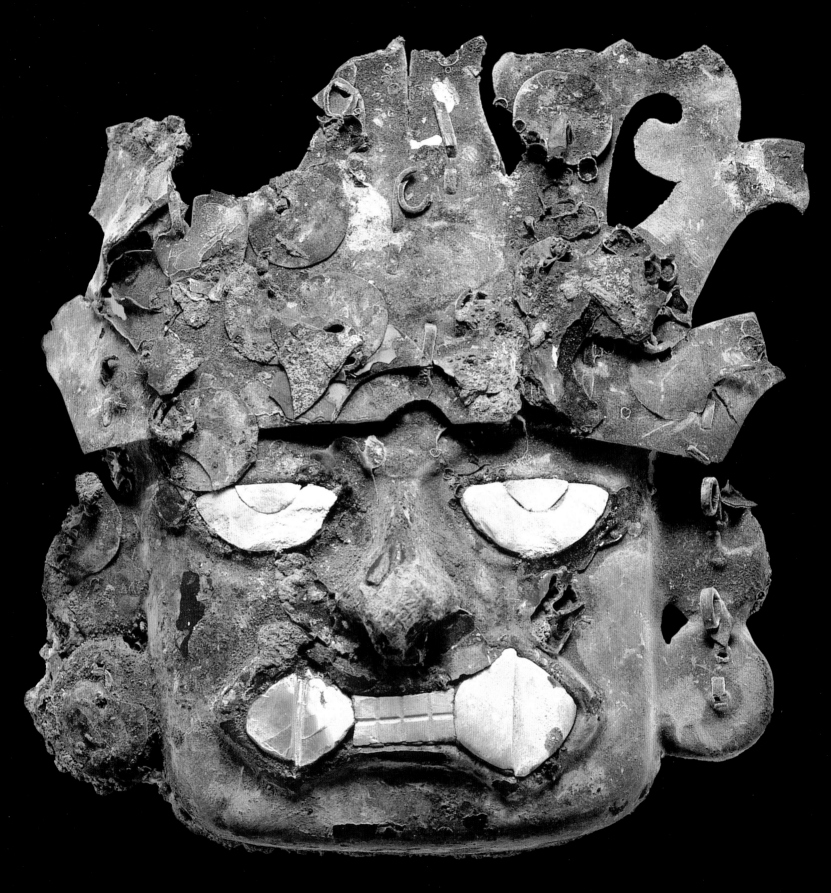

MOCHE ORNAMENTAL MASK from the 1st–3rd centuries AD. Found at Loma Negra, an ancient cemetery in Peru's Piura Valley, this was one of a large number of burial offerings discovered in an area where powerful Moche rulers had been interred. Made of silvered copper, the mask has eyes and a fanged mouth in carved shell. It depicts a deity known as 'the decapitator'. Full representations on ceramic and architectural reliefs show this god holding a ritual cutting knife in one hand and a severed human head in the other.

47

FRAGMENT OF A LARGE CARVED CONE SHELL
(*Conus* sp.) from Collingwood Bay, on the northeast coast
of New Guinea. This was found in a shell midden believed
to be several hundred years old.

CHIEF'S ORNAMENT or wealth item called a *barava*,
from Choiseul in the Solomon Islands, 19th century.
These beautiful objects were carved from the Giant Clam
shell (*Tridacna gigas*), and this example is 37.5 cm (14¾ in.)
high. Traditionally, a *barava* was ritually broken over the
grave of the dead chief. Surviving examples are therefore
rare and very valuable.

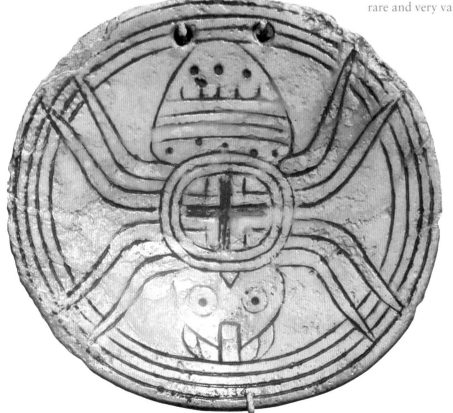

SHELL GORGET OR NECK
ORNAMENT from the Mississippi
culture of North America,
c. 1200–1600 AD. Carved out of a
Conch shell from the *Strombidae*
family, this gorget depicts a water
spider, the legendary bringer of fire
to mankind.

INCENSE CONTAINER from the Koryô dynasty,
10th–12th century Korea. During the Koryô period,
lacquerware with mother-of-pearl inlay (*najôn ch'ilgi*)
reached a peak of technical and aesthetic achievement and
was widely applied to Buddhist ritual implements, as well
as horse saddles and royal carriages. This rare tiered box,
4.1 cm (1⅝ in.) high by 10.2 cm (4 in.) long, is inlaid with
mother-of-pearl and painted tortoiseshell on a black lacquer
ground, producing an intricate pattern of chrysanthemums
and foliate scrolls.

Right
INLAID SWORD from Belau, Micronesia. This was given
to Captain Henry Wilson when he stayed in the Palau
Islands (now known as Belau) in 1783 after the shipwreck
of his East India Company packet *Antelope*. Tradition
required the exchange of gifts with the Palauans. This richly
decorated shell-inlaid sword was probably not made as a
weapon but had a ceremonial function.

Far right
MOSAIC COLUMN from the Temple of Ninhursag, Tell
al-'Ubaid, southern Iraq, *c.* 2600–2400 BC. This was found
in 1919, close to the remains of the city of Ur, at the foot
of a mud brick platform which had originally supported a
temple dedicated to the goddess Ninhursag. Formed from
palm logs, the 115 cm (45¼ in.) column was covered with
a coating of bitumen, against which were pressed tesserae
of mother-of-pearl, pink limestone and black shale. Each
small piece of mosaic had a copper wire passed through a
loop at the back of it, and the ends were twisted into a ring.
The wire was then sunk into the bitumen, which hardened,
fixing the mosaic in place.

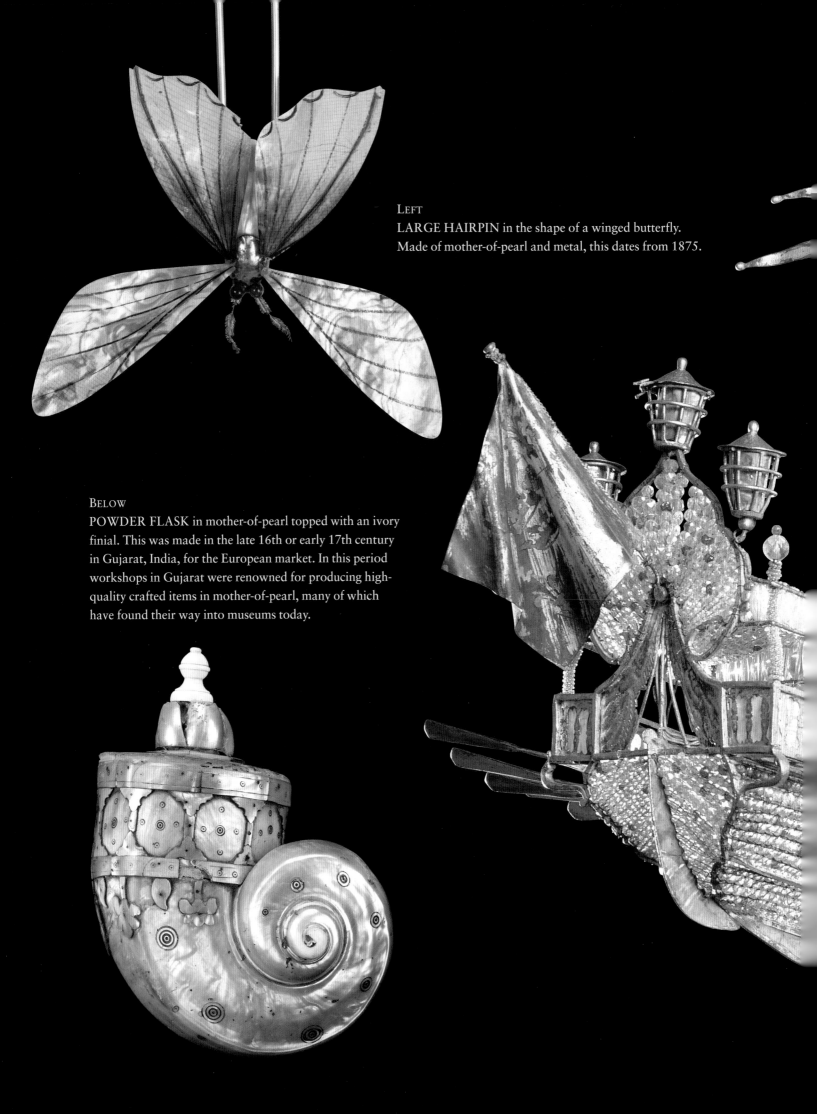

LEFT
LARGE HAIRPIN in the shape of a winged butterfly.
Made of mother-of-pearl and metal, this dates from 1875.

BELOW
POWDER FLASK in mother-of-pearl topped with an ivory
finial. This was made in the late 16th or early 17th century
in Gujarat, India, for the European market. In this period
workshops in Gujarat were renowned for producing high-
quality crafted items in mother-of-pearl, many of which
have found their way into museums today.

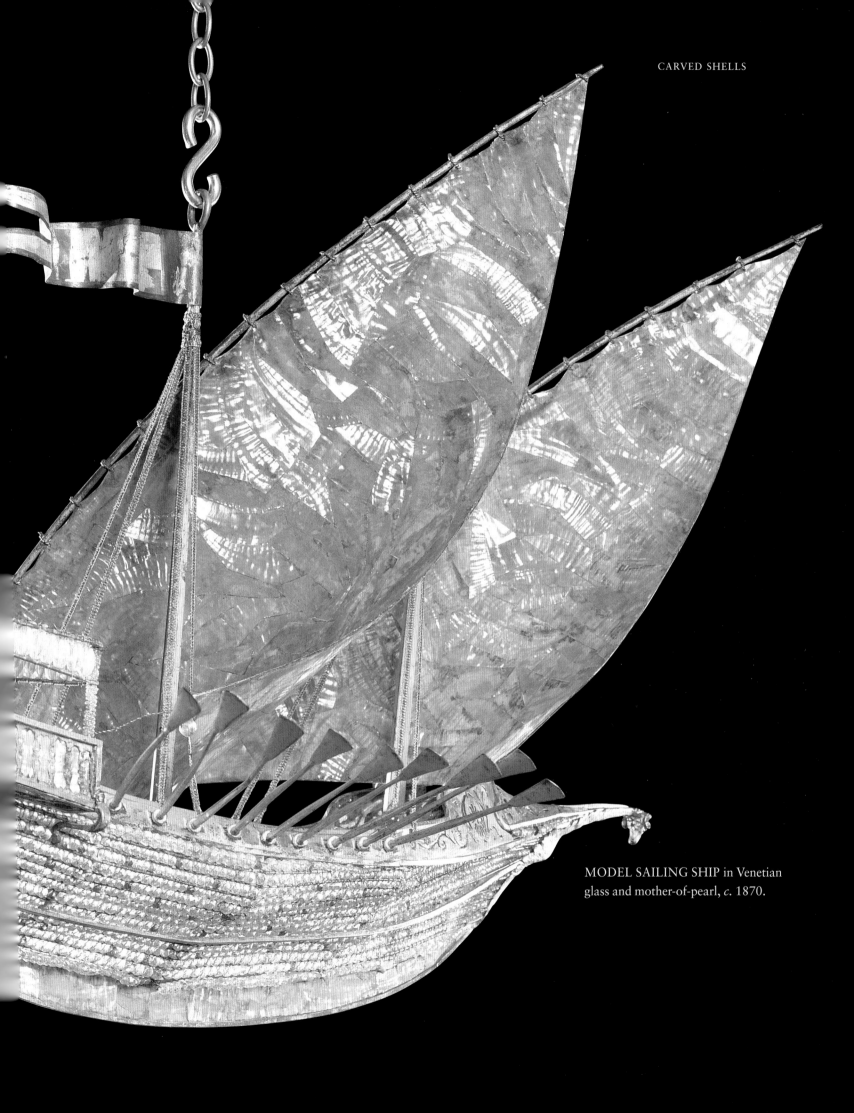

MODEL SAILING SHIP in Venetian
glass and mother-of-pearl, *c.* 1870.

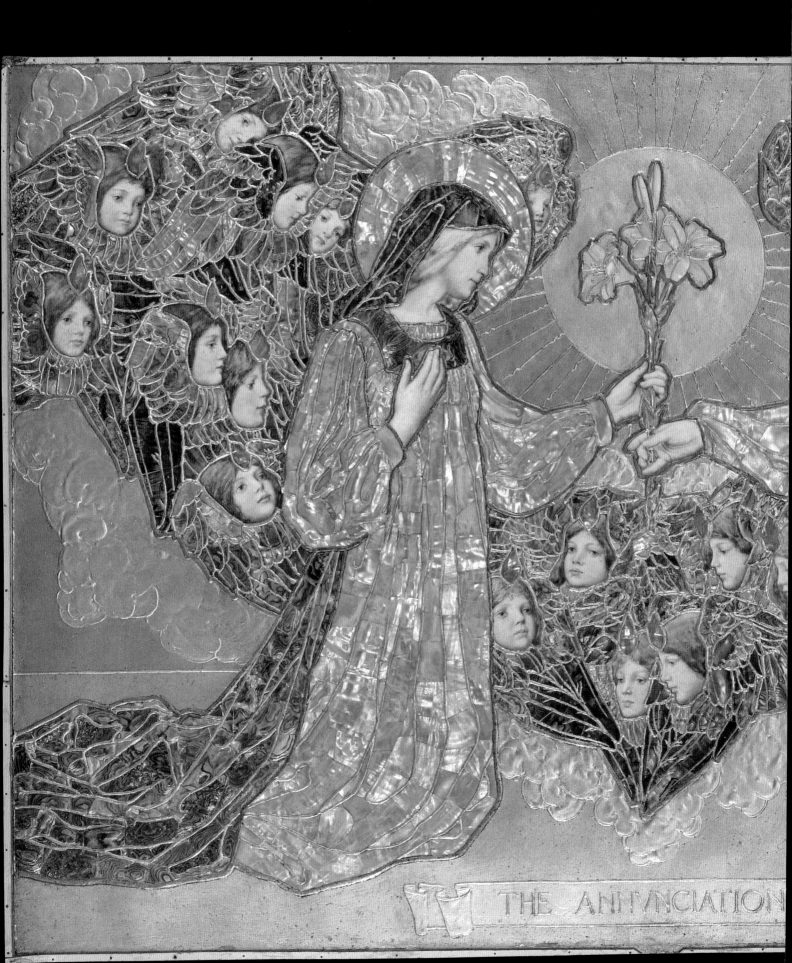

THE ANNVNCIATION

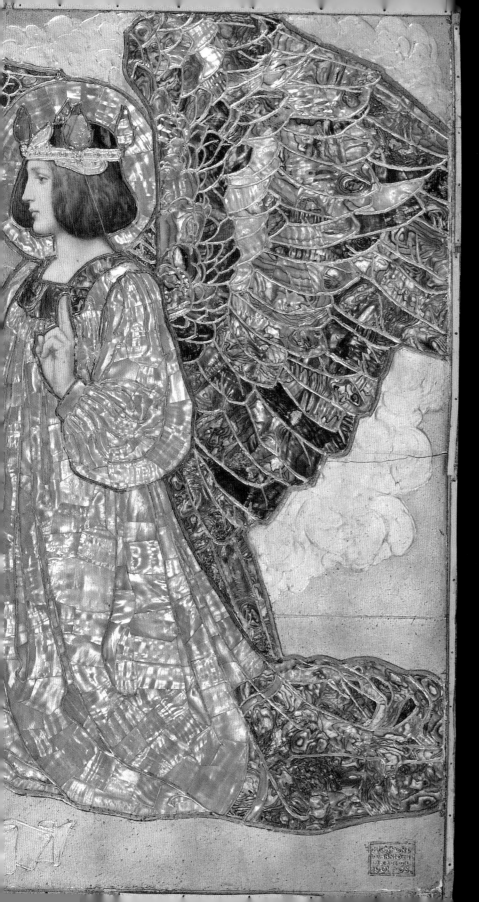

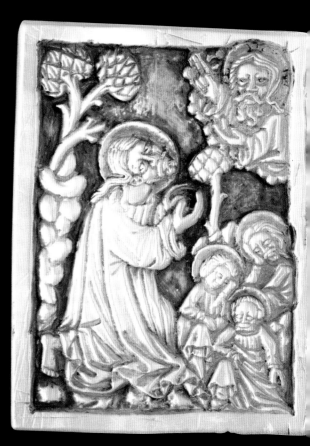

LEFT
THE ANNUNCIATION by F. Pickford Marriott
c. 1901–3. Gilt gesso panel inlaid with Abalone
(*Haliotis* sp.) and mother-of-pearl (unknown species).

ABOVE
THE AGONY IN THE GARDEN, a carved mother-of-
pearl panel from southern Germany, 1460–1500. The
relief design depicts Christ praying beneath a tree, his
face raised to heaven. At the top right, God the Father
gives his blessing from the clouds. Below him, three
apostles sleep.

BELOW
BASIN AND EWER made at the end of the 16th century. The mother-of-pearl inlaid basin was crafted in the workshops of Gujarat, then brought to Germany, where it was mounted in silver-gilt by renowned Nuremberg goldsmith Nikolaus Schmidt. The ewer, standing 41 cm (16⅛ in.) high, was also made by Schmidt. It incorporates three Great Green Turban shells (*Turbo marmoratus*), their outer layers removed to reveal the iridescent nacreous surfaces below.

OPPOSITE LEFT
THE 'ANGEL' CHALICE designed by Phoebe and Ramsay Traquair and made by J.M. Talbot in Edinburgh at the beginning of the 20th century. The cup is an Abalone shell (*Haliotis* sp.), mounted in silver with enamelled decoration, and supported on shaped wires terminating with moonstones. Three triangular frames are inset with painted enamels of angels with musical instruments. Enamelled cabochons decorate the stem and the base. Phoebe Traquair was a leading artist in the Scottish Arts and Crafts Movement.

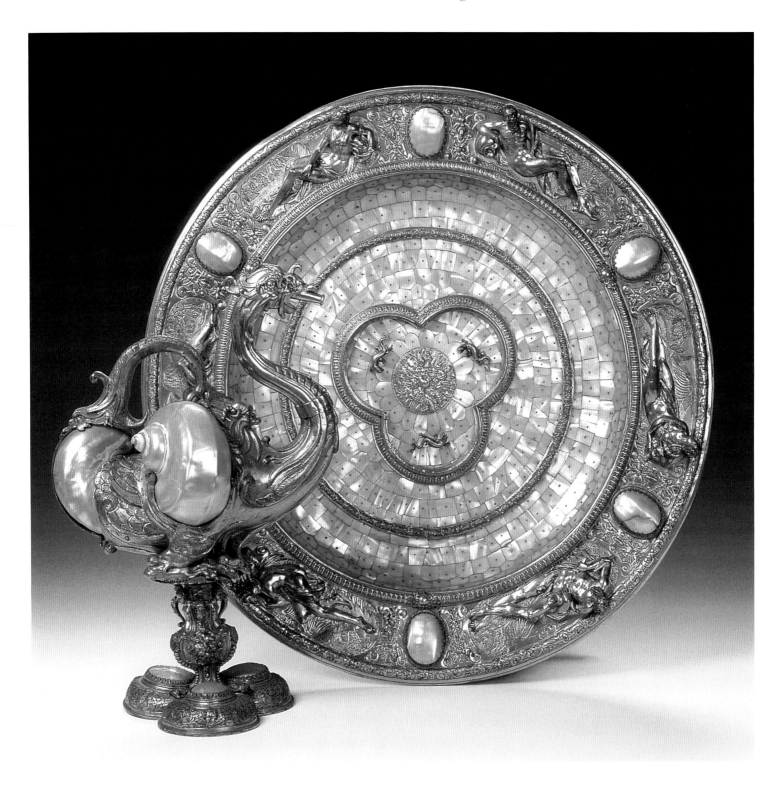

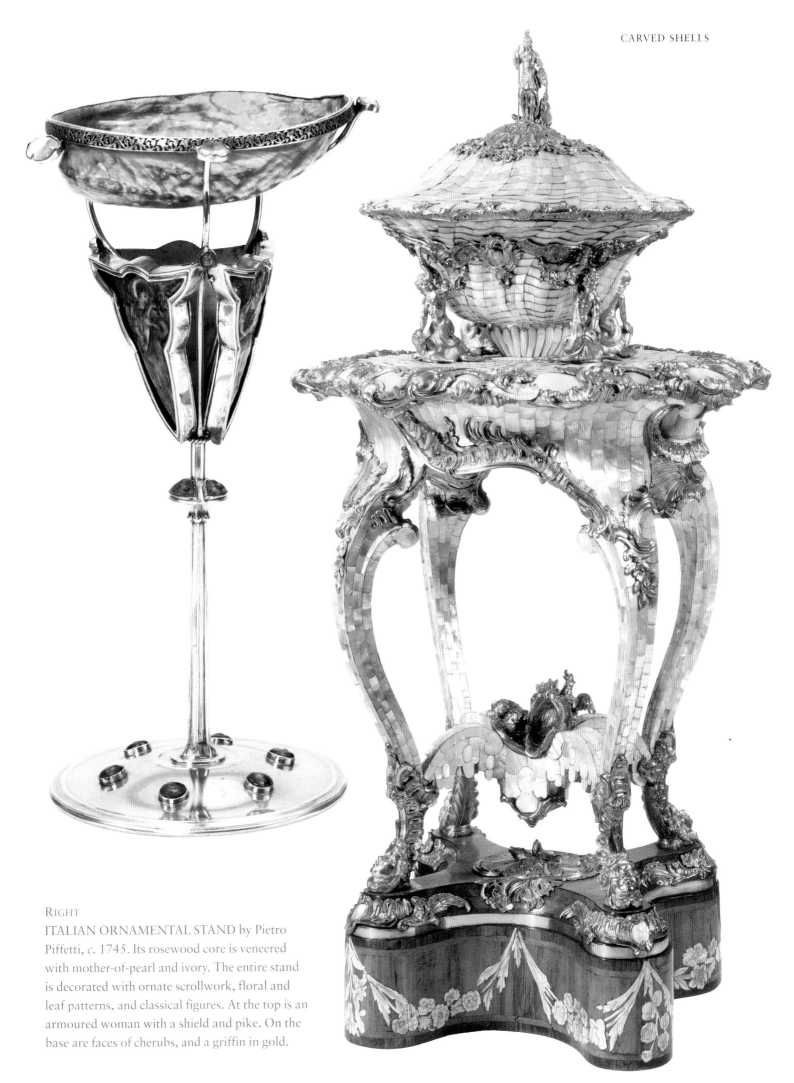

RIGHT
ITALIAN ORNAMENTAL STAND by Pietro
Piffetti, *c.* 1745. Its rosewood core is veneered
with mother-of-pearl and ivory. The entire stand
is decorated with ornate scrollwork, floral and
leaf patterns, and classical figures. At the top is an
armoured woman with a shield and pike. On the
base are faces of cherubs, and a griffin in gold.

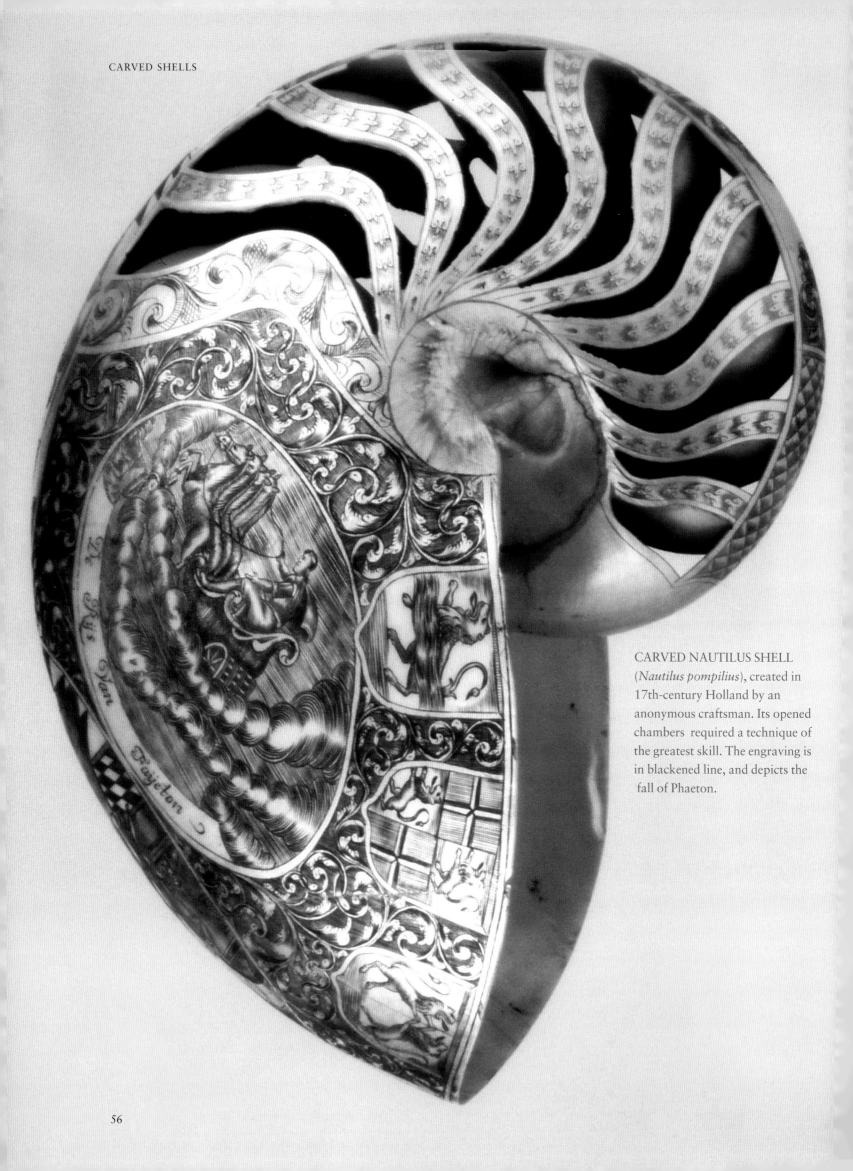

CARVED NAUTILUS SHELL
(*Nautilus pompilius*), created in
17th-century Holland by an
anonymous craftsman. Its opened
chambers required a technique of
the greatest skill. The engraving is
in blackened line, and depicts the
fall of Phaeton.

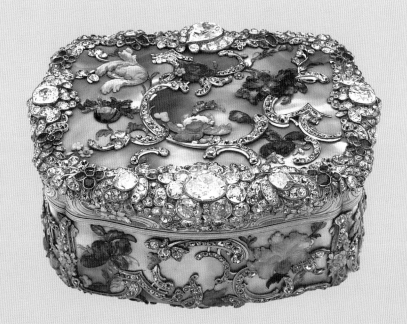

LEFT
SNUFFBOX commissioned by
Frederick the Great of Prussia, and
made in Berlin around 1765. This is one
of the most sumptuous of its kind, made
from mother-of-pearl plaques mounted
in a cage of chased gold. Decorated
with flowers and scrolls, it is set with
diamonds of exceptional quality and
other precious and semi-precious gems.

BELOW
CASKET covered with mother-of-pearl
plaques made in Gujarat in the early
16th century. Owned by François I of
France, it was embellished with silver-
gilt mounts by court goldsmith Pierre
Mangot in 1532–33.

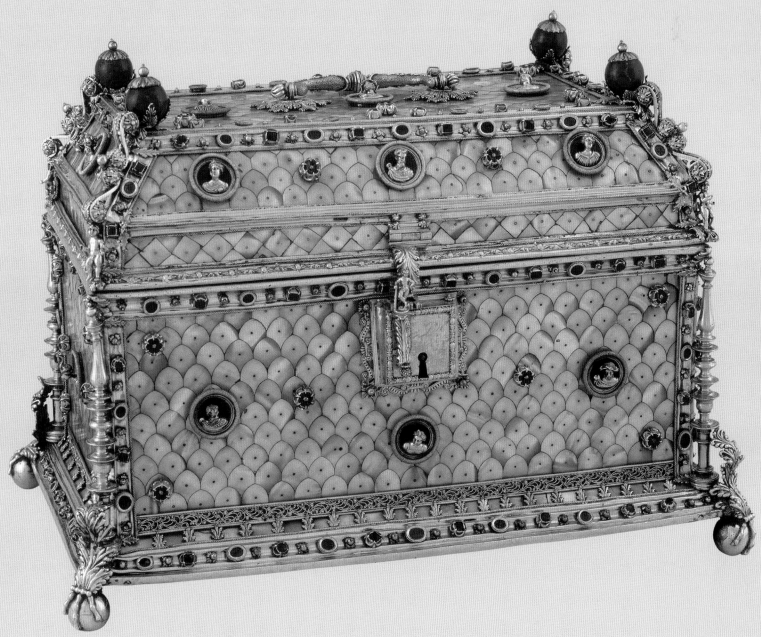

JEWELRY CASKET in the form of a late-Georgian house, made in 19th-century England. An immense amount of detailed work is revealed in this unusual model house, which stands 42 cm (16½ in.) high and is made of mother-of-pearl and tortoise shell. The roof opens to reveal three drawers lined with the exotic wood padauk.

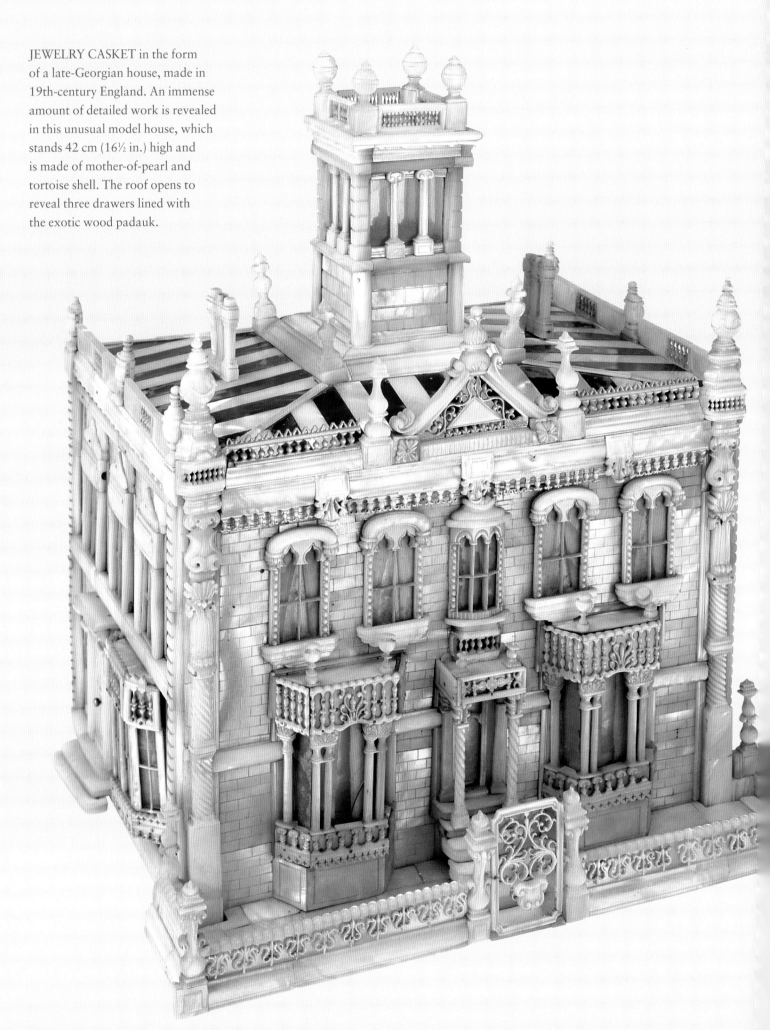

DESK SET designed by Josef Hoffmann and
made by the Wiener Werkstätte in Vienna, c. 1910.
All the pieces are veneered in mother-of-pearl
and ebony.

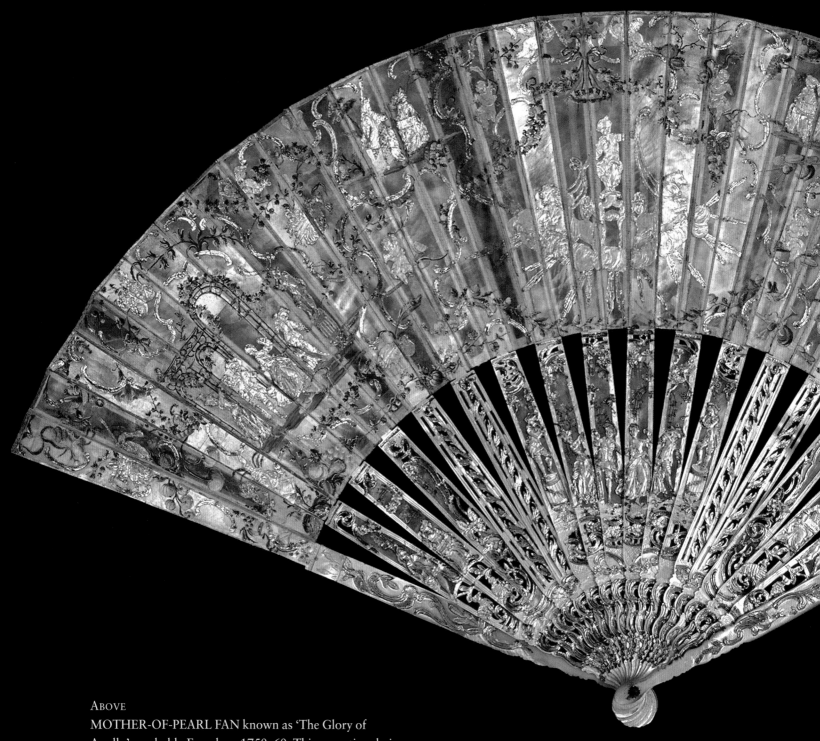

ABOVE
MOTHER-OF-PEARL FAN known as 'The Glory of
Apollo', probably French, *c.* 1750–60. This exceptional piece
is regarded by experts as a unique object. The sticks and
guards are carved and pierced with figures finely gilded in
different tones of gold, and partially painted. The 'leaf' (the
outer section of the fan, mounted on the ribs) is made entirely
of very thin mother-of-pearl (species of pearl shell unknown),
with the pleats held together by fine strips of gilded leather.
Painted flowers and architectural motifs and figures in gold
leaf adorn the leaf, in addition to the beautiful central golden
figure riding a chariot drawn by four horses, sending shafts
of golden light in a sunburst through the clouds.

BELOW
MOTHER-OF-PEARL FAN (oriental species of pearl shell unknown) made for Queen Isabella II of Spain, 1860–70. The sticks and guards are carved in high relief, pierced and gilded. The right guardstick is carved with putti climbing on a maypole, at the top of which is a rather 'macho' putto brandishing a gold pitcher and a drinking vessel. On the left guardstick are more putti on another maypole topped with a banner and seven golden hearts. A banner around the lower part of the pole on the right guard bears the inscription 'Fidelité'. Each stick is carved with garlands of flowers and Rococo shapes, and topped with a bow. A lady is seated in the centre with a putto across her knee while three others are chained with golden cord to the trunk of a tree.

The theme of love's attributes recurs on the painted leaf, signed E. Parmentier. The reverse of the fan bears a crown and bees, and is signed by the French maker, the famous évantailliste Alexandre.

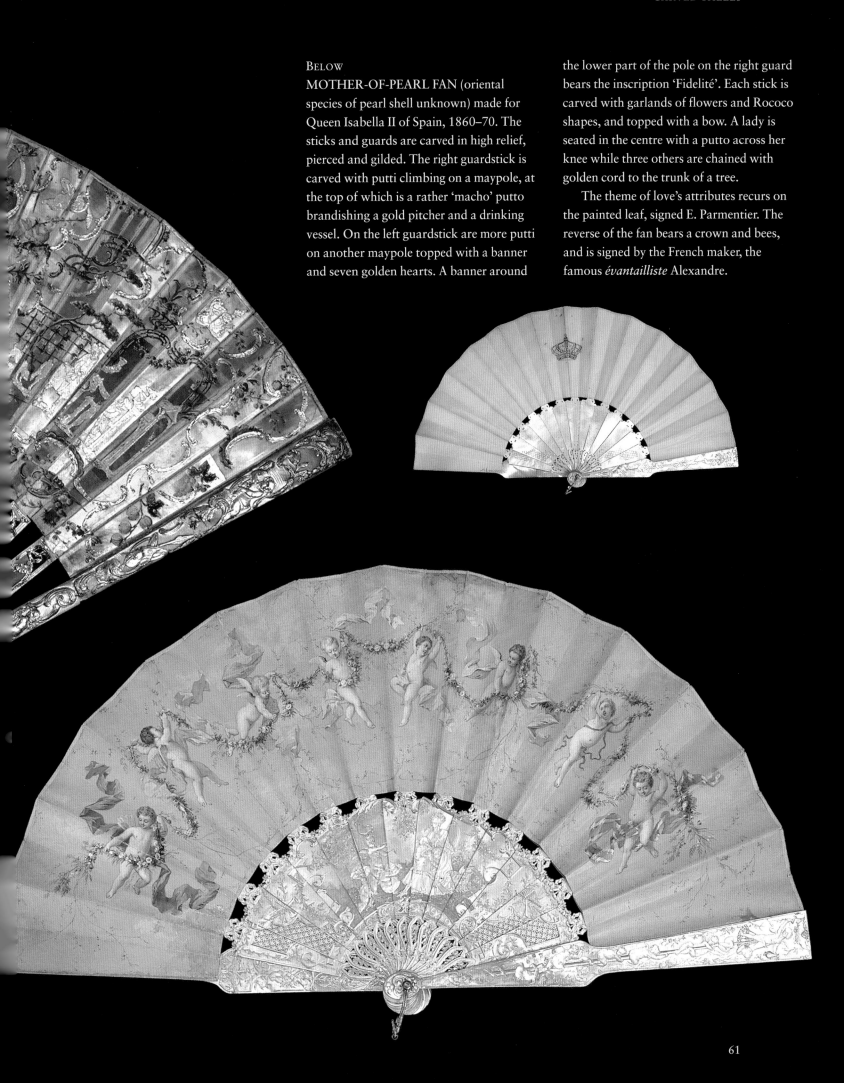

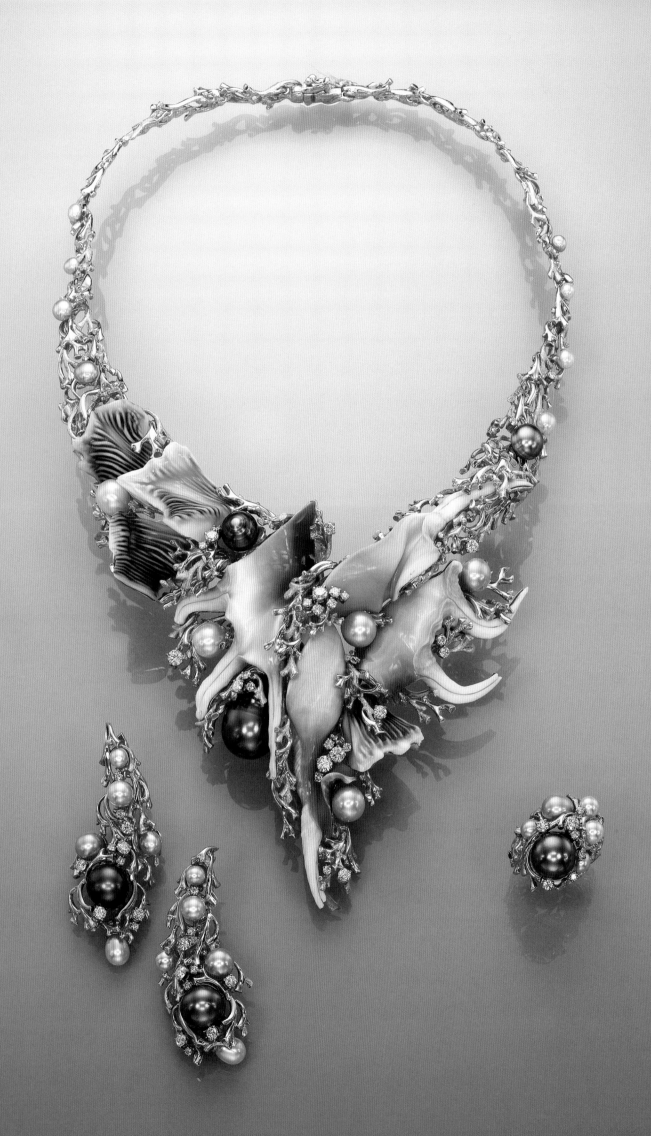

OPPOSITE The 'Lichen Suite' by Gilbert Albert (b. 1930). The award-winning Swiss jeweller created this necklace using cut portions of a species of Spider Conch shell (*Lambis* sp.) set in 18k gold, with diamonds and different coloured cultured pearls. The earrings and ring form a matching set.

BELOW A brooch by the American jeweller Seaman Schepps (1881–1972), who was hailed as 'America's court jeweller' for his pieces commissioned for the ladies of the White House. Here the designer has carved the shape of a Dog Conch shell (*Strombus canarium*), common in the southwest Pacific, out of rutilated quartz. The brooch is decorated with carved coral floral motifs, a baroque cultured pearl and branches in textured gold.

SHELL JEWELRY

See what a lovely shell
Small and pure as a pearl,
Lying close to my foot,
Frail, but a work divine,
Made so fairly well,
With delicate spire and whorl,
How exquisitely minute
A miracle of design

Alfred Lord Tennyson, 'Maud', 1855

In parts of the world, there are people who choose to wear no clothes, but nowhere are there human beings who do not wear ornaments. There is a deep human need for self-adornment, and we decorate ourselves either by altering our bodies – with tattoos, body painting or scarification, or even just adopting particular hairstyles – or by wearing jewelry, anywhere from the tops of our heads to the tips of our toes.

From a conventional Western viewpoint, we often think of jewelry as merely an accessory to our clothing. It may be intrinsically valuable, or it may just be decorative. Either way, it adds the finishing touch to what we are wearing, and we believe it enhances our appearance. But even in the modern West, jewelry continues to communicate a range of messages, from marital status to subcultural allegiances. In traditional societies, ornament often has a much broader function still. In many cultures jewelry may express a whole range of political and social subtleties beyond the merely aesthetic. Such symbolic associations are fascinating to unravel.

Jewelry made from shells is the most ancient form of human adornment. Scientists in 2006 discovered three shell beads between 90,000 and 100,000 years old, in Israel and Algeria. These predate other ancient examples by at least 25,000 years. The shells come from the genus *Nassarius*, and were deliberately perforated with a sharp flint tool, indicating that they were probably strung together as necklaces or bracelets. Our knowledge of traditional societies tells us that they would

LEFT The earliest shell necklace to have been found intact dates from the Paleolithic period, *c*. 28,000 BC; it was discovered at Pavlov, in the Czech Republic. Simply strung, it is made up of various fossilized shells, including broken Tusk shells (*Dentalium* sp.), and Cockles, from the family *Cardiidae*.

BOTTOM LEFT A pendant carved from an unidentified white shell, from a royal grave in the Sumerian city of Ur, *c*. 2500 BC. Rare outside royal graves, pendants such as this bull were either used as part of a headdress, or attached to a dress-pin.

have carried a social meaning, revealing that the wearers were powerful, or members of a particular group. It is also possible that they were worn to ward off evil.

Archaeologists have discovered other examples of early shell jewelry in the Middle East. At least three different shells or shell-shapes are known to have been used in ancient jewelry, the oldest being Tusk Shells (*Dentalium* sp.), examples of which date to *c*. 10,000 BC. So-named because they look like miniature animal tusks, these are naturally tubular, sometimes grooved, white shells of great

A necklace of Tusk shells (*Dentalium* sp.) and breast-shaped beads of bone made by the Natufians, inhabitants of the Jordan River valley. This is one of the earliest examples of Neolithic beadmaking, dating from *c*. 10,000–8000 BC.

charm. There are over a thousand species in the world, but those most likely to have been used are the European Tusk (*Dentalium dentale*), or the Common Tusk (*Dentalium vulgare*). Oyster shells (*Ostraea* sp.) were also modelled in gold, silver or electrum (a naturally occurring alloy of gold and silver), and were worn by women as amulets to promote good health.

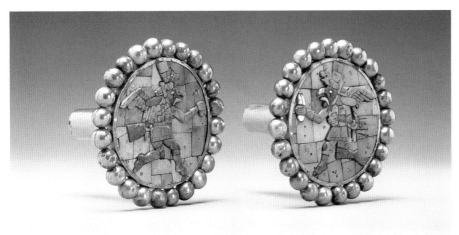

But by far the most commonly used shell in early Middle Eastern jewelry, *c.* 5000–1000 BC, was the Cowrie (*Cypraea* sp.). With their resemblance to female genitalia, Cowries were believed to possess powers to promote fertility and protect pregnant women. Actual shells, or gold beads cast in the shape of Cowrie shells, were strung into girdles and worn by women around their hips.

Across the Atlantic, in the pre-Columbian Americas, quite different shells were used in the making of jewelry. The most precious of all was the Pacific Thorny Oyster (*Spondylus princeps*), which lives in waters from the Gulf of California to northwest Peru. Despite its name, this bright orange-red spiny 'Oyster' is in fact more closely related to the Scallop. The early civilizations of

Mesoamerica revered this shell, and went to great lengths and great distances to obtain it. As jewelry, it was made into beads and pendants, and cut and shaped into pieces of mosaic inlay for pendants and earrings. More arcane symbolism was also associated with it; its motif has been found on pottery and in temple carvings, and actual shells have been found in many graves. A second shell was also highly regarded, the beautiful Lion's Paw (*Lyropecten nodosa*), a common form of Scallop that is found in waters from the southeast United States to Brazil. This was also used to make simple but beautiful jewelry, sometimes inlaid with gold.

In North America, native tribes wore shells because they communicated powerful messages. Religion, myth and status permeated all aspects

ABOVE Large circular ear ornaments, from the Moche culture in Peru, 3rd–7th centuries AD. Made in gold, with mosaic inlay of turquoise, sodalite and Pacific Thorny Oyster shell (*Spondylus princeps*), they depict a pair of bird-headed runners, possibly mythological messengers. Such earflares were popular adornments for prominent male members of the Moche culture, symbolizing their status and wealth.

ABOVE RIGHT A shell pendant from the Aztec civilization, Mexico, 14th–16th centuries AD. Simply made, it consists of a Lion's Paw shell (*Lyropecten nodosa*), its nodules cut away and inlaid with gold.

RIGHT A shell pendant figure, from Colima, Mexico, *c.* 200 BC–200 AD. It is made from the Pacific Thorny Oyster (*Spondylus princeps*), a precious and highly-valued shell among the early civilizations of Mesoamerica. It would have taken great skill on the part of the carver to produce an entire human figure from a shell of limited size and depth. The figure is male; he wears a loincloth, armbands and a turban.

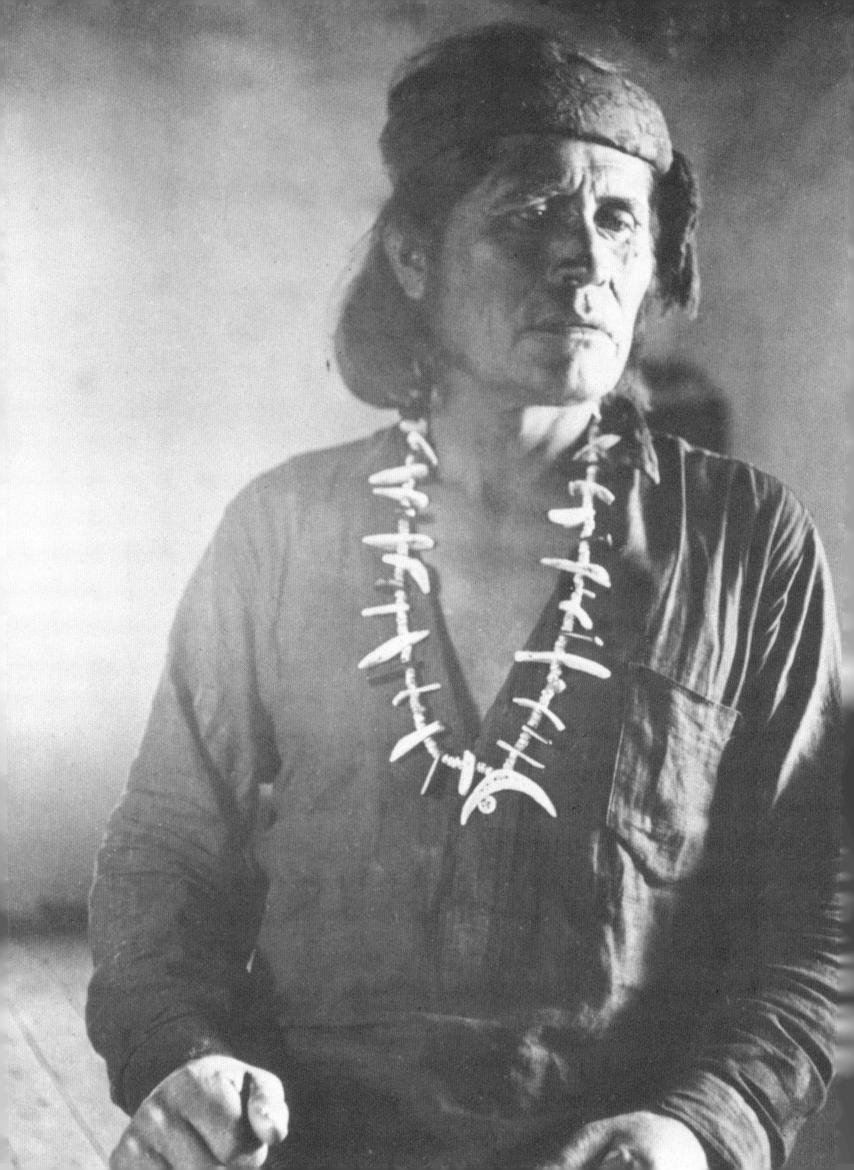

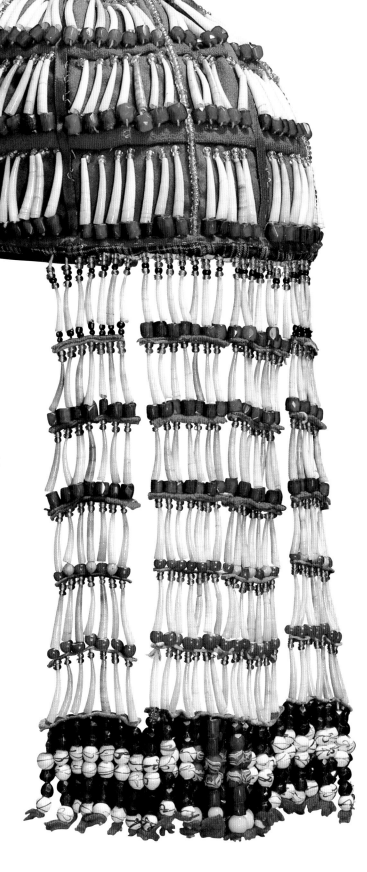

OPPOSITE A Navaho man wearing a shell and stone fetish necklace, probably used during rain ceremonies.

RIGHT Ceremonial headdress worn by the wife of 19th-century Tlingit shaman Berners Bay Jim, in Klukwan, Alaska. The cap is made of green woollen cloth decorated with red flannel and satin ribbons. It is covered with Indian-money Tusk shells (*Dentalium pretiosum*) and glass beads that extend down the wearer's neck.

of life in many Native American nations. Jewelry constituted a visual language that spoke of the wearer's position in society and gave tangible form to the spiritual. Indian-money Tusk shells (*Dentalium pretiosum*) were worn by the women of many Northwestern and Plains tribes, including the Inuit, Sioux and Yurok, as a visible mark of their wealth and social standing. Their common name derives from the fact that they were used by tribal nations as a form of currency before the Europeans arrived in North America (see pages 28–30). A high-ranking Indian woman's clothes would be liberally decorated with Tusk shells. She also wore them as necklaces, and her Tusk shell earrings could reach below her waist (see page 68).

Abalone shell (*Haliotis* sp.) was also highly prized by North American tribes, particularly the Indians of the North Pacific Coast. The brightly iridescent Green Abalone (*Haliotis fulgens*) was especially favoured and it was primarily used for jewelry and for decorating precious objects and ceremonial regalia, the size and brilliance of an individual's jewelry marking his status and wealth.

The Pueblo Indians of the Southwest regarded shells as a sacred hard substance originating in the ocean. Fetish shell necklaces were worn during many elaborate ceremonials, including rain-making ceremonies.

The Plains Indians lived in a large area stretching from Canada to Mexico, and from the Mississippi River to the Rocky Mountains.

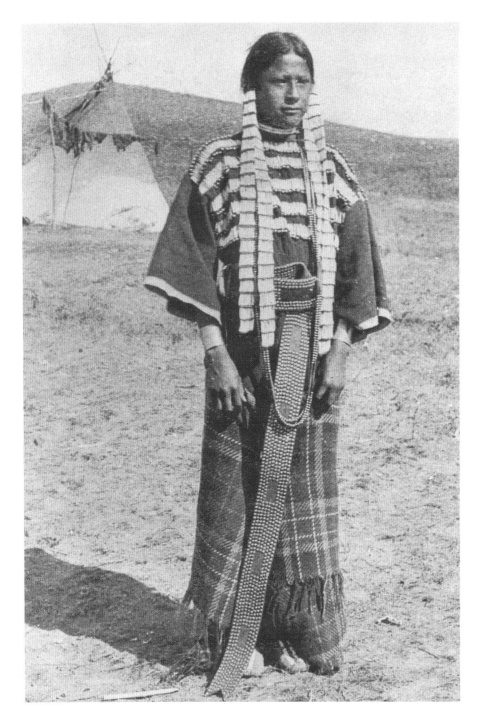

LEFT A Sioux woman from Dakota wearing a shirt decorated with Indian-money Tusk shells (*Dentalium pretiosum*), and long Tusk shell earrings, both sure signs of her considerable standing and wealth within the tribe. This photograph was taken *c.* 1886.

OPPOSITE ABOVE A bangle carved from Indian Chank shell (*Turbinella pyrum*) made in Ladakh, once an independent kingdom, and now the largest district in the Indian state of Kashmir.

OPPOSITE BELOW A Lettered Cone shell (*Conus litteratus*). Common in the Indo-Pacific region, these grow up to 10 cm (4 in.) long, and are very thick and surprisingly heavy. Sections of the shells are threaded onto sashes worn by different peoples of the Philippine Island of Luzon.

The most important tribes of the Plains were the Sioux, Blackfoot, Omaha, Cheyenne and Comanche. These peoples believed in a force, 'the Great Spirit', that encompassed the universe, with the earth as the mother of all spirits. Above all, however, it was the sun that held supreme power, capable of protecting against crop failure, disease and death. Clam shells were carved into discs to represent the sun and worn as necklaces by high ranking members of the tribes to invoke the sun's potent powers of protection.

Two different Clam shells were responsible for providing many American Indian nations with jewelry and wealth. Along the west coast, the Pismo Clam (*Tivela stultorum*) was collected by the Pomo Indians, though only the male members of the tribe who had inherited the craftsman's privilege could actually undertake

the task of drilling and shaping the shells into beads, and even then they had to observe special taboos. They had to work out of doors away from the house, and they had to abstain from contact with women and from eating meat while working on the beads. Failure to observe these restrictions would, it was believed, cause the drill and the beads to break. When the beads were strung, only women would wear them as necklaces, but feather belts were worn by both men and women as an outward sign of their wealth.

On the east coast of north America, the Northern Quahog Clam (*Mercenaria mercenaria*), found in lagoons from Eastern Canada to Georgia, was used as a form of currency known by early explorers as 'wampum' (see pages 29–30). These shells were also shaped into beads, and sometimes worn as necklaces on ceremonial occasions. They denoted wealth and prestige, and they could also act as a badge of tribal identification.

Across the world in India, shell jewelry has traditionally carried quite different meanings. In Bengal, there is an enduring Hindu tradition of reverence for the Indian Chank shell (*Turbinella pyrum*) (see pages 24–25), and traces of Chank shell workshops have been discovered all over India dating back more than 4,000 years. Chank shell jewelry was at one time also made in parts of

Bangladesh, but its manufacture is now confined to West Bengal, where it involves an estimated 12,000 craftsmen. Each stage and process requires specialist skills. Bangles are the principal product, but an assortment of other jewelry is also made, such as earrings, finger and toe rings, and necklaces of plain Chank beads. Medallions of various designs are either worn around the neck or fastened around the upper right arm by a cord as an amulet. On the advice of an astrologer, herbal ointment may be placed in the concave back of the medallion that is in contact with the skin, as a cure for various ailments.

In Southeast Asia, the Philippines stands out from its neighbours when it comes to shell jewelry. A Mecca for shell collectors, the seven thousand-odd islands that form the Philippine archipelago boast coastal waters rich in mollusc life. But it is in the highlands, far away from the sea, where the most interesting shell jewelry has traditionally been worn. The largest of the Philippine Islands is Luzon, and here there is a rich history of tribal shell ornaments, valued highly by their wearers, which signify particular status in the community. Mother-of-pearl sections are cut from either the Black-lipped Pearl Oyster (*Pinctada margaritifera*) or the Gold-lip Pearl Oyster (*Pinctada maxima*) and worn in several tribes as decorative necklaces, engraved earrings or preciously guarded hip ornaments. Sections of Lettered Cone shells (*Conus litteratus*) are threaded onto sashes called *ginuttu* and worn only by men of the social elite. Cowries (*Cypraea* sp.) are threaded onto girdles and bracelets; large tear-drop sections of the

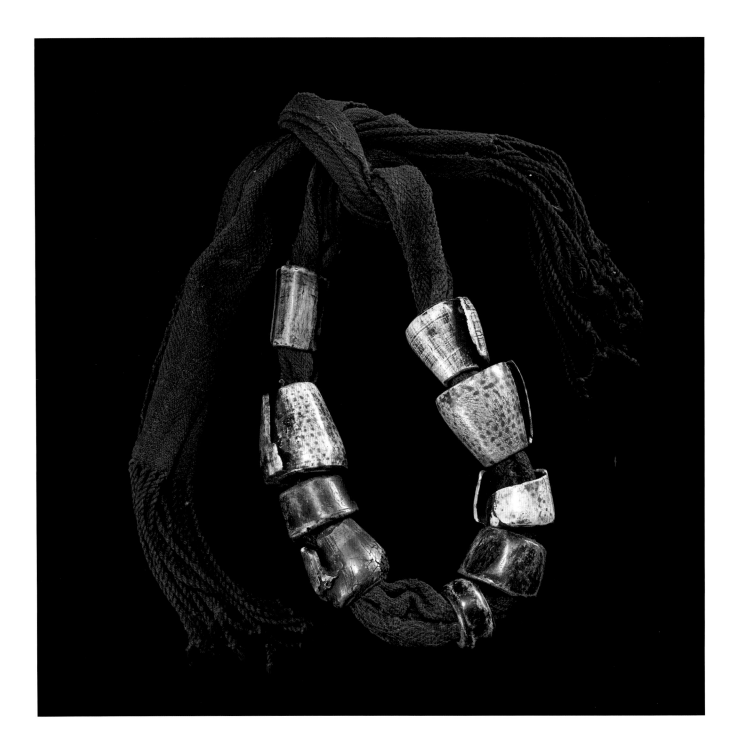

ABOVE AND OPPOSITE LEFT Treasured jewelry of the elite Bontoc and Tinguian people in the Philippines is kept safe by the women in a pouch worn round the waist called an *akosan*. A long piece of coarse cotton fabric acts as the receptacle, and the contents are kept in place by the use of several Lettered Cone shells (*Conus litteratus*), and sometimes brass wire rings as well. The shells and brass coils serve to conceal and secure the contents of the pouch.

OPPOSITE RIGHT Shell jewelry from southeastern New Guinea, used in the Kula Ring ceremonial gift exchange. On the left is an armband (*mwali*) of Leopard Cone shell (*Conus leopardus*) which has been drilled to allow strands of red Thorny Oyster shell (*Spondylus* sp.) beads to be attached. On the right is a necklace (*soulava*) of bivalve shells, shell sections and similar shell beads.

Chambered Nautilus shell (*Nautilus pompilius*) are worn as earrings by males of the elite class of the Ifugao tribe; and the Giant Clam (*Tridacna gigas*) forms the basis of a handsome buckle worn at ceremonial occasions and feasts. All these shells, often painstakingly ground down and shaped, etched and decorated, are treasured heirlooms, passed from generation to generation as articles of intrinsic value and marks of the importance of tribal heritage.

The Pacific islands contain the widely contrasting cultural regions of Micronesia, Melanesia and Polynesia. In each of these areas, traditional dress, body painting and ornament has its own distinct character, as does the tradition of 'shell valuables'. Shell jewelry is the focus of a ceremonial exchange system known as the 'Kula Ring', which spans eighteen island communities of the Massim archipelago, including the Triobrand Islands to the southeast of New Guinea, and involves thousands of individuals. Participants travel sometimes hundreds of miles by canoe in order to exchange Kula bracelets of Leopard Cone shell (*Conus leopardus*) for necklaces of Thorny Oyster shell (*Spondylus* sp.). This gift-giving may appear spontaneous, but it is actually highly ritualized and serves to foster strong bonds between individuals and communities across a wide geographical area. The necklaces (*soulava*) are exchanged northwards, circling the ring in a counter-clockwise direction, while the bracelets (*mwali*) are exchanged in a southern direction, circling clockwise. If the opening gift was a necklace, then the closing gift must be a bracelet, and vice versa. These special objects can only be traded for each other. The point of the Kula tradition is to establish strong, life-long alliances between exchange partners, and the partnership involves mutual obligations such as hospitality, protection and assistance. A good Kula relationship should be 'like a marriage'. As a local saying goes, 'Once in Kula, always in Kula'.

Of the many types of shell jewelry made and worn by Pacific islanders, perhaps the most well-known is the *kap-kap*. Worn on the forehead in the Solomon Islands, and as a pectoral ornament in New Ireland and other islands of New Guinea, the *kap-kap* is a strikingly beautiful piece of jewelry. It is made from a circular disc cut from the Giant Clam (*Tridacna gigas*), overlaid with a wafer-thin slice of turtle shell carved in intricate openwork patterns, its dark colour making a

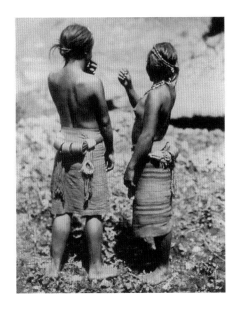

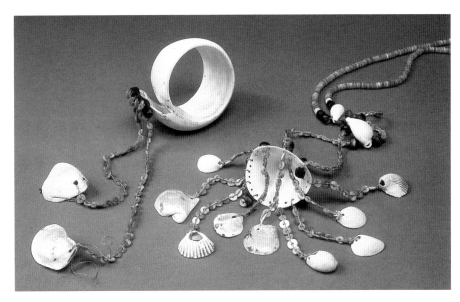

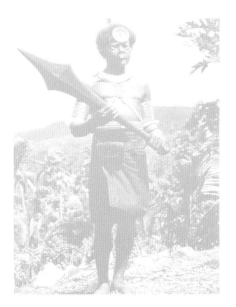

LEFT A war chief of the Baegu people on Malaita Island in the Solomons, wearing ceremonial regalia, including a *kap-kap* ornament on his forehead.

BELOW A *kap-kap* from the Pacific Islands, made from a disc of Giant Clam shell (*Tridacna gigas*) overlaid with turtle shell filigree. Only a man of high status may wear such a disc.

OPPOSITE ABOVE A carved shell pendant on a band of hair from the Roeburne Region in Western Australia. On the right, an Aboriginal man from northwest Australia is pictured wearing such a pendant, made from a Black-lipped Pearl Oyster shell (*Pinctada margaritifera*). Discs of mother-of-pearl shell are variously used by Aboriginal peoples in curing rituals, sorcery and in rainmaking ceremonies.

dramatic contrast against the white background of the shell disc. Worn as a badge of authority, leadership and warrior status, the *kap-kap* is reserved only for those elite males known as 'big-men'. These prestigious ornaments are handed down from father to son, but the youth must first earn the right to wear it.

For thousands of years, the communities of Australia's interior did not know that large bodies of water existed, so had no knowledge of the marine origins of shells. Black-lipped Pearl Oyster shells (*Pinctada margaritifera*), which are common in the waters around Australia, are considered as valuables even today, and the Aboriginal people believe that they were left behind by the mythological beings of the Dreamtime. Different groups use mother-of-pearl shells in curing rituals, sorcery and in rainmaking ceremonies. Jewelry can take the form of bands worn on the upper arm or forehead, and during rainmaking rituals the men of the Western Desert wear large carved pearl shells as pubic ornaments, both as a means of attracting rain and as a mark of rank.

New Zealand's justly famous shell jewelry is centred on one particular shell, the Rainbow Abalone, known locally as Paua (*Haliotis iris*). Strict quotas are imposed today on the retrieval of wild Abalone from the waters around New Zealand's South Island, but in addition to wild harvesting, rapidly developing aquaculture ventures are being established around the country to farm Paua for meat, pearls and jewelry-making. Modern Paua jewelry comes in every possible form and style, and with its characteristic blue-green iridescence, it makes for some exquisite necklaces, rings and bracelets.

The most well-known item of traditional New Zealand Maori

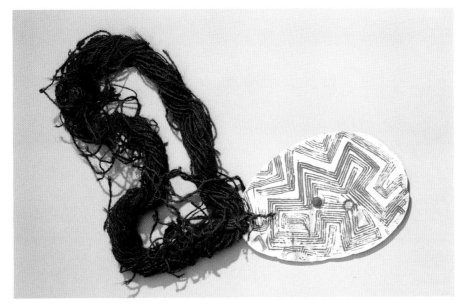

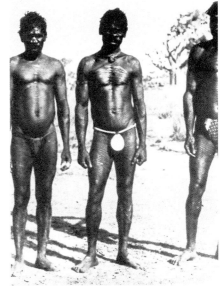

jewelry is the Hei-tiki, a small carved figurine usually made of nephrite, a stone related to jade, with the eyes often picked out in two small discs of Paua. There is much debate as to the origins and symbolism of these ornaments, which are worn as pendants. Some claim they were fertility symbols, others that they were intended to guard against deformities in birth. There are those who believe that the Hei-tiki was first and foremost a talisman, to protect against evil spirits of all kinds. Whatever the original symbolism, today they are marketed as ornaments that will bring good fortune to the wearer.

On the African continent, two types of shell have traditionally been used in jewelry, the Money Cowrie (*Cypraea moneta*) and the Cone shell (*Conus leopardus, C. betulinus* and *C. pulcher*), to the virtual exclusion of others. That is an extraordinary fact when one considers the vast scale of the region, the wide variety of shells available to different communities, and the importance of jewelry to the African people. The Money Cowrie, formerly a medium of exchange and hard currency, has also traditionally been used as decorative jewelry in a number of African

RIGHT A necklace of Cowrie shells – either Money Cowries or Gold-ringer Cowries (*Cypraea moneta* or *Cypraea annulus*) – and blue beads, made by the Kuba people of Zaire. The substantial number of Cowries used in this piece of jewelry indicate that only a member of the royal family would be entitled to wear it.

OPPOSITE BELOW An unusual Maori Hei-tiki ornament from New Zealand, dating from the 19th century, and made from human skull bone. Typically, the iridescent eyes are rings of Abalone shell, locally called Paua (*Haliotis iris*).

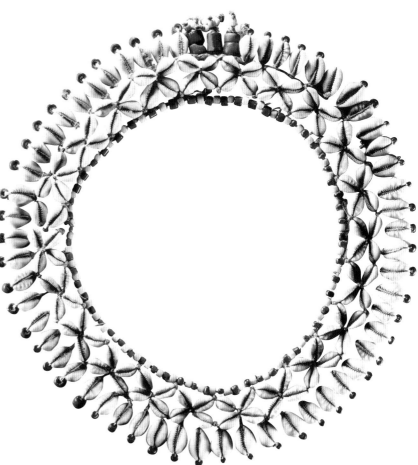

A bracelet by the famed French designer Jean Schlumberger (1907–87). One of the 20th century's most influential jewelry designers, Schlumberger drew lifelong inspiration from nature, transforming simple forms into luxurious extravagances. This bracelet is made of diamond-encrusted stylized shells set in gold and platinum, against a background of sapphires and emeralds.

countries, including Kenya, Tanzania, Mali, the Democratic Republic of Congo, and Zambia. Cowrie shells can easily be adapted to make jewelry. The dome of the shell is chipped or ground away, and a thread then passed through the hole created, and through the natural opening. In each case the jewelry design features the underside of the shell facing outermost, as a reminder of the importance of the Cowrie as a symbol of fertility.

Cone shell discs have traditionally been regarded as wealth items. They circulated widely as a medium of exchange in Angola, Zambia, Mozambique and the Democratic Republic of Congo. In the late 19th century two discs could purchase a slave, while five were needed to buy an elephant's ivory tusk. Locally called *mpande* or *vibangwa*, Cone shell discs also served as ornaments. The circular end of the shell was cut off and the disc flattened and smoothed, except for the raised natural spiral, which was perforated through the centre. Such Cone discs could be owned by anybody and used as a medium of exchange, but only individuals of high rank were permitted to wear them as jewelry, at which point their value as currency diminished. In the

last hundred years imported porcelain imitations have been introduced, and genuine Cone shell ornaments are sadly now very rare.

Few shells were used in European jewelry before the Renaissance. Mother-of-pearl appeared occasionally in medieval rings or bracelets, but in general decorative ornament was confined to materials of intrinsic worth, such as gold, silver and gems. Shells carried little or no value. But from the 16th century, cameos carved from shells became popular, and by the 19th century, shell cameos were in great demand (see pages 41–43).

From the mid-19th century the shell motif became a favoured decorative shape, part of a widespread fascination for all aspects of marine life. From cheap trinkets to *haute joaillerie*, shell forms appeared widely in European jewelry. Exotic shells were treated like gemstones, set in precious metal casings to form necklaces, pendants and brooches. As well as using the natural shell itself, jewellers designed pieces incorporating its motif and created exquisite work in gems, hardstones (*pietre dure*) and enamels.

The 20th century saw the emergence of the taste for novelty costume jewelry, of which shells

BELOW A shell pendant brooch, by the American jeweller Kenneth Jay Lane (b. 1930), known as 'the king of faux'. A Swift's Scallop (*Swiftopecten swiftii*), a shell common in the waters of Japan, and coloured glass simulated gems create this bold piece of costume jewelry, reminiscent of brooches by Fulco di Verdura (1899–1978).

BELOW RIGHT A Clam shell compact, 1967, by Verdura. The jeweller used 'a rough Quahog Clam' (possibly *Mercenaria* sp.) and applied seaweed of gold, sapphires and diamonds to the upper valve. Verdura was so drawn to shells for his work that he would often go beachcombing at weekends, and he sometimes bought shells from the shop at the Natural History Museum in New York. 'What I get a kick out of is to buy a shell for five dollars, use half of it and sell it for twenty-five hundred,' he once told the *New Yorker*.

were soon established as a popular shape. Some extremely high quality and lavishly expensive shell jewelry was produced in Europe and in North America. Shells were fashioned out of tourmalines and rubies, and shell-shaped diamond brooches were encrusted with tiny pearls. Mother-of-pearl was used to create exquisite necklaces, and shell itself was hand-carved into the shape of flowers and leaves to make earrings. Famous jewellers such as Fulco di Verdura, Jean Schlumberger and Andrew Grima produced their own designs, often using real shells set in gold or platinum, which were eagerly purchased by royalty, movie-stars and the rich. If they found their way into auction sale rooms, such pieces fetched fabulous prices. Shells had finally come of age as internationally sought-after and highly valued decorative objects.

Today, it would seem that shells are more popular in Western jewelry than they have been at any time in history. Mother-of-pearl and natural shells are the rage. Earrings made of mother-of-pearl, 'statement' necklaces using large cut sections of pastel-coloured shells, and chunky bracelets made from hundreds of small shells are to be seen on the pages of fashion magazines. Unashamedly bold, shell jewelry these days is both elegant and affordable, and designed to be worn on many occasions. Above all, shells have come to be valued for their beauty as objects of adornment, and as a reminder of our links with the natural world.

GOLD OYSTER SHELL AMULET
from the 12th Dynasty in Egypt,
1965–1920 BC. This type of amulet
was often worn by women during the
Middle Kingdom, c. 2040–1750 BC.
Because of a similarity between the
ancient Egyptian words for 'shell' and
'sound, healthy', shell amulets were
believed to promote good health.

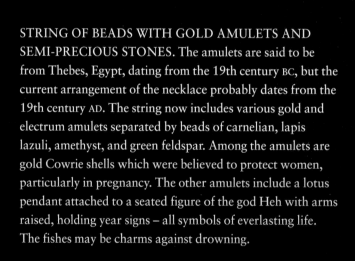

STRING OF BEADS WITH GOLD AMULETS AND
SEMI-PRECIOUS STONES. The amulets are said to be
from Thebes, Egypt, dating from the 19th century BC, but the
current arrangement of the necklace probably dates from the
19th century AD. The string now includes various gold and
electrum amulets separated by beads of carnelian, lapis
lazuli, amethyst, and green feldspar. Among the amulets are
gold Cowrie shells which were believed to protect women,
particularly in pregnancy. The other amulets include a lotus
pendant attached to a seated figure of the god Heh with arms
raised, holding year signs – all symbols of everlasting life.
The fishes may be charms against drowning.

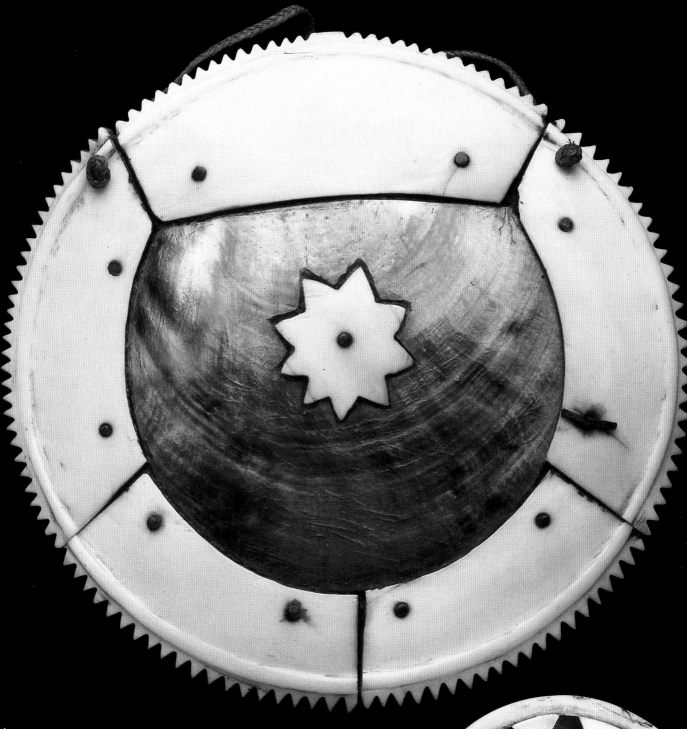

Above
FIJIAN CHEST ORNAMENT worn only by chiefs at ceremonial occasions and in battle. It is made of a lustrous disc of Black-lipped Pearl Oyster shell (*Pinctada margaritifera*), surrounded by sections of sperm-whale ivory with carved toothed edges.

Right
CLOTHING ORNAMENT FROM THE TIAHUANACO CULTURE which flourished at the southern edge of Lake Titicaca on the border of Peru and Bolivia between *c.* 300 BC and the 12th century AD. The mother-of-pearl disc is set with a mosaic of various stones and shells, including the orange Pacific Thorny Oyster (*Spondylus princeps*).

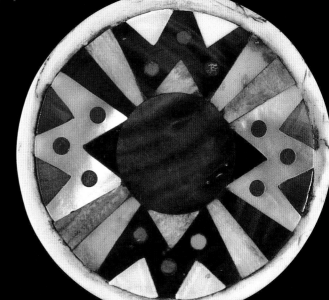

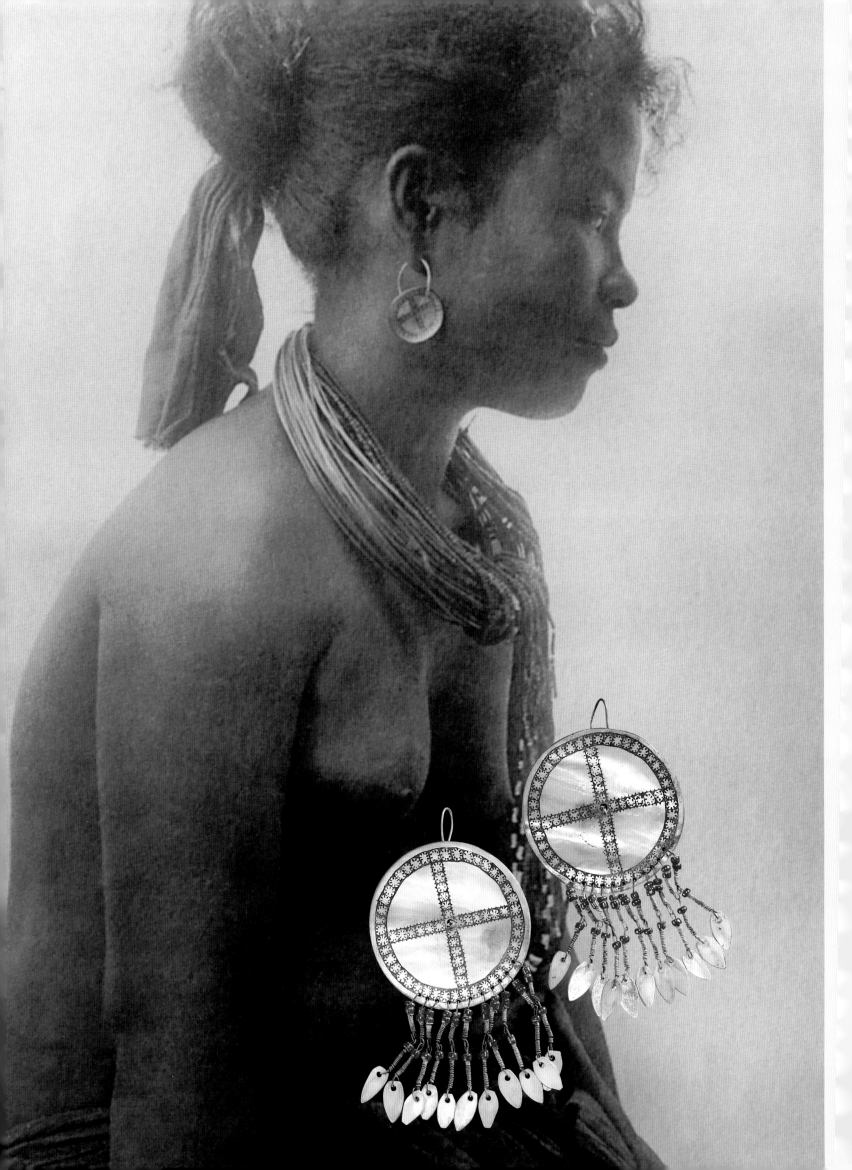

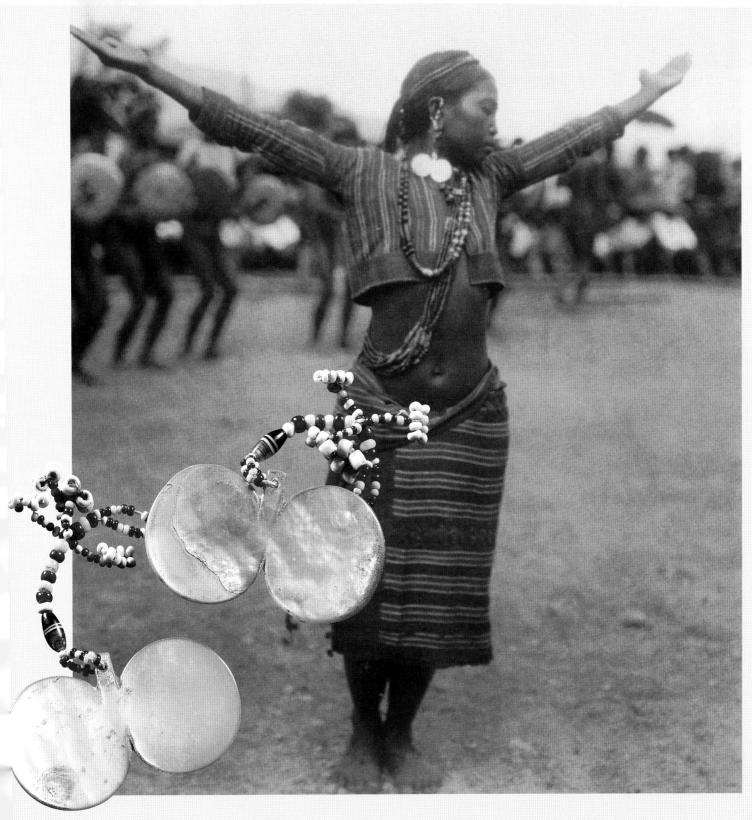

THE ILONGOT PEOPLE, now few in number, live in a forested area of southern Nueva Vizcaya province on the island of Luzon in the Philippines. They have a bloodthirsty reputation as former headhunters: at one time all men were expected to secure a head in battle before they could marry. Masters of the miniature, the Ilongot are known for their finely crafted work in embroidery, brass wire work and incised shellwork. This young woman is wearing shell earrings known as *calipan*. Finely etched, these are sometimes hung with rings of coiled brass wire, beads and shaped pieces of shell. The shell used for this jewelry was either the Black-lipped Pearl Oyster (*Pinctada margaritifera*) or the Gold-lip Pearl Oyster (*Pinctada maxima*).

ABOVE

PAWISAK EAR ORNAMENTS of the North Kalinga people of Luzon in the Philippines, made from large clover-shaped discs cut from either the Black-lipped Pearl Oyster (*Pinctada margaritifera*) or the Gold-lip Pearl Oyster (*Pinctada maxima*). These are worn only by elite women. The Kalinga woman pictured is dancing at a ceremonial feast. She wears *pawisak* earrings and special garments for the occasion.

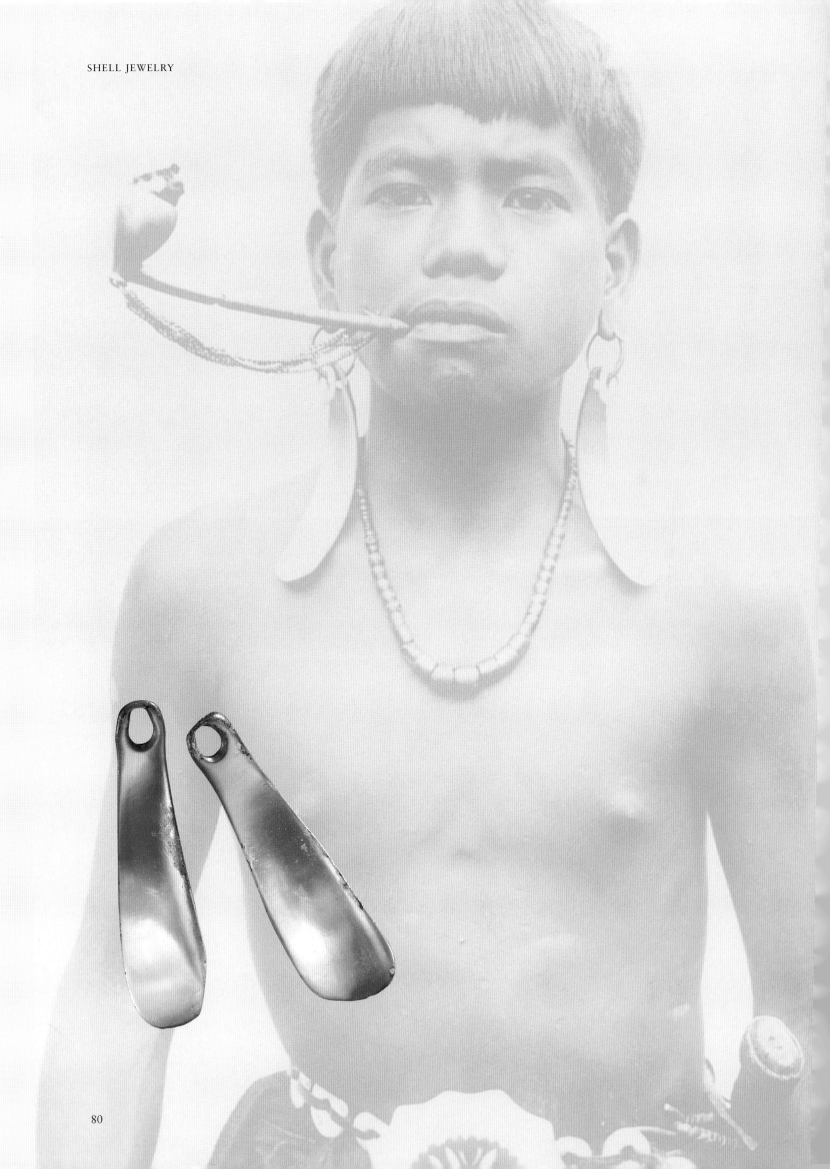

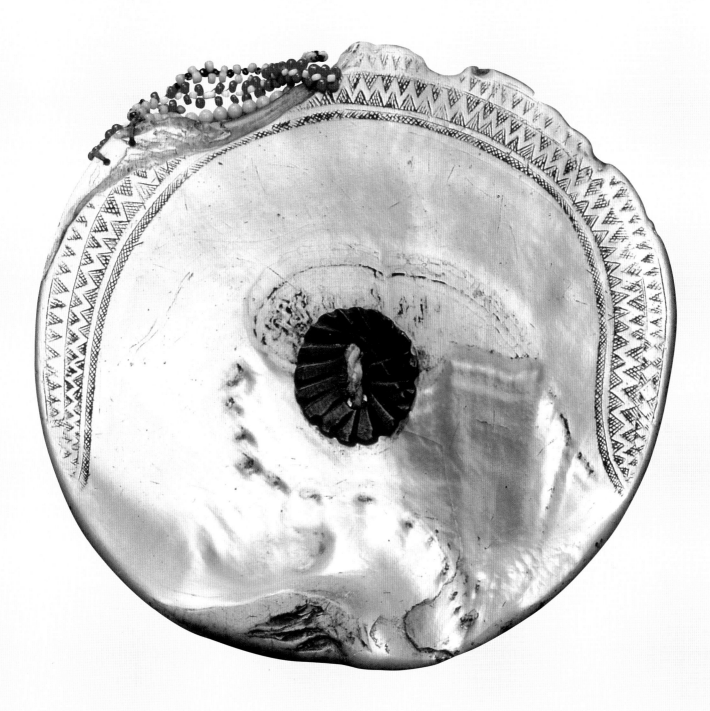

OPPOSITE
IFUGAO BOY from the highlands
of Luzon in the Philippines wearing
large shell ear ornaments known as
kilaong. Made from spatula-shaped
sections of the Chambered Nautilus
shell (*Nautilus pompilius*), and
hung from large brass rings, this
jewelry is worn only by the elite
members of the community.

ABOVE AND RIGHT
THE *FIKUM* is an incised shell
ornament worn by Igorot and Bontoc
men of Luzon island. The damage
at the top left on the example above
has been filled in with strings of tiny
beads. The only local shell large
enough to provide a disc of this
size is likely to be the Gold-lip Pearl
Oyster (*Pinctada maxima*). Pictured
right is a young Bontoc man from
the Mountain Province of Luzon.
He proudly wears the highly valued
fikum as a hip ornament.

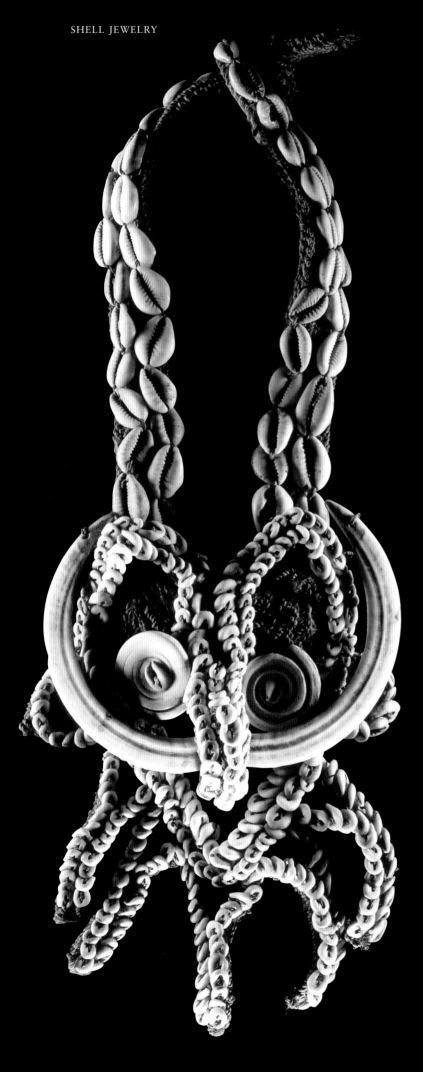

WARRIOR'S PECTORAL ORNAMENT from the Sepik River region of New Guinea. This is normally worn around the neck, but in battle is sometimes held between the teeth to make the wearer appear as fierce as possible. It is made from plaited fibre covered with Cowrie and Nassa shells (unidentified species). Pig's tusks are suspended on either side of the eyes, which are also shell.

BELOW

LUMI WARRIOR'S PECTORAL ORNAMENT, from the Torricelli Mountains in the Sepik River region of New Guinea. It was made using a circle of Common Egg Cowrie shells (*Ovula ovum*) and small Nassa shells (*Nassarius* sp.) woven onto a central ring of fibre. The significance of this piece is uncertain.

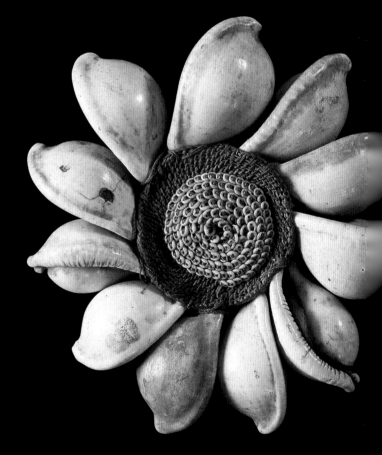

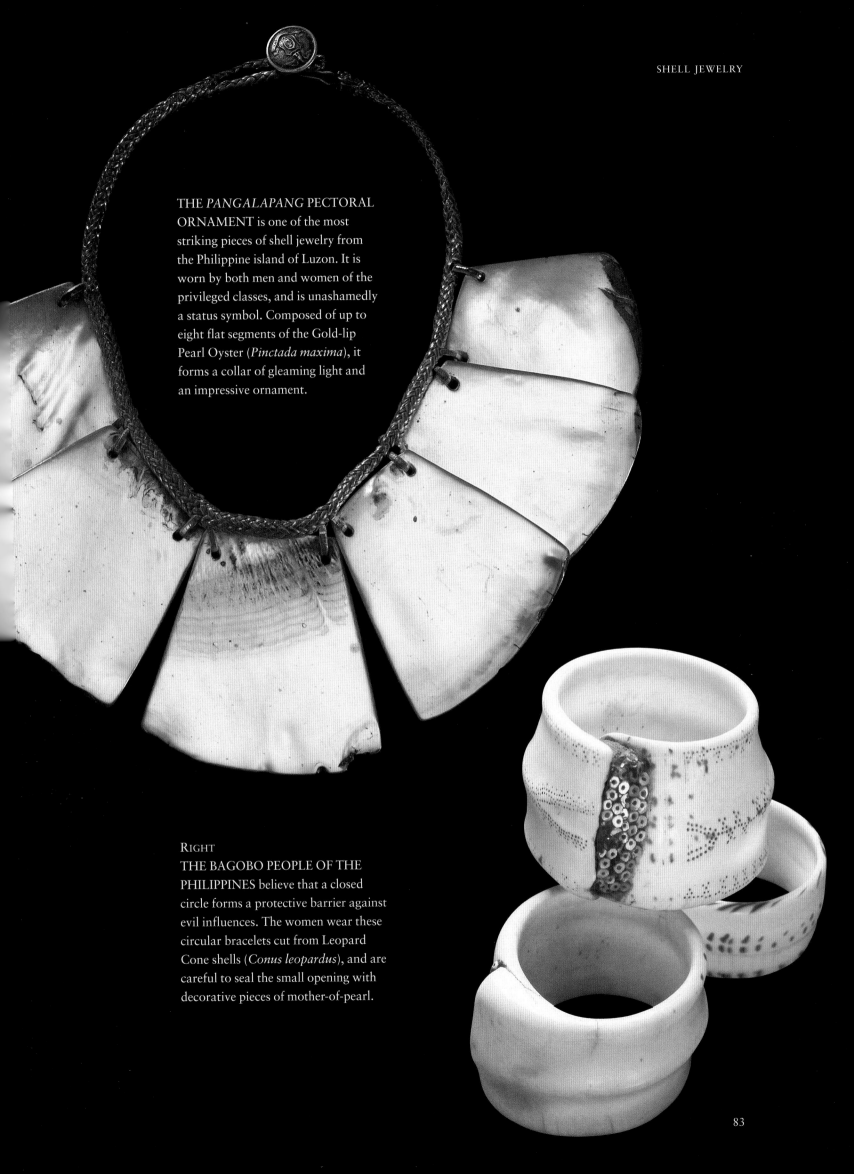

THE *PANGALAPANG* PECTORAL ORNAMENT is one of the most striking pieces of shell jewelry from the Philippine island of Luzon. It is worn by both men and women of the privileged classes, and is unashamedly a status symbol. Composed of up to eight flat segments of the Gold-lip Pearl Oyster (*Pinctada maxima*), it forms a collar of gleaming light and an impressive ornament.

RIGHT
THE BAGOBO PEOPLE OF THE PHILIPPINES believe that a closed circle forms a protective barrier against evil influences. The women wear these circular bracelets cut from Leopard Cone shells (*Conus leopardus*), and are careful to seal the small opening with decorative pieces of mother-of-pearl.

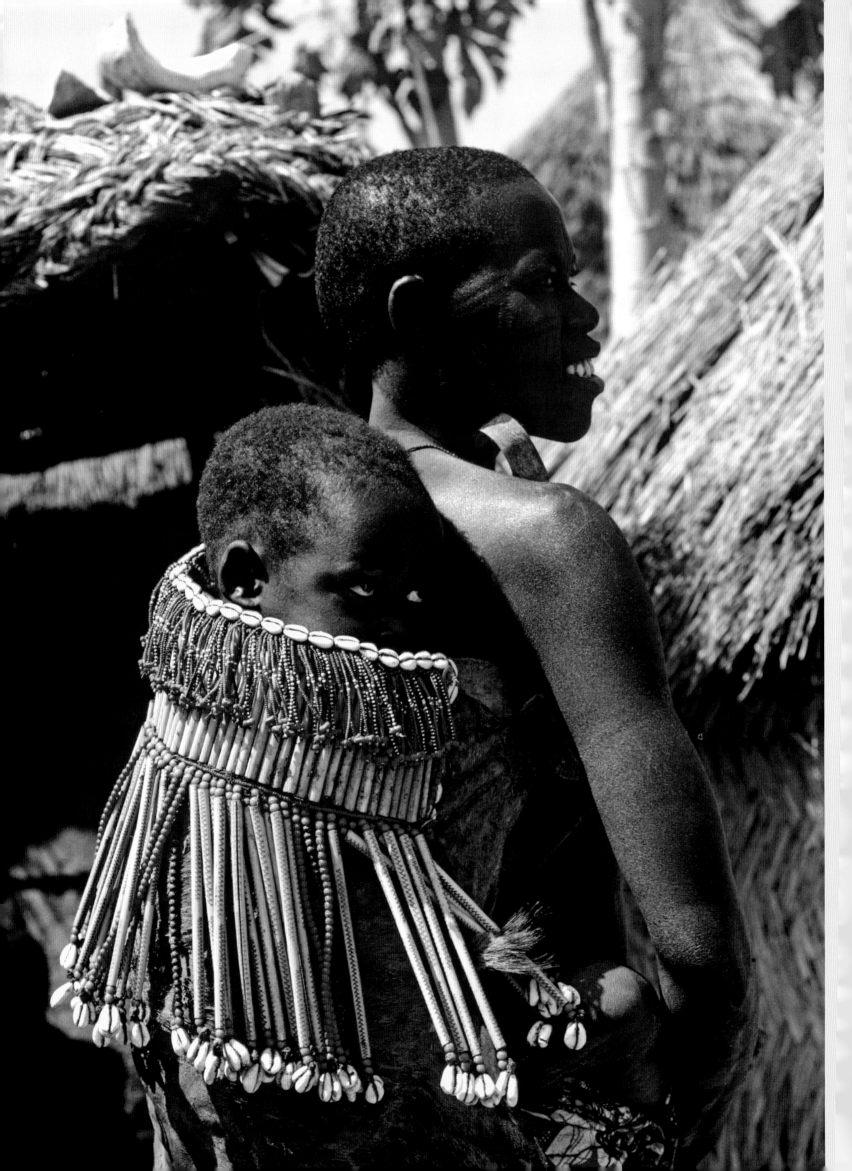

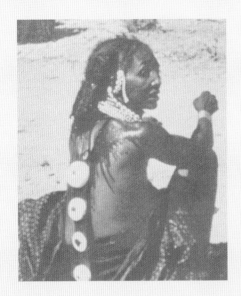

ABOVE AND RIGHT
HIGH-RANKING MEMBERS OF
WEST AFRICAN TRIBES wear
ornamental leather pendants studded
with cut sections of Butterfly Cone
shells (*Conus pulcher*). This Vahumbe
woman from Angola, above, shows
her status by wearing such a pendant
on her back.

OPPOSITE
THE FALI PEOPLE belong to one
of the Kirdi tribes of Cameroon.
They build their villages in tight
clusters, and live in huts thatched
with woven millet stalks. They also
use millet to make baskets and baby
carriers like the example shown
here, which is decorated with beads
and Cowrie shells (*Cypraea annulus* or
Cypraea moneta), a traditional symbol
of fertility.

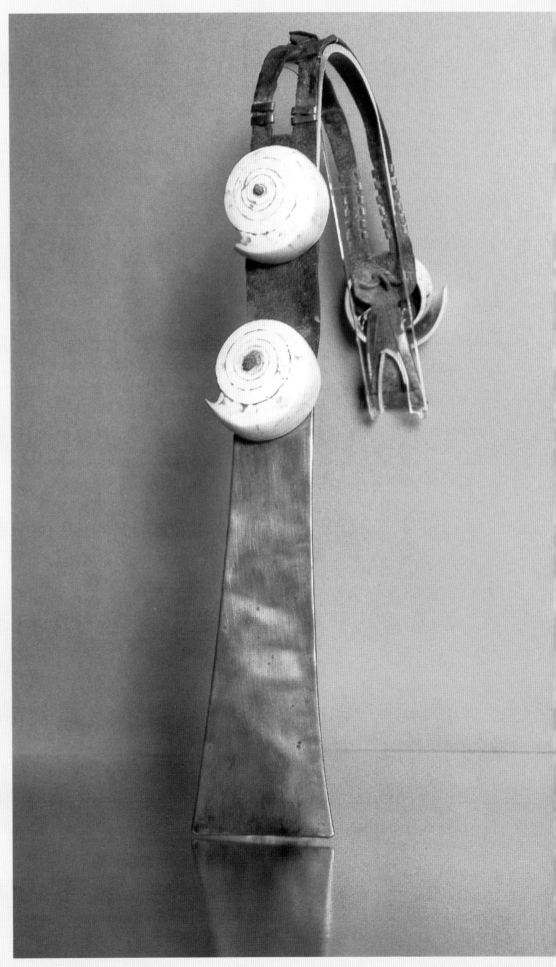

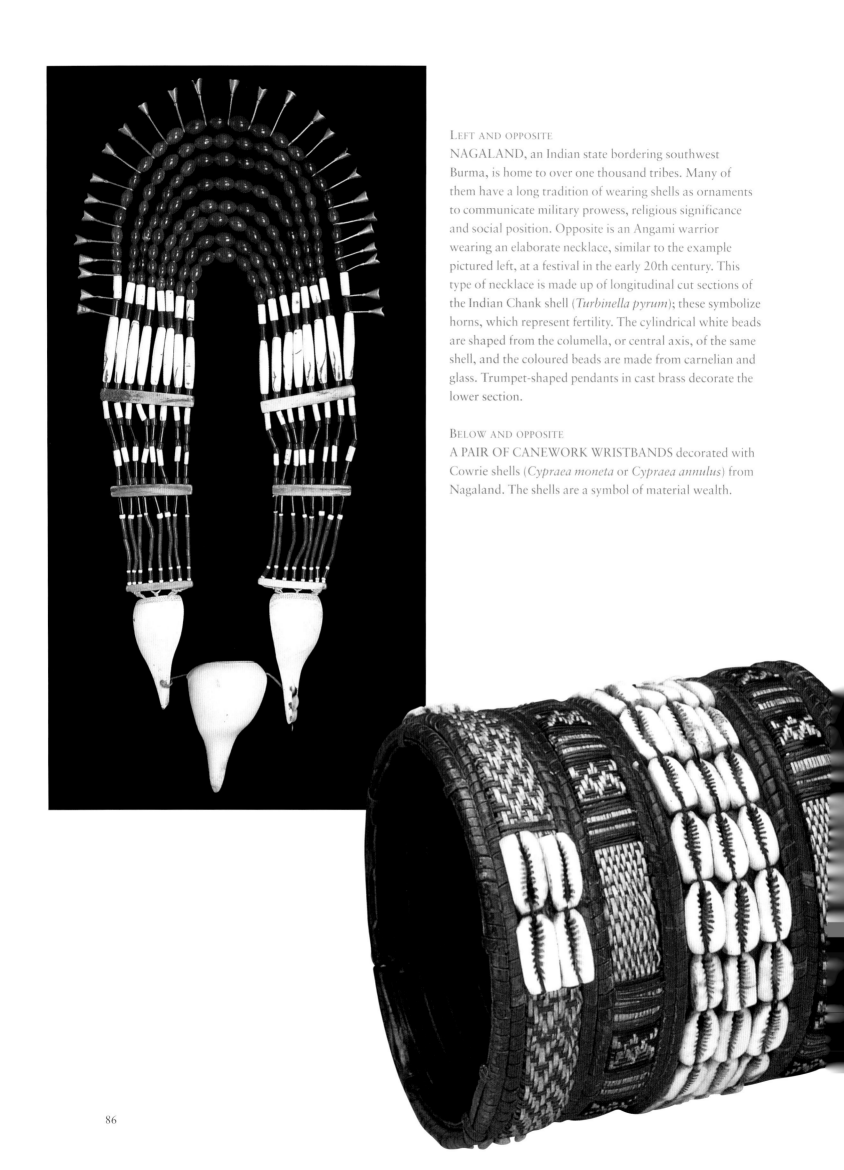

NAGALAND, an Indian state bordering southwest Burma, is home to over one thousand tribes. Many of them have a long tradition of wearing shells as ornaments to communicate military prowess, religious significance and social position. Opposite is an Angami warrior wearing an elaborate necklace, similar to the example pictured left, at a festival in the early 20th century. This type of necklace is made up of longitudinal cut sections of the Indian Chank shell (*Turbinella pyrum*); these symbolize horns, which represent fertility. The cylindrical white beads are shaped from the columella, or central axis, of the same shell, and the coloured beads are made from carnelian and glass. Trumpet-shaped pendants in cast brass decorate the lower section.

BELOW AND OPPOSITE

A PAIR OF CANEWORK WRISTBANDS decorated with Cowrie shells (*Cypraea moneta* or *Cypraea annulus*) from Nagaland. The shells are a symbol of material wealth.

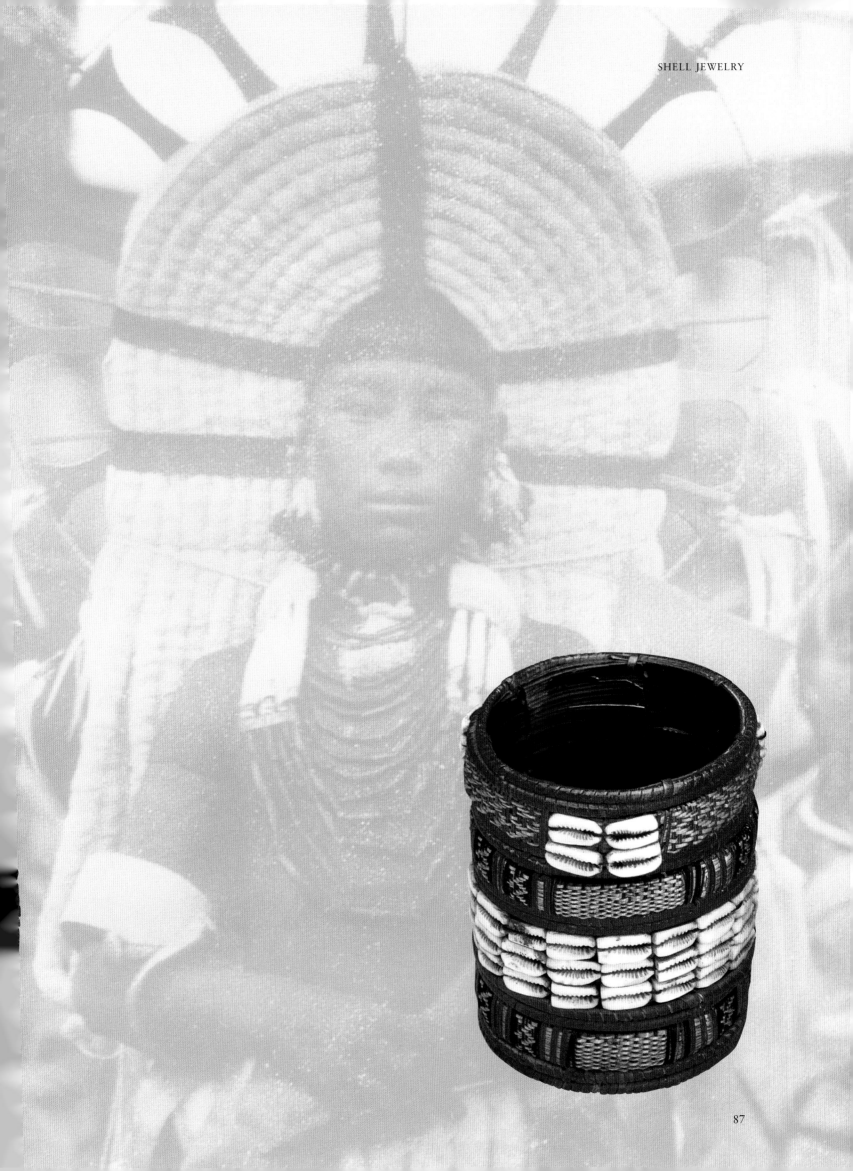

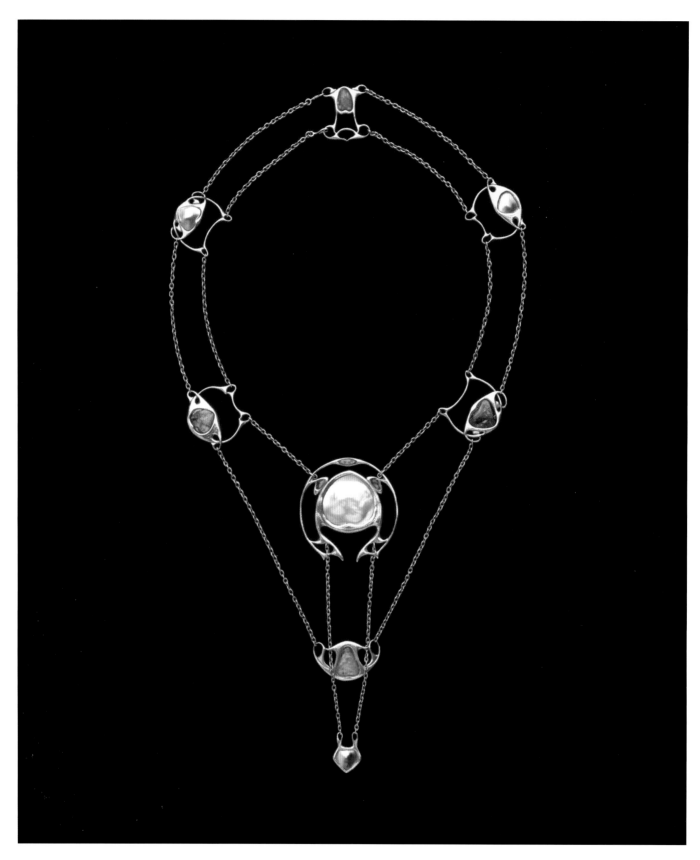

ABOVE
ART NOUVEAU NECKLACE designed by Archibald Knox
(1864–1933) for Liberty & Co, *c.* 1902. It is gold set with
mother-of-pearl and opals.

OPPOSITE
GOLD NECKLACE AND EARRINGS with plaques of lapis
lazuli inset with shells and pearls in *pietre dure* (hardstone)
mosaic. Made in the royal workshop of Naples in *c.* 1808,
these belonged to Napoleon's sister, Caroline Murat, Queen
of Naples.

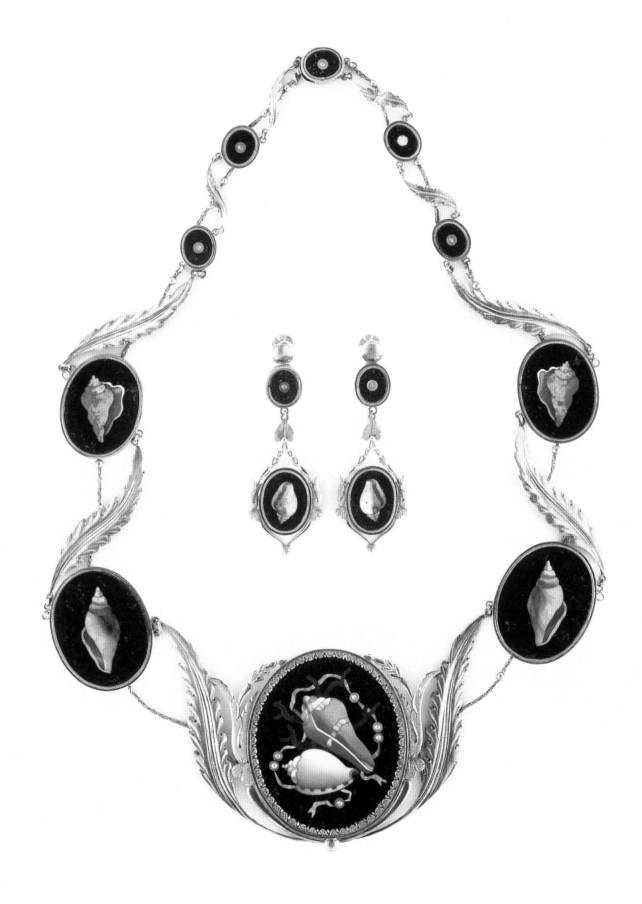

RIGHT
'LACE-PIN' BROOCH BY TIFFANY & CO, *c.* 1878, formed of two Australian Brooch Clams (*Neotrigonia margaritacea*), each one centred with a pearl. The shells are surrounded by additional pearls and strands of matte-finished gold seaweed. In the 19th century, lace-pins were worn at the neck, and often held together a detachable lace collar. *Neotrigonia* shells featured in jewelry shown at several exhibitions in Australia in the 1870s, and were also incorporated into pieces by contemporary Italian and English jewellers. Deep-water bivalves from the *Trigoniidae* family, they number a handful of species all found in Australian waters.

BELOW
SKETCH OF A BROOCH from the Tiffany & Co sales catalogue of 1880. It shows a single Australian Brooch Clam (*Neotrigonia margaritacea*) ornamented with a single pearl and backed by a branch of coral decorated with gold sea-grass.

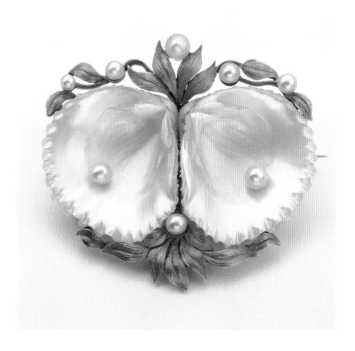

OPPOSITE
ART NOUVEAU 'BIRTH OF VENUS' PENDANT, *c.* 1900, signed by the French goldsmith and jeweller Georges Fouquet (1862–1957). The figure of Venus, carved from ivory, emerges from a sculpted gold shell, against an enamelled backdrop of sculpted fiery red coral branches. The background green and blue arched frame is decorated with pale green seaweed motifs, and from it is suspended a drop-shaped pearl.

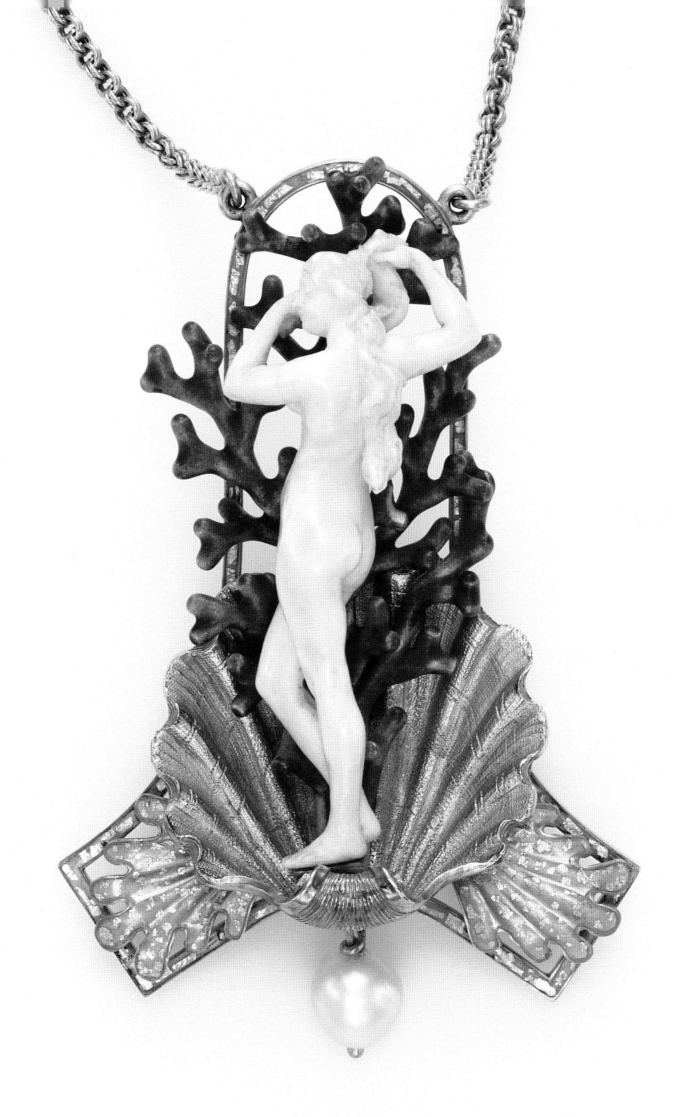

SHELL BROOCH, 1930s, by the Italian master jeweller Fulco di Verdura (1899–1978), who spent most of his working life in the United States. A Lion's Paw (*Lyropecten*

nodosa) is encrusted with diamonds and faceted citrines set in gold. Shells were a favourite subject for Verdura's opulent style, and his work was popular among the rich and famous.

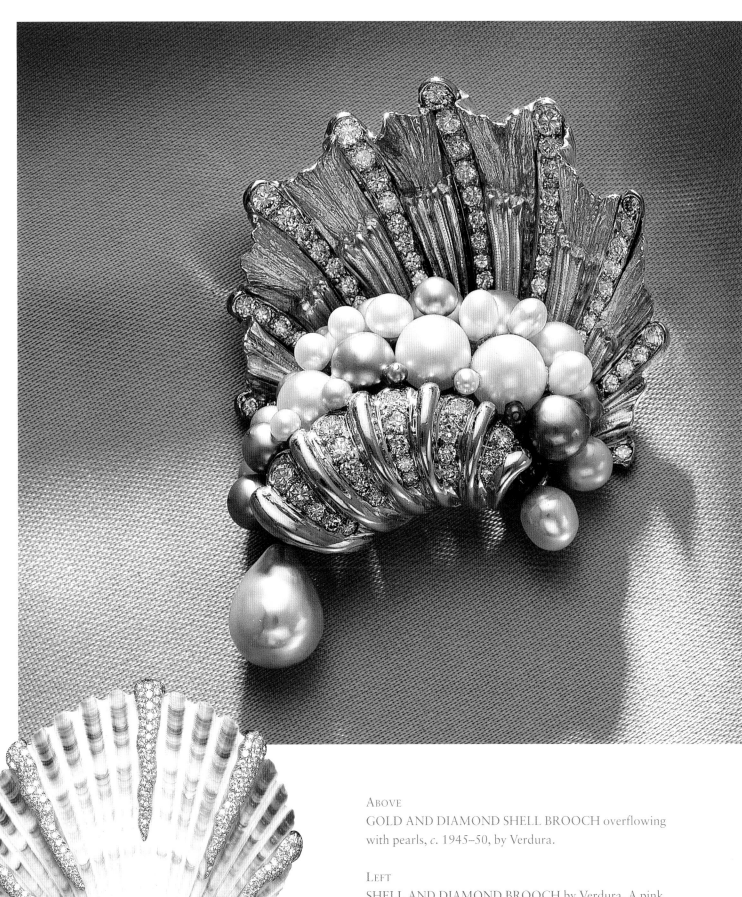

ABOVE
GOLD AND DIAMOND SHELL BROOCH overflowing
with pearls, *c*. 1945–50, by Verdura.

LEFT
SHELL AND DIAMOND BROOCH by Verdura. A pink
and white Scallop shell (*Pecten* sp.), mounted in platinum,
is decorated with tendrils of pavé-set diamonds. This is a
characteristic work from the famous jeweller, who loved the
simplicity of shells, and often used them as a basis for luxury
pieces. He believed that a natural shell in a precious mount
was the ultimate unique jewel: no example could ever exactly
replicate any other.

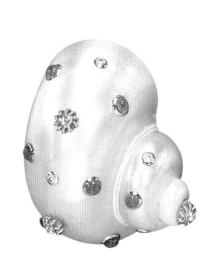

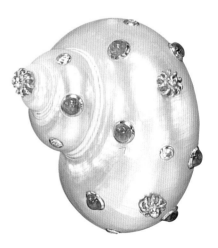

TOP
EAR CLIPS by Seaman Schepps
(1881–1972). These stylized shell
forms are carved in rock crystal and
decorated with bands and studs of
18k gold.

ABOVE
SHELL EAR CLIPS by Seaman
Schepps. The shells used are
Pontifical Mitres (*Mitra stictica*),
and they have been ornamented
with gold bead and wirework.

CENTRE
BLUE CHALCEDONY AND GOLD
BROOCH by Seaman Schepps,
designed as a stylized shell enhanced
by gold wirework.

FAR RIGHT
EAR CLIPS by Seaman Schepps in
shell, lapis lazuli and gold. Unusually,
these are not seashells at all but a
species of *Amphidromus*, which are
land shells. These two have been
truncated to allow large cabochons
of lapis lazuli to be inserted.

ABOVE AND RIGHT
SHELL AND EMERALD EAR CLIPS
by Seaman Schepps. The shells used
are of the *Turbo* species, most of which
have thick walls and an iridescent
interior. These highly polished
examples are studded with emeralds
and diamonds, and decorated with
gold wirework florets.

SHELL-SHAPED BROOCH BY
BULGARI, the famous Italian jewelry
company founded in 1884 and still an
international name synonymous with
luxury and prestige. A delicate brooch
only 4 cm (1⅝ in.) high, this stylized
gold shell is mounted with diamonds,
sapphires, coral and an emerald
cabochon at its tip.

BELOW
Jean Schlumberger's design for a box
lid with gem-encrusted stylized shells
to be set in gold.

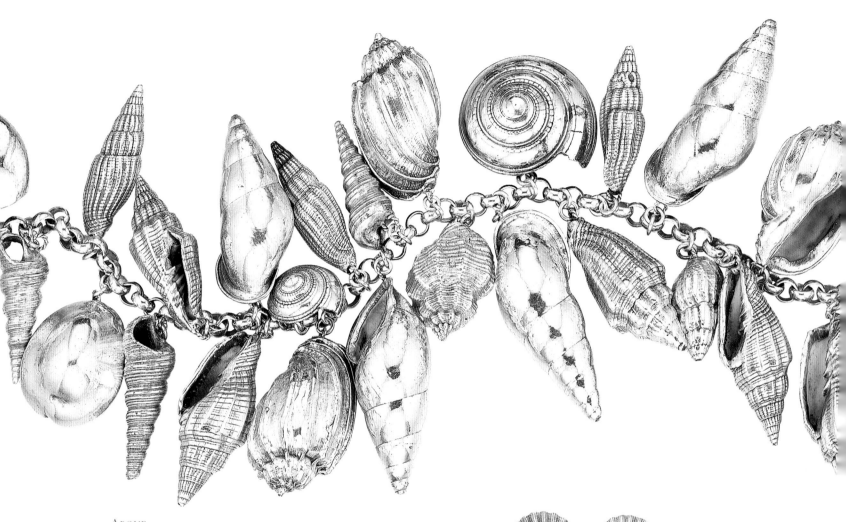

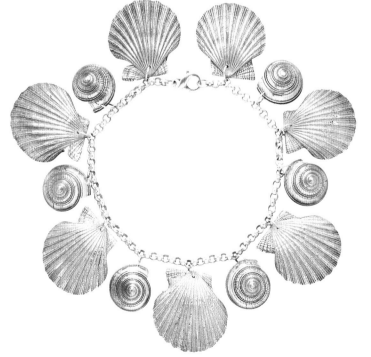

ABOVE
NECKLACE MADE FROM REAL
SHELLS, each with a silver overlay, 20th
century, designer unknown. The shells are
suspended from a silver chain measuring
32.5 cm (12¾ in.). They include the Minor
Harp (*Harpa amouretta*), a Giant Button
Top (*Umbonium giganteum*), two species
of Mitre (from the family *Costellariidae*), a
Cowrie (*Cypraea sp.*), and three specimens
of land snail shells.

RIGHT
SILVER SHELL NECKLACE, by Mario
Buccellati, mid-20th century. Natural
Scallop and land shells coated with silver
are suspended from a silver link chain.
Each shell is signed by the famous Italian
jewelry designer.

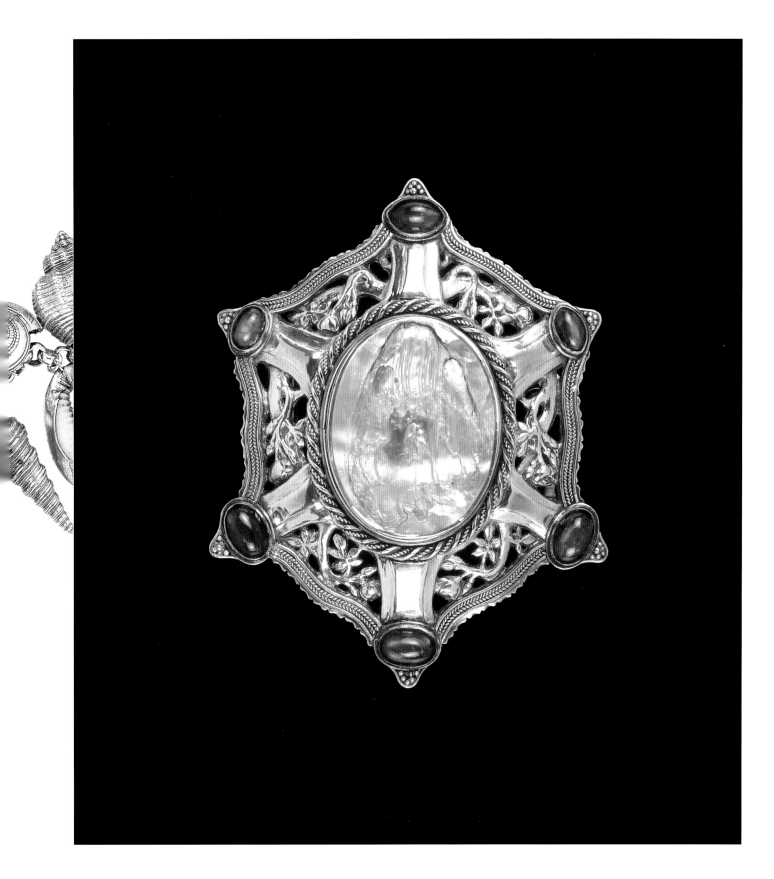

WAIST CLASP by John Paul Cooper (1869–1933), a prominent English designer and craftsman of the Arts and Crafts Movement. Cooper's work expressed his passion for the mystery and meaning of precious metals and stones, and carried echoes of late medieval and Renaissance jewelry. This waist clasp has a pierced rose and foliage design, executed in silver, Abalone shell (*Haliotis* sp.) and labradonte.

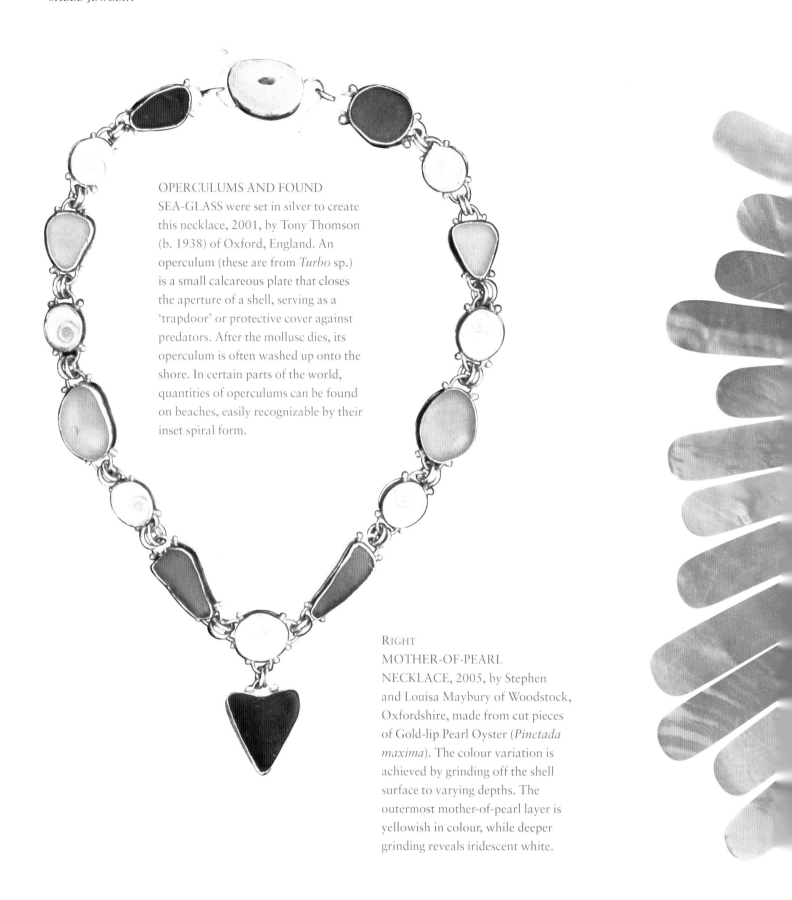

OPERCULUMS AND FOUND
SEA-GLASS were set in silver to create
this necklace, 2001, by Tony Thomson
(b. 1938) of Oxford, England. An
operculum (these are from *Turbo* sp.)
is a small calcareous plate that closes
the aperture of a shell, serving as a
'trapdoor' or protective cover against
predators. After the mollusc dies, its
operculum is often washed up onto the
shore. In certain parts of the world,
quantities of operculums can be found
on beaches, easily recognizable by their
inset spiral form.

RIGHT
MOTHER-OF-PEARL
NECKLACE, 2005, by Stephen
and Louisa Maybury of Woodstock,
Oxfordshire, made from cut pieces
of Gold-lip Pearl Oyster (*Pinctada
maxima*). The colour variation is
achieved by grinding off the shell
surface to varying depths. The
outermost mother-of-pearl layer is
yellowish in colour, while deeper
grinding reveals iridescent white.

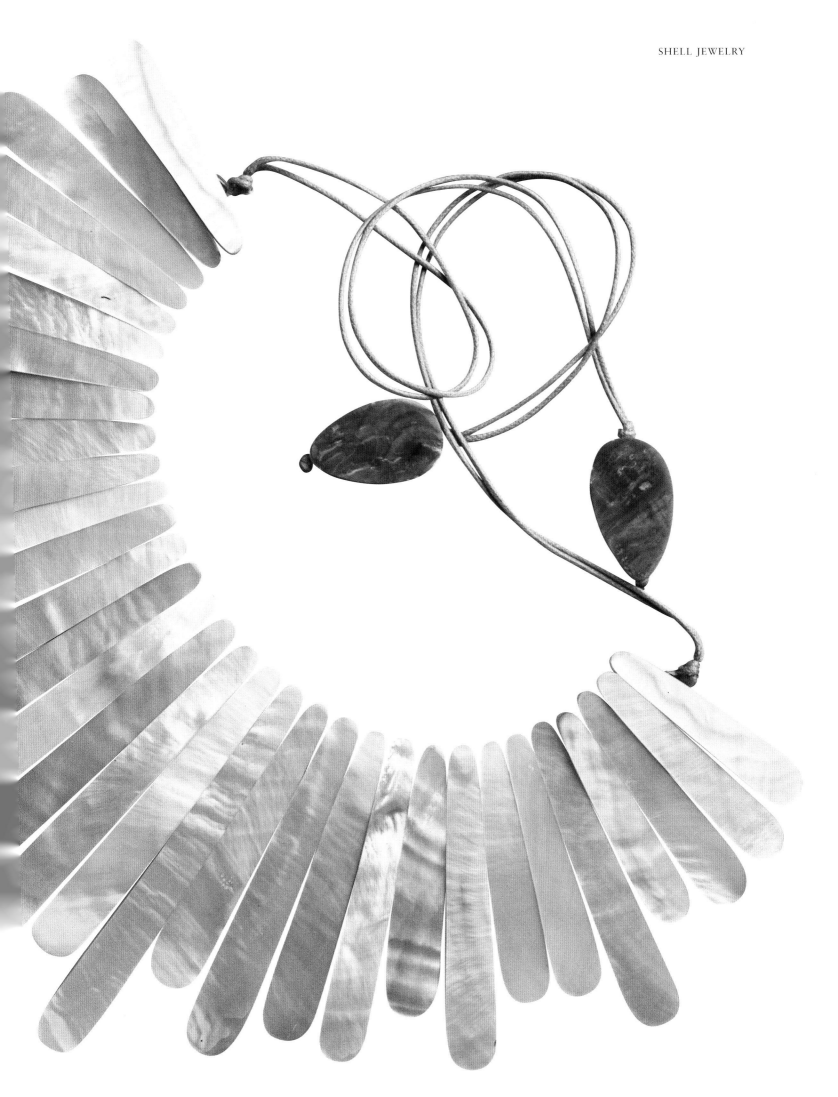

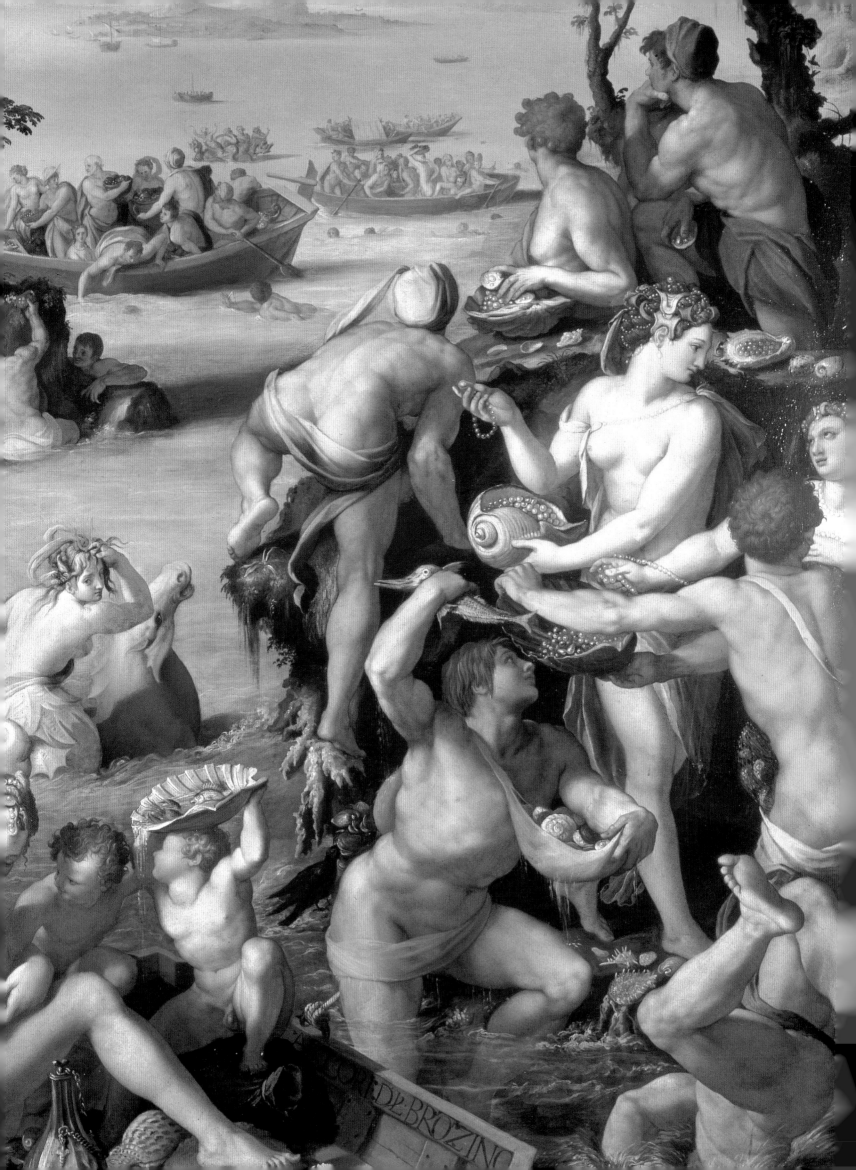

OPPOSITE *Pearl Fishers*, 1570–71, by Allessandro Allori (1535–1607). A number of shells are accurately portrayed in this famous Mannerist painting. The maiden at the right is holding a Giant Tun (*Tonna galea*), a shell that is distributed over a wide area, including the Mediterranean. The child with a shell on his head is holding a large Bear Paw Clam (*Hippopus hippopus*), from the Southwest Pacific.

BELOW *Triton Blowing on a Conch Shell*, *c.* 1615, by Jacques de Gheyn III (*c.* 1596–1641). The details in this etching suggest the shell was modelled on a Knobbed Triton (*Charonia lampas*). The term 'conch' is often used indiscriminately to refer to any big shell. True conches, of the genus *Strombus*, can be recognized by an indentation in the outer lip of the shell where the mollusc's eye stalk protrudes.

SHELLS IN ART

The study of shells is a branch of natural history which, although not greatly useful to the mechanical arts, or the human economy, is nevertheless, by the beauty of the subjects it comprises, most admirably adapted to recreate the senses, to improve the state of invention of the artist.

George Perry, *Conchology*, 1811

Nature has always provided artists with their greatest source of inspiration. One of her finest riches, the shell has been a constant and irresistible subject for artists the world over. Other organic forms are variously portrayed as either benign and harmonious, or melancholy, bleak and on occasion in a state of decay. Shells, by contrast, are consistently depicted as symbols of beauty, and sometimes of life eternal. Numerous artists of all disciplines have found their qualities to be mysterious and captivating. Shells may symbolize purity or the sacred; they may represent sexuality, fertility, renewal and peace. But above all, shells are quite simply objects of great natural beauty, and artists have always been inspired to capture that which is beautiful.

Many painters have featured shells in their work, from the old masters to the modernists of the 20th century. A shell may be a detail in a larger canvas, perhaps as the attribute of a saint or a *vanitas* symbol, a reminder of life's transience. Other times shells are the main focus, or the sole subject of a still life. From the vast repertoire of shells as possible subjects, it is noticeable how

certain species have been favoured over others by painters. We know that this was not because these were the only examples available to them; in part it was because of established iconographic traditions, but it was also doubtless thanks to the particular aesthetic qualities of certain shells. Also noteworthy, however, is just how many of the representations of shells over the centuries are stylized, with only a passing nod to scientific accuracy. Some artists have even taken off on flights of fancy and created shells that simply do not exist in nature.

But let us go back in time to the close of the Middle Ages and the dawning of the European Renaissance in the 15th century, when artists were deeply preoccupied not only with sacred but with classical themes. As the patrons and artists who shaped the Renaissance strove to recapture the former glory of Rome, the classical myths gained new popularity. The legends of Greece and Rome were well known to educated Italians, and represented to them a great deal more than mere fairy tales; they were felt to contain profound and mysterious truths. This conviction of the superior wisdom of ancient mythology prompted Florentine artists to strive to capture its essence in paintings.

One of these myths stands out above all others: the story of the birth of Venus, who as she rose from the sea brought the divine gift of beauty into the world. Accounts of her origins vary, but according to the poet Hesiod, who lived in the 7th century BC, Aphrodite (as she was known to the Greeks) was born when Uranus, the father of the gods, was castrated by his son Cronus. The severed genitals were thrown into the ocean, which immediately began to churn and foam. From this sea-foam, the goddess arose on a shell, upon which she was carried to the shores of Cyprus. The story has been translated onto canvas, sculpted in marble, and cast in bronze. But the most celebrated artistic recreation of the myth is by Sandro Botticelli, whose exquisite painting *The Birth of Venus* (1478) is one of the most famous works of art in the world today.

Since the end of the medieval period, artists and designers have, like Botticelli, invariably shown the goddess standing or reclining in a stylized Scallop shell. Yet this was not necessarily the case in classical times, when it was the Cowrie shell that was known as *Concha Venerea*, or Venus's shell. In the wall painting depicting the Birth of Venus at Pompeii, Venus reclines on what

OPPOSITE ABOVE *The Birth of Venus* (anon.), from a wall painting found in Roman Pompeii. Venus is traditionally shown in post-medieval art being borne on a Scallop shell, but in antiquity, it was sometimes a Cockle shell. In this painting, the goddess's shell, though stylized, shows more than a passing resemblance to a Great Ribbed Cockle (*Cardium costatum*). This is a species found only in West Africa, but since Roman trade routes extended to that region, it is possible that the artist had access to a specimen.

OPPOSITE BELOW The world's most celebrated painting featuring a shell is *The Birth of Venus*, 1478, by Sandro Botticelli (1446–1510). This shows the goddess standing, somewhat precariously, in a stylized Scallop shell. The species closest to the shell in the painting is the Great Scallop, sometimes known as the King Scallop (*Pecten maximus*), although its size here is of course greatly exaggerated; the real shell grows to a maximum of about 12 cm (4¾ in.). The Great Scallop is the common, edible variety familiar throughout Europe; Botticelli might easily have feasted on it in his day. Today it is cultured and harvested commercially to meet the demand for what is still a luxury food.

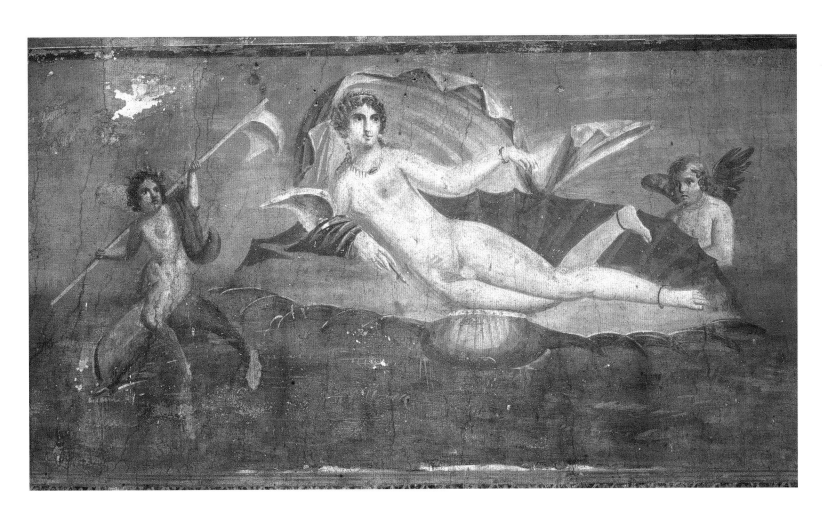

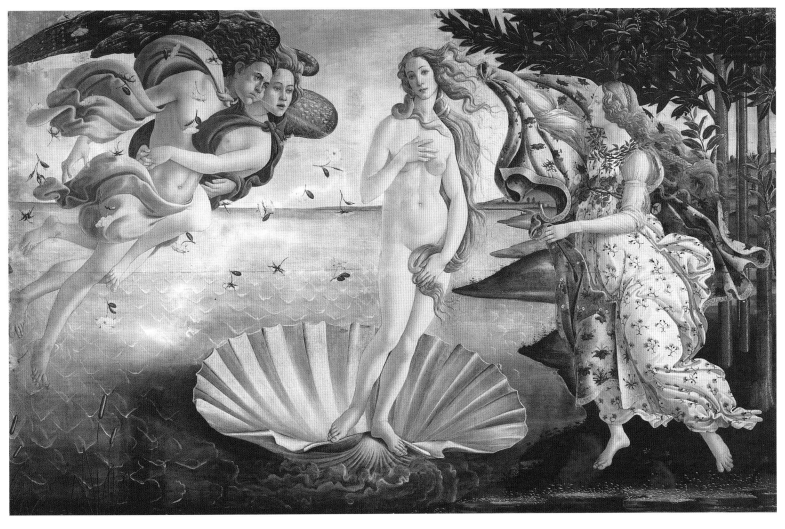

appears to be a stylized Great Ribbed Cockle shell (*Cardium costatum*). It would seem that artistic licence has permitted generations of painters to reinvent classical tradition, selecting the shell shape better suited to transporting the goddess ashore.

The 16th century saw the beginnings of developments that would eventually lead to shells, along with the natural world in general, becoming the subject of serious scientific study. In 1594, Francis Bacon, the English philosopher and writer, compiled a list of the essential apparatus of a learned gentleman of the age. After his first two requirements of a perfect library and a wonderful garden, Bacon specified the third: '... a goodly, huge cabinet, wherein whatsoever the hand of man by exquisite art or engine has made rare in stuff, form or motion; whatsoever singularity, chance, and the shuffle of things hath produced; whatsoever Nature has wrought in things that want life and may be kept; shall be sorted and included.'

Bacon was referring to the phenomenon of the 'cabinet of curiosities'. Variously known as the *Wunderkammer* (wonder room) or *Kunstkammer* (art room), these cabinets – which could be anything from a single display case to whole rooms stuffed with treasures – were originally inspired by the Renaissance yearning to gain greater understanding of mankind's position in the grand scheme of the universe. As maritime exploration by the Dutch, Portuguese, English and Spanish opened up new empires, and trading stations were established in far-flung tropical ports, the ships that returned home would empty their bulging holds to reveal treasures previously unknown to Europeans. Such 'curiosities' were eagerly purchased by the aristocracy and the wealthy, and they formed the basis of collections of natural and man-made objects for the advancement of learning. Cabinets were grand showcases for friends and learned colleagues to admire, and the collections they housed would

Engraving from *Historia Naturale* (second edition, 1672), by the Neapolitan apothecary Ferrante Imperato (1550–1625). Imperato's collection of natural history specimens was one of the earliest in Italy. This engraving shows tropical shells suspended from the ceiling of his cabinet. Doubtless there were more tucked away in the boxes and drawers below, because Imperato devoted several pages to shells in his catalogue.

Art Room, 1636, by Frans Francken the Younger (1581–1642). In this painting Francken invites us into a collector's cabinet of curiosities. We can spy some scholars engaged in debate in the next room, while on the table in front of us is a jumbled assortment of objects, including several exotic shells. A black and white Marble Cone shell (*Conus marmoreus*) stands out at the left of the picture. Nearer the centre lies an orange and white Episcopal Mitre (*Mitra mitra*), a common shell in the Indo-Pacific, but an object of great luxury and curiosity in 17th-century Antwerp.

inspire serious discussion and analysis; they were, in effect, the precursors of today's museums. Their contents varied as widely as the interests of their collector-owners, but all manner of items could be displayed there, including natural history specimens, coins and medals, ivories, sculptures, gems and works of art. Exotic shells were among the most prized pieces in collectors' cabinets.

For painters, particularly those who specialized in still lifes, these newly discovered natural objects represented a new repertoire of subject matter. Independent still life paintings first made their appearance in the Netherlands in the 16th century. Their subjects, often depicted with extraordinary precision, included flowers, fruit, vegetables, musical instruments and kitchen implements. As beautiful as flowers and considered as precious as gems, exotic shells featured in hundreds of such paintings. The most

prolific still life painter of this period was the Dutch artist Balthasar van der Ast (*c.* 1593–1656). He studied under his brother-in-law Ambrosius Bosschaert, and, together with three nephews, their family group, known to art historians as the Bosschaert dynasty, is renowned for their still life paintings. Ambrosius Bosschaert's idealized depictions of cultivated flowers were distinguished by their extraordinary, almost botanical precision. Alongside his dominant floral subjects were often accessories such as small animals, a few exquisitely painted drops of water, or rare and precious shells. But it was Balthasar van der Ast who painted the most remarkable still lifes featuring shells. These works (see pages 116–17) are now treasured in museums and private collections around the world.

Van der Ast's more famous contemporary Rembrandt van Rijn was only once moved to portray a natural object in a still life, but when he

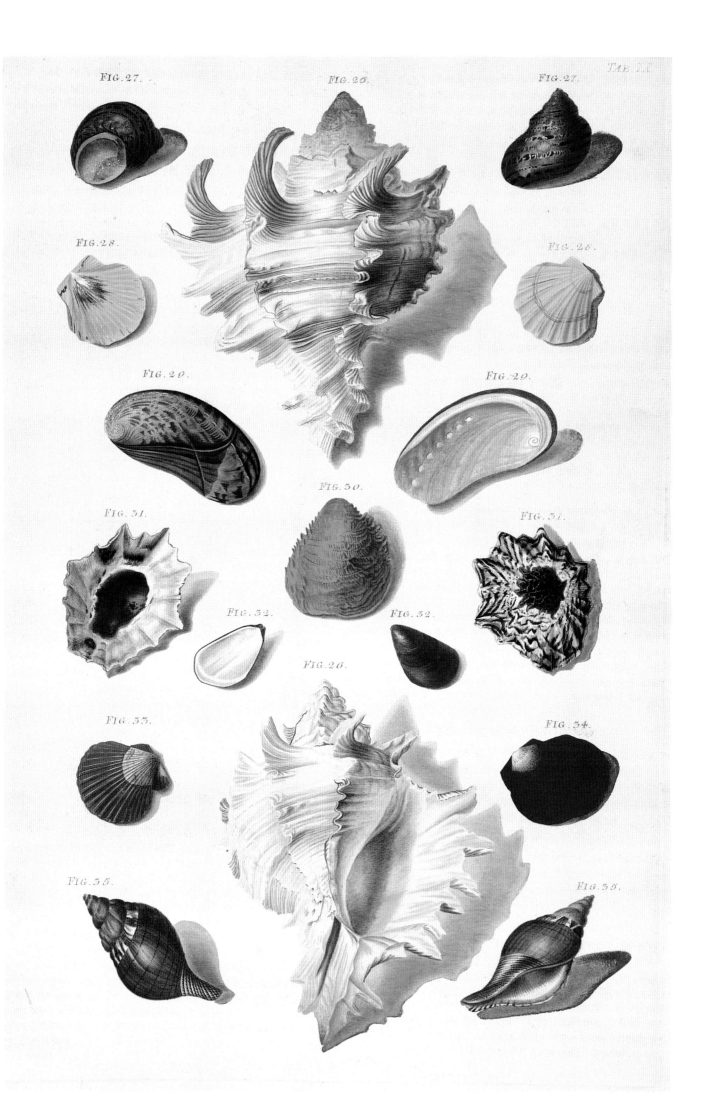

TAB. IX

FIG. 27.

FIG. 26.

FIG. 27.

FIG. 28.

FIG. 28.

FIG. 29.

FIG. 29.

FIG. 30.

FIG. 31.

FIG. 31.

FIG. 32.

FIG. 32.

FIG. 26.

FIG. 33.

FIG. 34.

FIG. 35.

FIG. 35.

LEFT *Rocaille* and *Leda*, *c*. 1736, by
François Boucher (1703–70), engraved
by Claude Duflos the Younger. These
engravings after Boucher's designs
typify the Rococo style, their fluid,
scrolling motifs revolving around
organic forms and natural settings.
The curves of shells are essential
themes in these compositions full
of light, grace and opulence.

OPPOSITE Illustration plate from
*Choix de Coquillages et de Crustacés
Etc.*, published in 1758, by German
artist, engraver and shell-collector
Franz Michael Regenfuss. It is
dominated by two views of a shell
that is probably a Duplex Murex
(*Hexaplex duplex*), surrounded by
smaller tropical shells. This large and
luxurious volume contained twelve
such engraved plates of Regenfuss's
accomplished drawings of shells,
mostly coloured by his wife.

was he too chose a shell (see page 124), a species
from tropical Indo-Pacific waters whose common
name is the Marble Cone (*Conus marmoreus*).
Like many others from the same family, it has
strikingly beautiful markings which Rembrandt
rendered in carefully observed detail.

In the 18th century there were men whose
passion drove them to portray shells with unerring
accuracy and precision, capturing the smallest
detail of form and pattern in engraving and paint.
Such men – who included Niccolo Gualtieri,
Franz Michael Regenfuss and Thomas Martyn –
were not motivated by art so much as by science;
they were among the first true conchologists,
men who introduced the world to the systematic
study of shells, and who wrote the first books on
the subject. The illustrations in such books were
either their own or were commissioned from
artists. They include some extremely fine
engravings, whose status as art is in no way
compromised by the scientific intent that
motivated their creators.

The main traditions of painting and the
decorative arts in the 18th century were headed
in a rather different direction: that of the playful,
light-hearted and opulent Rococo style. Beginning
in France in the early 18th century in reaction to
the Baroque excesses of Louis XIV's regime, the
Rococo style emerged first in the decorative arts
and interior design. The word Rococo derived
from *rocaille*, meaning a type of rock and shell-
work, and the Italian word *barocco*, meaning
Baroque. Rococo maintained the Baroque taste
for complex forms and patterns, but now these

RIGHT *Oysters*, 1862, by Edouard Manet (1832–83). This is one of Manet's earliest still lifes, reportedly painted for his fiancée, Suzanne Leenhoff, whom he married in 1863. But he kept the painting himself: it was in his studio when he died. He was an avid student of art history, and this painting is reminiscent of 17th-century Dutch still lifes. The shells depicted are Common European Oysters (*Ostrea edulis*).

BELOW *The Black Clock*, *c*. 1870, by Paul Cézanne (1839–1906). This masterly painting depicts a scene in the home of Cézanne's greatest friend, Émile Zola. Several objects are arranged on a white tablecloth, behind which stands a black clock, curiously without hands. The enormous shell with vivid colouring is stylized, but has many characteristics of a Conch (*Strombus* sp.), although its size is greatly exaggerated in relation to the surrounding objects.

were full of shell-like curves, and natural and graceful themes. Its designers delighted in asymmetry, leaving elements unbalanced for an effect called *contraste*. From furniture and interior design the style spread to painting and sculpture, exemplified above all by the works of the French artists Antoine Watteau and François Boucher.

Before long Rococo influence was felt in other parts of Europe, including England, where it was known as 'the French taste'. The light-hearted themes and intricate designs of Rococo always presented themselves best on a small scale, and as such it was principally at home indoors, expressed in designs for silverwork, porcelain, and furniture. For a more in-depth look at its themes see 'Shells in the Decorative Arts' (pages 192–93).

The break in tradition brought about by the French Revolution of 1789 and the Industrial Revolution changed the lives of artists forever. Painting ceased to be a respected trade, handed on from master to apprentice. The academies of Paris and London gave way in the mid-19th century to a world in which artists saw themselves almost as a race apart, driven by an inner urge to express their individual vision. It is from the Impressionist, modern and experimental styles of the last 150 years that some of the most interesting portrayals of shells have emerged. Through the many artistic movements and revolutions of the 19th and 20th centuries, artists have continued to take inspiration from both the beauty of shells and from the art historical traditions in which they have played such a longstanding part.

RIGHT *Idol with a Shell*, 1892–93, by Paul Gauguin (1848–1903). The artist spent many years in Tahiti, where he was disappointed by the scarcity of indigenous artefacts, a great many of which had been destroyed or removed by Europeans. In his exploration of native styles, Gauguin produced small-scale wooden sculptures that borrow Oceanic motifs and iconography from Asiatic art. This small figure of an idol bears a halo formed from a Black-lipped Pearl Oyster (*Pinctada margaritifera*).

LEFT
PAGE FROM A 14TH-CENTURY
ITALIAN MANUSCRIPT attributed
to Cybo d'Hyeres. His illustrations
feature crustaceans and shells, many
of which are well-known species from
the Mediterranean.

OPPOSITE
ALLEGORY OF DECEIT, 1490,
by Giovanni Bellini (1430–1516).
The species of shell depicted in this
allegorical painting is the Purple
Dye Murex (*Bolinus brandaris*).
It is tempting to wonder if the artist
knew that this was the shell used to
produce the purple dye that was so
prestigious in the ancient world.
He almost certainly did know that
it was an edible species, common in
the Mediterranean and Northwest
Africa. Even today thousands of
tons are fished each year, and are
widely available at fish markets
around the Mediterranean.

IOANNES · BELLINVS · P ·

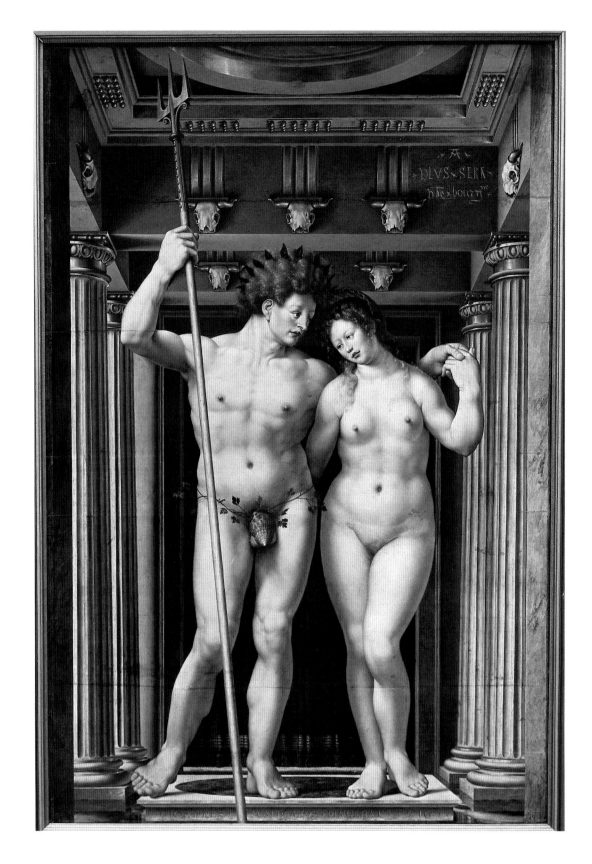

LEFT

NEPTUNE AND AMPHITRITE, 1516, by Jan Gossaert (*c.* 1472–1533). A painter, draughtsman and printmaker, Gossaert was the first Netherlandish artist to paint classically inspired, mythological nudes. Neptune's shell is difficult to identify, but it is probably a species of Triton (*Charonia* sp.).

OPPOSITE

THE TRIUMPH OF GALATEA, 1511, by Raphael (1483–1520). Working about thirty years after Botticelli painted *The Birth of Venus*, Raphael also placed his main subject, the sea nymph Galatea, in a stylized Scallop shell (*Pecten* sp.). But he added curious paddle wheels to her shell, transforming the craft into a chariot driven by two dolphins. At the far left of the picture, a Triton blows triumphantly into a large stylized shell trumpet.

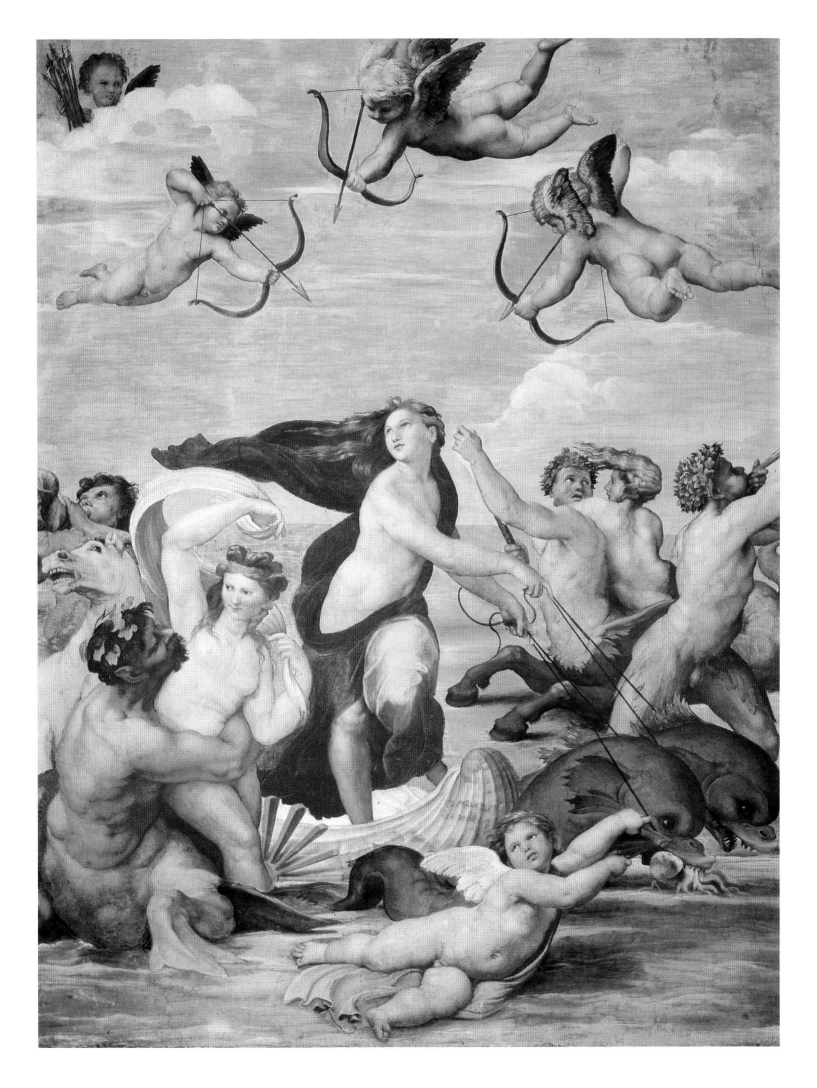

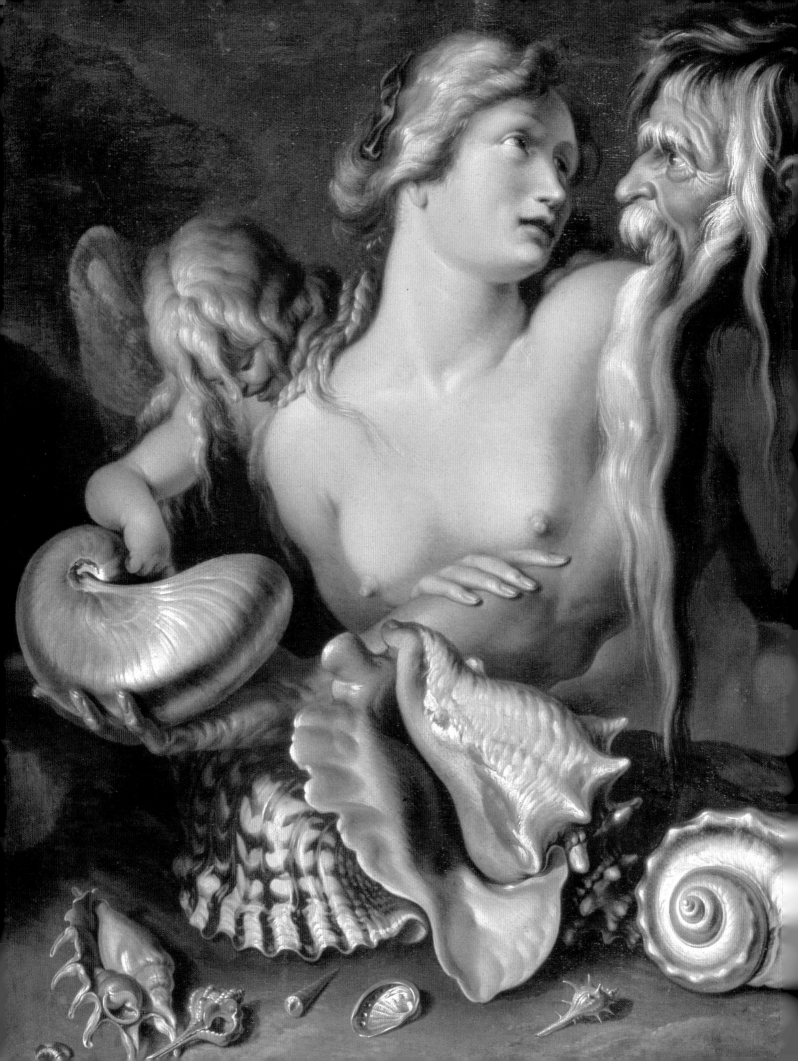

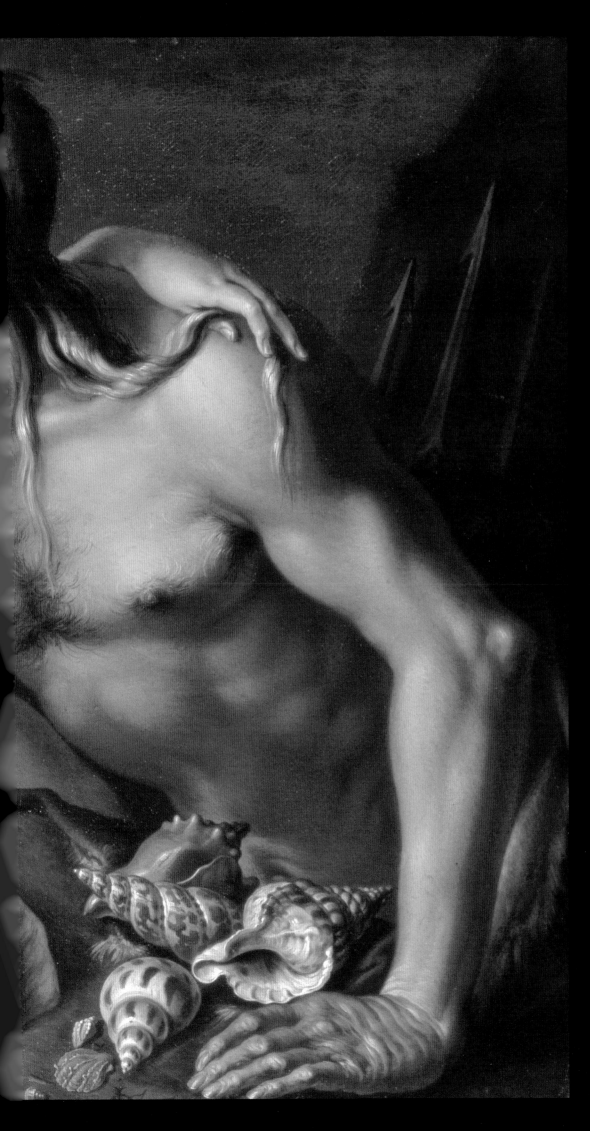

NEPTUNE AND AMPHITRITE,
by Jacob de Gheyn II (1565–1629).
The love of these two sea gods is
symbolized by Cupid and the shells
that surround them – an assortment of
exotic specimens dominated, in front
of Amphitrite, by a Queen Conch
(*Strombus gigas*), a species that comes
from the Caribbean. Two of the shells
shown have been ground down and
polished to show the underlying layer
of mother-of-pearl: in the centre,
a Great Green Turban (*Turbo
marmoratus*), and the shell in
Neptune's hand, the Chambered
Nautilus (*Nautilus pompilius*).

115

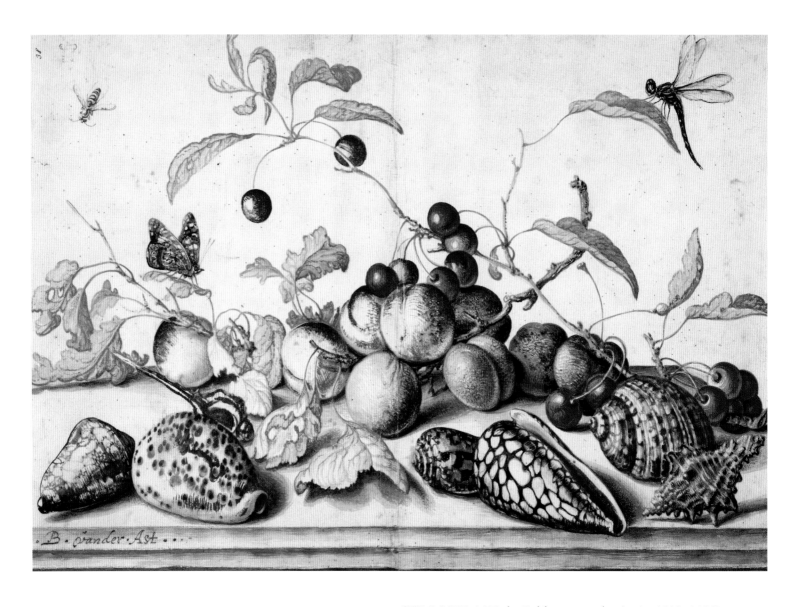

STILL LIFE, 1628, by Balthasar van der Ast (*c.* 1593–1656).
This unusual work in pen and watercolour shows several
Cone shells (*Conus* sp.), including a black and white Marble
Cone (*Conus marmoreus*). There is also a Tiger Cowrie
(*Cypraea tigris*) second from left, a Snipe's Bill Murex
(*Murex haustellum*) behind the Cowrie, and a Ceramic
Vase (*Vasum ceramicum*) at far right, in front of a Turban
shell (*Turbo* sp.).

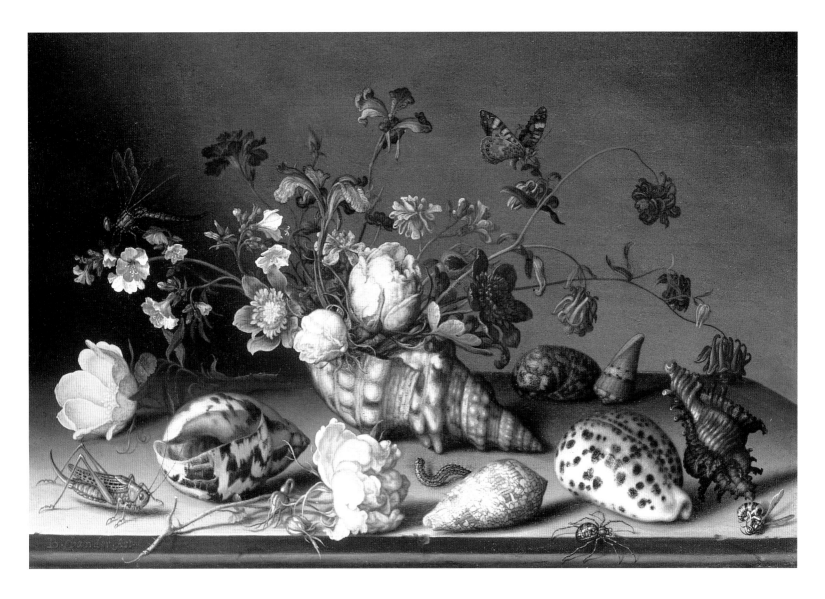

FLOWERS, SHELLS AND INSECTS ON A STONE LEDGE, by Balthasar van der Ast (*c.* 1593–1656). The shells painted in this picture are, front, left to right: a large African land snail, a Textile Cone (*Conus textile*), a Tiger Cowrie (*Cypraea tigris*), and an Adusta Murex (*Chicoreus brunneus*), all common species from the Indo-Pacific. The shell holding the flowers is a species of Triton (*Charonia* sp.), while at the back, from left to right, are a West Indian Top (*Cittarium pica*) from the Caribbean, and the uncommon Weasel Cone (*Conus mustelinus*) from the Indo-West Pacific.

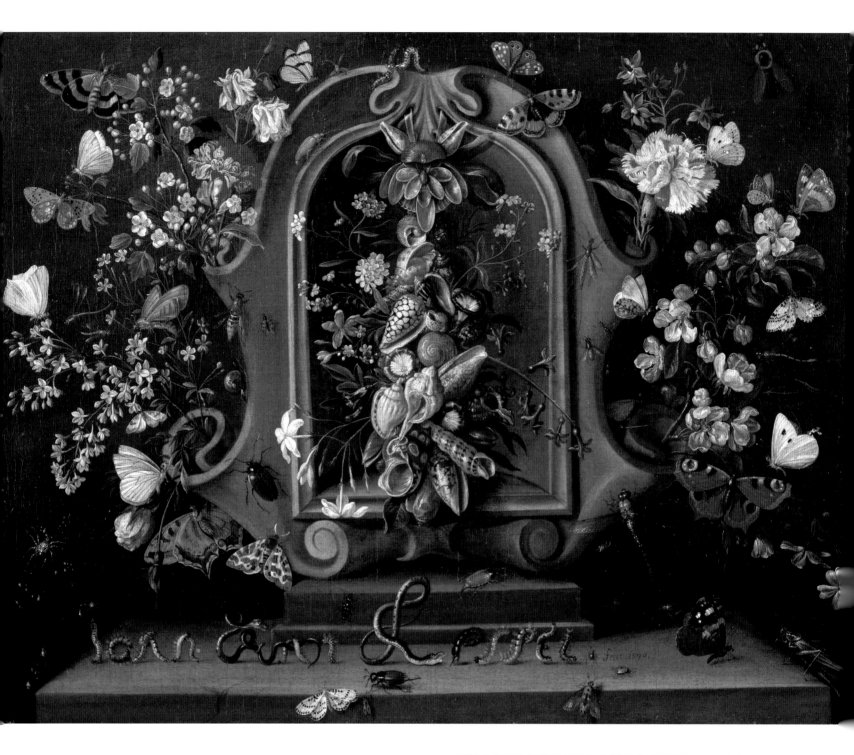

STILL LIFE WITH SERPENT SIGNATURE, 1670, by
Jan van Kessel (1626–79). Grandson of Jan Breughel the
Elder, and nephew of Jan Breughel the Younger, van Kessel
produced still lifes, often using flowers, insects and shells as
his primary subjects, reproducing them with sensitive detail
and almost scientific accuracy. The flowers and insects here
form delicate sprays at both sides of the composition, but it
is the shells, hung in a dramatic cascade in the central niche,
that first catch the eye. They are easily identifiable as exotic
species, popular among still life painters at the time. With a
light-hearted touch, van Kessel spells out his signature on the
ledge in front with calligraphic snakes and caterpillars.

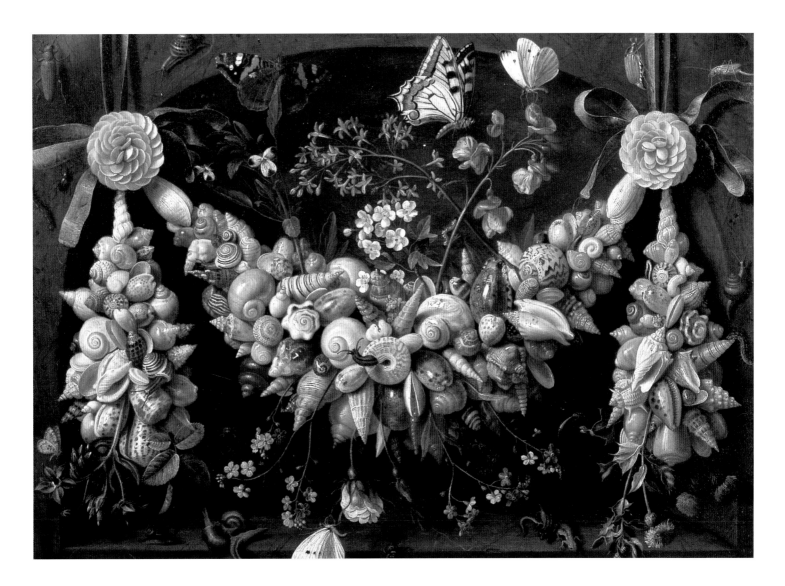

STILL LIFE OF SHELLS AND FLOWERS, 1654, by Jan
van Kessel. This exuberant celebration of shells is a typical
example of van Kessel's obsession with natural objects.
Painted in oil on copper, it measures only 31 x 43 cm
(12½ x 17 in.), demonstrating van Kessel's technical mastery
when working on such a small scale. Most of the shells are
tropical marine species from the Indo-Pacific and West Africa,
and the only European specimens seem to be the live land
snails crawling over the swags, possibly drawn from life.

BELOW

JOHN TRADESCANT THE YOUNGER WITH ROGER FRIEND AND A COLLECTION OF EXOTIC SHELLS, 1645, attributed to Thomas de Critz (1607–53). The two John Tradescants, father (*c.* 1570–1638) and son (1608–62), compiled a large collection of rarities during their lives, including many shells. Their collection formed the basis of the Ashmolean Museum in Oxford, the first purpose-built public museum in the world, which opened in 1683. Here we see the younger Tradescant with a friend, and on the table nearby a collection of shells. The largest of these (on the right of the table) is the Trumpet Triton (*Charonia tritonis*), a shell that can be blown to produce a musical note. Fairly common in the Indo-Pacific area, it grows up to 33 cm (13 in.) long, although rare specimens have been found up to 47.5 cm (18¾ in.) in length.

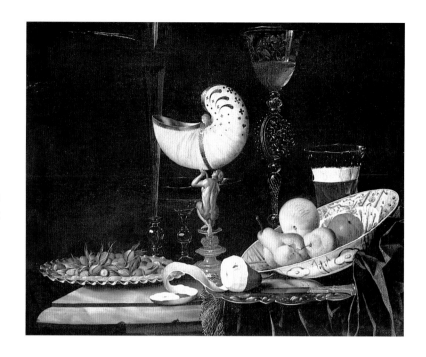

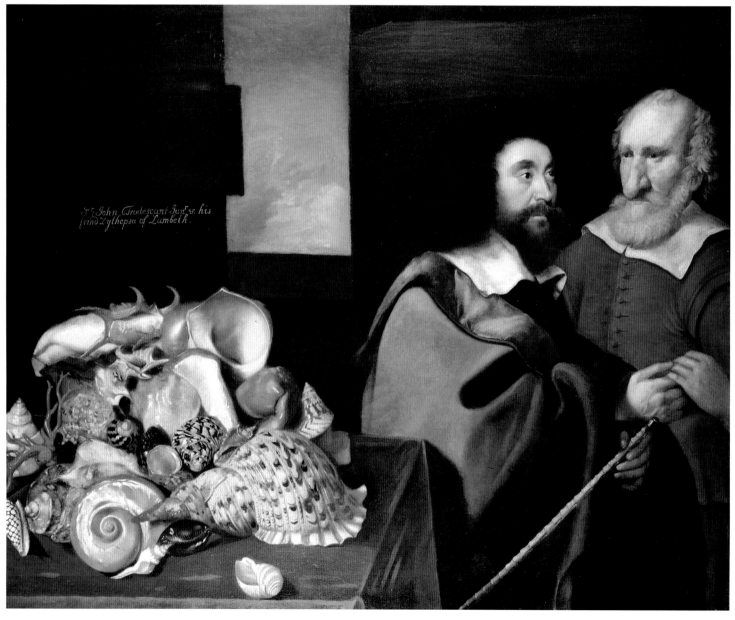

OPPOSITE ABOVE
A NAUTILUS CUP AND FRUIT,
by Johann Georg Hainz (1630–88).
Known by the Dutch at the time as
a 'Little Ship of Pearl', the mounted
Chambered Nautilus shell (*Nautilus
pompilius*) in this still life has been
skilfully incised to produce a delicate
pattern. The external layer of the shell
has not been removed to reveal the
mother-of-pearl beneath; its natural
orange-brown striping is still visible.
At the time it was painted, this was
a highly prized object.

RIGHT
PORTRAIT OF A MAN, 17th century,
Neapolitan School. This man wears
a chain of shells made up of two
European species. The large central
shell and four smaller specimens
are the Spiny Bonnet (*Galeodea
echinophora*), an edible Mediterranean
species that is commercially trawled
today along the Adriatic coasts and
in Spain. The remaining three are
probably the French Escargot or
Roman Snail (*Helix pomatia*), a
common land snail originally central
European in distribution. It was
commercially farmed by the Romans,
who introduced it to the United
Kingdom, and is still farmed for food
in Europe today. The significance of
the chain of shells is unknown, but it
is tempting to wonder whether it is
the chain of office of a guild.

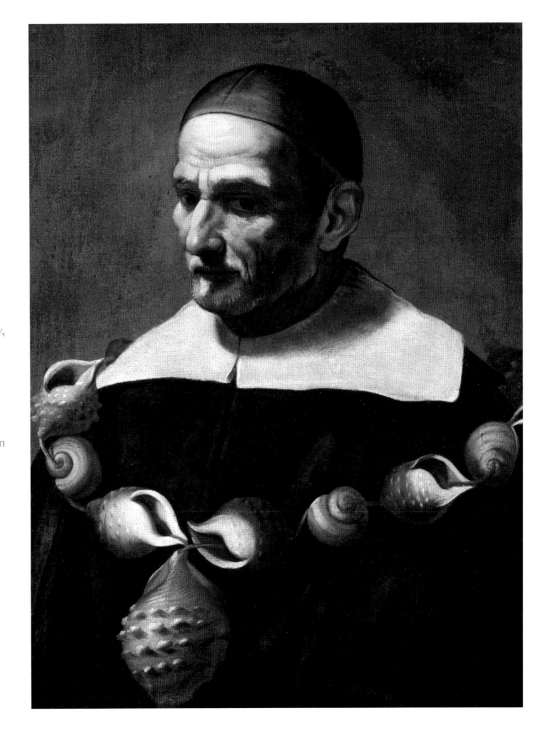

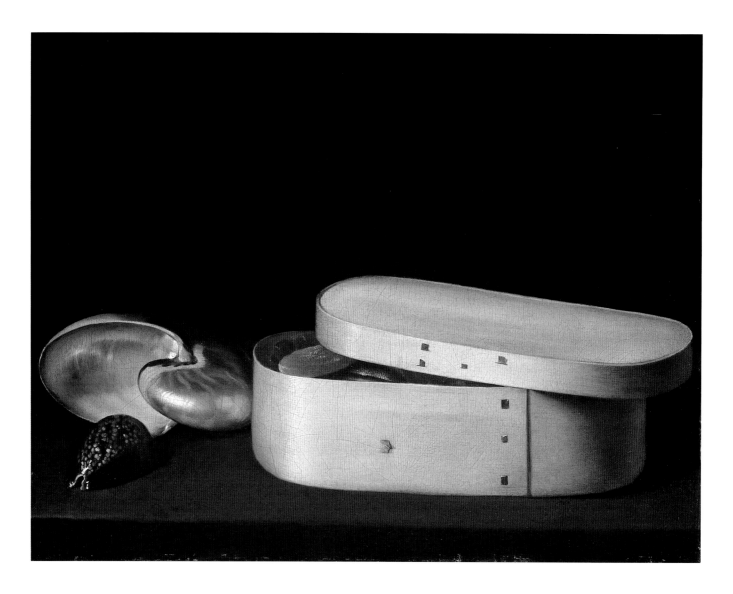

STILL LIFE WITH A NAUTILUS, PANTHER SHELL, AND CHIP-WOOD BOX, c. 1625–30, by Sébastien Stoskopff (1597–1657). Painted in the 1620s, this picture exemplifies the first great age of French still life painting. Stoskopff chose subjects that offered a special challenge to an artist, and he captured the lustre and gloss of the two shells masterfully. The Chambered Nautilus (*Nautilus pompilius*) is shown with its external layer removed, exposing the mother-of-pearl beneath. The 'Panther Shell' of the title is in fact a Humpback Cowrie (*Cypraea mauritiana*). A true Panther Shell is the species *Cypraea pantherina*, which has quite different markings.

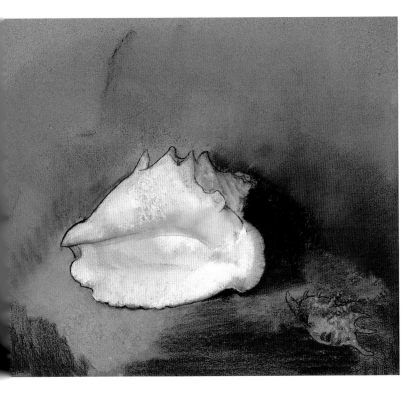

LEFT
THE SEASHELL, 1912, by Odilon Redon (1840–1916).
This famous pastel by the Symbolist artist has a single shell
as its subject, the Queen Conch (sometimes called a Pink
Conch) (*Strombus gigas*). A Caribbean species, it grows
to a length of 20 cm (7⅞ in.) in an average adult specimen.

BELOW
FIVE SHELLS ON A SLAB OF STONE, 1696, by Adriaen
Coorte (*c.* 1663–after 1707). Little is known about this Dutch
still life painter, whose favourite subjects were asparagus,
gooseberries and shells. His strength lay in the depiction of
well-lit objects against a dark background, often painted in
oil on paper pasted onto wooden panels. The two large shells
here are a white juvenile Common Spider Conch (*Lambis
lambis*) from the Indo-Pacific, shown before the spines have
fully developed, and a Common Music Volute (*Voluta
musica*), a Caribbean species of variable colour and shape;
different varieties can often be linked to individual islands.

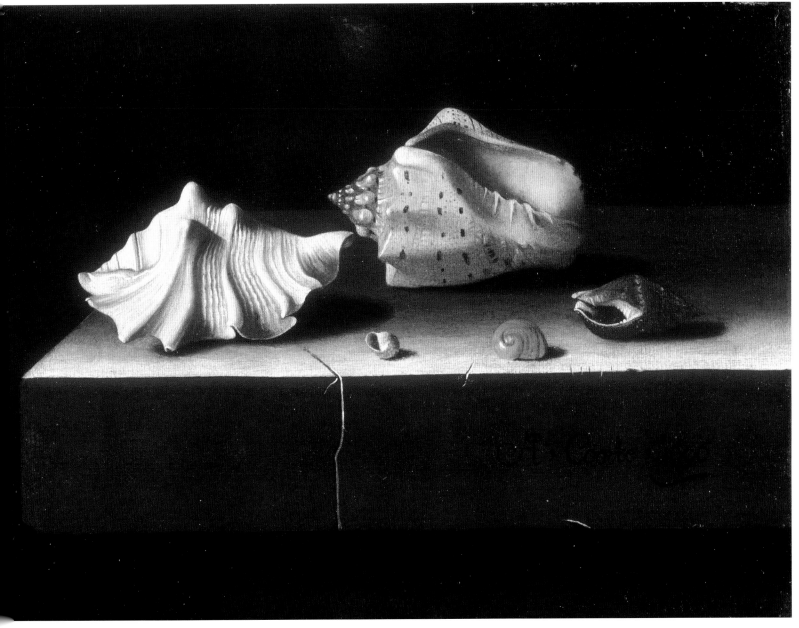

RIGHT
PAPER NAUTILUS, c. 1860, by John Ruskin (1819–1900).
This sensitive watercolour drawing conveys the fragile
character of the Paper Nautilus (*Argonauta argo*), which
is not a shell in the usual sense, but the egg case of an
Argonaut, a relative of the octopus. It is secreted by two
of the female cephalopod's tentacles and acts as a protective
cradle for her tiny eggs. After they hatch, the female dies
and sheds this thin, parchment-like cradle. Argonauts live
in open warm seas. There are fewer than a dozen species.

BELOW
THE SHELL (CONUS MARMOREUS), 1650, by
Rembrandt van Rijn (1606–69). The Marble Cone is a
common species from the Indo-Pacific. This is a magnificent
etching, sublime artistry indeed, except for one detail:
Rembrandt's engraver neglected to reverse his drawing on the
metal plate, so that when printed, the shell appears to be a
sinistral specimen, spiralling anti-clockwise, and so a great
rarity. It is a small oversight to an artist, but to a naturalist a
significant *faux pas*. The signature and date are reproduced
correctly, although they had to be etched in mirror image.

OPPOSITE
LIFE ON THE SEASHORE, by Ito Jakuchu (1716–1800).
This beautiful hanging scroll represents a shell collector's
paradise, accurately depicting over 150 shells scattered on
the shore, with starfish, sea urchins, barnacles and sand
dollars. Many are identifiable as distinct species, and apart
from the damaged Chambered Nautilus (*Nautilus pompilius*)
shown centre left, all the species are found in Japan.

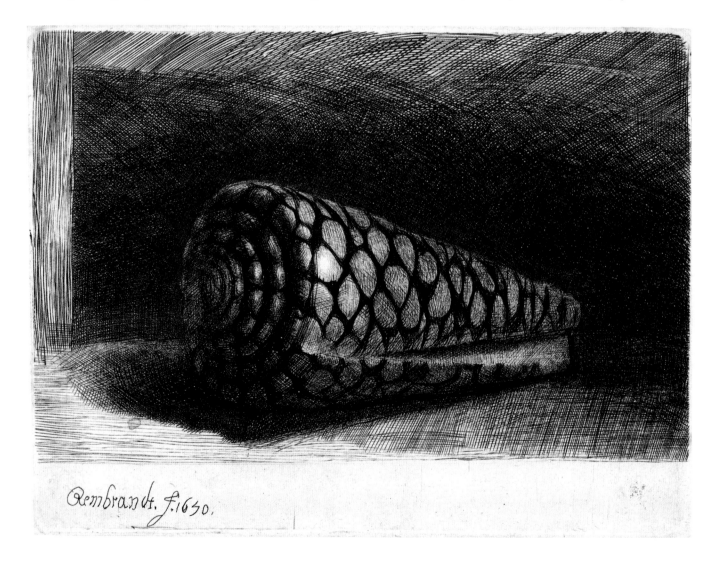

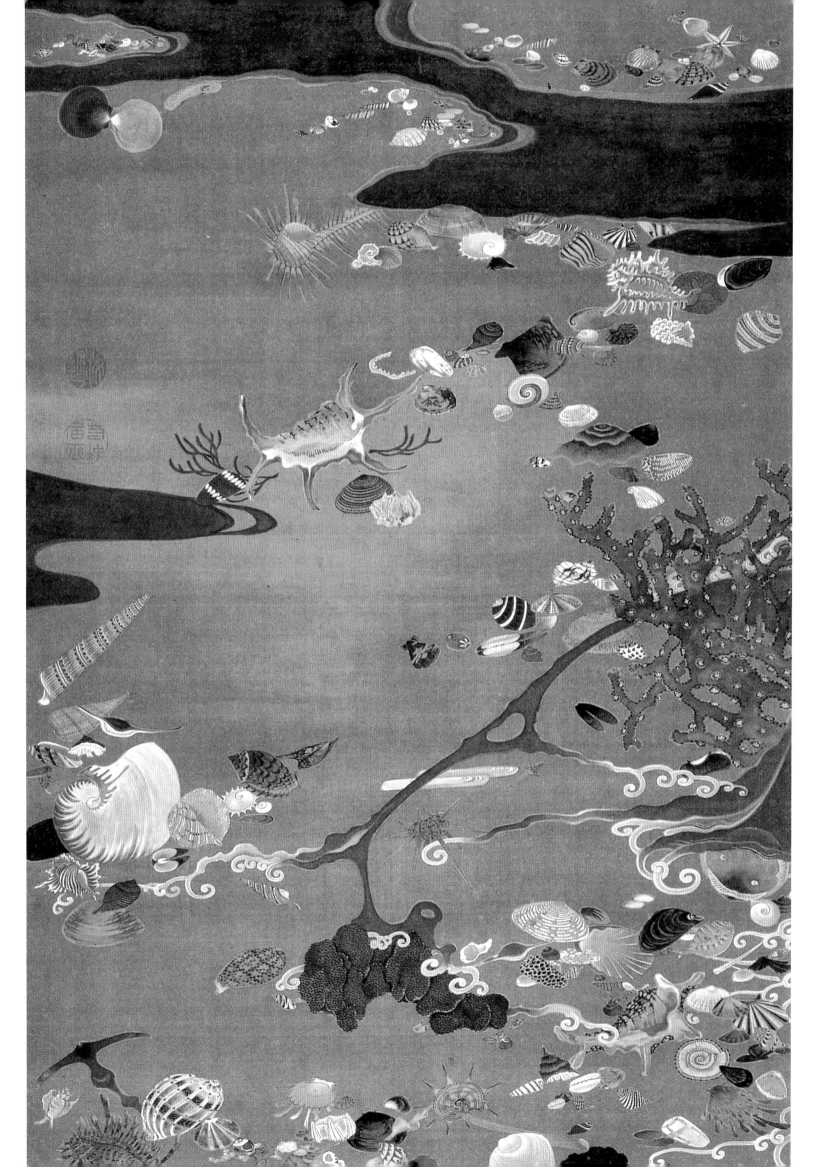

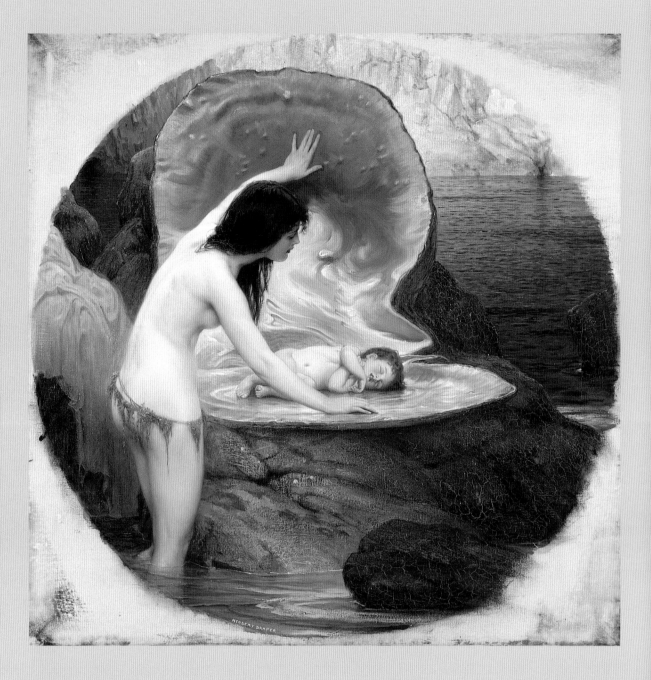

ABOVE

A WATER BABY, 1900, by Herbert James Draper
(1864–1920). A sea nymph opens a huge oyster and
finds not a pearl but a baby inside. Draper chose a
Black-lipped Pearl Oyster (*Pinctada margaritifera*) as
the receptacle for the baby, and the iridescence of its
mother-of-pearl interior is impressively conveyed.

RIGHT

THE WHITE ROSE AND THE RED ROSE, 1902,
by Margaret Macdonald (1864–1933). This painted
gesso panel is set with glass beads and shells. Married
to Charles Rennie Mackintosh, one of the leading
forces of the Arts and Crafts Movement, Margaret
Macdonald was herself one of the most outstanding
British women artists at the beginning of the 20th
century. The symbolic meaning of this work is unclear,
but the rose was a symbol of love and art in both her
and her husband's work.

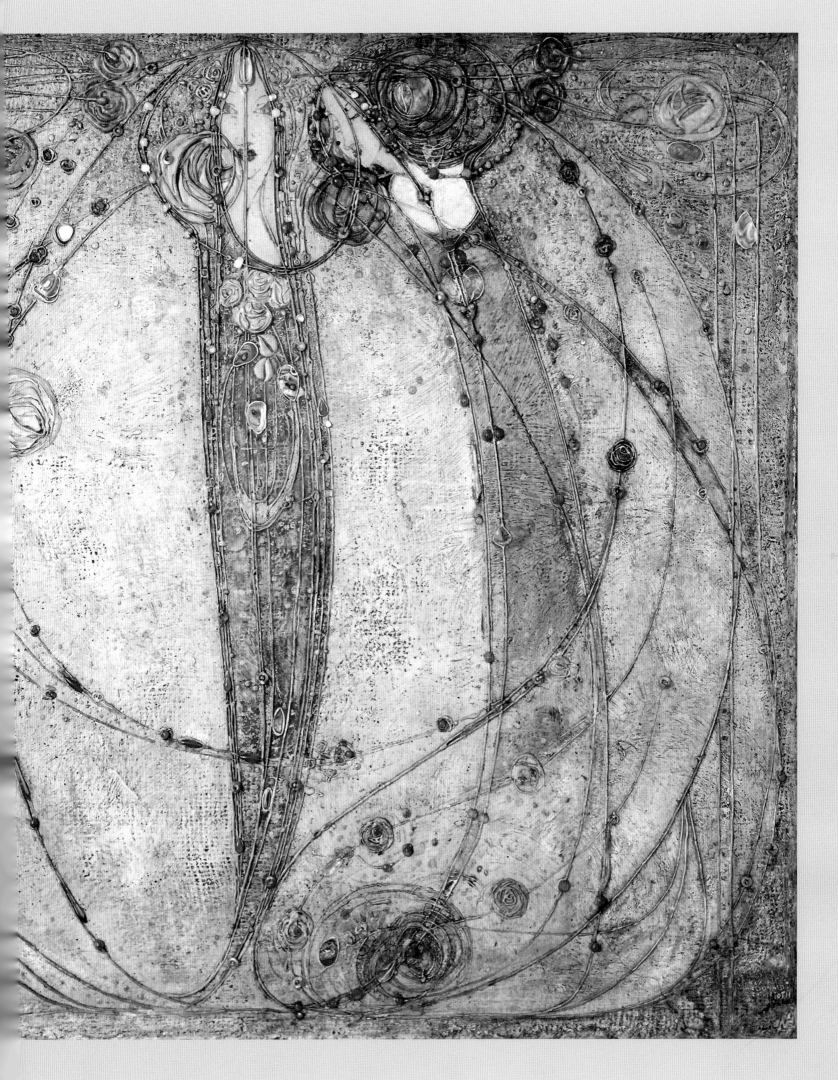

PREVIOUS PAGES
STILL LIFE WITH APRICOTS AND A SHELL, 1949, by
Lucian Freud (b. 1922). Five velvety smooth apricots and a
sculptured, creamy-white Common Northern Buccinum shell
(*Buccinum undatum*) lie on crumpled paper.

ABOVE
SCALLOP, 2003, by Maggi Hambling (b. 1945). Standing
on Aldeburgh beach in Suffolk, England, this towering
sculpture rises 4.1 m (13 ft 6 in.) high. It is dedicated to
British composer Benjamin Britten, who lived in Aldeburgh.
Reflecting upon her inspirations, Hambling recalled how
'As a child you hold a shell to your ear to listen to the sounds
of the sea, and that was *Scallop*'s simple beginning. For me,
the rising striations of this shell resemble the rays of the sun,
its corrugations suggest the waves of the sea and its curved
edge echoes Constable's "dome of the sky"… In *Scallop*
I have destroyed and re-created the form of the shell in an
attempt to reflect the original explosive power of Benjamin
Britten's music.'

OPPOSITE
TWO SHELLS, 1927, by Edward Henry Weston (1886–1958).
The American photographer created this sinuous form by
nesting a Chambered Nautilus (*Nautilus pompilius*) inside an
Indian Volute (*Melo melo*). Talking about this image, he wrote:
'It is this very combination of the physical and spiritual in a
shell…which makes it such an important abstract of life.'

OVERLEAF
FORMS WITHOUT LIFE, 1991, by Damien Hirst (b. 1965).
Exotic shells from Thailand are arranged in a glass cabinet
resembling a museum display case. 'You kill things to look
at them,' Hirst has said. His work is a reminder of the
importance of conservation and responsible shell collecting.

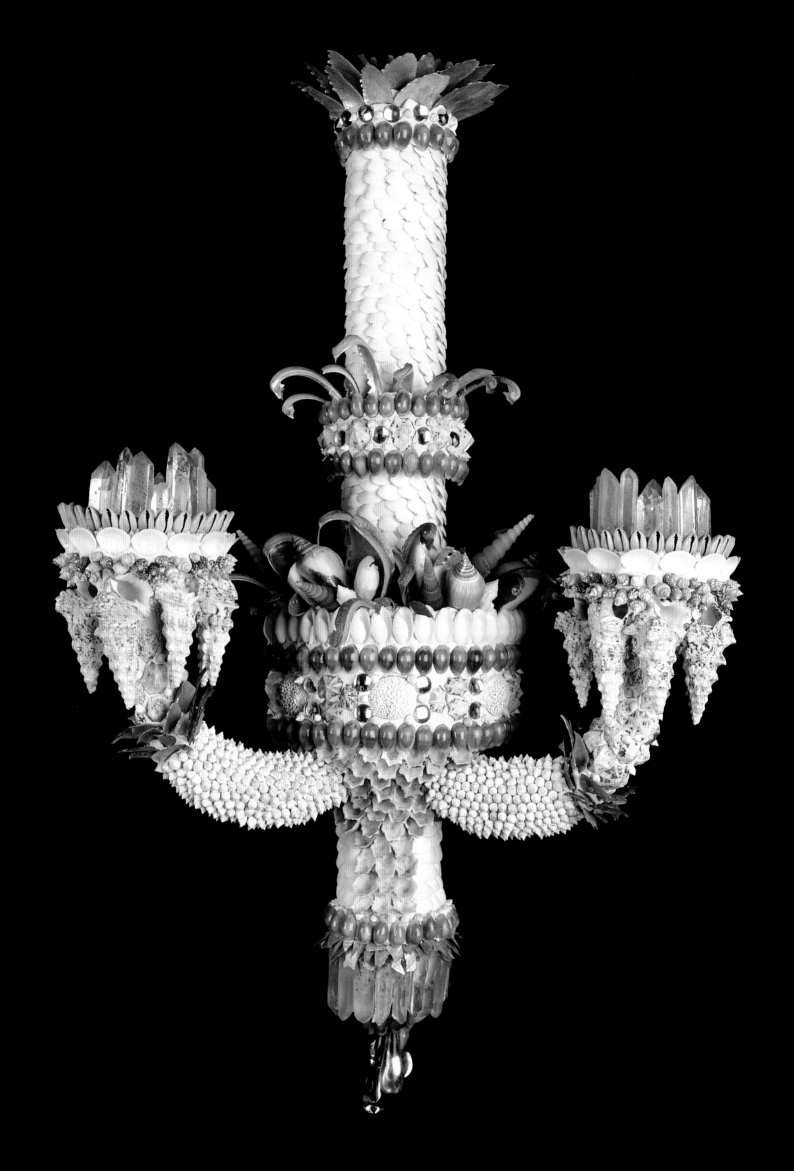

OPPOSITE *White Sconce*, 2001, by Belinda Eade (b. 1963), London. This sconce was one of a series of twelve plus two large chandeliers made to furnish a ballroom. White Distorted Nassa shells (*Nassarius distortus*) were chosen to tightly maintain the slender curve of the arms. Bands of Black Turreted Nerites (*Neritina turrita*) and Gold-ringer Cowrie shells (*Cypraea annulus*) give definition and offset the white. Curls of broken Donkey's Ear Abalone (*Haliotis asinina*) and clusters of larger shells add a touch of baroque flamboyance. Quartz and man-made crystal add sparkle and neatly finish the area around the light fittings.

BELOW Shell dolls and figurines dressed in elaborate shell outfits were fashionable in the early 19th century. It seems that this lady and her companion (page 150), made between 1810 and 1845, are both flower sellers. The market pedlar was a favourite subject for such figures.

ORNAMENTAL SHELLWORK

I've got a new madness! I'm running wild for shells.
The beauty of shells is as infinite as flowers.

Mary Delany, 18th-century shell artist

Take a cluster of small shells, and their subtle palette of colours and geometric shapes immediately conjure all kinds of artistic possibilities. Talented hands over the ages have created idiosyncratic and often exquisite shell decorations to gladden the most discerning eye. While it is true that modern, commercially made souvenirs in shellwork are often of questionable taste, cynics would do well to broaden their view. Fine ornamental shellwork is in a class of its own, and deserves more artistic credit than it is sometimes given.

Ornamental shellwork is a craft in which delicate and elaborate designs are created using shells in profusion. Historically, it often meant reinventing nature: floral arrangements, birds, butterflies and insects were made out of hundreds of carefully chosen shells. Small ceramic figurines wore shell clothes, miniature temples were built using thousands of the tiniest shells, and mirror frames, caskets and boxes of all kinds were encrusted with intricate shell patterns. Whole pictures were 'painted' in collages of shellwork; human faces were created out of shells, with strange but realistic features and expressions. Shells invited imaginations to run riot. And they did.

By contrast, today's generation of artists bring a new way of working with shells. Conscious of pressing conservation issues, they are careful only to use sustainable sources of shells for their work. While they may be influenced by tradition and historical styles, they use innovative designs that

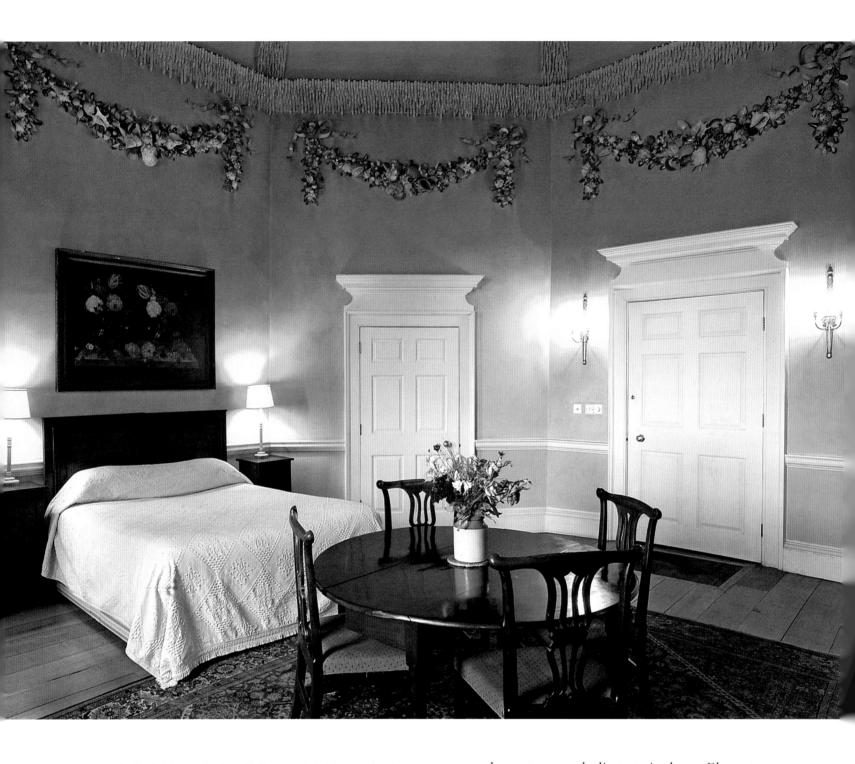

The Bath-House, Walton Hall, Warwickshire, England. These lively shell festoons, 2.5 m (8 ft) long, were designed by shell artist Mary Delany in c. 1754 for this octagonal room, originally a tea-room above a spring-fed stone bath-house built by the owner of Walton Hall, Sir Charles Mordaunt. Almost totally destroyed by time, they were faithfully recreated in 1990 by the UK's leading shellwork restorer Diana Reynell, who took great pains to match the original design, visible from surviving imprints on the wall that revealed the scale and proportion of the lost shells.

complement our catholic taste in decor. Elegant, witty and lyrical, the best examples of decorative shellwork today promote the craft to an art form. A growing number of skilled artists are taking the genre a quantum leap forward, exploring the timeless allure of shells with sensitivity and skill. We can only marvel at the flair of artists such as Blott Kerr-Wilson, Belinda Eade, Tess Morley, Peter Coke and Thomas Boog (see pages 152–61).

Ornamental shellwork as we know it began in the early 18th century, and was initially very much a European tradition. It was directly inspired by the quantities of exotic foreign shells which poured into European ports from expeditions to the East and West Indies, and from the American continent. Some of the shells, especially rarer specimens, were immediately snapped up by influential collectors, and displayed by affluent society in their 'cabinets of curiosities' (see pages 104–5). Others were purchased – sometimes in huge quantities – to adorn the shell grottoes and pavilions that were becoming all the rage in fashionable society.

The Rococo style of the 18th century was dominated by feminine taste and influence. As well as showing off their grottoes, ladies of society competed for the most elaborate and elegant interior decorations. The availability of foreign shells, many of them of dazzling beauty, suggested a new pastime that would introduce a different kind of decoration into their houses. Thus alongside the traditional pursuits of tapestry and embroidery there emerged a new hobby, shellwork, the perfect embodiment of the Rococo ideal.

What started as a pastime exclusive to the rich and privileged grew gradually, by the late 18th century, into a vogue for a great many ladies of culture. Among a number of accomplished shell artists, one in particular must be singled out, both for the quality of her designs and for her influence. Mary Delany (1700–1788) was an artist, intellectual and highly respected member of the social and cultural elite in England in the 18th century. Politicians, explorers, botanists and musicians frequented her drawing-room, and she became a close friend of King George III and

Queen Charlotte. She also befriended the Duchess of Portland, who was a patroness of natural history and a well-known conchologist, with a large and important collection of shells. Through her, Mrs Delany discovered the aesthetic delights of shells, and she started to create shellwork in original and intricate designs. She soon made a name for herself with her work, and inspired many others to take up the craft. Later in her life, when she was past seventy, Mrs Delany transferred her artistic talents to paper mosaics of flowers, and her unique collection of beautiful collages is now held in the British Museum. But regrettably, it seems that her captivating shellwork has been lost. All that remain are written descriptions.

By the late 18th century, shellwork had caught on in North America, and was popular throughout Europe. Shops opened to provide the materials needed for the craft, including, in 1782, one in Grosvenor Square, London, owned by Mrs Hannah Robertson. She wrote that her shop was crowded with nobility and that she was 'employed in teaching the first families in Europe'. King George III, who founded the Royal Academy of Arts, encouraged artistic activities among his many daughters, and at least one of them was instructed in shellwork by a governess who had studied with Mrs Robertson.

Shells were very much to 19th-century tastes too, blending well in the decor of the time, with its velvet curtains, ferns, and carpets from the Orient. The styles of the 18th century had given way to a sentimental, florid and romantic period, where interiors were cluttered and richly colourful. Homes were filled with ornaments, and although shells had lost their stature as exotic objects

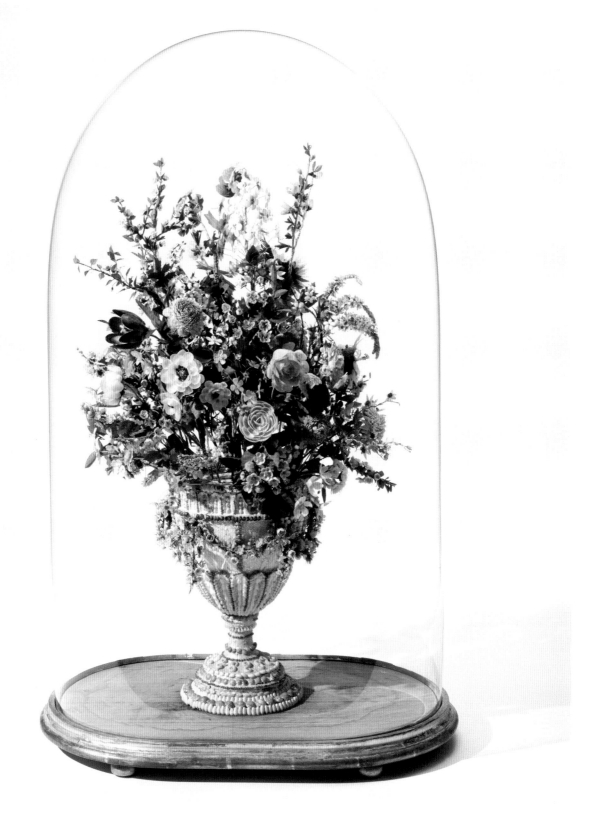

ABOVE A fine example of late 18th-century shellwork
known as the Bonnell Vase, completed in 1781. Over three
hundred shell flowers are held together by wire to form a
large arrangement that is placed in a neoclassical vase, also
in shellwork. Standing 60 cm (24 in.) high, it was created by
Mrs Beal Bonnell and Miss Harvey Bonnell, and was the
product of more than two years' work.

RIGHT An early 19th-century shellwork picture, spectacular for its use of thousands of tiny shells, each one painstakingly glued into position. It would probably have taken the artist many months to complete, not to mention excellent eyesight.

BELOW An 18th-century shellwork picture of a house, possibly Italian or Portuguese. It was acquired by two spinster cousins, Jane and Mary Parminter, on their decade-long Grand Tour of Europe which started in 1794. On their return to England they built an extraordinary sixteen-sided thatched house in Exmouth, Devon, called 'A La Ronde'. They decorated the gallery and staircase of the building with a fantastic assemblage of shells, feathers and cut paper work on vivid green and marbled walls. A La Ronde can now be visited by the public, although the shell gallery can only be seen on video and in photographs.

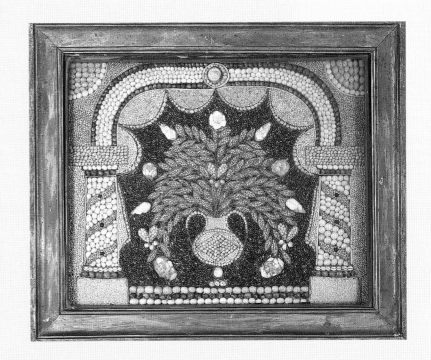

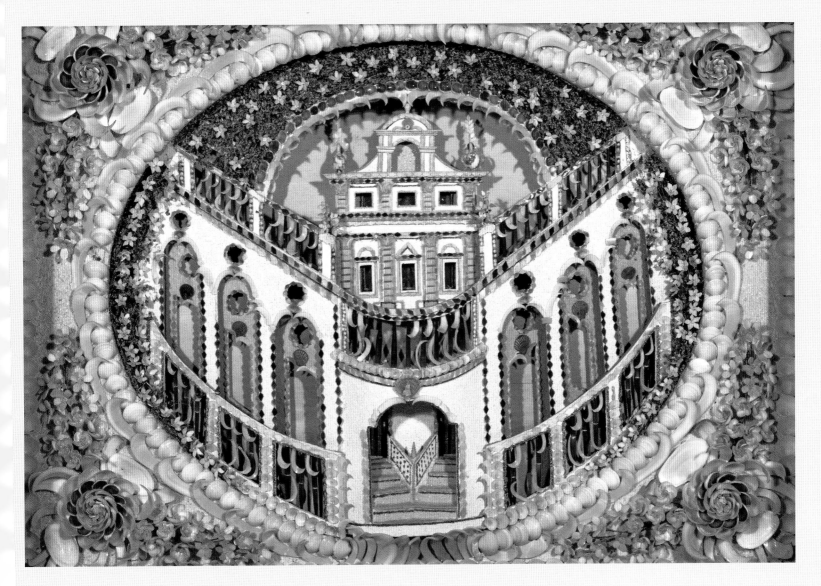

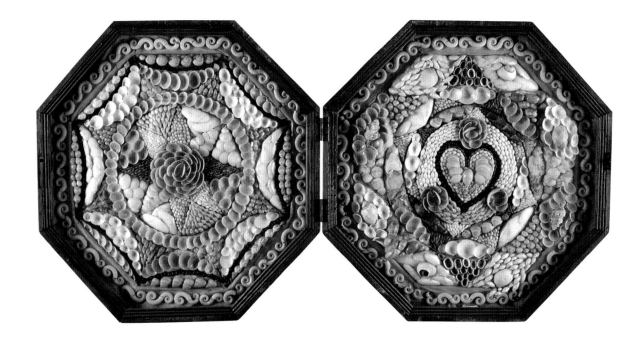

ABOVE AND OPPOSITE 19th-century Sailors' Valentines,
probably made in Barbados and brought home by sailors
as gifts to their wives and sweethearts. All the shells used
in these keepsakes are species common in the Caribbean.

affordable only by the very rich, they retained a
romantic appeal as messengers from the shores of
faraway places. The glass dome sitting in pride of
place in the Victorian parlour often housed a busy
arrangement of shell flowers, and there might be
a mirror framed with hundreds of shells hanging
over the fireplace. Shell pictures hung on the
walls, and trinkets included pillboxes, tea caddies,
and small figurines all elaborately encrusted with
shells. This plethora of shellwork included some
fine craftsmanship, but a lot of it was of limited
artistic merit.

One particular form of shellcraft became
fashionable in the Victorian era thanks to the
rugged voyaging of 19th-century mariners.
This was still the days of sail, when whaling
boats and merchant ships often spent months
at sea. The West Indies, enjoying close ties with
England and America, was an important trading
destination for many of these ships, whose
cargoes included sugar, spices, rum and timber.
While they were docked in Caribbean ports,
sometimes for weeks at a time, sailors would
search for gifts they could take home to their
sweethearts and wives. The popular appeal of
shellwork in Europe encouraged sailors to bring

back gifts made from tropical shells. The
Caribbean boasted an abundance of small
colourful shells, and it was here in the West Indies,
notably in Barbados, that many sailors found
the ideal souvenir: a hinged pair of octagonal
wooden display boxes filled with many different
kinds of shells that formed intricate and usually
symmetrical patterns. These colourful shell
mosaics often incorporated sentimental phrases
such as 'Remember Me' or 'Forget Me Not', and
thus they became known as 'Sailors' Valentines'.
There has been a long-held romantic belief that
they were made by the seamen themselves as they
whiled away the doldrums hours on long voyages.
We now realize that they were almost certainly
commissioned or bought directly from local
craftspeople. Today, original Sailors' Valentines
sell for high prices at auction, and a growing
number of artists, particularly in the United States,
are reviving this charming tradition by copying old
patterns or creating their own modern versions.

As the market for mass-produced ornaments

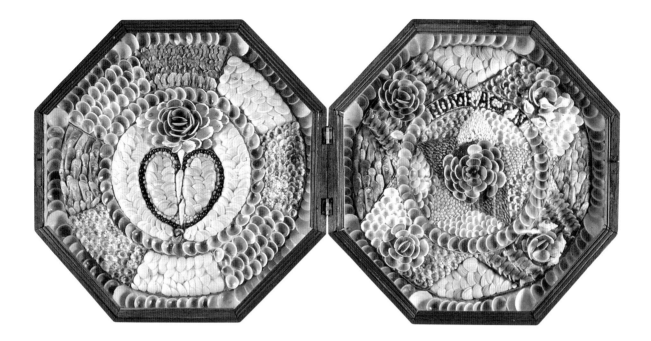

developed in the 20th century, so the tradition of home-crafted decorative shell pieces slowly died away. Cheap mementos were available to the millions who could now afford to travel overseas. Shellwork trinkets were, and still are, available in holiday resorts everywhere, and are imported for sale in local seaside souvenir shops. These knick-knacks bear little resemblance to the delicate work of earlier centuries. But the 21st century is witnessing a healthy revival of craftwork of all kinds, and the recent appearance of books on the subject of shellcraft is a sign that times and tastes are changing. The new wave of artists whose pieces are illustrated in these pages cannot keep pace with the demand for their work. Their talent is recognized internationally, and they are commissioned by clients all over the world. Ornamental shellwork, recognized once again as an art form in its own right, has entered an exciting new era.

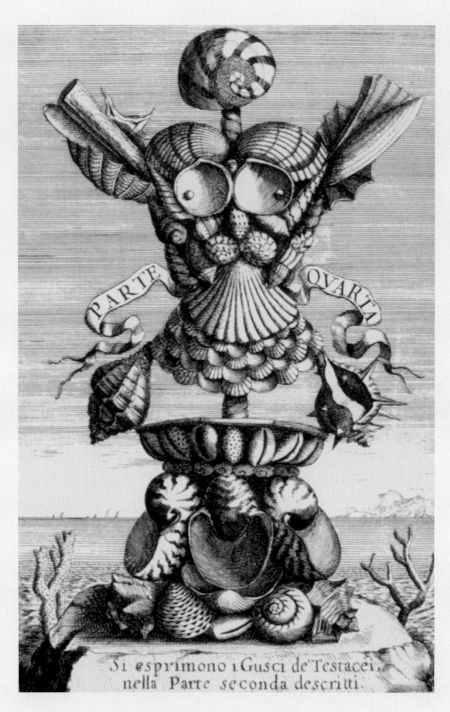

BAROQUE ENGRAVING from Filippo Buonanni's pioneering work
on conchology, *Ricreatione dell'Occhio e della Mente nell'Osservation'
delle Chiocciole*, published in Rome in 1681. This image is a light-hearted
celebration of shells, reminiscent of Giuseppe Arcimboldo's composite faces
a century earlier.

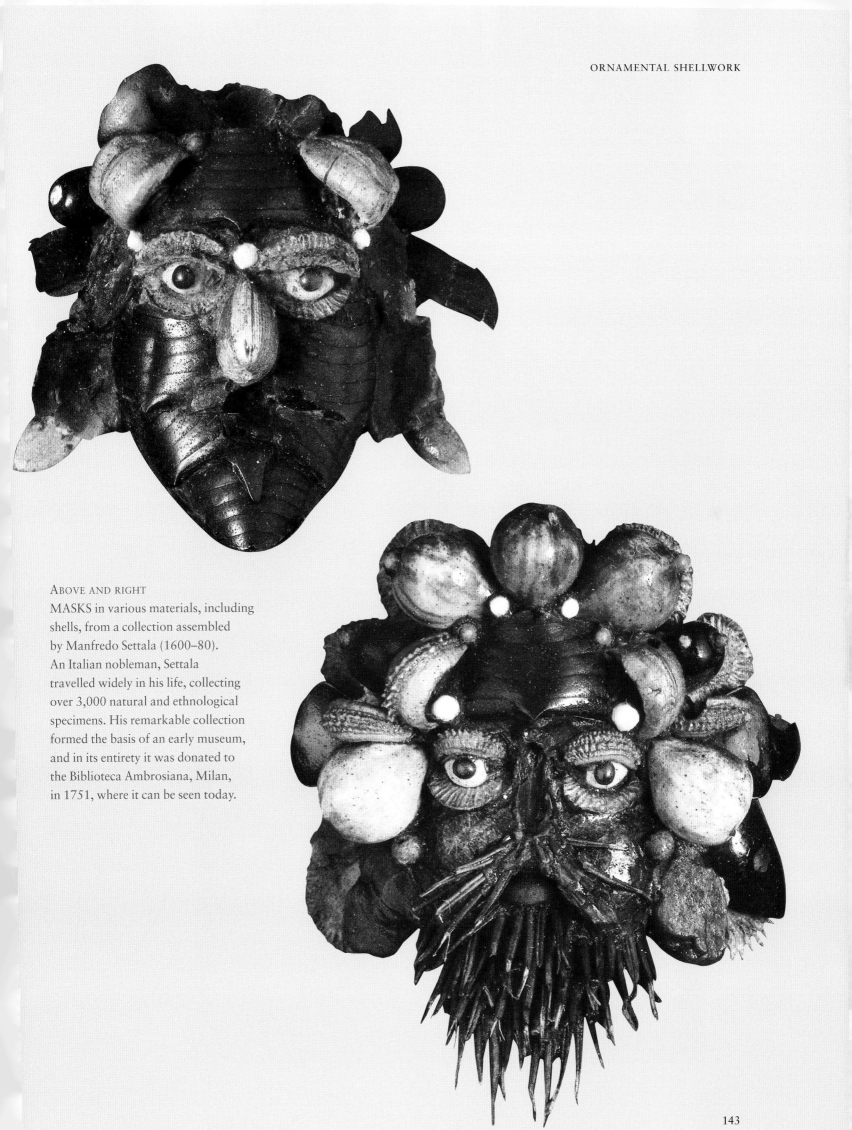

ABOVE AND RIGHT
MASKS in various materials, including shells, from a collection assembled by Manfredo Settala (1600–80). An Italian nobleman, Settala travelled widely in his life, collecting over 3,000 natural and ethnological specimens. His remarkable collection formed the basis of an early museum, and in its entirety it was donated to the Biblioteca Ambrosiana, Milan, in 1751, where it can be seen today.

FINE FLORAL SHELLWORK from the 18th century. In this rare example, one of a pair, an elaborate arrangement of shell flowers is placed in an urn within a japanned case. Each flower head is made entirely of shells, many of which are tropical species. The flowers are set on wire stems and the leaves are of painted fabric. This arrangement was the work of Sara Newenham, wife of John Dennis, member of a prominent Quaker family of County Cork, Ireland, c. 1750.

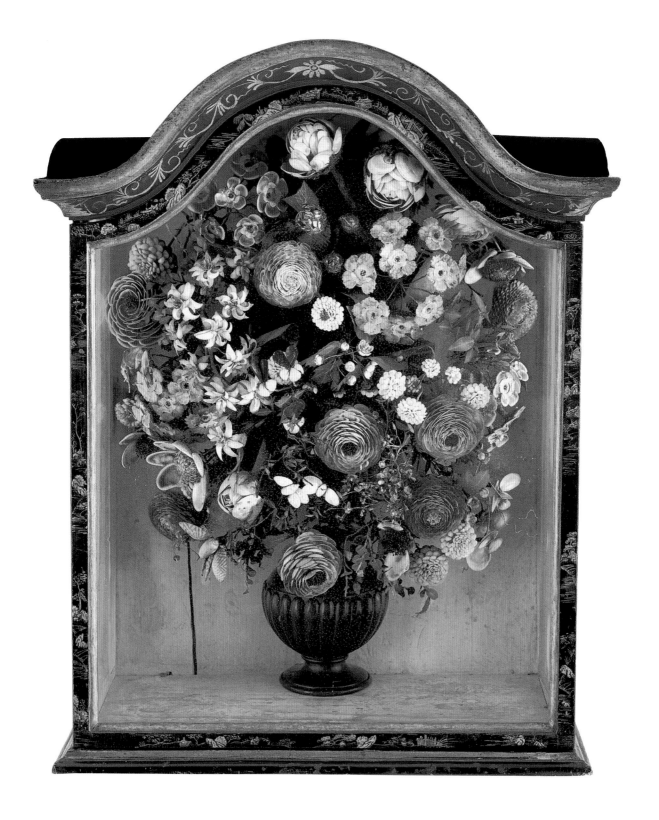

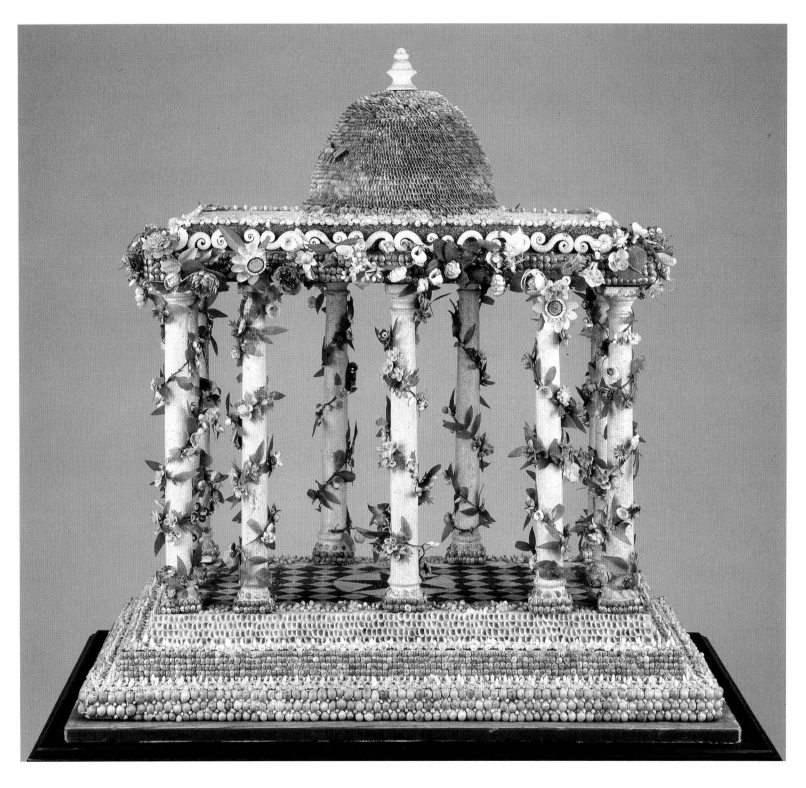

THE SHARPHAM SHELLWORK,
c. 1770, attributed to Jane Pownoll
(neé Majendie). Her husband, Captain
Philemon Pownoll (1735–80), was a
successful privateer, and in his time he
plundered Spanish galleons and their
cargoes of gold in the West Indies.
The shells in this magnificent piece
originated in the West Indies, and the
design reflected the architecture of the
portico and hall of Sharpham House,
a splendid Palladian villa built for
Philemon Pownoll. It is a *tour de force*,
and there is no known surviving
example of an architectural subject
in shellwork that compares to it.

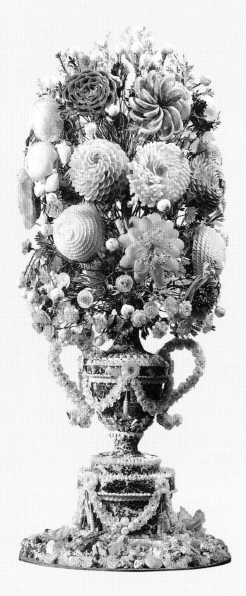

ABOVE
SHELLWORK VASE OF FLOWERS
made in 19th-century England.
The result of many hours of nimble-
fingered work, Victorian shellwork
artefacts such as this were commonly
placed under glass domes to protect
them from damage and dust, and
prominently displayed in the home.

RIGHT
LID OF A BOX containing an early
19th-century shell collection, which
is now displayed in the Morning
Room of Arlington Court, a grand
Regency period house in Devon,
England. Almost all the hundreds
of shells used to make its decorative
pattern were foreign specimens, and
many of them have retained their
original colour and lustre.

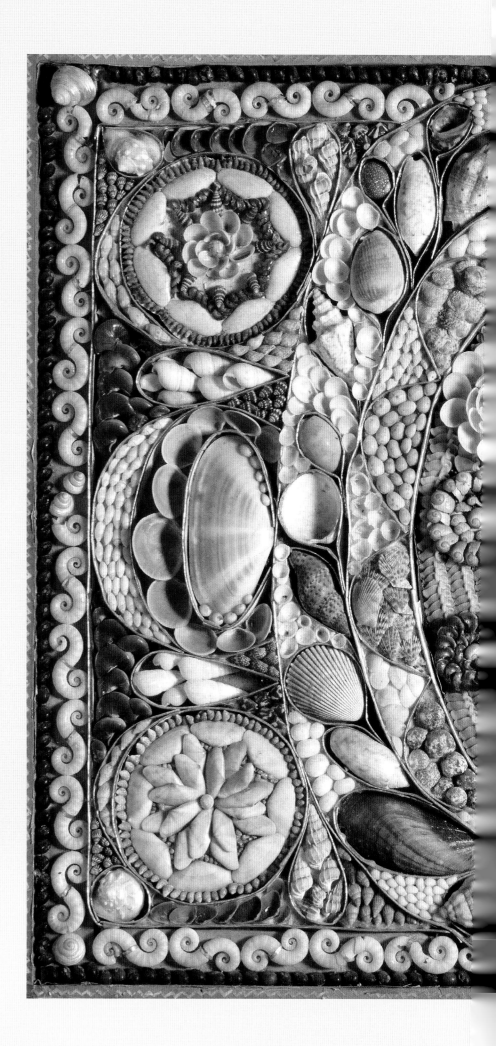

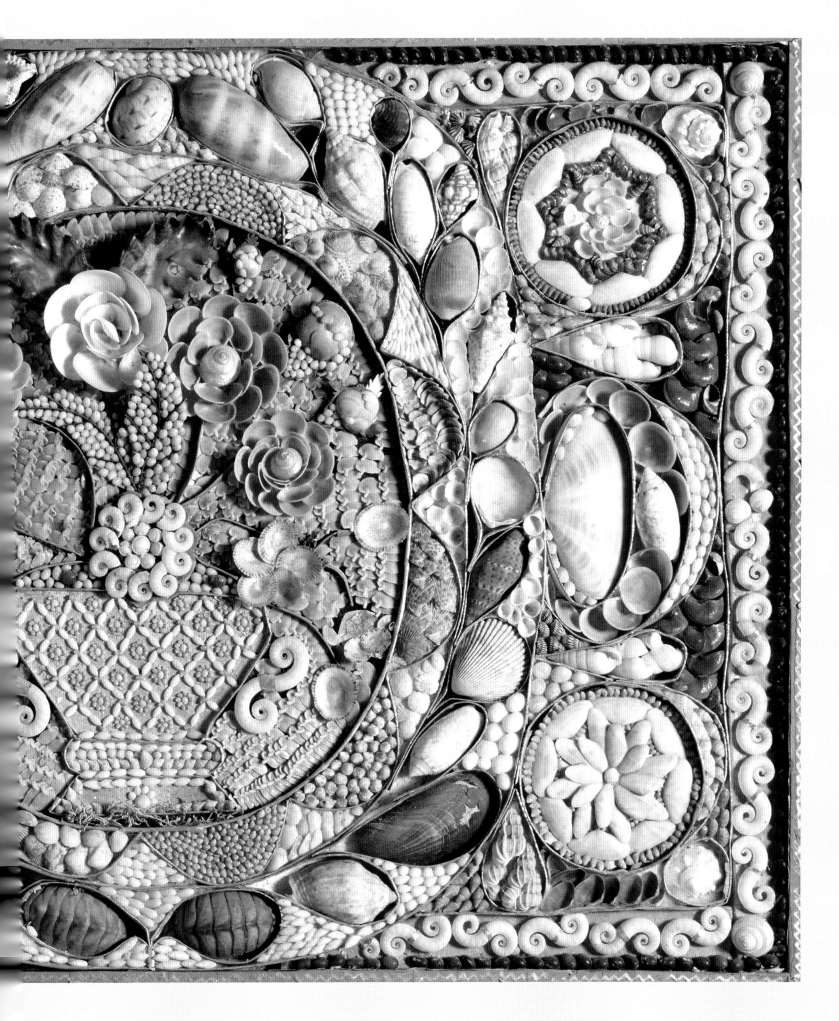

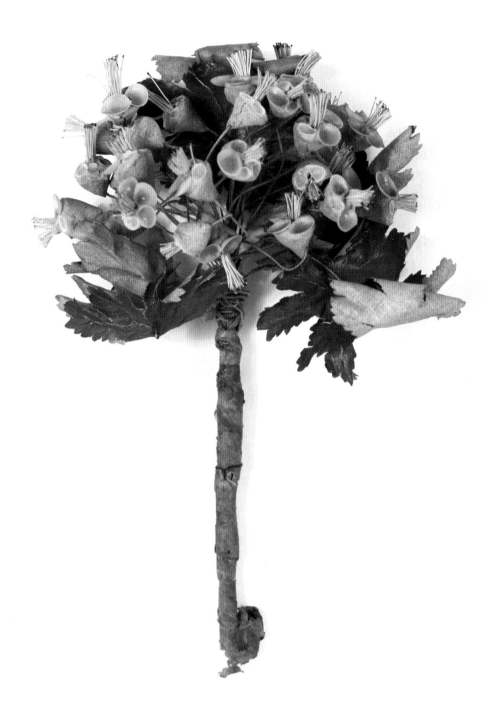

SPRAY OF PINK SHELL FLOWERS held on wire,
with green glazed-cotton leaves. The species used for
this charming 19th-century English piece is Pea Strigilla
(*Strigilla pisiformis*), a tiny pink and white shell abundant
in waters from the Bahamas to Brazil.

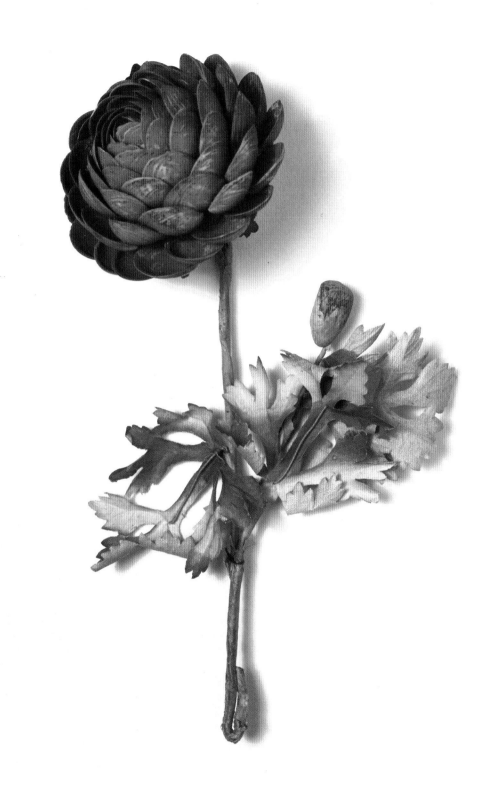

IMITATION DAHLIA made in 19th-century England.
The flower head is made of shells, probably Thin Tellin
(*Tellina tenuis*), which are normally pink but may have been
dyed or painted to provide the rich orange colour. The stem
and leaves are of glazed cotton and wire.

Below
CHINESE MEN FIGURES from
the late 18th or early 19th century.
The small round shells with spiral
striping are Button Tops (*Umbonium*
sp.), found in warm waters around
the world.

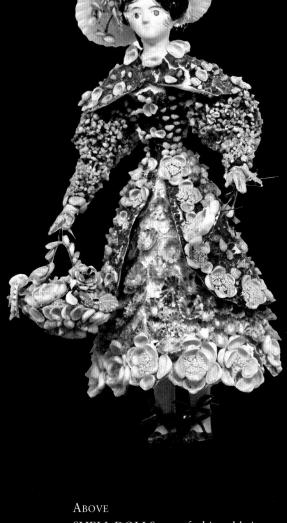

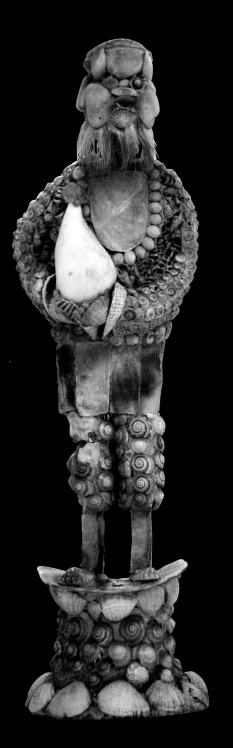

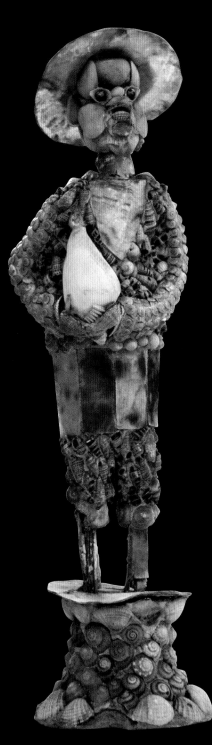

Above
SHELL DOLLS were fashionable in
the early 19th century, and were not
only made by private individuals but
could be bought from manufacturers
who sold their goods at tourist
centres. This doll and her companion
(page 135) were probably made
between 1810 and 1845, and could be
French, English, American or Dutch.

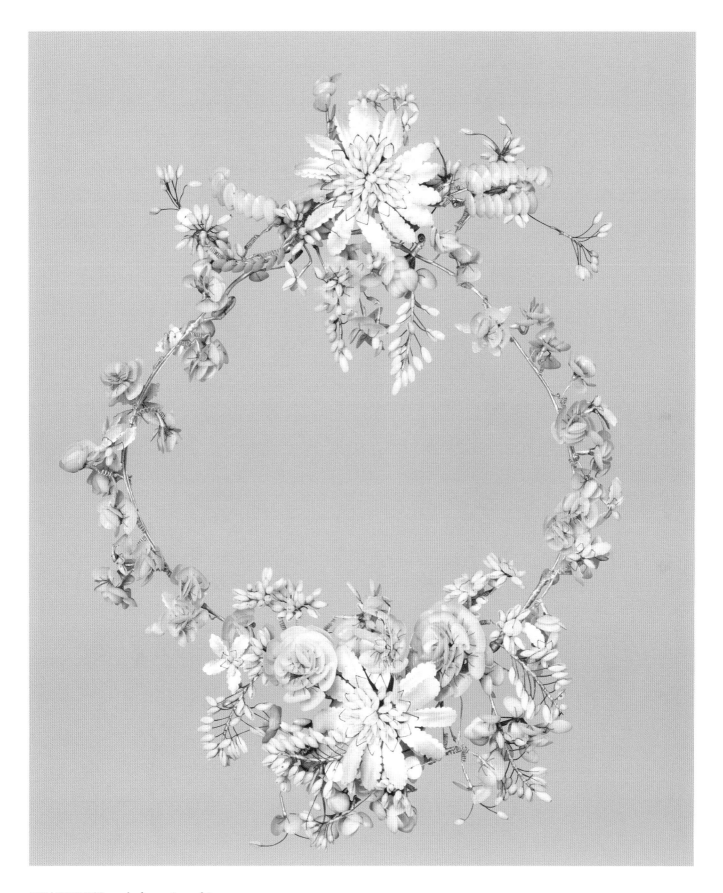

HEADDRESS made from tiny white
shells and pieces of cut mother-of-pearl
that form a ring of flowers. Dated
1862, this delicate piece was made in
the Bahamas.

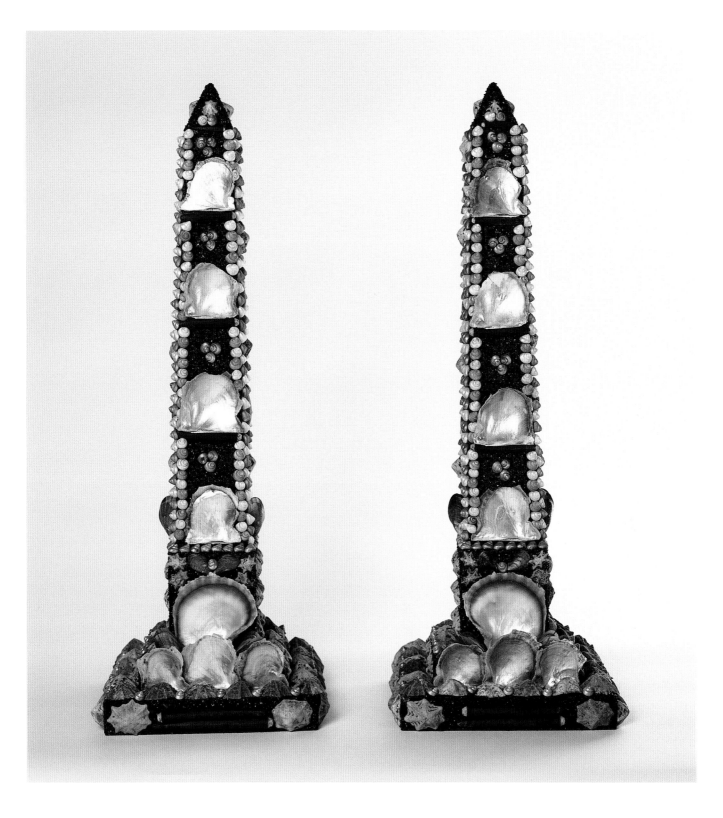

ABOVE

PAIR OF OBELISKS, 1999, by Tess Morley (b. 1973), Suffolk, England. The edges are outlined with dyed blue and pearlized Tegula shells (*Tegula* sp.). Black-lipped Pearl Oysters (*Pinctada margaritifera*) are arranged on a dramatic black background of crushed anthracite, and dyed Pacific Sugar Limpets (*Patelloida saccharina*) are set in rows at each base to suggest a stormy sea. Each obelisk stands 48 cm (19 in.) tall. Morley's shellwork includes caskets, caddies and shell grotesques. Some of her pieces are encrusted with shells and semi-precious stones; others have intricate designs and are set on backgrounds of crushed shell and minerals.

OPPOSITE

MIRROR, 2000, by Belinda Eade (b. 1963), London. This ornate work illustrates the great variety of colours and textures in the shell world, even across just a handful of species: the deep blue of the Common Blue Mussel (*Mytilus edulis*), the creamy-white insides of an Oyster (*Ostrea* sp.), and the warm colours of the Chiragra Spider Conch (*Lambis chiragra*), the Dog Conch (*Strombus canarium*) and the Screw Turritella (*Turritella terebra*). The dull matt backs of the Mussels and of Donkey's Ear Abalone (*Haliotis asinina*) offset the iridescence of the Abalones' interiors, generously used to bring light into the piece.

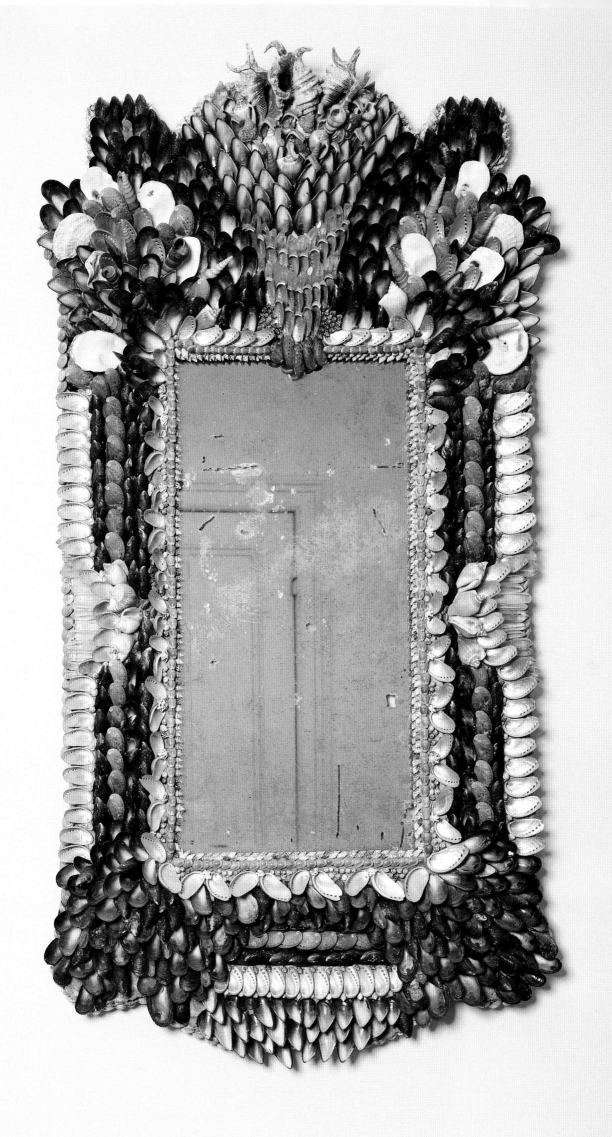

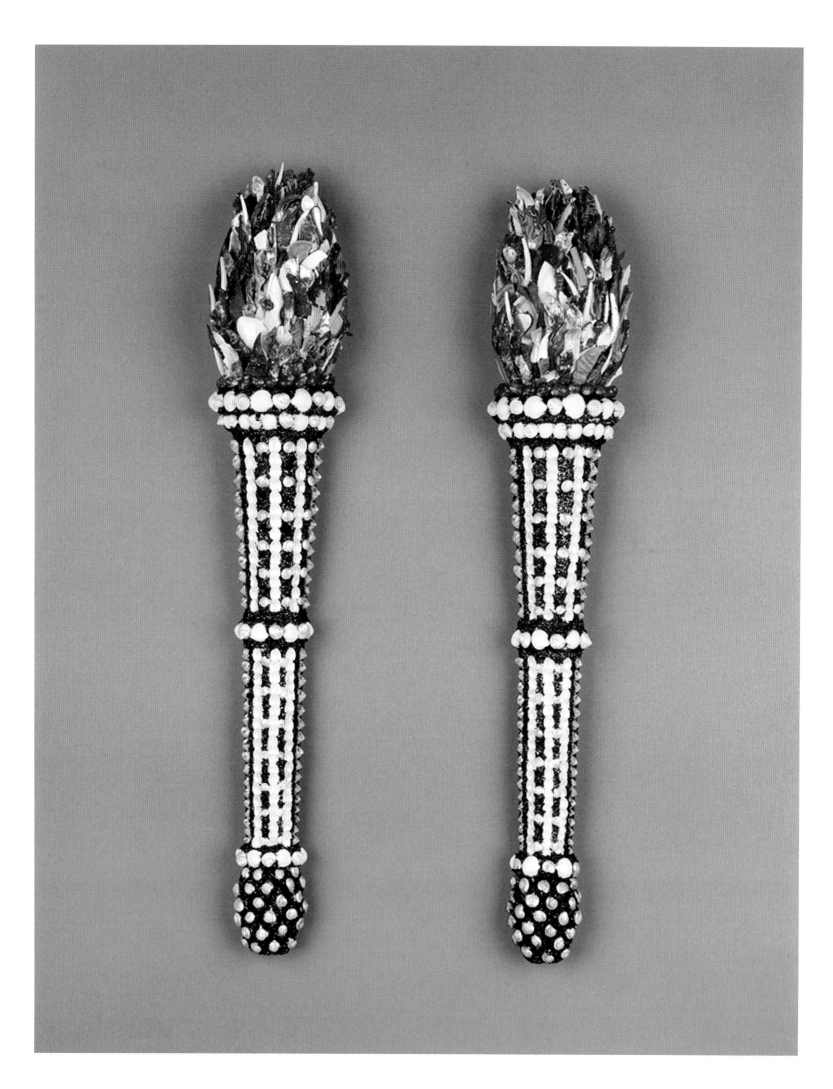

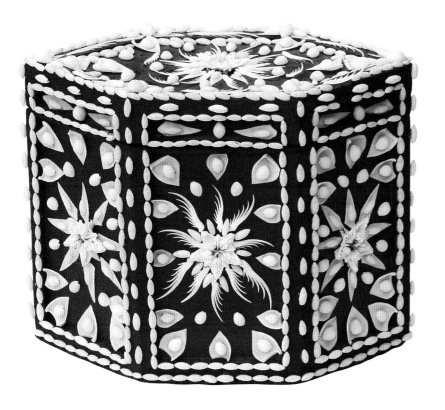

LEFT
RED CASKET DECORATED
WITH SMALL WHITE SHELLS,
2005, by Peter Coke. It includes small
Cowrie shells (*Cypraea* sp.), Olivellas
(*Olivella* sp.) and feathery 'squilla
claws', which are not shells at all,
but the sun-bleached casings from
a tropical species of small crustacean.
Peter Coke has been creating elegant
and unusual shell designs for over
thirty years. His work has been
exhibited regularly in London,
and he has sold pieces to clients
from many countries. They include
original designs for shellwork caskets,
mirrors, table-tops and delicate
floral arrangements.

OPPOSITE
PAIR OF OLYMPIC 'FLAMBEAUX',
2001, by Peter Coke (b. 1914),
Norfolk, England. The bodies of these
torches, designed to be used as wall
ornaments, are worked in white and
dark grey shells, and the 'flames' are
created with fragments of different
coloured shells and antique coral.

RIGHT
SMALL CASKET COVERED IN
BLACK AND WHITE SHELLS, 2004,
by Peter Coke. The large shells are
Striped Engina (*Engina mendicaria*)
and Lightning Dove-shells (*Pyrene
ocellata*), both from the Indo-Pacific.
The smaller white shells with thin
black markings are Zebra Nerites
(*Puperita pupa*), which are abundant
in southeast Florida, the West Indies
and Bermuda. The background is
covered with dyed crushed shell.

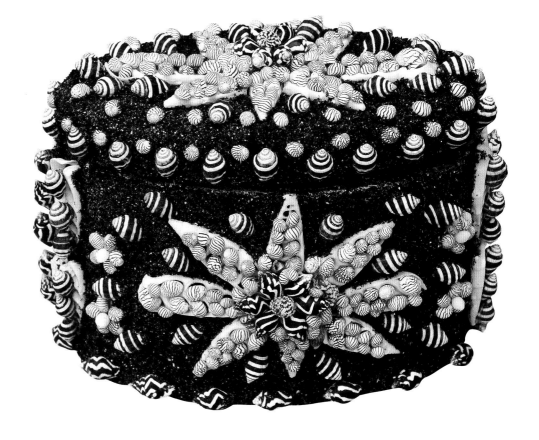

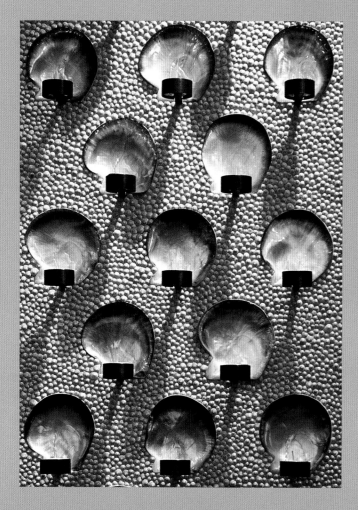

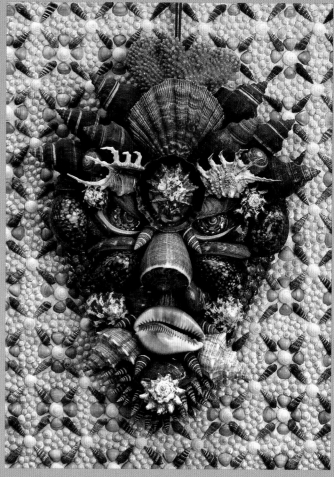

LIGHT SCREEN, 2003, by Thomas Boog (b. 1960), Paris. Iridescent Black-lipped Pearl Oyster shells (*Pinctada margaritifera*) provide a reflective backdrop to tea-light candleholders on this framed screen, all surrounded by thousands of tiny pearlized Button Top shells (*Umbonium costatum*).

SHELL COLLAGE in the form of an expressive human face, 2002, by Thomas Boog. Boog took inspiration from the eccentric portraits by 16th-century Italian artist Giuseppe Arcimboldo when he created this collage made out of many different shells and old coral, placed on a patterned background of small shells. A few of the most prominent species are as follows: the eyes are South African Turbo shells (*Turbo sarmaticus*), the hair contains several Giant Hairy Melongena (*Pugilina morio*), the cheeks are Humpback Cowries (*Cypraea mauritiana*), the mouth is a Map Cowrie (*Cypraea mappa*), and the nose is a Fig Cone (*Conus figulinus*).

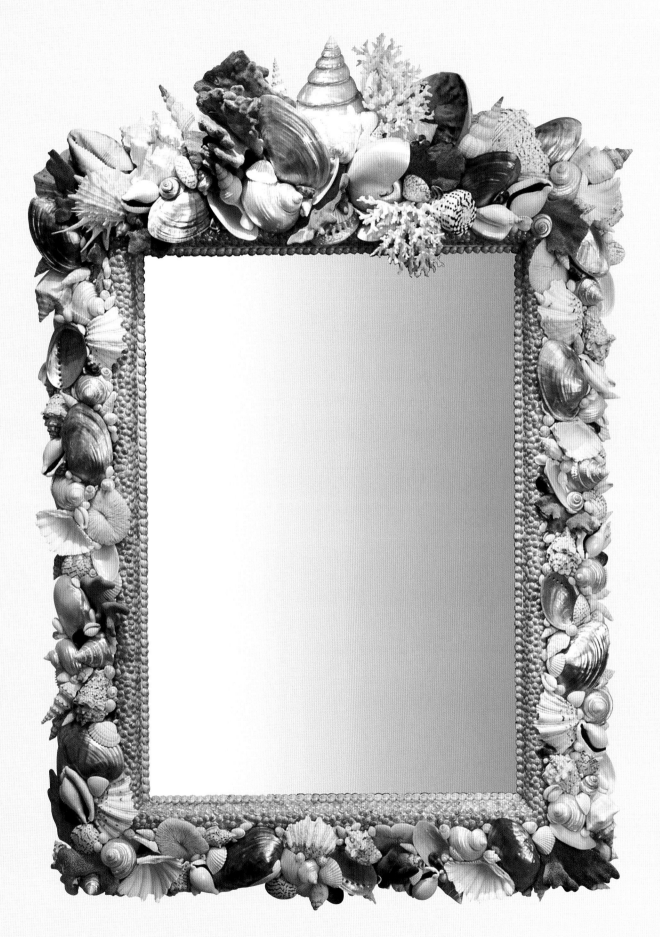

SHELL-FRAMED MIRROR, 2004, by Thomas Boog.
The artist chose a blue and creamy-white theme for this
delicate, Baroque-inspired work.

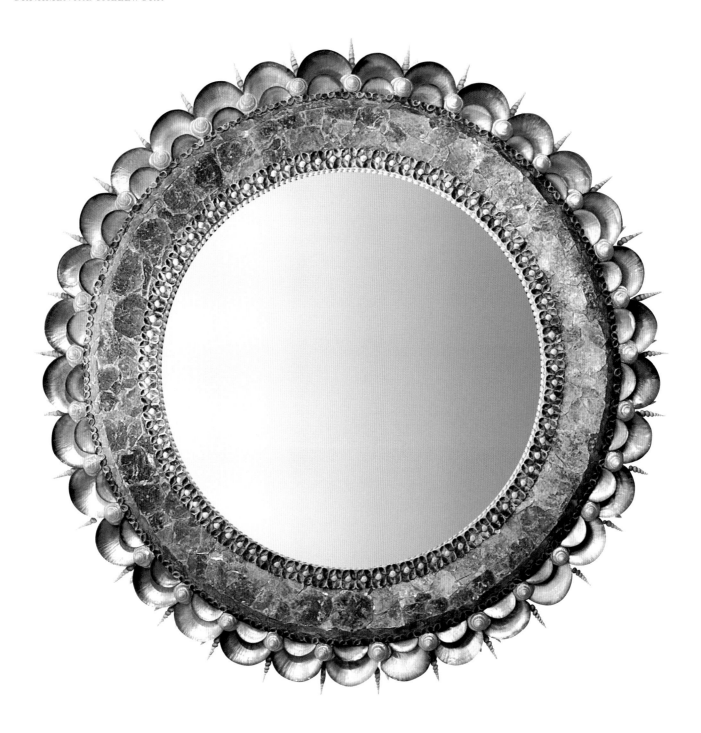

CIRCULAR MIRROR FRAMED WITH SHELLS
AND MICA, 2004, by Thomas Boog (b. 1960), Paris.
The inner circle is made with small purple Donax
shells (*Donax* sp.), and the outer circle is finished with
Black-lipped Pearl Oysters (*Pinctada margaritifera*),
pearlized Pyramid Tops (*Tectus pyramis*), and Duplicate
Turritellas (*Turritella duplicata*).

OPPOSITE
MOTHER-OF-PEARL NAUTILUS SHELL CUP, 2002,
by Tess Morley (b. 1973), Suffolk, England. The pearlized
Chambered Nautilus (*Nautilus pompilius*) is edged with
river pearls and held on a rocaille stand of grey Giant Pacific
Oyster shells (*Crassostrea gigas*) and antique white coral.
This magnificent, Baroque-inspired piece stands 28 cm
(11 in.) tall.

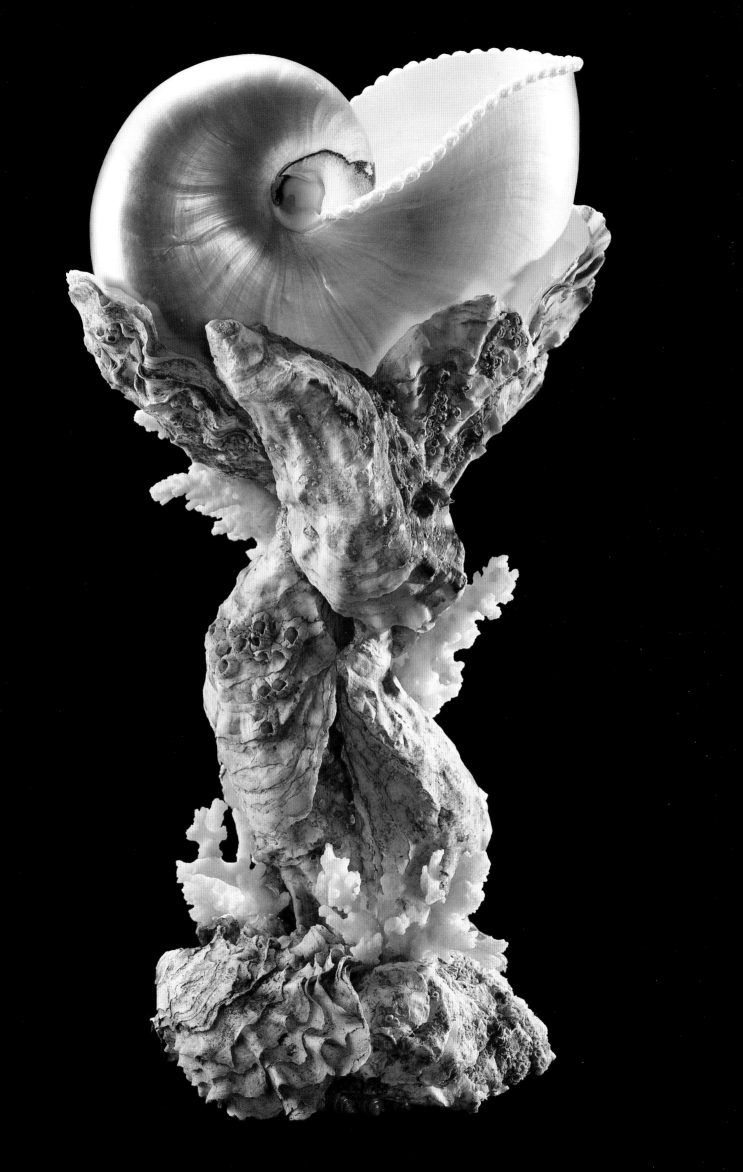

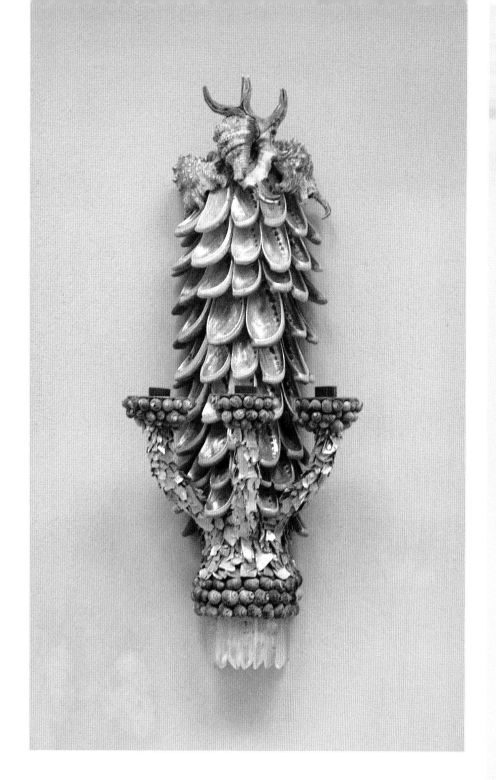

ABOVE

ABALONE SCONCE, 1999, by Belinda Eade (b. 1963), London. This informal, organic sconce is designed to show the natural beauty of the shells used. Turreted Nerites (*Neritina turrita*), small pieces of broken Donkey's Ear Abalone (*Haliotis asinina*) and quartz crystals create the formal structural elements. The top is a simple structure which shows off the Abalone and Chiragra Spider Conches (*Lambis chiragra*) in all their natural splendour.

RIGHT

MARINE-THEMED CHANDELIER, 2005, by Diana Reynell (b. 1938), London. This piece was designed for a house on the coast of western Ireland. The artist tells us: 'The blue iridescent Abalone shells represent water falling, corals and Murex shells the splash of foam. The central globe has mirrored eyes to reflect the candles, and eight octopus arms hold the Limpet cups.' The shells include Glistening Abalone (*Haliotis glabra*), Duplex Murex (*Hexaplex duplex*) and the Common European Limpet (*Patella vulgata*).

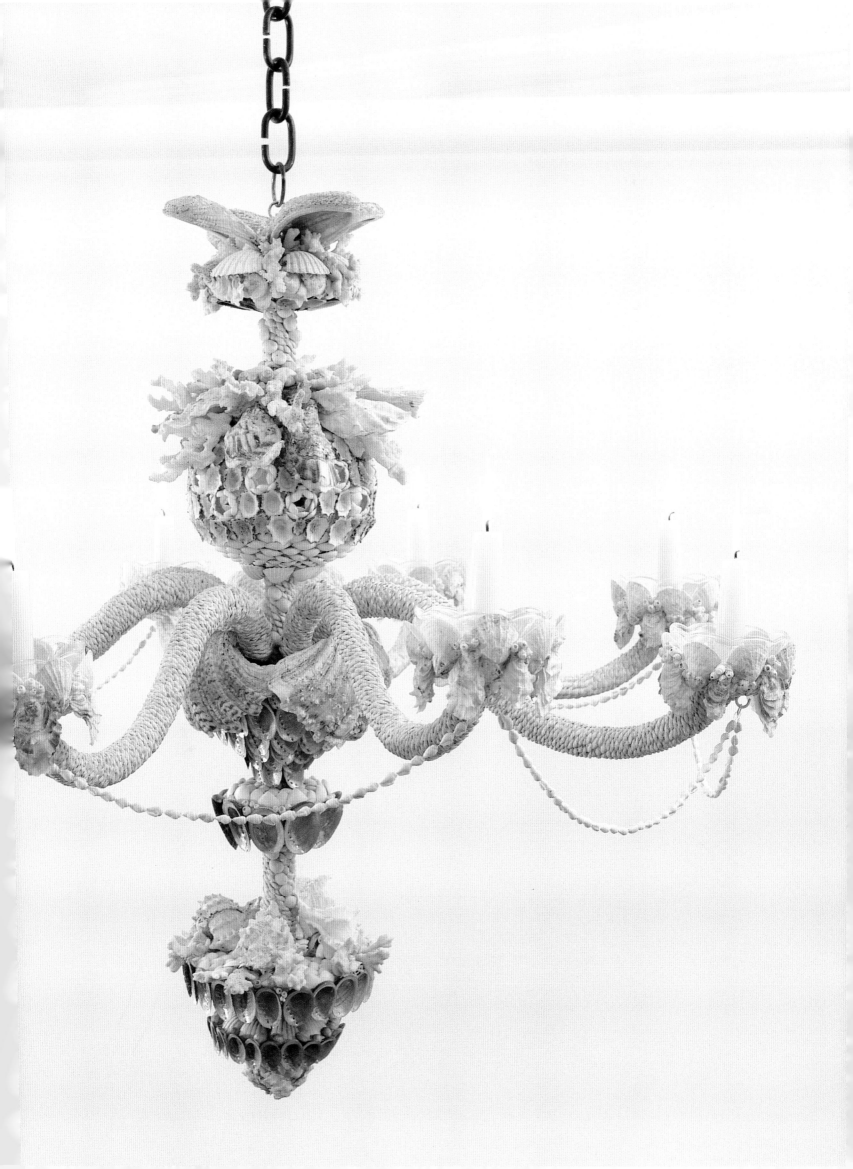

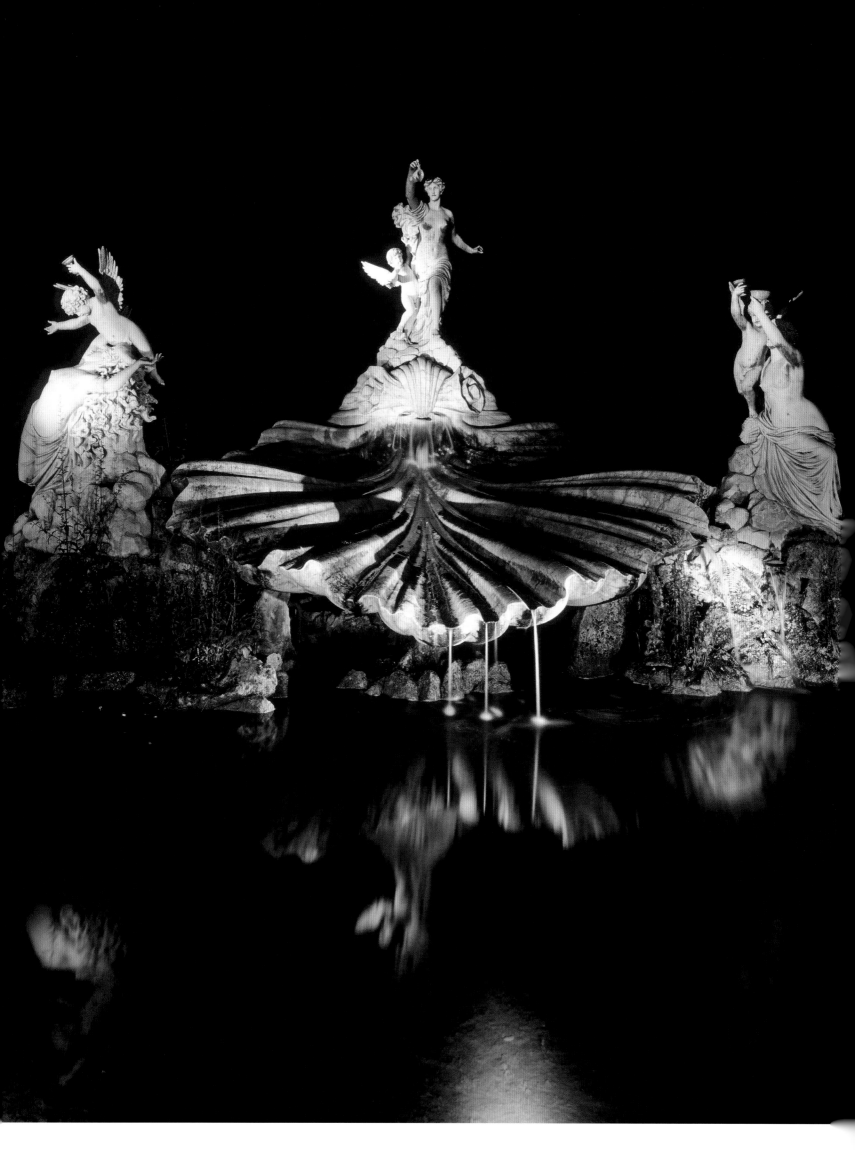

OPPOSITE The floodlit 'Fountain of Love', at Cliveden, near London, England. It was designed and carved in Rome by Thomas Waldo Story (1855–1915), the son of the American sculptor William Waldo Story. The fountain in the shape of a giant sloping stylized Scallop shell is situated in the magnificent grounds of Cliveden, an Italianate mansion formerly home to the Astor family, and now a luxurious hotel.

BELOW AND OVERLEAF Masks of shells and rockwork in the Grotto of Versailles, as depicted in engravings by Jean Le Pautre in his *Description de la Grotte de Versailles*, published in 1679. The artist who created these grotesque masks cleverly simulated human facial expressions, and they would have been an arresting sight to the grotto visitor.

SHELLS IN ARCHITECTURE

Here, in these shells, we see housing of the life of the sea. It is the housing of a lower order of life, but it is housing with exactly what we lack – inspired form… Certainly Divinity is manifest here in these shells in their humble form of life, such greatness with such simplicity.

Frank Lloyd Wright, *Taliesin Fellowship Lecture*

The shell, any shell, is one of the most extraordinary creations of nature as architect. Its form and function are in perfect harmony. Never too big, never too small, it is beautiful, adaptable, strong and efficient, the acme of organic design inspiration. In the world of shells there are many thousands of different shapes and forms as possibilities, so it is perhaps surprising that humankind has so rarely chosen to use the shell as an architectural blueprint. Instead, we choose nearly always to accommodate our rounded bodies in the right angles and straight lines to which conventional building materials more readily lend themselves.

The 20th century produced a handful of notable exceptions. Among them is the guru of organic architecture,

Frank Lloyd Wright, the American architect who used shells as model design forms. Most famously, he chose the spiral of a shell as the basis for the design of the Guggenheim Museum in New York (see page 164). Sarasota in Florida is home to the handsome Performing Arts Hall on the waterfront, its building modelled on a Clam shell. It was designed by Frank Lloyd Wright's son-in-law William Wesley Peters. And the Sydney Opera House, designed by the Danish architect Jørn Utzon, is said to have been inspired by a shell from the Oyster family, the Cock's-comb Oyster (*Lopha cristagalli*). The building's instantly recognizable and breathtaking sectioned roofs leaning towards the harbour are certainly identical to the shell's curving shapes, even if

163

LEFT The Guggenheim Museum, New York. Frank Lloyd Wright, a pioneer of organic architecture, was inspired by the spiral of a shell when he designed his famous building, though sadly he died before its completion in 1959. Since then countless thousands of art-lovers have appreciated the experience of moving gradually down its continuous ramp, enabling them to view works of art at different levels simultaneously.

documentary proof of this inspiration is hard to come by.

With the expanding possibilities offered by computer-aided design and high-tech construction techniques, the potential for shells as an architectural inspiration may finally be fully realized in the 21st century. But if the miraculous and manifold structural forms of shells have been of limited influence on the structure of buildings, they have abounded and excelled as ornamental architectural features for millennia. And one shell more than all others has stolen this particular scene, partly because of its aesthetic simplicity and symmetry, but also because it carries its own legendary significance.

The Scallop shell (*Pecten* sp.) is one of the most widely celebrated symbols to have been used in ecclesiastical as well as public and domestic architecture for over two thousand years. Since classical antiquity, it has graced buildings of all kinds. It is not difficult to understand why. The Scallop's sinuous ridges radiate into a glorious curved form, and artists of all kinds have seized on its harmonious qualities. But the Scallop shell also had a specific role in the mythology of the classical world, and its historic use as an architectural ornament is linked with those legendary associations. Aphrodite (or Venus to the Romans), goddess of love and beauty, fertility and the sea, was said to have been born fully formed from sea-foam and transported to the shore upon a shell (see page 102). The legend of Aphrodite's birth became a popular subject for Greek craftsmen, who portrayed her emerging from her shell on sculpture, terracotta, ceramic and metal ornaments. Aphrodite's shell was usually depicted as a stylized Scallop, and the same shell appeared repeatedly as a motif in classical architecture, whether as a half-domed niche in public and garden buildings; in murals and mosaic flooring; or on tombstones and coffins. Its popularity seems to have spread quickly from about 200 BC through Roman civilization and eventually into the Byzantine Empire.

We will probably never know the degree to which the shell motif was a sacred symbol as opposed to a simple decoration, but the symbolic context of its earliest depictions suggests that at least for the first millennium of its appearance,

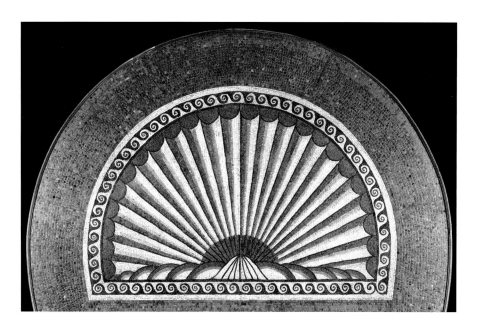

RIGHT Mosaic floor from a house in the Roman city of Verulamium, St Albans, England. The most important rooms in Roman houses often had mosaic floors. This well-preserved example dating to *c*. 150 AD shows a Scallop-shaped design.

it retained a meaning related to its mythical connections. If nothing else, it would have been viewed, as was the goddess, as a symbol of beauty. Some classical historians believe that it also signified rebirth, and was used on funerary ornaments because it was seen as a token of resurrection, of life eternal. Both the Greeks and the Romans held a belief in the journey of the soul across the ocean to the Islands of the Blessed – imaginary islands somewhere in the west where favoured mortals were conveyed at death by the gods to dwell in everlasting joy.

The use of the Scallop shell in European architecture dwindled during the Dark Ages, but medieval Christianity gave it a new role as the emblem of St James the Apostle. The origins of its association with St James are not altogether clear (see page 26). But to the devout, St James's Scallop shell (*Pecten maximus jacobaeus*) became synonymous with pilgrimage, and from the Middle Ages it spread across much of Europe in stained glass and church carvings as the emblem of the patron saint of pilgrims.

To architects of the Renaissance, their new age represented a rejection of the barbarian Gothic style and the rebirth of 'the grandeur that was Rome'. Classical architecture was studied and created anew. With it came the reappearance of the decorative motif of the Scallop shell, perfectly complementing the Renaissance ideal of symmetry. Now stripped of its former symbolic meaning, it was appreciated for its own qualities as a natural object. It became widespread in public architecture, appearing on the facades of buildings, and as the central focus in fountains, another feature revived from the Roman tradition. It adorned column pedestals, and sculptors placed their statues in niches modelled in its form.

From the 15th to the 19th centuries, the Scallop shell's career as an architectural ornament continued and spread across much of Europe as different styles came in and out of fashion. The architects of Palladian, Queen Anne, Adam and Rococo styles all adopted the Scallop motif as external decoration or in the interior of buildings, in carved wood and plasterwork. It was not confined to Europe, but travelled to North America and other parts of the world where European styles were adopted. Its elemental beauty had taken it on a long journey from its classical beginnings.

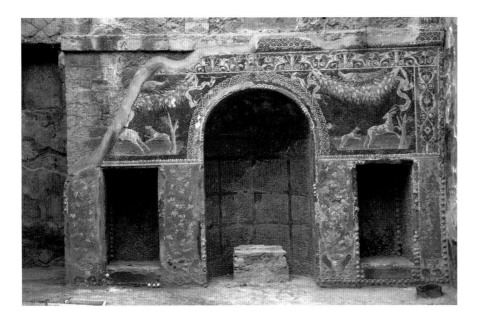

LEFT The *nymphaeum* or shrine to the nymphs in the House of Neptune and Amphitrite, Herculaneum, Campania, Italy. Mosaics and bivalve shells decorate this Roman grotto, probably built in the third quarter of the first century AD, and destroyed by the eruption of Mount Vesuvius in 79 AD.

'And after having remained at the entry some time, two contrary emotions arose in me, fear and desire, fear of the threatening dark grotto, desire to see whether there were any marvellous things within it.'

Leonardo da Vinci's emotions as he explored the caverns of Mount Etna perfectly capture the contradictory inspiration of another architectural tradition in which shells have played a central part. The grotto was an improbable, even bizarre, invention. Gloomy, damp caverns decorated with pebbles, shells and tufa, grottoes were first created by the ancient Greeks as shrines in which to pay homage to water spirits. Located in natural caves near a water source, these shrines gradually became temples, or *nymphaea*, meaning 'temples dedicated to water nymphs'. The Romans made them more popular, building formal temples and artificial grottoes around public fountains. They even built smaller *nymphaea* in their villas and gardens, possibly for religious reasons, but probably also for the more practical use as shelter from the sun.

Italian Renaissance garden designers revived these grottoes of ancient Rome, which added an air of historical authenticity to neoclassical villas and their landscaped grounds. They were decorated with a variety of materials, including coloured marble, locally collected shells, coral, pebbles, and fragments of lava rock. The renowned architect Leon Battista Alberti even published suggestions for simulating mossy slime by pouring green wax onto the stonework of a new grotto. In time, some of these garden ornaments took on a more sophisticated and playful air. Many of them housed statues of mythical beasts and gods. New discoveries in hydraulics allowed engineers to introduce elements of theatre into garden design. *Giochi d'aqua* or water features were introduced, and sound effects were added to some of the more elaborate grottoes. But underlying the frivolous (*giochi* translates literally as 'games'), there was a deeper allegorical significance to the design of many of these gardens. In an age in which the quest for knowledge was paramount, a grotto with a water source, reached at the top of a landscaped hillside, symbolized the visitor's spiritual journey through life to awareness.

BELOW Grotto of Thetis at the Palace of Versailles, France, as depicted in an etching by Jean Le Pautre for his *Description de la Grotte de Versailles*, published in 1679. The grotto, decorated with shells and rockwork, was built in 1664–65 for Louis XIV at the north side of the principal chateau. This etching depicts the magnificent interior, with Apollo in the central niche, surrounded by nymphs of the nereid Thetis. In the two lateral wings Apollo's horses are being groomed by tritons. The design glorified and paid homage to the Sun God Apollo, and so, by extension, to the Sun King, Louis. The grotto was kept secret at times, but at others it served as a venue for entertainments or illuminated suppers. Regrettably, the life of this extraordinary building was brief, possibly because of the necessity of frequent and difficult repairs to its fragile materials. In 1684 it was replaced by a chapel 'worthy of God, whose king Louis XIV is the defender on earth.'

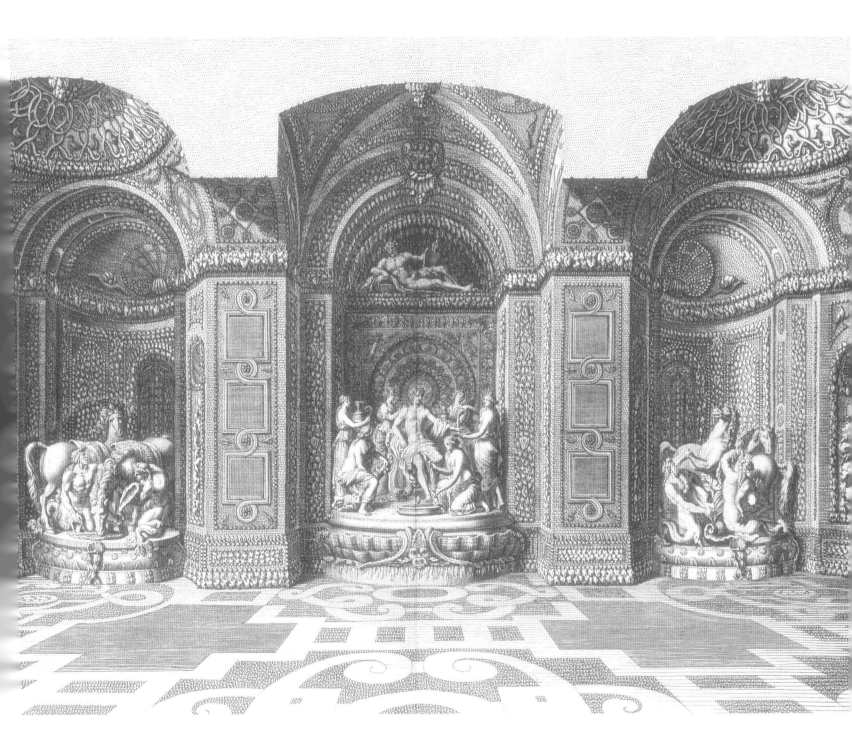

From the 16th century onwards, as the influence of Renaissance styles and ideas spread throughout Europe, grottoes became steadily more fashionable, reaching their heyday in the 18th century. In Italy, France, Austria, Germany, Holland and especially in Britain, grottoes were built by the aristocracy and the wealthy in their gardens and sometimes even in the basements of palaces and mansions. A number of these were very ambitious, and cost enormous sums of money. Extravagant designs were created and embellishments added to what became, in effect, status symbols for the rich. Most of these grottoes were built to imitate rustic, natural caves, and a water feature was frequently included to add some damp authenticity to the atmosphere. Artificial stalactites, rock crystals, fossils and shells were used in fantastical decoration on the walls and ceilings. Gone were the pagan temples of old; these were caverns of delight, designed to fascinate and impress onlookers with their mysterious passageways and cool decorated interiors.

Cave-like grottoes were not the only kind of shell-adorned structure built by the fashion-conscious rich in the 18th century. Some wealthy individuals purchased huge loads of exotic shells from merchant ships returning from the tropics and used them to adorn specially designed garden pavilions, complete with windows and mirrors to allow the entry of natural light. From the outside, these pavilions often had a rugged and rustic appearance, but it was the interior that counted. When visitors entered, they were greeted by the sight of elaborate patterns of decorative shellwork that covered every surface, ceiling to floor. Thousands of shells of every colour formed geometric and glowing designs; Samuel Johnson pronounced one 'a fairy hall'. There was a certain amount of competition to create the most richly decorated shell-rooms, or *Nymphées* as they became known, and a fine one was a prestigious showcase for guests. It was also a far cry from the dank, slippery underground cavern of classical times.

Like so many historic buildings, numerous grottoes, shell-rooms and shell-houses have been lost for all time. But happily, some fine examples have survived, a number of which can be visited by the public (see pages 248–49 for details of a selection of these). Wear and tear have taken their toll over the centuries, but public and private money has been spent on the restoration of several of the finest shell-houses in Europe. The leading restorer in the United Kingdom, Diana Reynell, has recreated the magic of a number of grottoes and shell-rooms in England's great houses and parks. And with the revival of interest in shellwork in recent years, talented artists such as Blott Kerr-Wilson, Thomas Boog and Belinda Eade are working internationally, introducing innovative and fabulous new designs in architectural shellwork, and giving new life to a very old tradition.

Opposite The Shell Gallery at Rosendael Castle, near Arnhem, Netherlands, designed by Daniel Marot, *c.* 1730. This is one of the treasures in the park of the castle, whose history dates back to the Middle Ages. The exotic species used in its 1970s restoration were donated by Dutch Customs and Excise from those impounded as illegal imports into the country.

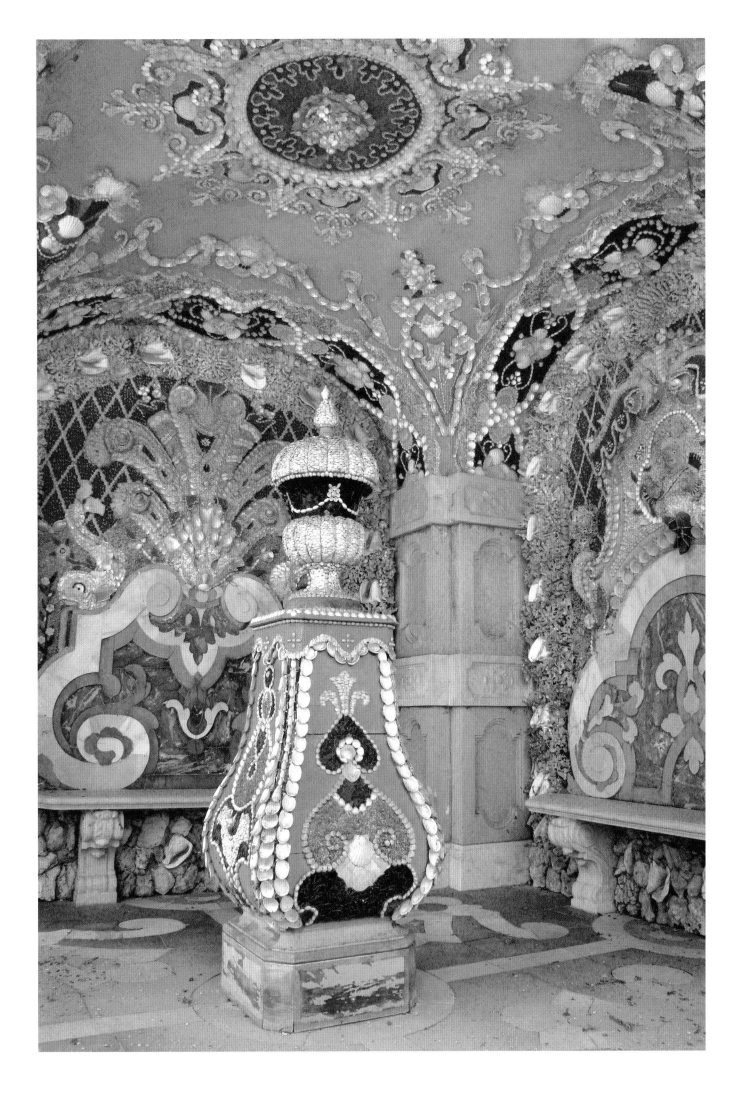

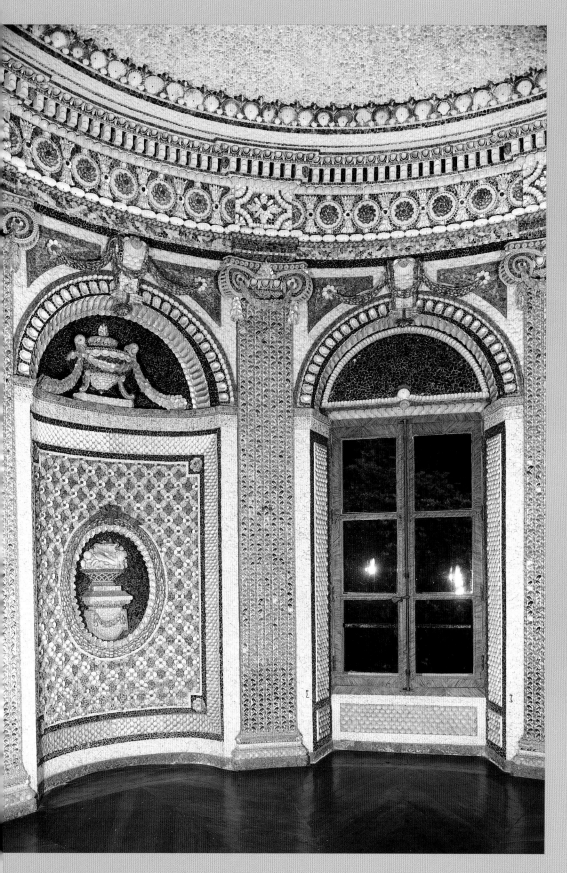

LEFT
LA CHAUMIÈRE AUX
COQUILLAGES in the chateau of
Rambouillet, France. Built in the
second half of the 18th century, this
is one of the most celebrated follies
of the time. Designed at the height of
the fashion for grottoes, it was built
by the Duc de Penthièvre for his
widowed daughter-in-law, the
Princesse de Lamballe. The exterior
has a thatched roof and simple rustic
appearance, giving no suggestion of
the lavish and glittering shellwork
covering the entire interior.

OPPOSITE BELOW
THE SHELL HOUSE, GOODWOOD
HOUSE, West Sussex, England.
Probably the finest shell house in
England, this was built in the 1740s
for Charles Lennox, 2nd Duke of
Richmond, and originally may have
been decorated by the Duchess herself
with her two daughters. Shiploads
of shells were acquired, and it was
said to have taken seven years in
construction, including a floor made
up of hundreds of polished horses'
teeth bordered by black marble. Time-
worn and weather damaged, it was
renovated over six years from 1989 to
1995 by grotto restorer Diana Reynell
and conservationist-builder Roger
Capps. Great pains were taken to
replicate the original designs: it took
two years to gather the 55,000 shells
needed. Reynell even developed a
special putty from 18th-century recipes
to glue the shells in place.

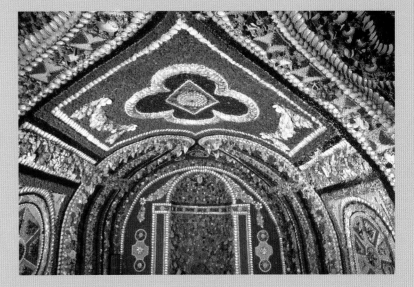

RIGHT
LE NYMPHÉE, DOMAINE DU PIÉDEFER, Viry-Chatillon, France. This vaulted room was designed as a shell grotto dedicated to Pan in the early 17th century. It is a fine example of an early European grotto, and is fabulously decorated with shells and pebbles in Italian Baroque style.

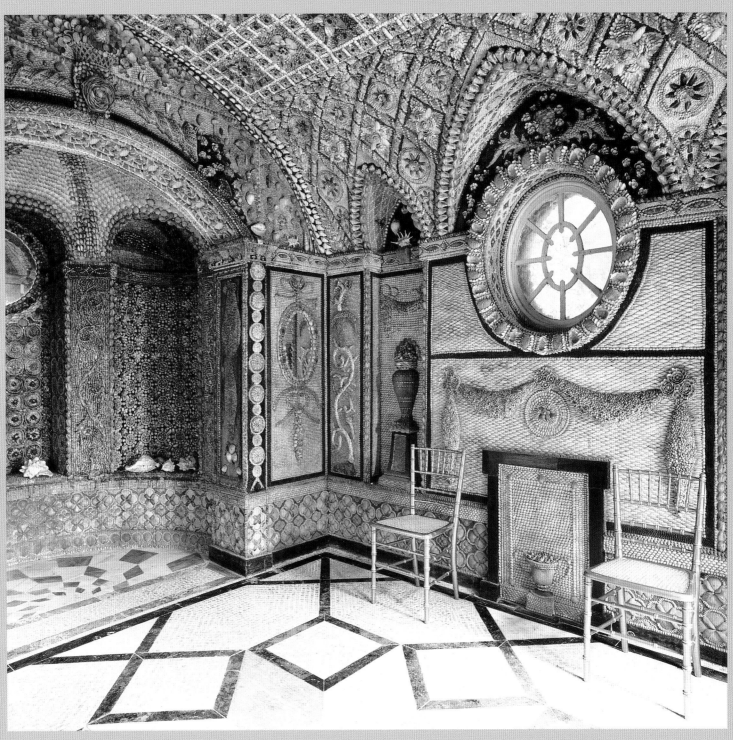

RIGHT
THE SHELL ROOM at Basildon Park, Reading, England, a grand 18th-century Palladian mansion. The decoration was restored in the 18th-century spirit by Gordon Davies in 1978; it was designed to provide a backdrop for the large display cabinet containing a collection of shells.

OPPOSITE
THE MUSCHEL SAAL (Shell Hall) in the Neues Palais at Sanssouci Park, Potsdam, near Berlin, decorated with corals, minerals, and thousands of shells. This sumptuous Baroque palace was built by Frederick the Great of Prussia in 1763–69.

BELOW
PAINTED CEILING in La Fondazione Marco Besso, Rome. The Strozzi family amassed a handsome collection of shells in the 16th century, including some very beautiful specimens. Painted panels illustrating some of their collection were incorporated into this coffered ceiling.

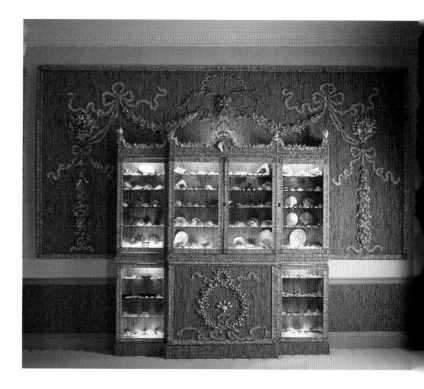

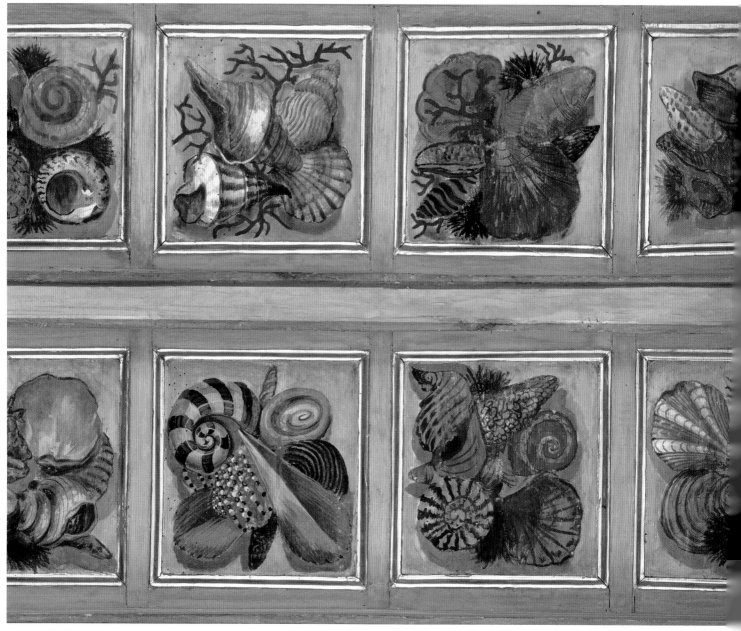

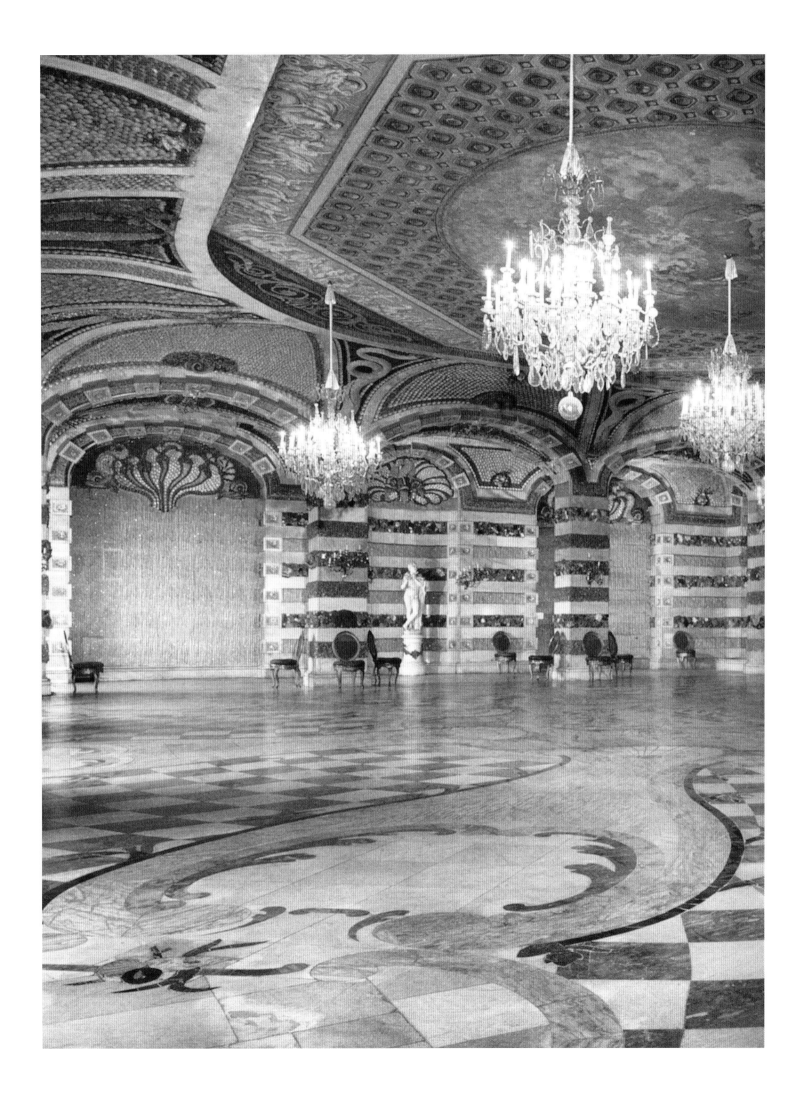

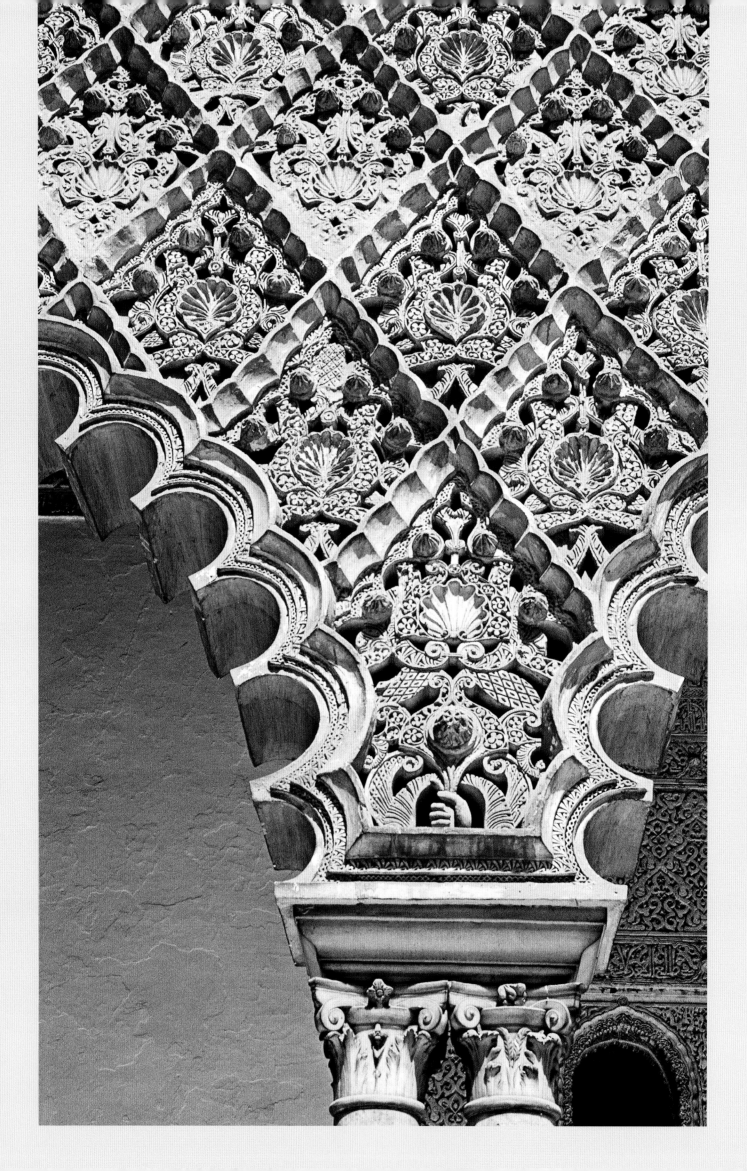

CASA DE LAS CONCHAS,
Salamanca, Spain. This impressive
15th-century mansion was built for
Dr Talavera Maldonado, Chancellor
of the heraldic Order of Santiago.
He particularly wanted the symbol
of his Order, and of St James, applied
to the facade of the building, so after
the walls were constructed, over 300
stone carvings of St James's Scallop
shells (*Pecten maximus jacobaeus*)
were secured in regular formation
across its entire surface. Not
surprisingly, it has ever after been
known as the 'House of Shells', and
it is as impressive today as when it
was first built.

THE ARCADE IN THE PATIO DE
LAS DONCELLAS (Courtyard of the
Maidens) in the Alcázar, Seville, Spain.
This beautiful palace was built in the
1360s, serving as a royal residence in
the centuries that followed. Today it is
the Spanish monarch's official
residence in Seville. The palace is one
of the best surviving examples of
Mudéjar architecture, a fusion of
Christian and Moorish styles. This
famous courtyard is paved with white
marble, has a large central fountain,
and is surrounded by an arcade
ornamented with elaborately carved
stucco. In the centre of each geometric
section is the motif of a Scallop shell.

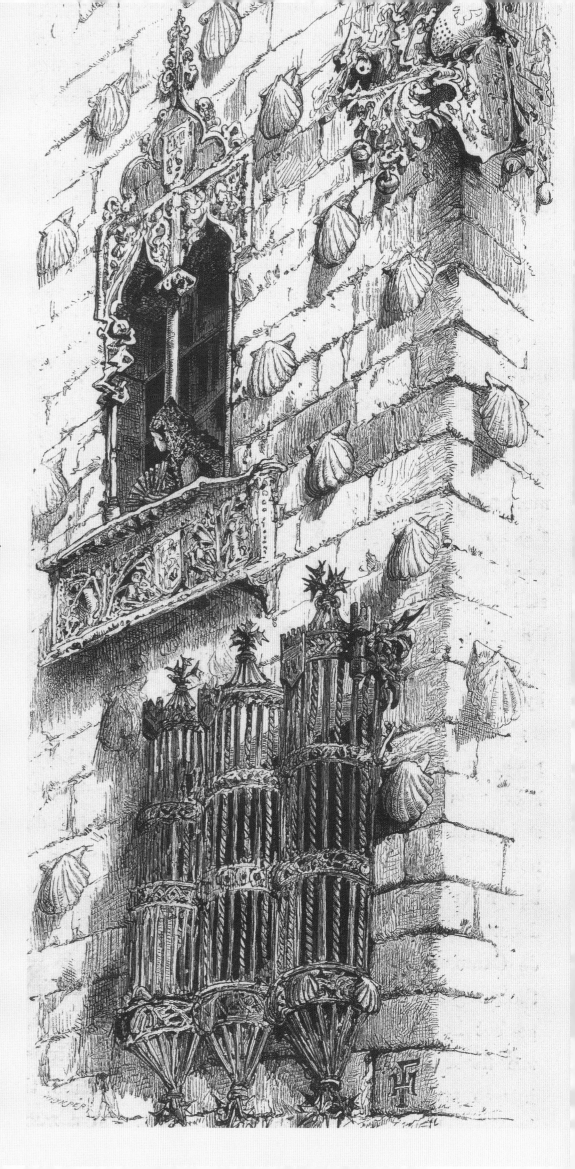

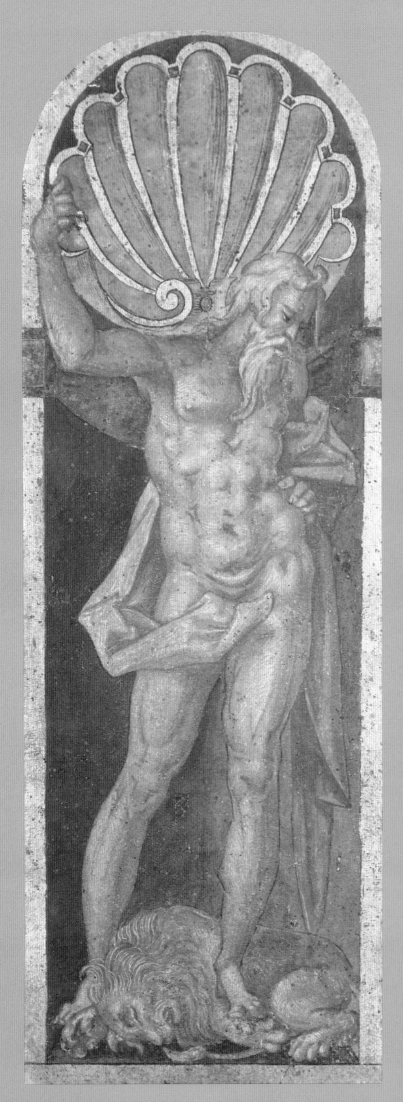

ABOVE
ROMAN FOUNTAIN NICHE, mid-1st century AD, from Baiae, near Naples. Niches such as this were built to house fountains in the gardens of Roman town houses, and served as *nymphaea*, or shrines. They were decorated with coloured glass or stone tesserae, and often Scallop shells (*Pecten* sp.).

LEFT
HERCULES, pencil drawing by Bartholomaeus Spranger (1546–1611). An inert lion at his feet, Hercules supports a great Scallop shell on his shoulders that fills the niche in which he stands. Spranger was one of the most important artists at the Prague court of Emperor Rudolf II, combining Netherlandish tradition and Italian Mannerist influences.

OPPOSITE
MADONNA AND CHILD WITH SAINTS, mid-1470s, by Piero della Francesca (*c.* 1415–92). The magnificent shell depicted at the back of the niche in this sublime painting is one of the most famous in architecture. It is a St James's Scallop (*Pecten maximus jacobaeus*), a shell of Mediterranean distribution that was probably familiar to the artist as an edible species. Suspended from its apex by a silver cord is an ostrich egg. From medieval times, it was believed that the mother ostrich left her egg out in the sunlight to hatch, without her involvement. For this reason it became a symbol of the Virgin Birth and was depicted over church altars and in Renaissance works of art.

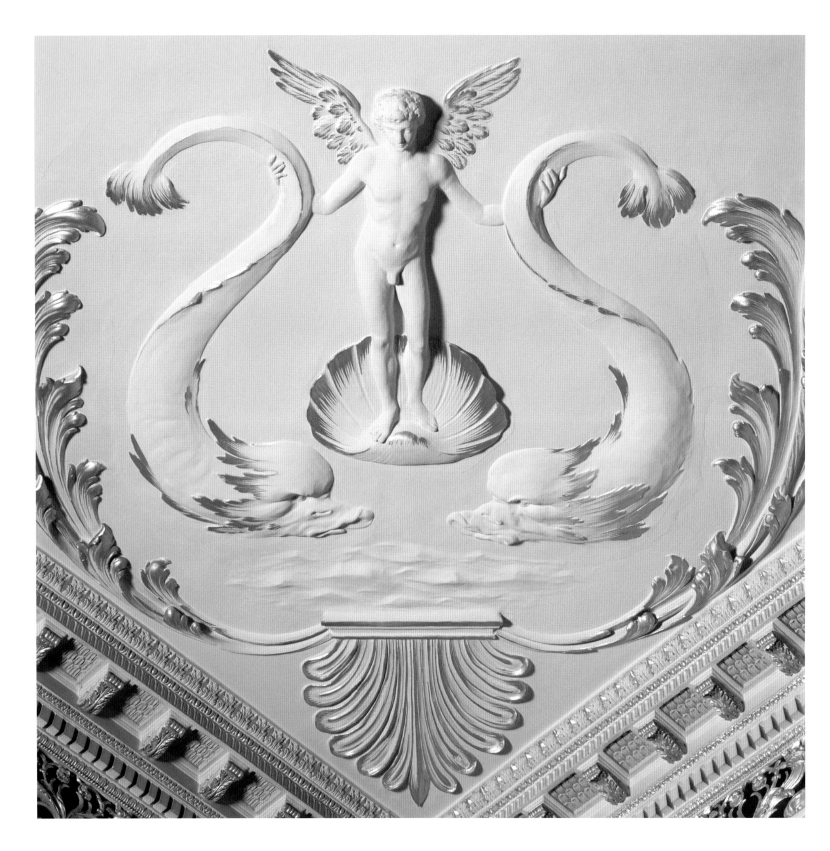

ABOVE
DETAIL OF INTRICATE PLASTERWORK showing
different shell motifs by Scottish architect Robert Adam
(1728–92) on the ceiling of the saloon at Hatchlands, a
mid-18th century mansion in Guildford, Surrey, England.

OPPOSITE
FOUNTAIN FROM THE GARDENS OF VERSAILLES,
as illustrated in *Plans et Vues de Versailles* by Jean Le Pautre,
1679. The engraving shows Cupid sitting astride a dolphin
upon tiered supports of open Scallop shells, the whole
structure decorated with coral and many shells. From
Cupid's quiver fly 'arrows of water'.

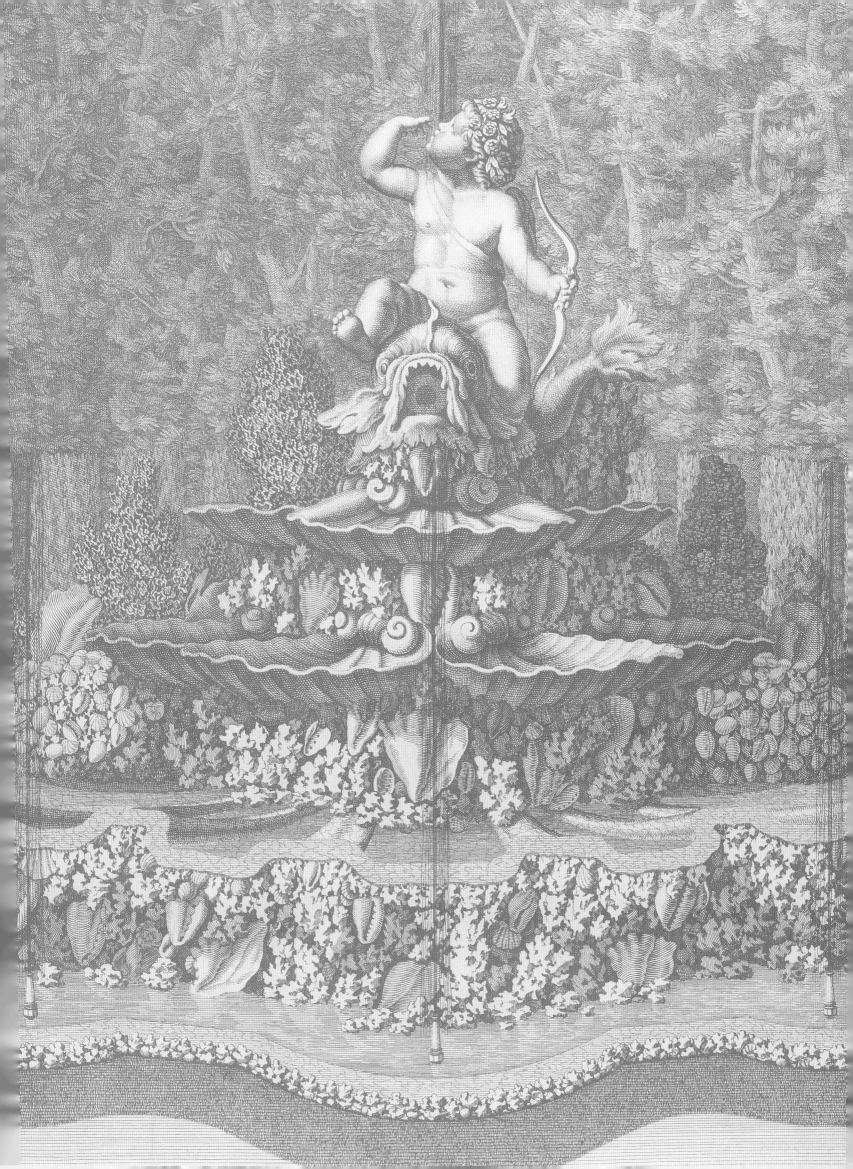

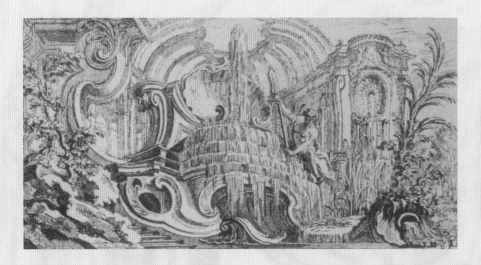

ABOVE

AN ARCHETYPAL EXAMPLE OF ROCOCO STYLE
by Juste-Aurèle Meissonnier (1695–1750). His drawing
shows a cascading fountain with an enormous stylized
Scallop shell (*Pecten* sp.) in an irregular, extravagant and
graceful stonework setting. The most original practitioner
of the *genre pittoresque*, Meissonnier's asymmetrical and
undulating designs were filled with fluid movement, and
stretched the boundaries of caprice and fantasy.

OPPOSITE ABOVE

THE TRITON FOUNTAIN IN THE PIAZZA BARBERINI
IN ROME, designed and sculpted by Gian Lorenzo Bernini
in 1643. This engraving is from *Le Fontane di Roma nelle
Piazze* by G.B. Falda, published by G.G. de Rossi in 1691.
The fountain is depicted here in magnificent splendour,
if exaggerated in scale. The sea god Triton, half-fish, half-
man, kneels on an opened Scallop shell. His head is thrown
back with a shell raised to his lips from which a jet of water
spurts to a great height. This was the first of Bernini's many
fountains, and it remains a famous landmark in the Piazza
Barberini in Rome, even if in reality Triton's shell produces a
rather less dramatic jet of water. Modern visitors still throw
lucky coins into the pool below, said to guarantee their
return to Rome.

OPPOSITE BELOW

THE SHELL GROTTO AT ROSENDAEL CASTLE,
near Arnhem in Holland. This grotto with trick fountains,
designed by the French architect Daniel Marot, was built
by sculptors and a number of *grotwerker* (grotto workers)
beginning around 1740 and continuing for over ten years.
It is situated in the 19th-century landscaped gardens of
the castle.

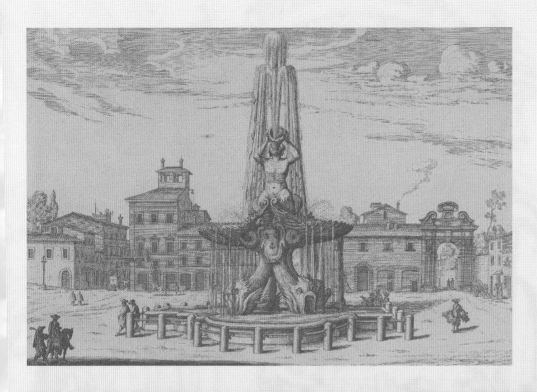

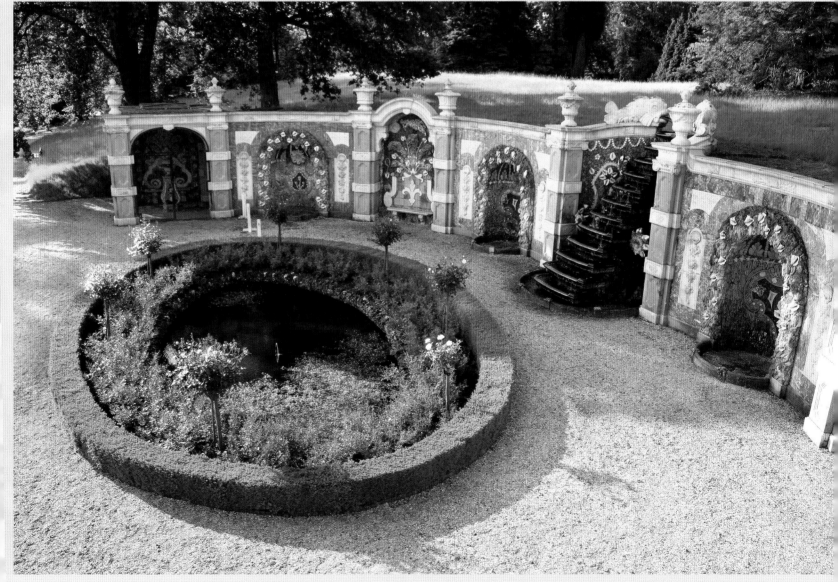

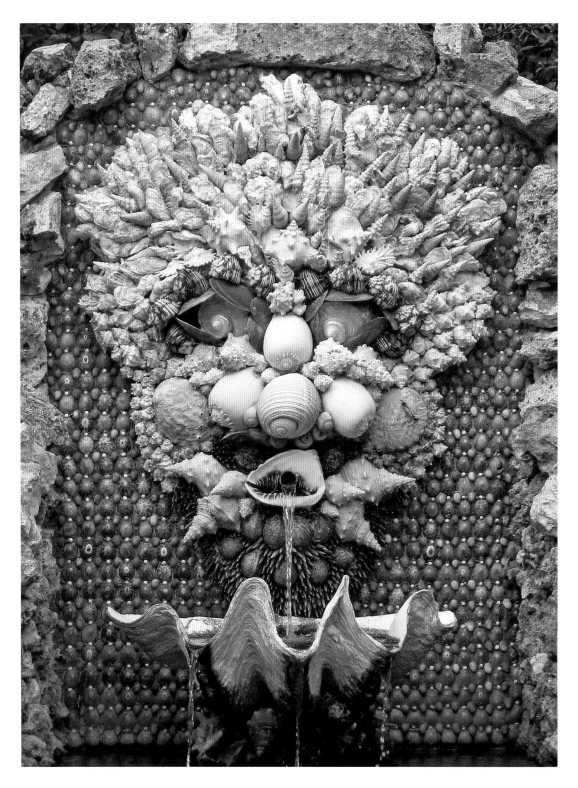

ABOVE
ARCIMBOLDESQUE SHELL-HEAD
FOUNTAIN, in the garden of the Petit Château,
Parc de Sceaux, Hauts-de-Seine, France. Water
gushes from the mouth of this modern shellwork
face, and pours into a basin formed by a Giant
Clam (*Tridacna gigas*).

OPPOSITE
SHELLWORK FOUNTAIN with lead frostwork
created for a London garden by designer George
Carter (b.1948), 1993. Inspired by Italian
Baroque shellwork, Carter designed the fountain
so that the play of water over the Mussel shells
would bring out their colour and make them
glisten. Only two species were used, to great
effect: the Common Blue Mussel (*Mytilus edulis*)
and the Queen Scallop (*Aequipecten opercularis*).

THIS PAGE, LEFT AND RIGHT
SHELL, 2006, a site-specific installation by the award-winning British artist Susie MacMurray (b. 1959) covering the walls of a stairwell in Pallant House Gallery, Chichester, England. Inspired by the mass of shells that were reportedly found when the foundations of the present Queen Anne house were dug around 1712 – debris from the previous medieval settlement on the site – the artist created this work from 20,000 Common Blue Mussels (*Mytilus edulis*), each one stuffed with a small piece of opulent red silk velvet. The whole has been described as '…pulsing exotica, a heavily-textured wallpaper, darkly decorative…broodingly present, with more than a hint of the uncanny or the gothic.'

OPPOSITE LEFT ABOVE
ENGLISH CONSERVATORY ALCOVE by Belinda Eade, 1994. Water pours from a lead spout in this arched alcove into the trough below. The area around the spout features decorative shellwork in cream, blue and silver, including Common Blue Mussels (*Mytilus edulis*), Donkey's Ear

Abalone (*Haliotis asinina*) and Common European Cockles (*Cerastoderma edule*). Surrounding this panel is rougher shell and rock work which includes industrial waste slag, tufa and larger shells such as Jeffrey's Colus (*Colus jeffreysianus*).

OPPOSITE RIGHT ABOVE
BELINDA'S GROTTO, London, 1990. Built by shell artist Belinda Eade, this grotto is a transitional space between a house and garden. The walls are encrusted with Rainbow Abalone (*Haliotis iris*) and Donkey's Ear Abalone (*Haliotis asinina*), Giant Pacific Oysters (*Crassostrea gigas*), Pacific Sugar Limpets (*Patelloida saccharina*) and stone. Two shell caryatid figures flank the doorway to the house and a mysterious shell face forms the capital of a central column.

OPPOSITE BELOW
WALL-MOUNTED 'MAZE' in a private shell house in Wiltshire, England, 1998, by Blott Kerr-Wilson (b. 1962), North Wales. This was devised to encourage viewers to see the progression of the shells in its design.

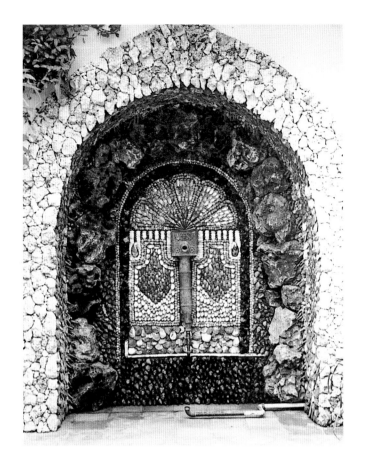

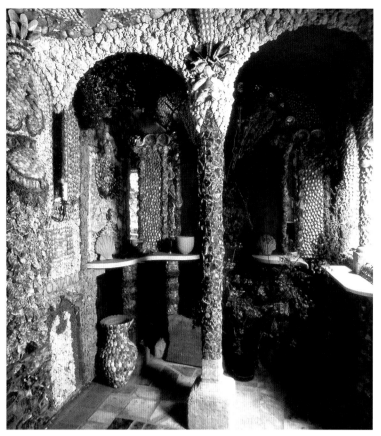

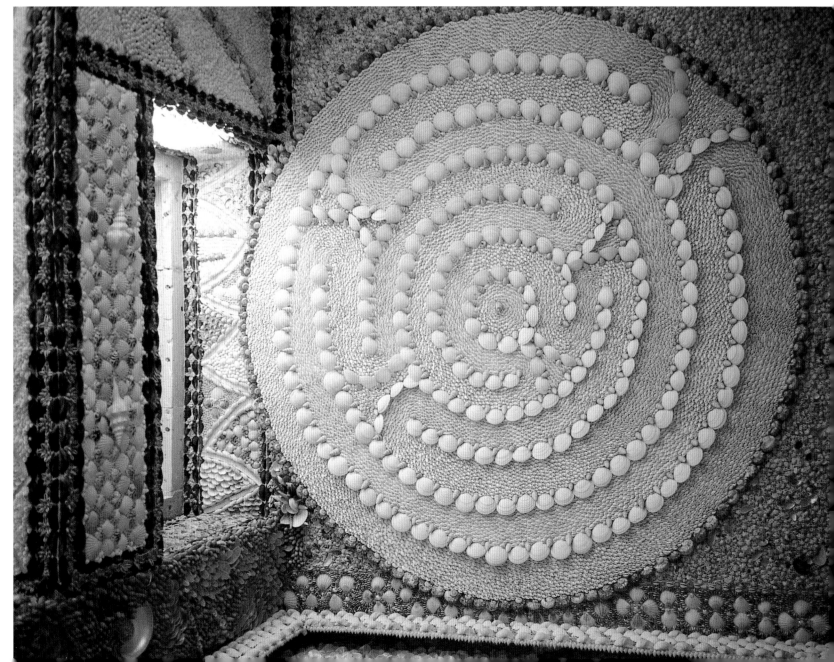

BELOW LEFT
WALL OF A SHELL HOUSE AT BALLYMALOE
COOKERY SCHOOL, Shanagarry, County Cork, Ireland,
1995, by Blott Kerr-Wilson (b. 1962), North Wales. For this
commission the artist wanted to create a wholly new style of
architectural shell design. She used many different shells to
create its modern geometric pattern, which is consciously
reminiscent of knitting and textile designs. The shells in the
lower section of the wall were recycled from the kitchens of
the cookery school.

BELOW RIGHT
SHELL WALL OF A CROQUET PAVILION, in the garden
of a private house in Wales, 2004, by Blott Kerr-Wilson. This
small octagonal building is a feminine and restful retreat,
the shells predominantly blue, pink, cream and silver. Kerr-
Wilson used considerable numbers of iridescent Donkey's
Ear Abalone shells (*Haliotis asinina*), which together with
pearlized Trochus shells (*Trochus* sp.) encourage a rich glow
of light in what had previously been a small dark building.

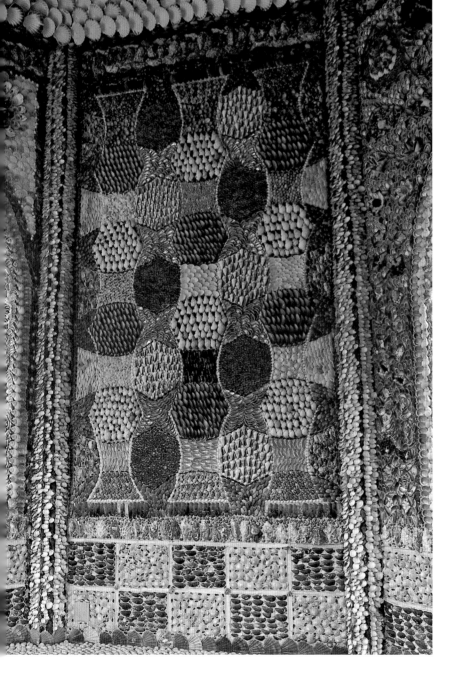

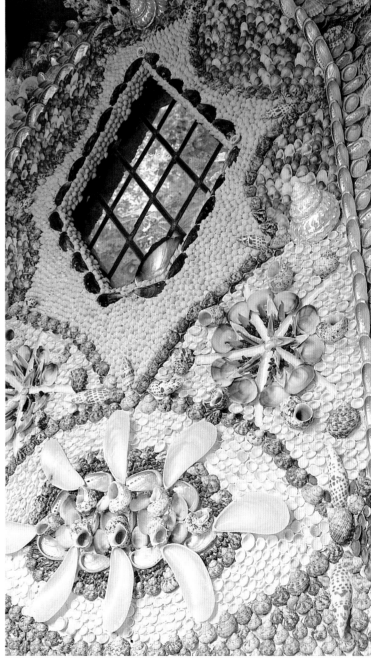

DETAILS OF A SHELL ROOM in a private house in Mustique, 1998, by Blott Kerr-Wilson. The artist was invited to cover the walls of the entire room using only two types of shell: Common Blue Mussels (*Mytilus edulis*) and Glistening Abalone (*Haliotis glabra*). Working without plans or sketches, she simply allowed her creativity to take her forward. The result is one of her most spectacular pieces of work, in which thousands of blue and silver shells flow and swirl in undulating waves across the walls. Three thousand fibre-optic threads placed within the Abalone shells create a gentle and subtle lighting effect.

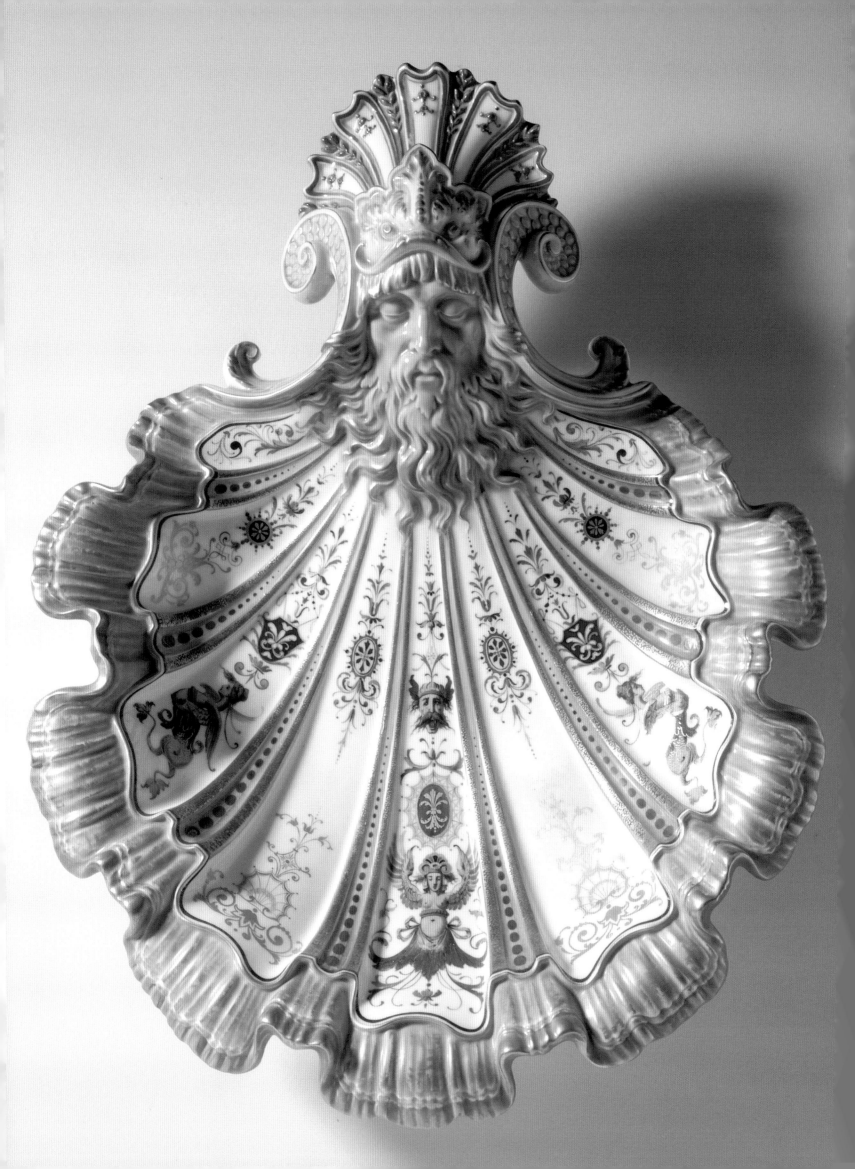

OPPOSITE Ribbed porcelain shell bowl with coloured glaze and gold decoration in the form of grotesques, made by the Königliche Porzellanmanufaktur (Royal Porcelain Manufactory) Berlin, *c.* 1888. At the apex is Neptune's head, wearing a crown that echoes the shape of the bowl.

BELOW Two-handled ceramic vase, one of a pair, made by Barr, Flight and Barr, England, *c.* 1810. Its skilfully painted face depicts three shells: at front left, a Lightning Moon Turban (*Subninella undulata*), at front right, a Spotted Tun (*Tonna dolium*), and at the back an Australian Pheasant (*Phasianella australis*), once a highly sought-after species.

SHELLS IN THE DECORATIVE ARTS

All art is but imitation of nature.

Seneca, *c.* 4 BC–65 AD

If you did not know otherwise, you might easily believe a shell to be a small object modelled in ceramic. It looks and even feels rather like ceramic. In fact some shells, with their translucence and seemingly highly polished glaze, could be mistaken for the finest bone china. So it is no real surprise to discover that the origins of the word porcelain are linked to a shell. Before the introduction of high quality ceramics from China in the 16th century and their subsequent manufacture in Europe, the word *porcelaine* had been used in medieval France to describe the very glossy Cowrie shell, and is still occasionally used today as a generic term for Cowries. The word derived from the Italian *porcellana*, meaning 'like a young sow' (from the Latin *porcus* or pig), which described the similarity in shape between a Cowrie and the back of a pig.

Ceramic is one of a wide range of media in which the shell has provided inspiration in the decorative arts for millennia. The great civilizations of pre-Columbian South America used and depicted shells in their art. Earthenware sculptures bearing the theme of a goddess emerging from a shell have been found in graves in Chile dating to around 3,000 BC. Later, across the Atlantic, ancient Greek and Roman terracottas portraying Aphrodite/Venus rising from the valves of a Scallop shell were produced for visitors to buy at her shrines in Athens and Corinth. Peruvian vases have been found painted with uncannily similar themes, and shells found in the graves of pre-Columbian high priests are

BELOW A Roman beaker, 3rd century AD, found in a grave in Cologne, Germany. Glass, ceramic vessels and coins were frequently placed in the graves of affluent Romans. Scallop shells were regarded as tokens of resurrection and life eternal.

BELOW RIGHT Salt Cellar, the 'Saliera', 1540–44, by Benvenuto Cellini (1500–71). Made for Francis I of France, this is probably the most famous work by any Renaissance goldsmith. Cellini himself wrote in his autobiography, 'When I exhibited this piece to his Majesty, he uttered a loud outcry of astonishment, and could not satiate his eyes with gazing at it.' The artist also describes his sculpture: 'I represented the Sea and the Land, both seated, with their legs intertwined just as some branches of the sea run into the land and the land juts into the sea…The water is represented with the waves…The Land I had represented by a very handsome woman…entirely naked like her male partner. On a black ebony base…I had set four gold figures…representing Night, Day, Twilight and Dawn.' The figure of the Sea, or Neptune with his trident, reclines upon a large shell.

similar to those found in sites sacred to the worship of Aphrodite. The exact significance of these shells is not known, but they are one of many striking similarities between the ancient cultures of Europe and South America. Indeed, the parallels are so strong when it comes to the symbolic use of shells that it is tempting to wonder whether there is any truth to theories of contacts between the New and Old Worlds well before our history books tell us of the arrival of Europeans in the Americas. In the absence of firm evidence, all we can do is speculate.

For some of the finest examples of work in the decorative arts inspired by shells, we must move forward to the late Renaissance and the Mannerist period of the 16th century. From this time onward, shells would be portrayed in all branches of the decorative arts in Europe and beyond, including metal, glass, ceramics, textiles and furniture, in thousands of different designs and styles.

The Italian Mannerist era was defined by a richly decorative and intricate style, with complex mythological references and iconography. Its most important surviving work by a goldsmith is the spectacular salt cellar, the 'Saliera', by Benvenuto Cellini. This elaborately sculptural vessel is an allegorical portrayal of planet Earth, and features a male figure representing the Sea reclining on a gold shell. Also renowned as a sculptor, Cellini was a flamboyant character, whose life included some hair-raising adventures, including murder and sexual scandals, all recorded in an audacious autobiography which remains in print to this day. The 'Saliera' is Cellini's most famous work, and was commissioned by King Francis I of France. It was made of solid gold and enamel, and according to Cellini, the price for it was one thousand *scudi* (whereas his own annual salary,

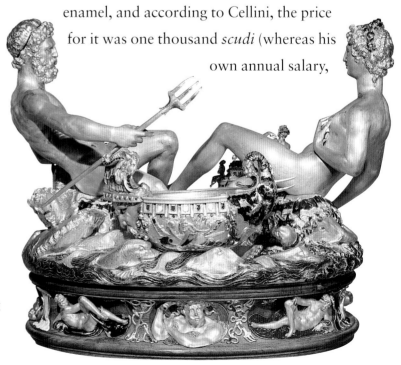

BELOW *Rustic Basin with Knotted Snakes, Turtles and a Ray*, 1556–90, attributed to Bernard Palissy (1510–90) and his atelier. Palissy owes his fame mainly to his rustic ceramic bowls, dishes, ewers and basins, on which shell-encrusted imitation rock serves as a background to a liberal decoration of animal life. His earlier commissions to design grottoes for French nobility gave him a taste for the use of shells in his work. He almost certainly used real shells to create his moulds, arranging them on a soft clay base upon which he then integrated casts of his principal animal subjects. Once satisfied with the result, he made a mould of the entire composition, so producing exact copies of the original shells.

also paid by the king, was seven hundred *scudi*). It has been admired for over four hundred years, and is one of the prized objects in the collection of the Kunsthistorisches Museum in Vienna. News of its theft in 2003 prompted international dismay, but it was fortunately recovered in 2006 and returned undamaged to the museum.

In 16th-century France, an innovative and original ceramicist created some very different and extraordinary pieces of work. Bernard Palissy, religious reformer and writer, and a man of many contradictions, was both a favourite of the Catholic kings of France and a fervent Protestant. Often persecuted and even imprisoned for his beliefs, he was finally pronounced a heretic, and died in the Bastille. A passionate man in everything he did, he was a fine amateur scientist and an accomplished draughtsman. In his ceramic atelier in Paris, he created his idiosyncratic 'rustic' wares, using a jealously guarded technique that he never divulged, to produce basins and ewers covered with a strange bestiary of reptiles, crustaceans, amphibians and shells, all in an unprecedented

range of authentic and delicate colours. He was also renowned as a designer of grottoes (see pages 166–68), whose interior spaces he adorned with his colourful glazed terracotta. His work inspired imitations for centuries, particularly in the 19th century, by which time Palissy had acquired the status of a cult hero.

The 16th and early 17th centuries were also the golden age of the mounted shell, particularly in Holland, Austria and Germany. Extraordinary workmanship and value were invested in these fantastic objects. Goldsmiths in particular were

191

BELOW LEFT Seashell cup and cover made in late 16th-century Germany. Tropical shells were highly valued in 16th-century Europe, and goldsmiths particularly favoured the Chambered Nautilus (*Nautilus pompilius*) and the Great Green Turban (*Turbo marmoratus*) for the creation of exotic vessels. This polished Turban shell with a silver-gilt mount was fashioned in the Mannerist style at a time when goldsmiths were eager to

break free from Renaissance rules of symmetry and balance.

BELOW CENTRE Maiden goblet, *c*. 1603–9, by Meinrad Bauch the Elder of Nuremberg. Such goblets were mainly used at wedding feasts, where the groom drank from the vessel formed by the large bell-shaped skirt, and the bride was expected to empty the smaller cup suspended over the figure's head. Normally made of silver,

here the bride's cup is a pearlized Great Green Turban shell (*Turbo marmoratus*), in a decorative silver-gilt mount.

BELOW RIGHT Gilt-bronze inkwell, *c*. 1735, by Juste-Aurèle Meissonnier (1695–1750). This piece was produced at the pinnacle of Meissonnier's career, its beautiful detail demonstrating the quality of his craftsmanship.

kept busy turning out ornately fashioned drinking vessels, decorated with mythological and natural themes. A prized Nautilus or Turban shell (*Nautilus pompilius* or *Turbo marmoratus*) would be set among fantastic creatures and characters sculpted in gold or silver gilt. These shells are beautiful in their natural state, but in these sumptuous objects they usually had the outer layer burnt off by acid to expose the pearlized lining. Many such mounted shells were also exquisitely engraved (see pages 36–37).

As exotic shell species became coveted collectors' items in 17th-century Europe, so they came to be regarded as perfect subjects to be reproduced in a range of decorative arts. But it was in the Rococo style of the 18th century that shells enjoyed a decorative heyday unmatched before or since. Rococo work of all kinds was scattered with shells of every variety, their curves freely interpreted, at times asymmetrically twisted and furled beyond recognition amid the playful opulence that defined the style.

The master designer of Rococo was Juste-Aurèle Meissonnier. Born in Turin in 1695, he migrated from Italy early in his career to work for the royal Gobelins Manufactory in Paris. In 1724 he received his warrant as master goldsmith from King Louis XV, and his appointment as designer for the king's bedchamber and cabinet in 1726 confirmed his position as an influential figure in matters of style. There are relatively few surviving pieces that were actually made by him, and their rarity has made them immensely valuable. Instead, the majority of his work can be seen through the drawings of objects he designed to be made by other craftsmen. These boast an abundance of flowing shellwork, asymmetrical foliage and scrolls, and playful cupids. An extravagant and fearless pioneer, Meissonnier was described by one contemporary as 'an unruly genius'. He designed an astonishing variety of objects,

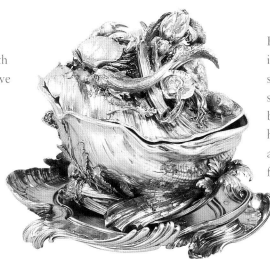

RIGHT A Louis XV silver tureen, by Juste-Aurèle Meissonnier, mid-18th century. Shaped as an elaborate bivalve shell, this gold and silver piece is typical of Meissonnier's style. Pioneer of the French Rococo movement, Meissonnier's designs challenged convention, replacing symmetrical forms with lighter, more irregular shapes.

BELOW A George II silver basket made in London, 1752. Formed as an open shell with a fluted interior, the basket sits on three dolphin feet. The handle bears the head and torso of a mermaid, her hair arranged in Grecian style, on a terminal of realistically chased shells, foliage and rockwork.

including candlesticks, tureens, centrepieces, inkwells, clocks, picture frames, and all kinds of furniture and panelling.

During the second quarter of the 18th century, the Rococo style spread from France to other countries, above all the German-speaking regions of Europe. Francophile German royalty and aristocrats draped themselves in the latest fashions from Paris, and employed French-trained architects and designers. However, Germany and to some extent Italy and Austria also produced their own indigenous form of Rococo, a style that particularly found expression in architecture and architectural ornament, and can be seen in many churches and palaces built at the time.

A characteristic of German Rococo style was its fondness for chinoiserie. This was partly thanks to the introduction in 1710 of the Chinese art of porcelain manufacture at Meissen, near Dresden. This was the very first ceramics factory in Europe to produce 'true' porcelain that matched the quality of imported wares from East Asia. Successfully blending technical mastery with artistic innovation, Meissen wares became very popular, and soon every major court in continental Europe boasted a porcelain factory of its own.

ABOVE A coffee or chocolate pot made by the Bow porcelain factory in England, c. 1760–65. The design of this soft-paste porcelain piece, painted in enamels, includes shell shapes on the body, base and lid.

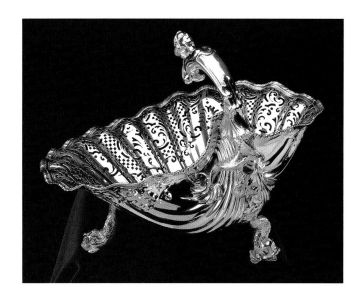

England, meantime, was developing its own ceramic industry, with potteries in Staffordshire producing lead-glazed earthenware and unglazed or salt-glazed stoneware. The abundance of local clays and coal gave rise to a concentration of factories that made Staffordshire one of the foremost pottery centres in Europe. Among the distinguished factories located there were Spode, Minton, New Hall and, most notably, Wedgwood. Thanks largely to the pioneering designs and techniques of Josiah Wedgwood (1730–95), who discarded traditional forms and began incorporating elements of higher Rococo and neoclassical art into his work, English ceramics became fashionable all over Europe and beyond. Wedgwood's famous 'Queen's Ware', a creamy yellow lead-glazed stoneware, was particularly popular. In 1767 Wedgwood wrote that 'The demand for this said cream colour…still increases. It is really amazing how rapidly the use of it has spread almost over the whole globe and how universally it is liked.'

Josiah Wedgwood was a competent scientist as well as a distinguished artistic and commercial innovator. With characteristic enthusiasm, he took up the study of shells. In 1778, he wrote to a friend: '…in turning my back on the pottery I have got my face over a shell drawer and find myself in imminent danger of becoming a connoisseur. You can scarcely conceive the progress I have made in a month or two in the deep and very elaborate science of shell-fancying.' Recognizing the artistic potential of what he called these 'beautiful mansions', Wedgwood soon introduced a range of ceramic shapes and patterns based on his own shell collection. Around 1790, he produced a masterpiece in conchological design, the Queen's Ware Nautilus dessert service. A wide range of dishes, plates and compotiers was modelled faithfully on the design of the Nautilus (*Nautilus* sp.) and Scallop (*Pecten* sp.) shells. After his death, ranges of shell designs were regularly introduced by the company that bore his name, and even today shell shapes are produced by Wedgwood, a testament to the enduring qualities of the shell as a decorative motif, and a tribute to the founder,

ABOVE Gold-cased rack-lever watch by Moncas, Liverpool, *c.* 1827. The cast case is decorated with many different species of shell.

LEFT Three shell-shaped lustreware plates by Wedgwood, England, *c.* 1820–30. Each plate is speckled with pink, purple, ochre and grey lustre, giving the effect of an iridescent sheen. Shell-shaped objects were regularly made by the company, reflecting the interest in conchology of its founder, Josiah Wedgwood.

RIGHT A rare salt-glazed stoneware teapot, made in
Staffordshire, England, *c.* 1745–50. On each side of this
square-shaped teapot is a Scallop shell within key-fret
borders. The spout takes the form of a dragon's head
and neck, while on top of the lid is a recumbent animal.

BELOW A group of Wedgwood Queen's Ware, England,
c. 1790. Known as the 'Nautilus Dessert Service', this
cream-coloured earthenware includes a centrepiece dish in
the shape of a Nautilus shell, a similar cream bowl with shell
finial on the lid, and a Scallop-shaped plate. The border
is hand-enamelled in brown and blue.

BELOW Shell dish from Wedgwood's Queen's Ware range, England, late 18th century. This cream-coloured earthenware was extremely popular. The shell-shaped dish shown here, enamelled with sprays of purple flowers, is virtually identical to that supplied in 1770 to Catherine the Great as part of the 'Husk' service. Some of the original pieces still survive at the Peterhof Palace in St Petersburg.

OPPOSITE LEFT A William IV silver soup ladle, London, 1831. The shell-shaped bowl has a handle that is elaborately cast and chased with textured foliage and scrolls, and the terminal bears a model of a caryatid.

whose love of shells was encapsulated in his own description of them as these 'wonderful works of nature'.

With shell collecting a hugely popular pastime in the 18th and first half of the 19th century, shell shapes and images were incorporated into all the decorative arts. Shells appeared in textile designs. In precious metals, shell designs were used in tableware, ornaments and watches. In ceramics and glass, English,

French and German factories produced a vast range of shell shapes in vases, candlesticks, tableware and figurines. The Scallop shape was the most popular, its concave symmetrical form making it an ideal model for use as a vessel or container, but other shell forms were also copied, usually stylized to an extent, but easily recognizable as a Nautilus, Argonaut, Cockle or Triton. One of the most prolific manufacturers of shell shapes was the Belleek Pottery in Northern Ireland, where a delightful range of shell vases and ornaments was produced from the mid-19th century until the end of the 20th century.

The shell was also a recurrent inspiration through the Art Nouveau movement of the later 19th century and its successor Art Deco in the

RIGHT A porcelain dessert stand or serving dish for fruit or sweetmeats, manufactured by the Irish pottery of Belleek, c. 1857–71. With a lustrous glaze and partly coloured pale yellow, this dish is in the form of three shells wrapped with reeds, and joined by a handle in the shape of twisted coral.

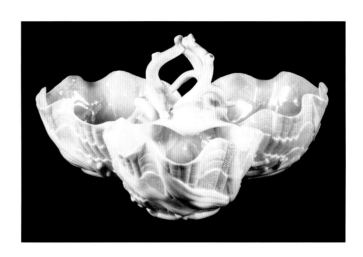

BOTTOM A silver shell cluster centrepiece by Mario Buccellati, Italy, mid-20th century. A typically brilliant piece of craftsmanship, this takes the form of a cluster of various shells, dominated by six Chambered Nautilus (*Nautilus pompilius*) which provide the vessel with its compartments.

RIGHT A silver centrepiece tureen carrying the mark of Georg Jensen, Copenhagen, mid-20th century. Designed by Henning Koppel, this streamlined tureen is in the form of a Clam shell. Its domed cover has slightly upturned edges.

early 20th century. Designers and artists of both movements drew on a decorative repertoire based largely on organic and natural forms which were often stylized and geometricized. The most famous glassmaker and jeweller of the period was René Lalique (1860–1945), whose main source of inspiration was nature; he had grown up in the French countryside, and his love of natural shapes and forms stayed with him all his life. He created an original and sensuous artform in his glassware, and his work has become synonymous with luxury. Lalique was captivated by shells, and they are beautifully represented in some of his pieces (see page 221).

The Danish designer Georg Jensen (1866–1935), a contemporary of Lalique, devoted his art to creating everyday objects that combined utility and beauty. A superb silversmith, Jensen made jewelry and tableware, and he used the Scallop shell as an embellishment in his famous flatware. Another master craftsman who chose to model complete shells in his work was Italian silversmith and jeweller Mario Buccellati, who started his own company in 1919 and remained its driving force until his death in 1965. The shells he created were crafted with extraordinary detail and finesse as exact replicas of the originals. His family still run the company, producing luxury jewelry and silverware, and today they continue the tradition of producing a range of exquisite shells, each one handcrafted in silver.

The 20th century produced echoes of former styles, and also innovative designs as new young artists arrived and made their mark on the world of the decorative arts. Shells continue to inspire designers and artists today just as they did in antiquity; artistic fashions come and go, but the aesthetic appeal of the shell endures.

BELOW
ROCK CRYSTAL BOWL, *c.* 1605–10, by Ottavio
Miseroni, Prague. Extraordinarily delicate work was
required to cut the hard surface of rock crystal and produce
this virtuoso masterpiece with its wafery thin, feather-light
walls. A shell served as the model for the bowl, which rests
on a base in the form of a playful, curving dolphin.

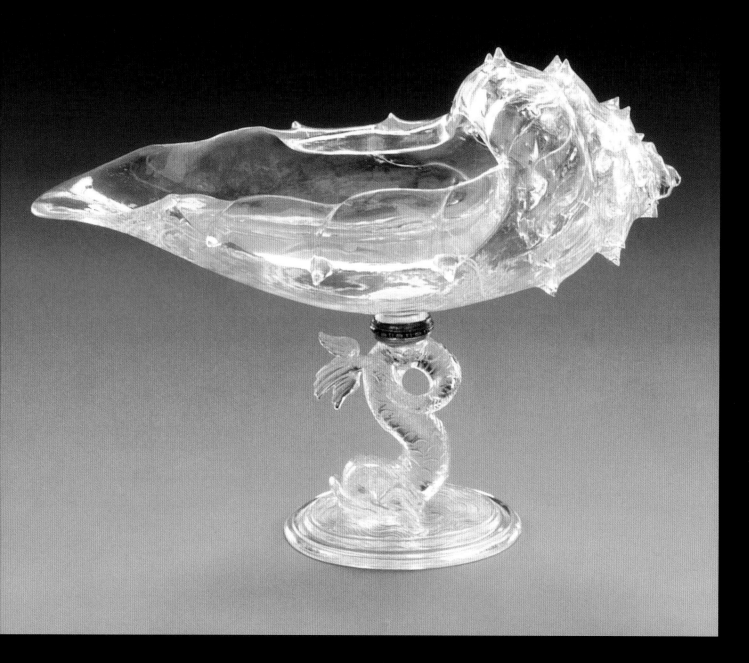

OPPOSITE LEFT
NAUTILUS CUPS in the form of a hen and a rooster,
c. 1593–1602, by Friedrich Hillebrand, Nuremberg.
Nautilus receptacles mounted in the shape of roosters
are recorded in Europe as far back as the 14th century,
originally serving as reliquaries, aquamanilia or salt cellars.

By the end of the 16th century Nautilus cups had become
fashionable objects in princely collections, whether or not
they were actually used as drinking vessels. This pair of
silver-gilt birds encase pearlized and engraved Chambered
Nautilus shells (*Nautilus pompilius*), whose low-relief
designs become visible when the hinged wings are lifted.

BELOW RIGHT
SMOKY QUARTZ CUP by Carl Fabergé (1846–1920),
St Petersburg, Russia. A single piece of smoky quartz, named
'smoky topaz' by Fabergé, is carved in the form of a shell,
and supported on a coiled snake with gold mounts decorated
with coloured enamels and set with eight old brilliant-cut
diamonds. It was made by Fabergé's Chief Workmaster
Michael Perchin.

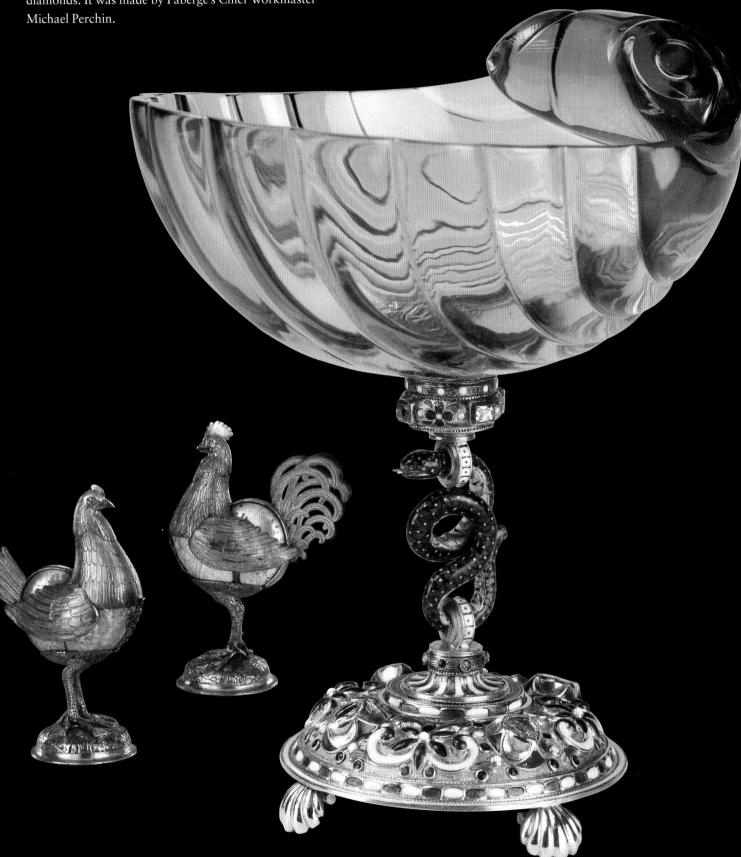

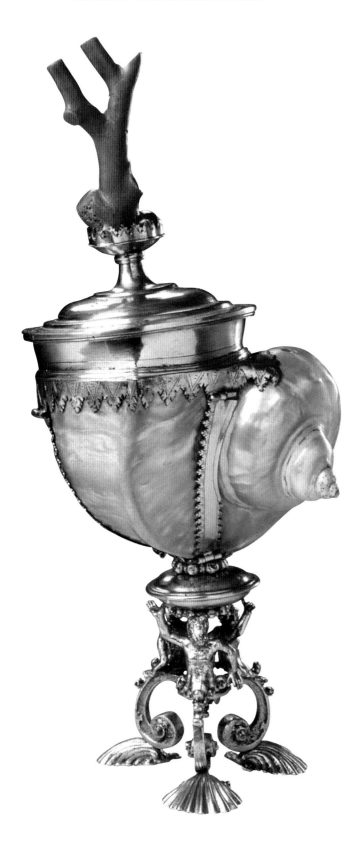

BELOW
THREE SHELL-SHAPED SALT CELLARS depicted in pen and ink drawings by Giulio Romano (*c.* 1499–1546), Italy. These drawings were made in the 1530s by the Renaissance artist, who first worked in the studio of Raphael and then for the Ducal court at Mantua, where his patrons were the Gonzaga family. His designs covered a wide range of forms, from tableware to fresco cycles and buildings, and his brilliance became widely known through engravings made after his work. These shell-shaped salt cellars were probably to be made in silver; the strong outlines provided a clear guide for the silversmith who would execute the piece.

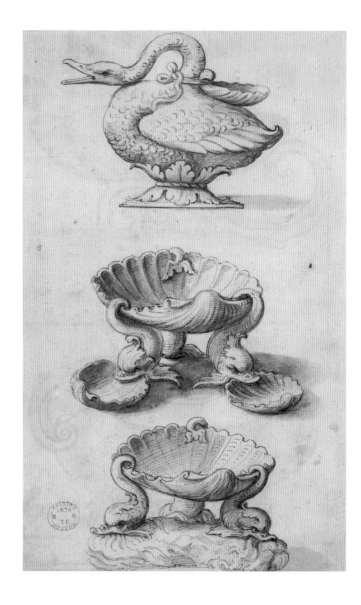

ABOVE
TURBAN SHELL CUP AND COVER, early 17th century, Germany. This cup is almost certainly the one that was given by George II of Hesse in 1626 as a wedding gift to the Elector of Saxony, father of his bride-to-be Sophia Eleonora. A pearlized Great Green Turban shell (*Turbo marmoratus*) is mounted in silver-gilt, and the cover is decorated with a branch of coral.

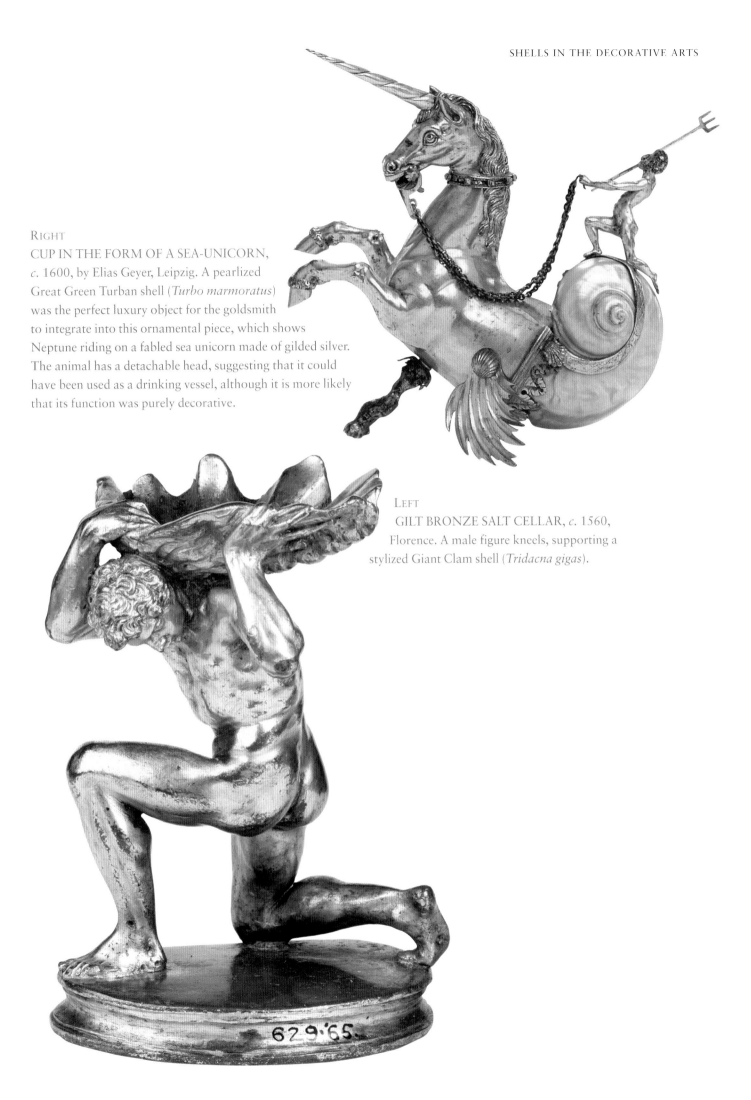

CUP IN THE FORM OF A SEA-UNICORN,
c. 1600, by Elias Geyer, Leipzig. A pearlized
Great Green Turban shell (*Turbo marmoratus*)
was the perfect luxury object for the goldsmith
to integrate into this ornamental piece, which shows
Neptune riding on a fabled sea unicorn made of gilded silver.
The animal has a detachable head, suggesting that it could
have been used as a drinking vessel, although it is more likely
that its function was purely decorative.

LEFT
GILT BRONZE SALT CELLAR, *c.* 1560,
Florence. A male figure kneels, supporting a
stylized Giant Clam shell (*Tridacna gigas*).

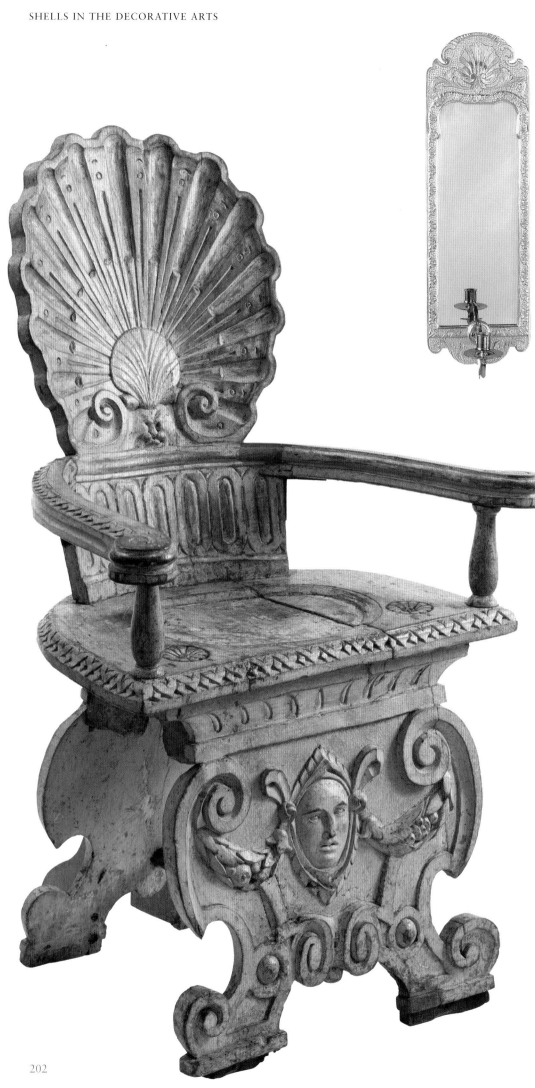

ABOVE
PAIR OF GIRANDOLES, 20th
century, England, based on original
designs from the period of George I
(1660–1727). Girandoles are
ornamental branched candlesticks,
commonly in pairs. They originally
came into use in the 17th century.
These are made of gilt-gesso, each
one backed by a mirror in a shaped
and bevelled frame surmounted by
a Scallop shell.

LEFT
CARVED OAK ARMCHAIR,
formerly gilt, from the second quarter
of the 17th century, England. The
Scallop-shaped back of this chair
is based on the *sgabello*, an ornate
form of hall chair widely used in
Venice from about 1570. The arms,
balusters and front slat are made of
beech, and the back and seat of oak.

RIGHT BELOW
SNUFFBOX, 1740–50, European. Exquisitely carved and chased, this tortoiseshell snuffbox is shaped like a shell, creating a svelte and elegant trinket.

BELOW
BUREAU, *c.* 1765, attributed to John Townsend (1732–1809), Newport, Rhode Island, United States. One of the iconic signatures of this famous 18th-century cabinetmaker was the 'block and shell' form, as seen on this mahogany bureau, with three front sections embellished with carved Scallop shells.

RIGHT
SNUFFBOX, *c.* 1720, origin unknown. This oval tortoiseshell box is decorated with fine gold piqué patterning in the shape of a Scallop shell, with smaller shells and dolphins around the outside edge. The rim is silver-gilt.

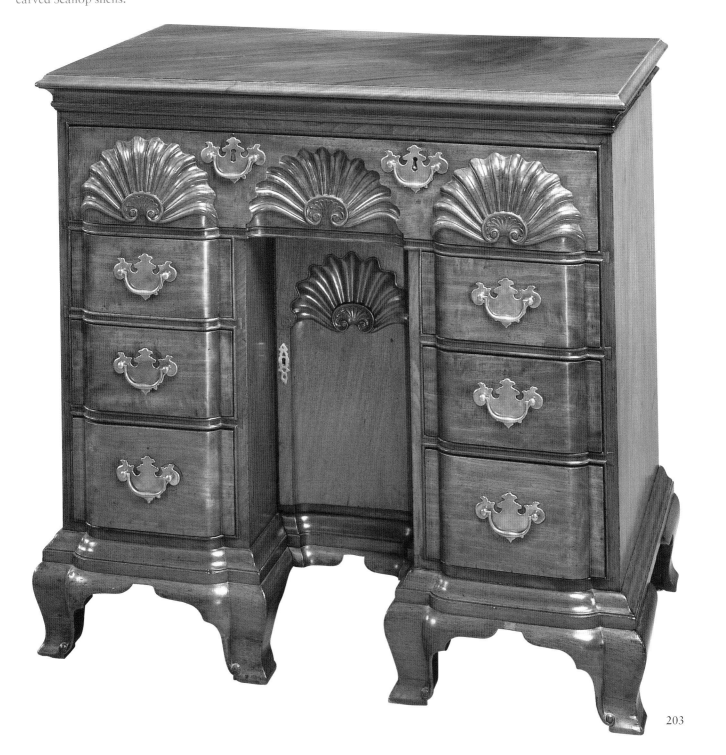

ENGLISH DELFTWARE BASIN, dated 1683. Shaped as a Scallop shell, this dish has elongated ears or flanges decorated with a merman and a mermaid holding up mirrors. Originating in the Dutch city of Delft, this type of blue and white painted earthenware was first inspired by Chinese imported porcelain brought to Europe in the 16th century by traders working for the Dutch East India Company. Local Dutch potters refined their early imitations, and Delftware became very popular in the 18th and 19th centuries. English Delftware, originally called galleyware, was renamed in the 18th century because of the popularity of Dutch products.

RIGHT
CHINESE ARCHITECTURAL
ORNAMENT from Yuanming Yuan,
the complex of imperial gardens built
under the Qing dynasty of the 18th
century. A harmonious ceramic shape,
this has leaf and shell forms and curls,
with a turquoise glaze.

BELOW
'CANTON ENAMEL' EWER AND
BASIN, c. 1740–45. The ewer is
modelled as a Nautilus shell, and the
basin has the shape of a deep Scallop
shell. Both are decorated with blue,
green and pink panels filled with
scrolling, flowering vine.

LEFT
PORCELAIN CENTREPIECE OR
SWEETMEAT STAND, *c.* 1765–70,
made by Worcester Porcelain, England.
Ten painted shell-shaped dishes are
flanked by clusters of small shells. This
design was almost certainly inspired by
the fashion for using shells in garden
grottoes, where desserts would have
been taken in the summer months.

OPPOSITE
PORCELAIN SWEETMEAT DISH,
c. 1760–80, made by Derby, England.
Fine porcelain Scallop shells are
supported by an ornate base decorated
with shells, coral and greenery. The
whole is topped by a kingfisher.

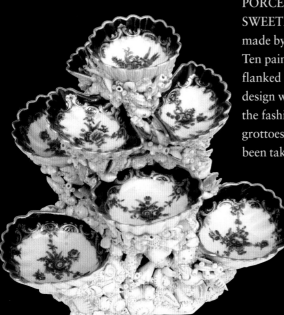

BELOW
CARD TRAY WITH MODELLED
SHELL BORDER framing an early
design of the Houses of Parliament in
London. Made by the Chamberlain
factory of Worcester Porcelain,
England, *c.* 1845–48.

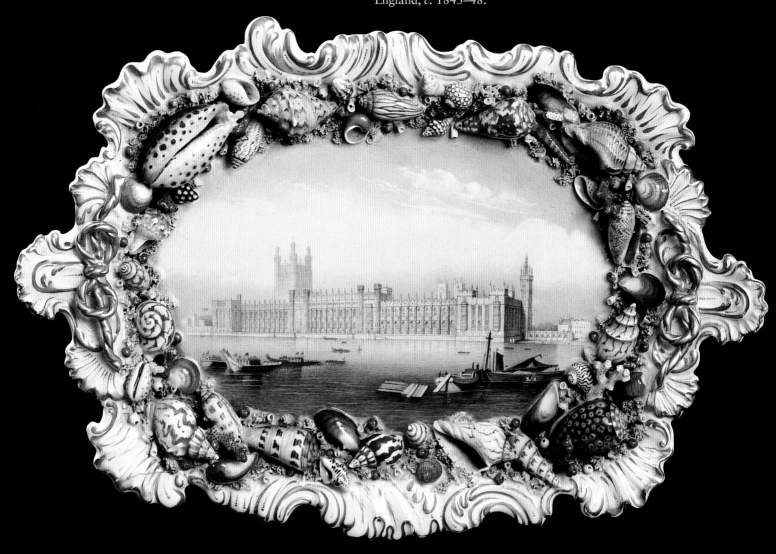

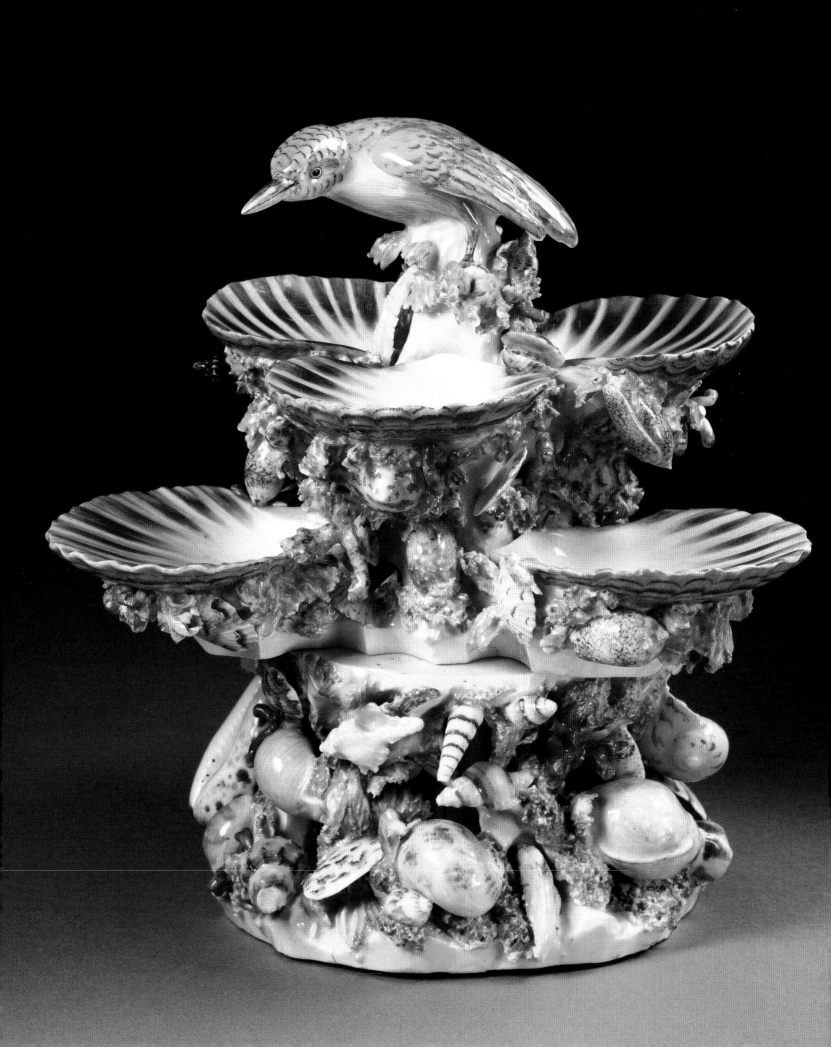

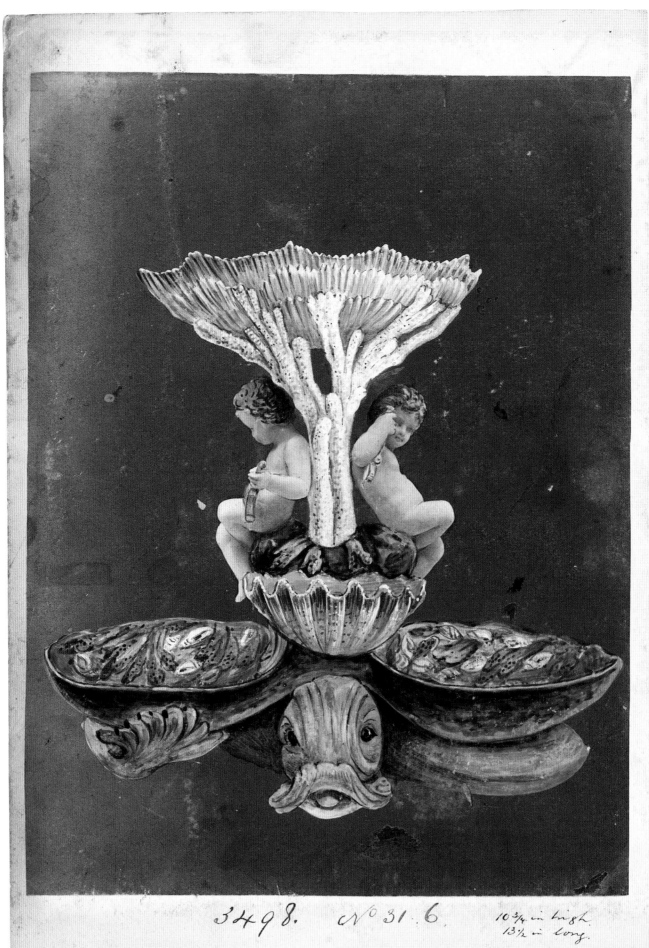

3498. N° 31.6. 10¾ in high.
13½ in long.

OPPOSITE
DESIGN FOR A COMPORT OR CENTREPIECE, *c.* 1875, by the British ceramicist George Jones. Part of the George Jones Majolica records, this centrepiece is elaborately moulded with a marine theme. A grotesque sea turtle supports three shells, and two sea-nymph children lean against a column of seaweed or coral that holds up another stylized shell.

BELOW
DESIGN FOR A HIGH-HANDLED EWER, from a 19th-century William Adams pattern book, England. Possibly for manufacture in earthenware, this ewer has a turquoise background and print and enamel decoration of coral, seaweed and shells. The Adams family had potteries in Staffordshire as early as 1650, and still operate today as part of the Wedgwood Group.

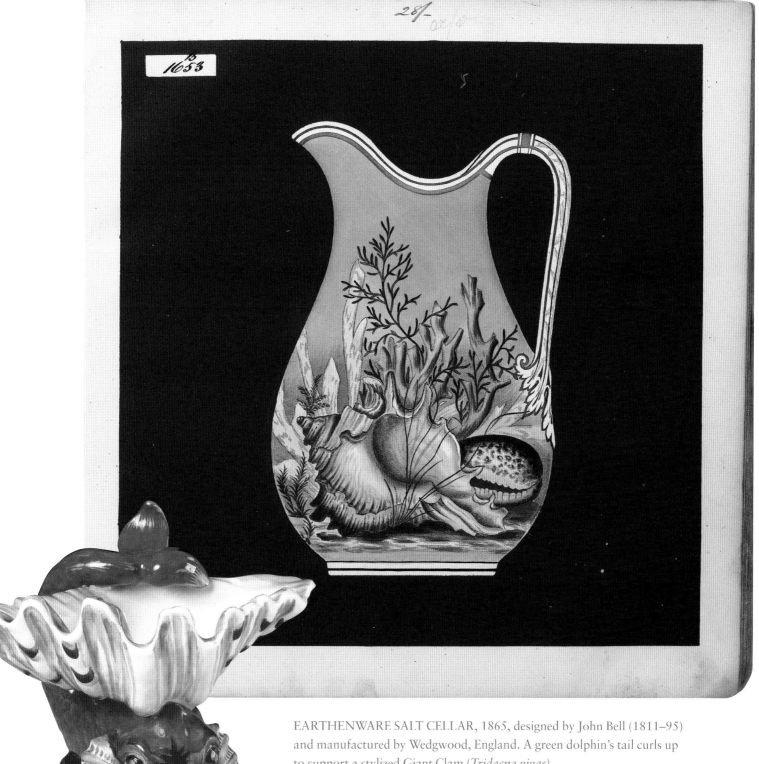

EARTHENWARE SALT CELLAR, 1865, designed by John Bell (1811–95) and manufactured by Wedgwood, England. A green dolphin's tail curls up to support a stylized Giant Clam (*Tridacna gigas*).

BELOW RIGHT
WOODEN NETSUKE from the Edo period, Japan, 19th century, signed Hideharu. A Netsuke is a carved toggle serving as a fastening device that secures a cord attached to a box or pouch worn on Japanese garments. Netsukes were most popular during the Edo period, 1603–1867, but the art lives on today, some modern works commanding high prices. In this example, a long-haired *kappa* or water-sprite is struggling to free his foot from a stylized bivalve shell. Netsukes of this period regularly featured shells, which were popular subjects in Japanese carvings.

OPPOSITE
BACK OF A KIMONO, Ayatal tribe, northern Taiwan. This is an astonishing example of shell beadwork. Each tiny shell disc bead, no larger than 0.25 cm ($^1/_{10}$ in.), has first been cut from a Giant Clam (*Tridacna gigas*), then ground down, hollowed and shaped. There are many thousands strung and sewn onto the garment, which represents a staggering amount of painstaking work.

LEFT
IVORY CARVING in the form of a slightly open clam shell, 19th century, Japan. Inside are revealed a man fishing from a boat, near other figures beneath pine trees. The whole piece is no more than 8.3 cm (3¼ in.) wide.

RIGHT
IVORY NETSUKE, 18th–19th century, Japan. Only 4.7 cm (1⅞ in.) long, this carving shows a tiny hermit crab emerging from a small shell, on top of a larger stylized Scallop shell.

LEFT
IVORY NETSUKE, 19th–20th century, Japan. A puppy has clambered onto a large shell, the species resembling a spotted Cowrie (*Cypraea* sp.), though both shell and puppy are considerably out of scale.

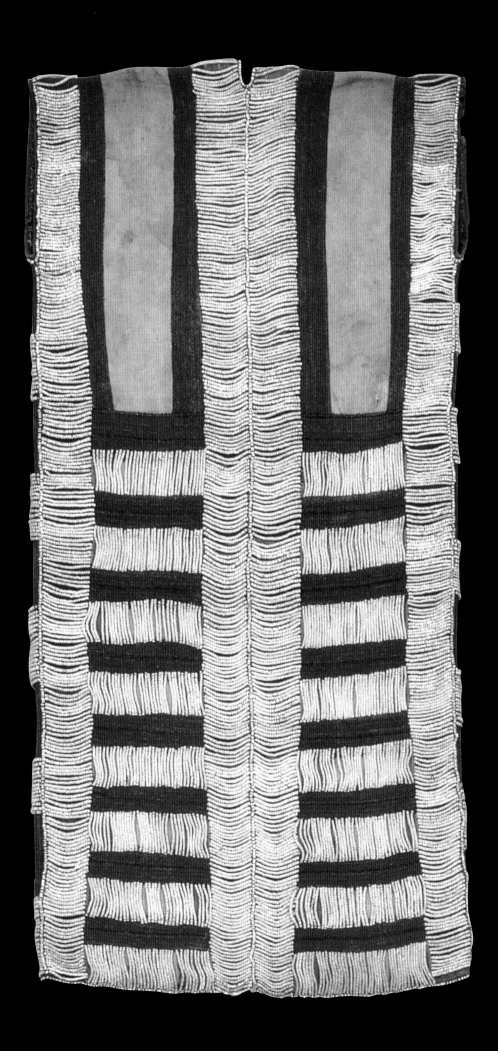

LEFT
PAIR OF GROTTO SIDE
CHAIRS, late 19th to early
20th century, Venice.
Furniture makers in
Venice have established
a tradition of designing
grotto furniture based on
18th-century Rococo styles
and the natural forms and
materials used in grottoes,
notably shells. This pair of
side chairs have Mussel-
shaped backs with dolphins,
Scallop-shaped seats,
and splayed coral and
shell legs.

BELOW
SHELL-ENCRUSTED
DROP-FRONT DESK,
c. 1920, France. Elaborately
ornamented with over a
dozen species of varnished
shells, both European and
tropical, this extravagant
piece was found in 1995
by an American furniture
specialist in an antique
shop in southern France.
At auction less than a year later,
it raised three times the sum he
had paid for it.

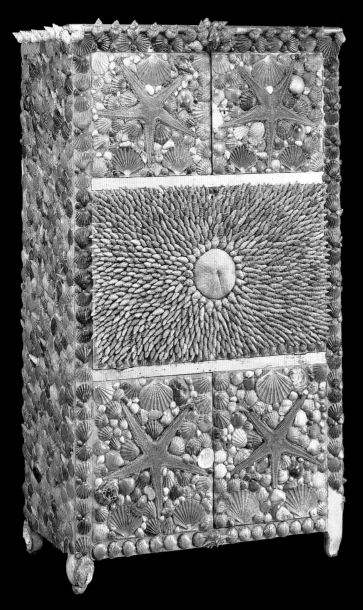

BELOW
CARVED SILVERED GILT GROTTO TABLE, 20th century,
probably Venice. This elegant table has a Scallop-shaped top
on three dolphin supports, joined by stretchers with Scallop
shells in the centre.

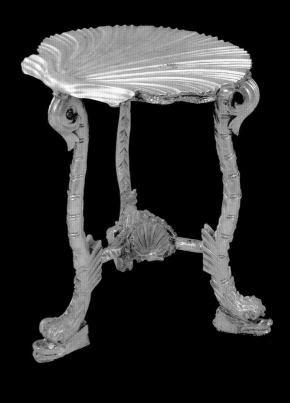

RIGHT

GILTWOOD SIDE TABLE, 19th century, Ireland. The 'picturesque' frame of this ornate table is reminiscent of Louis XIV furniture, with elaborate carvings throughout. On the apron there is a Bacchic lion-mask displayed in a Scallop shell cartouche, with further shell shapes either side. Finally, a Scallop shell in a sunburst cartouche rests in the centre of the scrolled stretchers.

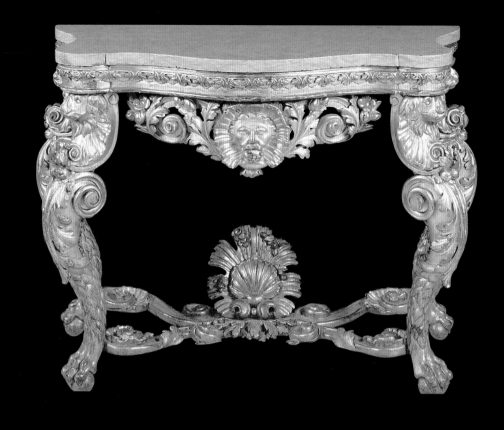

BELOW

WILLIAM IV MAHOGANY SIDE CHAIRS, *c.* 1835, England. The Scallop motif was popular in English Regency furniture of the early 19th century. The backs of these chairs were carved with large Scallop designs decorated with 'C-scrolls'.

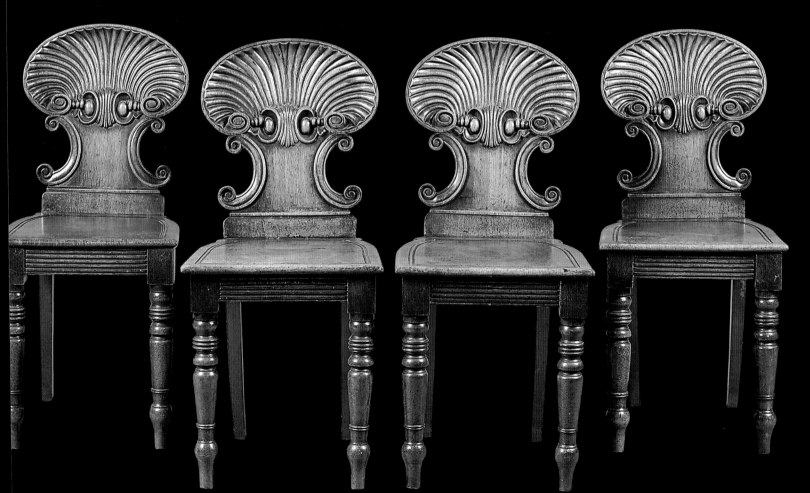

TRITON SALT CELLAR, 1810–11, by
Paul Storr (1771–1844), for Rundell,
Bridge and Rundell, London. Made
for King George VI when he was
Prince Regent, this is one of 24 similar
salt cellars. It shows a triton bearing
away a stylized Paper Nautilus shell
(*Argonauta* sp.). The design was almost
certainly inspired by the Rococo-style
Marine Service supplied to Frederick,
Prince of Wales in the 1740s.

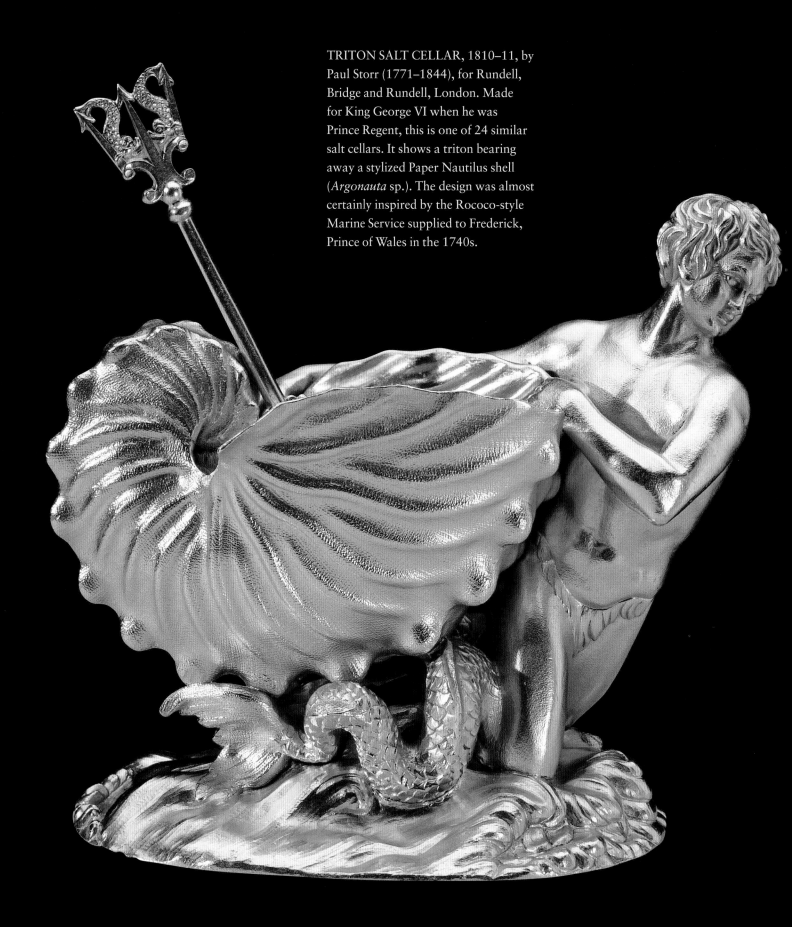

SILVER GILT TUREEN, 1826–27, designed by John Flaxman (1755–1826) and made by John Bridge (1755–1834) for Rundell, Bridge and Rundell, London. This impressive tureen was one of four supplied for King George IV's Grand Service, all designed to match the Marine Service made for Frederick, Prince of Wales in the 1740s. Described as 'four richly chased gilt shell pattern Soup Tureens supported by Sea Horses with Triton handle', the bowls themselves were modelled on Giant Clam shells (*Tridacna gigas*). Of grand scale and extremely heavy, they reflect the increasingly opulent tastes of George IV.

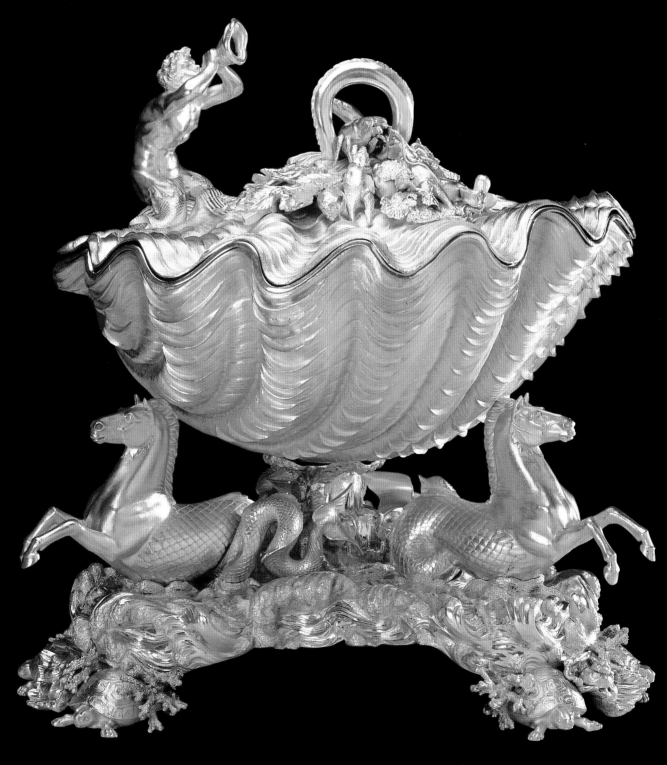

LEFT
SILVER DISH, early 20th century, Germany. Shaped as
a shell with fluted sides, this bears the mark of Carl
Rusch of Hannover.

OPPOSITE
TEA KETTLE WITH STAND AND BURNER,
probably 1730–32, made in the workshop of
Charles Kandler in London. Shells are an
essential decoration on this splendid example
of Rococo design in cast, chased and engraved
silver with a basketware handle.

BELOW
SILVER CUP WITH HANDLES, 17th century, Portugal.
Each of the three sections of this wide cup features shell
motifs, the lower two including patterns of leaves.

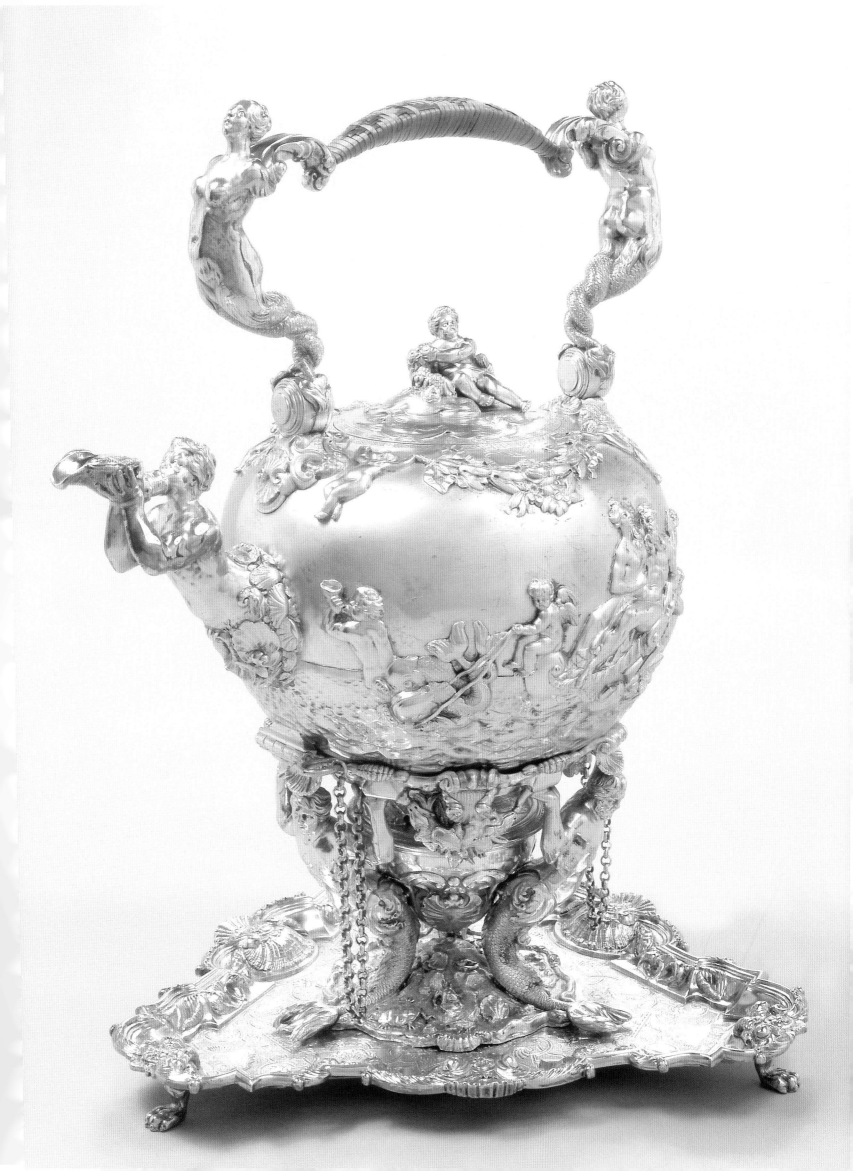

BELOW
PEWTER AND ABALONE CLOCK,
c. 1905, part of the 'Tudric' range of
Celtic-inspired Art Nouveau pewter
designed by Archibald Knox for
Liberty and Co., London. Made
of high quality pewter, the body is
inset with strips of Abalone shell
(*Haliotis* sp.).

OPPOSITE LEFT ABOVE
SILVERED-METAL AND FROSTED
GLASS CHANDELIER with six
moulded shell-shaped sections. It was
made by Sabino, the French glass
manufacturer famous for its Art
Nouveau designs.

BELOW
ART NOUVEAU BELT BUCKLE in
silver and copper with a cabochon of
Abalone shell (*Haliotis* sp.). Designed
by Oliver Baker for Liberty and Co.,
London, *c.* 1905.

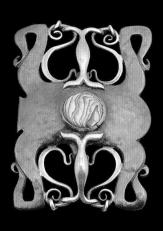

OPPOSITE LEFT
ART DECO VASE with enamel
decoration in spiral shell-shaped
forms, 1925, by Camille Fauré
(1874–1955), Limoges, France.

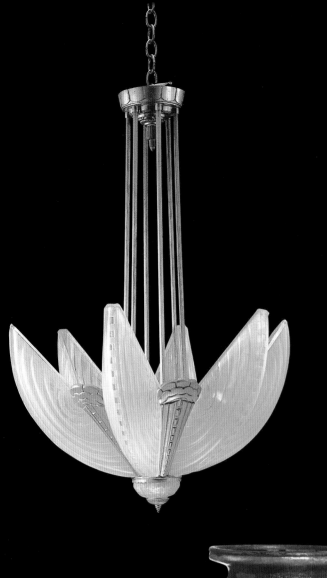

RIGHT
LA PERLA, an Art Nouveau alabaster table light, *c.* 1900, in the form of a stylized Conch shell, reminiscent of a *Strombus* species. The shell is draped with a maiden on a rockwork base. The lamp is 66 cm (26 in.) wide.

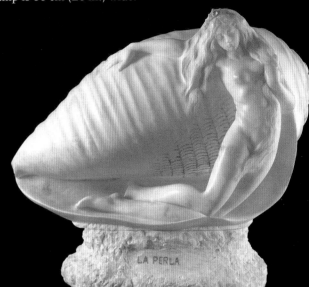

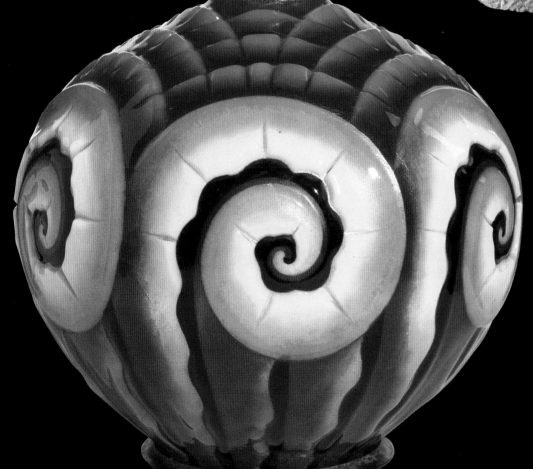

BELOW
THE PEARL, by Fritz Christ, *c.* 1900. This Art Deco piece in silvered bronze features a kneeling figure of a young woman with flowing hair. She is surrounded by two polished Black-lipped Pearl Oysters (*Pinctada margaritifera*).

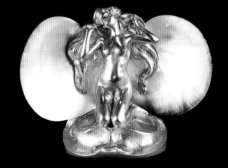

RIGHT
IRIDESCENT GLASS VASE, *c.* 1900, by Loetz. The stylized
shell rests on a base, and seaweed tendrils climb up its sides.

BELOW LEFT
ART NOUVEAU SHELL LAMP, early 20th century.
A pearlized Great Green Turban shell (*Turbo marmoratus*)
forms the shade to this sinuous lamp in silvered pewter.

BELOW RIGHT
SHELL CUP SUPPORTED BY FEMALE 'BLACKAMOOR',
c. 1709, by Johann Melchior Dinglinger (1664–1731),
Dresden. The figure is carved from a single piece of rhinoceros
horn. She holds up a gold shell cup decorated with enamel
and diamonds, surmounted by a green enamelled dragon.

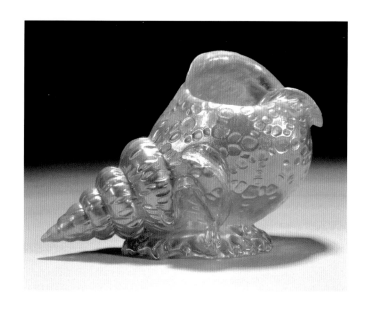

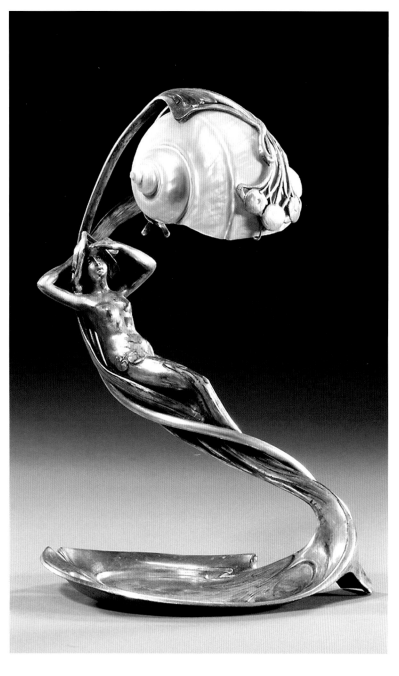

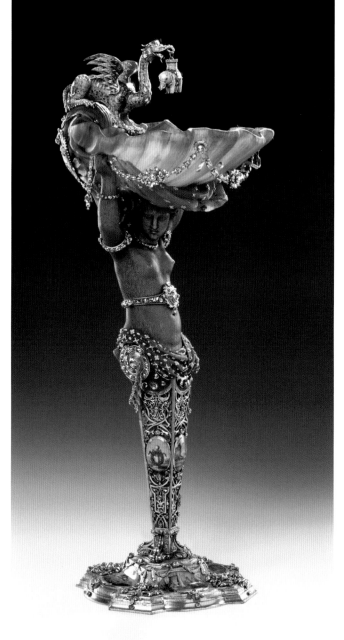

LEFT
'SNAIL' VASE, by René Lalique
(1860–1945). After the First World
War, Lalique expanded his already
successful glass business and built a
factory in Alsace. There he began to
mass-produce glass tableware and
goblets, including this discus-shaped,
moulded amber glass vase in the form
of a spiralling shell.

BELOW
MAJOLICA CENTREPIECE, by
Minton, England, c. 1877. The Scallop
shell dish is held by seaweed swags and
carried on the backs of two mermaids.
Their fishy tails entwined with
bladderwort curl about the shell to
form the base.

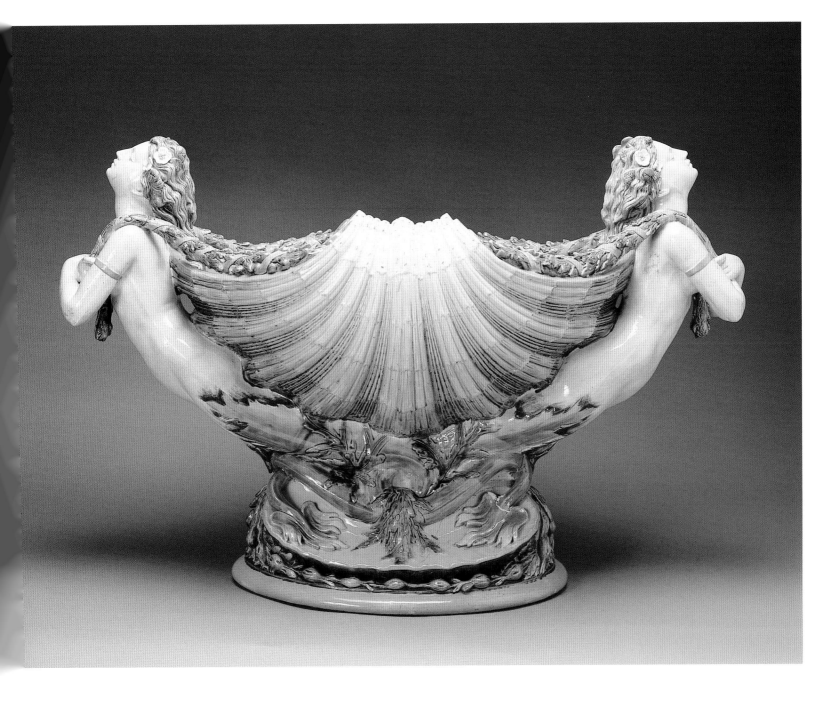

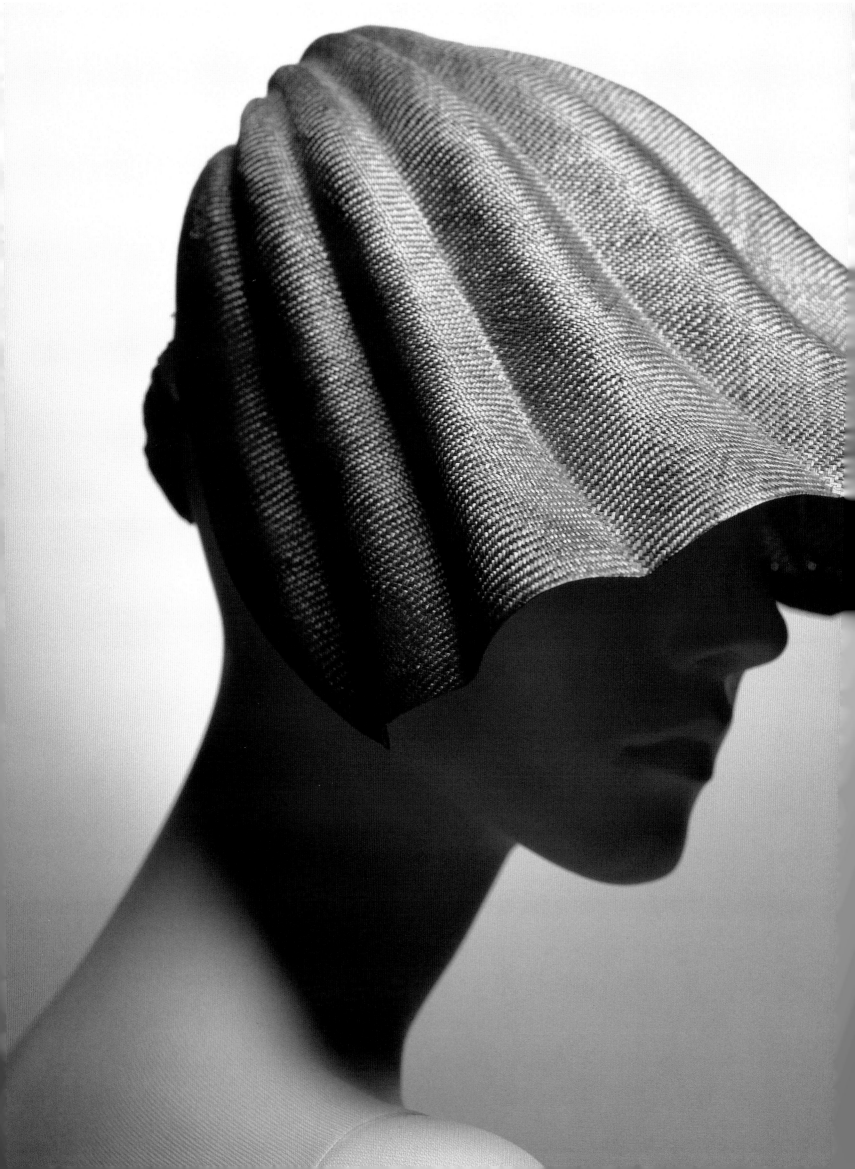

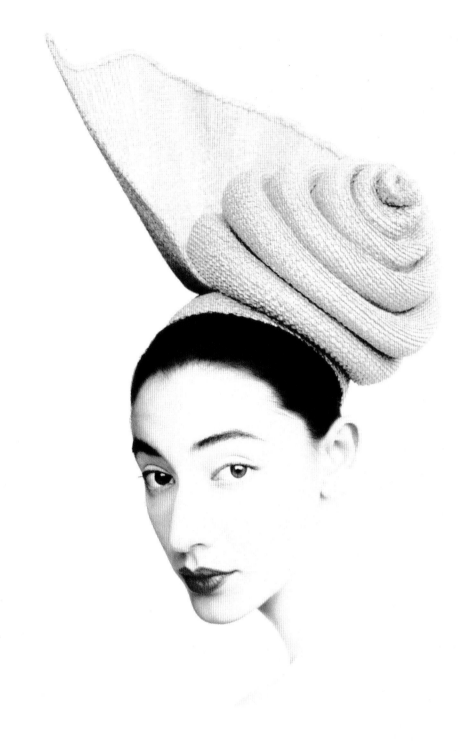

LEFT
SHELL HAT, by Krizia, 1980. Many shells have shapes perfectly suited to the couturier for hat designs. Romantic and feminine, they have provided inspiration for some of the world's greatest fashion designers, including this example by Mariuccia Mandelli of Krizia.

ABOVE
STRAW HAT, by Christian Lacroix, 1988. Here, the designer chose a natural object and used a natural material to make an extravagant statement in this surreal shell-shaped straw hat.

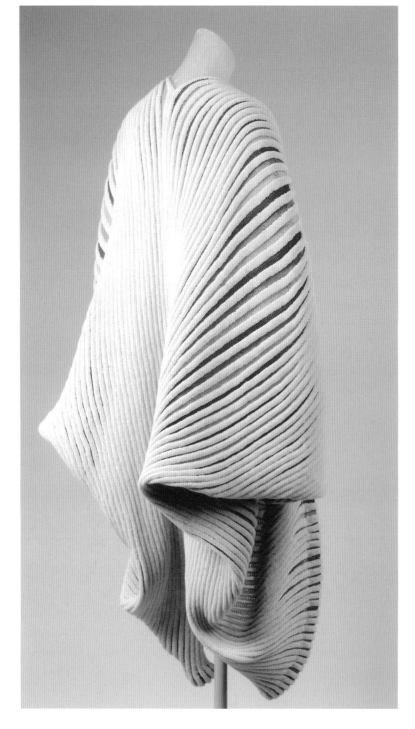

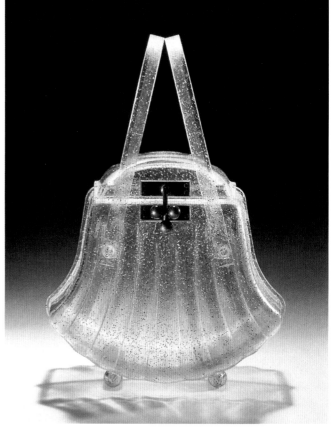

ABOVE
'THE BEACHCOMBER', plastic handbag by Ranhill, *c.* 1954, United States. The plastic handbag, sometimes called the Lucite bag, was all the rage in the 1950s, particularly in North America. Hundreds of designs were created, including this translucent bag in the shape of a shell.

LEFT
'SEASHELL' COAT, 1985, by Issey Miyake (b. 1938). This sculptural garment, sometimes referred to as 'Shell-knit', is one of the designer's most celebrated and iconic creations.

OPPOSITE ABOVE LEFT
'NEPTUNE'S FOLLY', 1996, a furnishing fabric by the Jane Churchill design studio for the London interior design company Colefax and Fowler.

OPPOSITE ABOVE RIGHT
'BARMOUTH', *c.* 1970, by George Oakes, for Colefax and Fowler. Oakes was head designer for the company when he produced this elegant furnishing fabric depicting 'trophies of seashells and corals, entwined with pearls'.

BELOW
SHELL FORM, 2005, by Peter Fraser Beard (b. 1951), an artist-ceramicist whose work often takes inspiration from shells and ammonites. Wax was used as a resist between multiple layers of glaze to create the patterns on this piece. The form evolved by drawing spiral shapes on paper which were then refined down to create a simple but powerful object that is simultaneously modern and connected to our history and evolution.

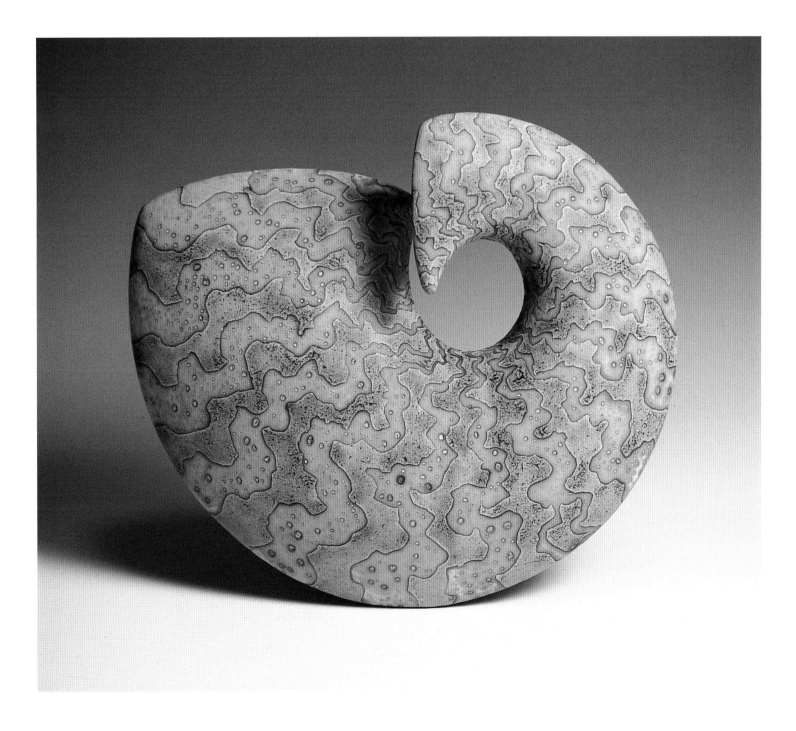

FIG.38.

TAB.IV.

FIG.39.

FIG.40.

FIG. 41.

FIG.42.

FIG.42.

FIG.38.

FIG.43.

FIG.44.

FIG.45.

FIG.45.

FIG.46.

FIG.47.

FIG.47.

FIG.48.

THE CLASSIFICATION AND NAMING OF SHELLS

Light as a flake of foam upon the wind
Keel upward from the deep emerged a shell,
Shaped like the moon ere half her horn is fill'd;
Fraught with young life, it righted as it rose,
And moved at will along the yielding water.

James Montgomery, *The Pelican Island*, 1828

Shells are composed almost entirely of calcium carbonate, making them strong and durable. Their long-lasting qualities have enabled scientists to chart the history of molluscs on earth via the fossil record. Shells tell us where and when molluscs first appeared, and we know that this was hundreds of millions of years before humans came on the scene.

Molluscs with shells were among the very first primitive animal groups to appear on earth. They were already established in the Cambrian period of the Paleozoic Era, some 550 million years ago. In that early phase of their evolution, they were all marine creatures. It would be another 100 million years, in the Ordovician period, before some molluscs adapted to live in freshwater, and others ventured onto land, as the shape of the world's continents and seas changed.

By 400 million years ago, all classes of shells were represented. The vast majority of the species alive at that time have long been extinct, either through natural catastrophe or because individual species failed to adapt to the hazards of life on earth. But the great family of molluscs was clearly good at surviving, and today, the planet is populated with a richer and more varied assembly of species than at any previous period in history. There are now approximately 100,000 species of molluscs, living in the sea, on land, and in freshwater, and scientists are discovering new ones every year. This means that new types of shells are being found, to add to the enormous number already known.

CLASSIFICATION

The scientific classification of molluscs is complex, mainly because this division within the animal kingdom is so large and disparate. Molluscs are divided into seven classes, described briefly as follows:

1. GASTROPODA The word 'Gastropoda' comes from two Greek words which literally mean 'stomach-foot'. This describes the fact that the molluscs' bodies, including the stomach, sit on top of a large foot-like

OPPOSITE Plate 4 from Franz Michael Regenfuss's *Choix de Coquillages et de Crustacés*, 1758, depicting a variety of tropical shells.

structure. The largest and most successful class of molluscs, gastropods include Limpets, Whelks, Cowries, Conches, Abalones, etc. Sometimes called 'univalves', these molluscs normally have shells in one piece, usually spirally coiled. They inhabit the sea at all depths, they live in freshwater, and also on land, from sea level to above the snow line. They are the only class of molluscs to have adapted to life on land. It is estimated that there are over 40,000 living species of marine gastropods, and more than 25,000 freshwater and land species.

The gastropods are divided into three large sub-classes: Prosobranchia, Opisthobranchia, and Pulmonata. Prosobranchs include the majority of shells in this book. A principal feature of this sub-class is that on the 'foot' of most species there is a calcareous *operculum*, or 'trap-door', which closes the aperture of the shell when the animal has withdrawn inside, or is used to help get a foothold during locomotion. Opisthobranchs contain many forms without shells, but when one is present, it is thin and fragile. Pulmonates are air-breathing land snails; only two of these feature in this book.

2. BIVALVIA The second largest class, bivalves include Clams, Scallops, Mussels, Oysters, Razor shells, etc. They are laterally compressed animals protected by a two-piece hinged shell which can open and close tightly by means of special muscles. Bivalves live in the sea, and have adapted successfully to life in freshwater, but not on land. Estimates put the total number of species at 15,000. There are many bivalves in this book.

3. SCAPHOPODA Molluscs in this class are known as Tusk shells, or Tooth shells, and there are about 350 living species, all marine dwellers. The name 'Tusk shell' derives from their resemblance to a miniature elephant's tusk. These shells have been used widely by humankind, both decoratively and as a form of currency. They can be seen in several chapters of this book.

4. CEPHALOPODA It is surprising to many people that the octopus and squid, which have no outer shells, should be members of the molluscan clan. But they are in fact members of the Cephalopoda class, a highly developed class of ancient origin living exclusively in the sea. It may include as many as 1,000 different species alive today. The shell-covered Chambered Nautilus (*Nautilus pompilius*) is the only cephalopod to feature in this book.

5. MONOPLACOPHORA This ancient class describes the approximately ten species known as 'gastroverms'. These are Limpet-like molluscs with

internal segmentation and a thin, almost circular, cap-like shell. They all live in deep water, and are rarely seen in shell collections. No examples from this class are included in this book.

6. POLYPLACOPHORA Chitons, or 'coat-of-mail shells', these molluscs are elongated in shape, with an articulated, eight-piece shell. (They resemble, but of course are not related to, large, legless woodlice.) All Chitons are marine dwellers, and about 650 species are known. They do not feature in this book.

7. APLACOPHORA Known also as 'solenogasters', these are worm-like molluscs, mostly very small, covered with tiny calcareous spines, but without a shell. Exclusively marine, about 250 species have been discovered. They do not appear in this book.

A Common Blue Mussel (*Mytilus edulis*), an abundant species living in all the subarctic seas of the world.

Classification of molluscs does not end here, as the seven classes described are further subdivided into subclasses, orders, superfamilies, families, subfamilies, genera and species, in that descending order of importance. To show the relationship of these categories, the classification of the Common Blue Mussel (*Mytilus edulis*) is set out below:

PHYLUM	Mollusca
CLASS	Bivalva
SUBCLASS	Pteriomorpha
ORDER	Mytiloida
SUPERFAMILY	Mytilacea
FAMILY	Mytilidae
SUBFAMILY	Mytilinae
GENUS	*Mytilus* *
SPECIES	*edulis* *

*See under Nomenclature, below

NOMENCLATURE

Ever since the birth of language, animals have been given common, or vernacular, names. This is as true of molluscs and their shells as of any other creature. Historically, names were given to shells nationally, and even locally, but these were meaningless in another place or in a different language. By the time that shell collecting grew into an international pastime, and conchology, the scientific study of shells, was becoming established, classification and nomenclature were in a

Carolus Linnaeus (1707–78), the famous Swedish botanist who laid the foundations of the scheme for naming all plants and animals that is still used by scientists today. Portrait by Per Krafft the Elder, 1774.

state of confusion. There was no universal name by which shells from the same species of mollusc could be referred to without risk of misunderstanding.

It was not until the 18th century that a logical system of zoological nomenclature was proposed. In 1758, the great Swedish scientist Carolus Linnaeus wrote the first volume of the tenth edition of a monumental work called *Systema Naturae*, in which he set out to describe and name every animal known to him, including the molluscs. He developed the principle of using double names in a simple and ingenious system of nomenclature known as the binominal system. He chose Latin as the language most suitable for this system because it was a dead language, precise and simple, and structured with well-defined rules. It was a perfect choice for scientific nomenclature, and would be acceptable in parts of the world where Latin had never been used as a living language. Linnaeus's system firstly gave an animal the name of the genus, and secondly the name of the species. In this way a generic name could not be used for more than one group of animals, and the same specific name could not be used for more than one species within a genus. This meant that there could only ever be one species called *Mytilus edulis* (see the classification table on page 229).

After the Latin name of the shell, it is common practice in some books, and in all scientific works, to name the 'author' of the shell. This is the person who first published an authenticated description of it and gave it a name. It is in effect a record of the authority by which the shell is named. So in scientific literature, the Common Blue Mussel is listed as *Mytilus edulis* (Linnaeus, 1758).

It took some time for Linnaeus's binominal system to be widely accepted; old and familiar names die hard, and at first there were critics of this new-fangled form of nomenclature. But as it came to be more widely used, scientists found it invaluable for recording and exchanging information, and it was gradually adopted by students of all animal life. Since Linnaeus's day it has been somewhat modified and rearranged, but his method of naming shells and other animals continues to be used across the world today.

CONCHOLOGY:
THE COLLECTION AND STUDY OF SHELLS

I have always understood that the study of shells
brings contentment to those who engage in it.

Bertrand Russell, *The Conquest of Happiness*, 1930

In the spring of the year 40 AD, Emperor Caligula marched his legions
to the beaches of Gaul, and lined them up in battle formation facing the
English Channel. He had his siege engines moved into position, and it
looked very much as if he was preparing for an invasion of Britain. 'No
one had the least notion what was in his mind,' wrote his Roman
biographer Suetonius, 'when he suddenly gave the order, "Gather sea
shells!" He made his troops fill their helmets and tunic-laps, and
promised every soldier who did so a bounty of four gold pieces.'
Caligula referred to the shells as 'plunder from the sea, due to the
Capitol and the Palace', and sent them off to Rome as the spoils of war.
He left the more risky task of invading Britain to his successor Claudius.

ABOVE, BELOW AND FOLLOWING PAGES
Illustrations of individual shells from
Franz Michael Regenfuss's *Choix de
Coquillages et de Crustacés*, 1758.

Mad Caligula may have been the most eccentric of the shell collectors
of antiquity, but he was by no means the first. People had been collecting
shells since prehistoric times, for food, for essential tool-making, and for
ornamentation. But as far as we know, nobody collected shells for the
sake of knowledge until the 4th century BC, when the Greek philosopher
and natural historian Aristotle compiled his *Natural History of Animals*.
This was an attempt at an orderly approach to the physical sciences,
which included a detailed account of molluscs and their shells. Four
centuries later, when the hub of the civilized world had shifted to Rome,
the writer Pliny the Elder added further observations to Aristotle's
treatise in his own *Natural History*. Together these two works not only
laid the foundations of conchology – the scientific study of shells – but
provided the answers to most zoological questions for over 1,500 years.

The Aristotelian view of the world remained unchallenged through
the scientific slump and religious heat of the medieval era, during which
conchology, not surprisingly, languished. But then the Renaissance
burst into being, brimming with scientific and artistic curiosity. With it
came the giants, the world changers: men like Newton, Galileo and
Copernicus, who stood the ancient ways of thinking on their head.

The 15th and 16th centuries brought great voyages of discovery.
Columbus found the New World, and other explorers turned east.
New empires were being built by the Portuguese, Spanish, Dutch and

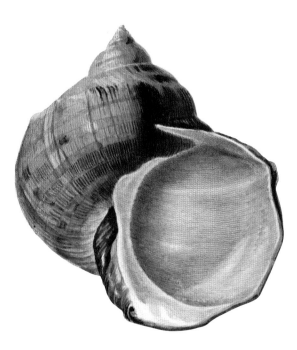

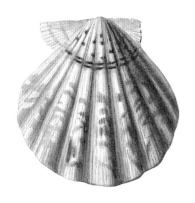

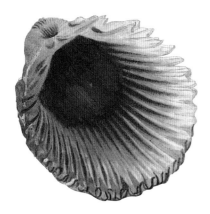

English, and the treasures from these exotic lands flowed back into Europe. Ships' holds were filled with a host of strange new objects, man-made and natural. Among them were shells from tropical waters, larger, more varied, and more colourful than any of the familiar species from the cooler waters of the temperate north.

Hand in hand with the enthusiasm to rediscover Europe's classical heritage, the Renaissance brought a desire to possess works of art and antiques, and also the newly acquired treasures from far-flung places. Princes, dilettantes and the wealthy began to assemble their Cabinets of Curiosities (see pages 104–5). In the 16th and 17th centuries, important collections of *naturalia*, including shells, were amassed by men of status and learning. Scholars, doctors, and apothecaries were driven by a desire to understand nature in all its complexity. Their cabinets were filled with objects that were categorized and displayed in an increasingly systematic fashion.

The growing interest in natural objects created a demand for books on the subject, especially for books with illustrations, from which the collector could identify his specimens. Conchology came of age as a worthwhile field of study in the second half of the 17th century with the publication of books by the Italian Jesuit Filippo Buonanni, the English royal physician Martin Lister, and the German Georg Rumphius, an employee of the Dutch East India Company. These pioneering writers were more or less the founding fathers of conchology, and they paved the way to an increased interest and a greater understanding of the field.

By the 18th century, shell collections were growing in number and size, and collectors found themselves facing confusion. The same shell in varying collections would be called by different 'local' names. Different languages only added to the difficulty. Many scientists had attempted to bring order to the problem, but it took the genius of Linnaeus to succeed with his revolutionary binominal system of nomenclature (see page 230).

Another great stimulus to the emergence of conchology was Captain James Cook's famous voyages to the South Seas between 1768 and 1780. Cook took with him two naturalists, Joseph Banks, a wealthy young English botanist, and Dr Daniel Solander, a Swedish scholar and former pupil of Linnaeus. Aboard the *Endeavour* on the first voyage there was also a retinue of artists, employed to keep pictorial records of the natural history of the islands visited. Banks' and Solander's task was to collect as many plants and animals as possible, including shells. Their extensive collection filled every nook and cranny on board the *Endeavour*, transforming it into a floating museum. The crew had other ideas. Their interest in collecting shells on the journey was to sell them for maximum profit on their return. They knew that dealers would pay

good prices for shells brought back from the tropics, and they were keen to make the most of the opportunity, filling their own meagre cabin spaces with as many shells as possible.

The mania for collecting shells reached its peak from the 18th to the mid-19th centuries. At this time very few collectors were able to collect shells for themselves. They acquired them by purchase or exchange, and high prices were paid for the finest specimens. Auctions were held across Europe, and records show that extravagant sums were paid not just for truly rare shells, but also for those now known to be quite common. One of the most prolific shell collectors was Dutchman Pierre Lyonet of The Hague. He built up a vast collection of some 8,000 specimens, and he was a favourite client of the many dealers of the time. After his death, Lyonet's shells were put up for auction in April 1796, together with his collection of insects, minerals and art treasures. One species of Cone shell regarded at the time as a rare specimen fetched 273 guilders; in the same sale, a painting by Vermeer entitled *Woman in Blue Reading a Letter* was sold for just 43 guilders.

In the early part of the 19th century a new kind of collector appeared on the scene, one whose passion was to find and gather shells in their natural habitat. The Englishman Hugh Cuming, 'prince of shell collectors', was to herald a new era in conchology. Born to a humble family, Cuming became a sailmaker, moving from England to set up his trade in Chile. By the time he was thirty-five, he was able to retire from business and spend the rest of his life achieving his life's ambition: to build the greatest shell collection ever known. Cuming built the yacht he named *Discoverer*, and with only a master mariner on board, set sail in 1827 on the first of three great collecting expeditions. So far as we know, *Discoverer* was the first ship ever built specifically for natural history collecting purposes, and was fitted out with facilities for both collecting and storing specimens of animals and plant life. But shells were Cuming's primary passion, and his foremost interest was in finding as many different species as possible. His first voyage lasted eight months, and took him to Polynesia. He and his companion braved considerable dangers. During one stop at Timoe Island in the Tuamotu Archipelago, the two men were attacked by the inhabitants and were extremely lucky to escape with their lives. To Cuming, the journey was worth the risks, however, and he returned weary, but successful, with thousands of specimens of new shells, birds, plants and minerals.

Cuming's second voyage lasted nearly two years from 1828 to 1830, and took him along great stretches of the west coast of South America. Six years later, in 1836, he made his third and final expedition which lasted over four years, to the Philippines, one of the richest shell

Hugh Cuming (1791–1865), 'prince of shell collectors'. Cuming's collection of shells was the most important ever to have been put together by a single individual. It was bought by the British Museum in 1865 for the then considerable sum of £6,000. Photograph *c.* 1861.

collecting grounds in the world. On his return to England, he was mobbed by leading conchologists, eager to secure some of his extraordinary cargo. Among them was Lovell A. Reeve, the subsequent author of an ambitious twenty-volume work called *Conchologia Iconica*, in which he reproduced illustrations of many shells obtained by Cuming. These depictions are widely recognized as the most accurate and among the most beautiful ever published.

Cuming was very highly regarded in the scientific world, and his expertise in identification rarely questioned. He was chosen to name most of the shells collected by Charles Darwin after the voyage of the *Beagle*. After his death in 1865, the British Museum acquired most of Cuming's collection, which is universally acknowledged as the most important ever to have been put together by a private individual.

The latter half of the 19th century saw shell collecting gain increasing popularity. Many of the great collections of the day eventually passed to museums in Europe and the United States. Of particular importance in North America was the valuable collection built up by Dr J.C. Jay, now housed in the American Museum of Natural History in New York. However, it was a woman who proved the most dedicated and discriminating collector of rare shells in the 19th-century U.S. Mrs S.L.Williams of Chicago spent approximately $75,000 on her purchases, an immense sum by the standards of the time, concentrating on the finest and rarest shells she could obtain. Sadly, this important collection was dispersed after her death.

Inevitably, the major wars of the 20th century caused a decline in the study of natural history, including conchology, which more or less languished until the end of the Second World War. But servicemen returning from overseas brought home shells as gifts and souvenirs, and peacetime saw a slow but gradual re-emergence of an interest in shell collecting across the world.

Today it is enjoyed by more of us than at any time in history, both as a popular pastime and a serious field of study. Clubs, conventions, magazines, books and websites all testify to the global enthusiasm for shell-collecting and study. Travel to foreign locations to collect or exchange material is relatively cheap, and shells do not degrade by transporting them from one place to another. However, there are issues today around the collection of shells that did not inhibit the early pioneers of conchology. Hand in hand with our hunger to understand the natural world goes an increasing awareness of our responsibilities as guardians of the planet's ecosystems, and of the fragile balance of nature in a world of changing climate patterns.

SHELL COLLECTING AND CONSERVATION TODAY

It is perhaps more fortunate to have a taste for collecting shells than to have been born a millionaire.

Robert Louis Stevenson, *Lay Morals*, 1911

The urge to collect seems to be inherent in the human character. We collect a bewildering assortment of objects, from bottle-tops to Old Masters, from teddy bears to steam engines. Some of us collect things for their beauty, others for their monetary value, for prestige, or just for the thrill of the hunt and the urge to possess. Some collect indiscriminately; others become very selective, settling only for the biggest or the smallest, the rarest or even for the flawed or misshapen.

Shell collecting is a rather special case, however. Shells generate a sense of wonder, an appreciation of the aesthetic; to many they are objects of mystery. There is fascination and delight in the discovery that the sea can produce a small, perfect object of beauty that costs nothing, and which is often more pleasing than any costly man-made ornament. So collectors want to keep them and even display them; they become cherished belongings. And having found those first shells, there is often a desire to find more, or at least to continue to seek them out whenever time and circumstances permit. Shell collecting knows no geographical boundaries, nor does it recognize any differences in age. Children and adults alike delight in the activity; it is free for all to enjoy.

Like any collecting habit, shells can become addictive. What starts out as an occasional pastime can become a passion. The imperative to keep collecting as many different kinds of shell as possible acts as a powerful magnet to those who have 'caught the bug'. Travel to different shores in search of shells becomes the essential way to spend free time. Every spare space in the home is sacrificed to a growing assortment of drawers, cabinets, boxes and containers. Books about shells start to fill the shelves, and every spare moment is spent working on the identification, labelling and recording of newly acquired species. There are clubs and associations to join, meetings to attend, other collectors to contact for exchange of shells, and magazines and periodicals to read, all dedicated to the world of shells. It is a pastime that can easily, and happily, occupy the collector's time very fully, and it opens a window on the natural world that is a source of constant fascination.

The collectors of the 18th and 19th centuries took it for granted that they could harvest everything they found. Nature was robust, and shells

Illustration plate from Thomas Martyn's The Universal Conchologist, 1784.

235

BELOW AND OPPOSITE BELOW
Illustrations of individual shells from
Franz Michael Regenfuss's *Choix de
Coquillages et de Crustacés*, 1758.

and other natural objects were there for the taking, regardless of the
measures required to obtain them. But times have changed, and we now
know that if we are to safeguard the future of the wealth from the sea,
we must pay heed to the experts. Whether somebody wants to collect
when time and circumstances permit, or to develop their interest in a
more systematic fashion, perhaps specializing in certain kinds of shell,
there are guidelines to be observed. There are also matters of conscience
to be considered, at a time when conservation is an essential and urgent
concern facing us all.

Conservation of the ecosystems of the sea is as important as those
of our forests, our rivers, and the many different environments on land.
At present, life in our oceans is being threatened, and increasingly lost,
by habitat destruction caused principally by pollution, industrial fishing
practices, and land reclamation. Conservation agencies admit that in
comparison with these massive culprits shell collecting by individuals
is responsible for negligible damage to the marine environment. While
this is reassuring for the private collector, it remains important to heed
the advice on best practice set out by a number of international bodies.
This can be summarized as follows:

• Limit collection to beached, empty shells. This allows for thousands
of species to be found worldwide, and no harm is done, either to the
individual mollusc, or to the environment as a whole.
• Always replace rocks and stones on a beach when looking underneath
for empty shells. These rocks are the chosen habitats of many live
marine animals, and disturbing them may place them at risk.
• A good way to 'collect' live shells is simply to photograph them
in situ. Underwater cameras can now be bought at relatively low cost,
and photography offers an admirable way for snorkellers and divers to
acquire a permanent record of a shell while not actually removing it
from its natural habitat.
• If a collector requires live specimens for the purposes of study (and
it must be stressed that museums and other scientific institutions often
rely on such collectors to add to their own collections), care must be
taken never to take more specimens than are strictly required, and
equally, never to take either a juvenile specimen or one that is
demonstrating reproductive behaviour (e.g. egg-guarding, breeding
aggregations).
• Careful checks must be made before embarking on a collecting
expedition, and all national and local regulations respected regarding
the collection of shells. An increasing number of countries are placing
limits on the number of shells that can be taken from particular areas,

and some local laws prohibit shell collection, live or dead, in order to conserve stocks and limit exploitation.

• Internet access to clubs and individuals is to be encouraged as a method of increasing a shell collection by exchange or purchase, thereby avoiding the need for non-essential air travel to coastal areas overseas. Some of the most active websites are listed on page 250.

No discussion of marine conservation can take place without a particular mention of coral reefs. These are the living 'rainforests of the sea', home to a great diversity of fauna, including many species of shells. Unfortunately, reefs in many parts of the world are being damaged by human activity. They are broken up to provide souvenirs for tourists; they are built over to make jetties, harbours, runways, and to create more land. Coral is dynamited by fishermen, and ripped up by anchors. Simply by treading on coral reefs, paddlers, snorkellers and divers cause damage that takes years to repair. Most ominously of all, reefs are significantly threatened by an increase in water temperature as a result of climate change.

There are 109 countries in the world with coral reefs. It is estimated that reefs in ninety of them are being damaged, and coral can take fifty years or longer to recover. The simple rule for collectors in tropical areas is *always* to avoid treading on coral, however carefully, in search of shells.

Despite today's need for guidelines towards a greater respect for the balance of nature, and a need to safeguard the planet's fragile resources, there is nothing to prevent a new generation of shell collectors and true lovers of nature from enjoying an occasional pastime, or indeed devoting a lifetime to what may become a passion. The pursuit of knowledge is always worthwhile, and some of tomorrow's marine biologists and museum curators are the young shell collectors of today. Many conchologists share their knowledge with others, and pass on their expertise – and their collections – for the benefit of scientific research and understanding.

Equally, we profit from the artists and craftsmen in our midst, and to them we are especially grateful. Each artist has a unique appreciation of the shell, and we pay tribute to many in this book for capturing the enduring qualities of these wonderful creations of nature.

ABOVE Illustration plates from Thomas Martyn's *The Universal Conchologist*, 1784.

ILLUSTRATED GLOSSARY OF SHELLS

The accurate naming of shells is a complex matter and at times it can be confusing, even to experts. Some of the names given here may have been altered in recent scientific works, but for ease of comparison and in the interest of conformity, scientific and common names of almost all marine shells in this book are taken from the standard reference work *Compendium of Seashells* by R.Tucker Abbott and S. Peter Dance. It is important also to bear in mind that common names can vary from place to place, even within the English-speaking world.

<
Aequipecten opercularis
Queen Scallop

7 cm (3 in.)
Northwest Europe
to Azores and
Mediterranean
Common

<
Amblema plicata
Three-ridge

Freshwater Mussel
10.5 cm (4 in.)
North America
Common

<
Anadara granosa
Granular Ark

6 cm (2½ in.)
Southwest Pacific
Abundant

>
Arca navicularis
Indo-Pacific Ark

6 cm (2½ in.)
Indo-Pacific, Japan
Common

>
Argonauta argo
Common Paper
Nautilus

20 cm (8 in.)
Warm seas worldwide
Common seasonally

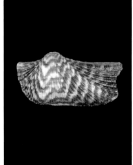

>
Atrina vexillum
Indo-Pacific
Pen Shell

40 cm (16 in.)
East Africa to Polynesia
Common

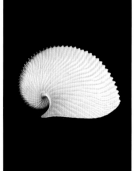

<
Beguina semiorbiculata
Half-round Cardita

7.5 cm (3 in.)
Tropical Southwest
Pacific
Common

<
Bolinus brandaris
Purple Dye Murex

9 cm (3½ in.)
Mediterranean and
Northwest Africa
Abundant

<
Buccinum undatum
Common Northern
Buccinum

7.5 cm (3 in.)
Arctic Seas to New
Jersey and to Portugal
Abundant

>
Busycon canaliculatum
Channelled Whelk

18 cm (7 in.)
Cape Cod,
Massachusetts, to
northeast Florida
Common

>
Busycon carica
Knobbed Whelk

20 cm (8 in.)
Massachusetts to
northeast Florida
Common

>
Cardium costatum
Great Ribbed
Cockle

10 cm (4 in.)
West Africa to Angola
Common

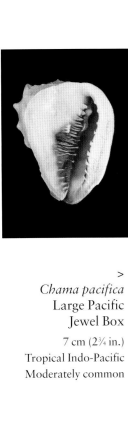

< *Cassis madagascariensis* Emperor Helmet

16.5 cm (6½ in.)
Florida to Lesser Antilles, Bahamas
Common

< *Cassis tuberosa* King Helmet

15 cm (6 in.)
Brazil, Bermuda, North Carolina to Caribbean
Common

< *Cerastoderma edule* Common European Cockle

5 cm (2 in.)
Norway to Northwest Africa
Abundant

Chama pacifica Large Pacific Jewel Box >

7 cm (2¾ in.)
Tropical Indo-Pacific
Moderately common

Charonia lampas Knobbed Triton >

18 cm (7 in.)
Mediterranean and adjacent coasts
Moderately common

Charonia tritonis Trumpet Triton >

33 cm (13 in.)
Indo-Pacific
Moderately common

< *Chicoreus brunneus* Adusta Murex

6 cm (2½ in.)
Southwest Pacific
Abundant

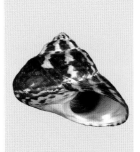

< *Cittarium pica* West Indian Top

7 cm (2¾ in.)
Caribbean
Common

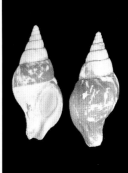

< *Colus jeffreysianus* Jeffreys's Colus

6 cm (2½ in.)
Western Europe
Uncommon

Conus betulinus Beech Cone >

10 cm (4 in.)
Indo-Pacific
Common

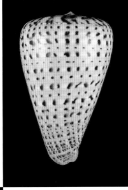

Conus figulinus Fig Cone >

7.5 cm (3 in.)
Indo-Pacific
Common

Conus gauguini Gauguin's Cone or Barthelemy's Cone >

6 cm (2½ in.)
Indian Ocean and South Pacific
Moderately rare

< *Conus leopardus* Leopard Cone

14 cm (5½ in.)
Indo-Pacific
Common

< *Conus litteratus* Lettered Cone

10 cm (4 in.)
Indo-Pacific
Common

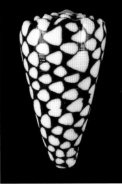

< *Conus marmoreus* Marble Cone

10 cm (4 in.)
Indo-Pacific
Common

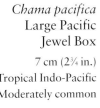

239

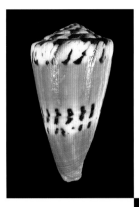

< *Conus mustelinus*
Weasel Cone

6 cm (2½ in.)
Indo-West Pacific
Uncommon

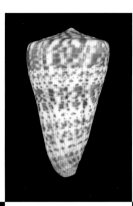

< *Conus pulcher*
Butterfly Cone

10 cm (4 in.)
Southwest Africa
Common

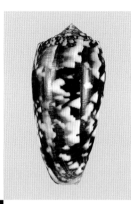

< *Conus striatus*
Striate Cone

10 cm (4 in.)
Indo-Pacific
Common

>
Conus textile
Textile Cone

7.5 cm (3 in.)
Indo-Pacific
Common

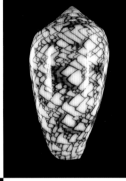

>
Crassostrea gigas
Giant Pacific Oyster

15 cm (6 in.)
Western Canada to
California, Japan
Common

>
Cristaria plicata
River shell

Freshwater Mussel
28 cm (11 in.)
China, Japan,
United States
Common

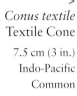

< *Cypraea annulus*
Gold-ringer Cowrie

2.5 cm (1 in.)
Indo-Pacific
Common

< *Cypraea maculifera*
Reticulated Cowrie

6.5 cm (2½ in.)
Central Pacific
Common

< *Cypraea mappa*
Map Cowrie

7.5 cm (3 in.)
Indo-Pacific
Uncommon

>
Cypraea mauritiana
Humpback Cowrie

7.5 cm (3 in.)
Indo-Pacific
Common

>
Cypraea moneta
Money Cowrie

2.5 cm (1 in.)
Indo-Pacific
Abundant

>
Cypraea pantherina
Panther Cowrie

6.5 cm (2½ in.)
Red Sea and
Gulf of Aden
Uncommon

< *Cypraea tigris*
Tiger Cowrie

9 cm (3½ in.)
Indo-Pacific
Common

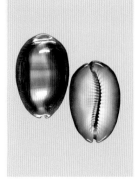

< *Cypraea ventriculus*
Ventral Cowrie

5 cm (2 in.)
Central Pacific
Uncommon

< *Cypraecassis rufa*
Bullmouth Helmet

15 cm (6 in.)
Indo-Pacific
Common

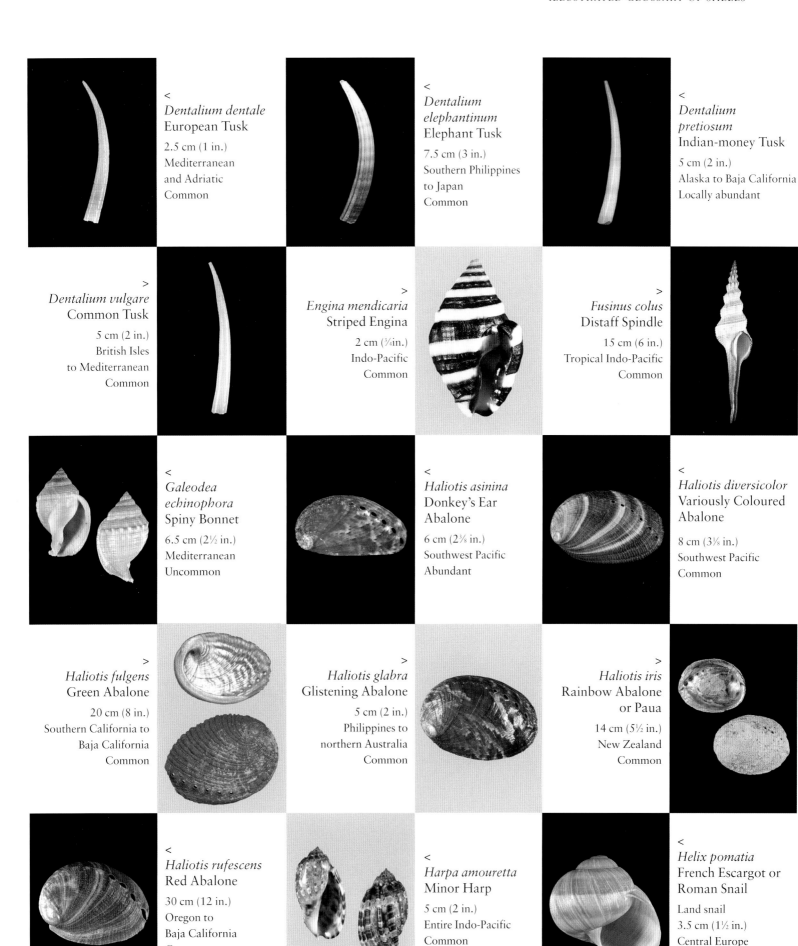

<
Dentalium dentale
European Tusk

2.5 cm (1 in.)
Mediterranean
and Adriatic
Common

<
Dentalium elephantinum
Elephant Tusk

7.5 cm (3 in.)
Southern Philippines
to Japan
Common

<
Dentalium pretiosum
Indian-money Tusk

5 cm (2 in.)
Alaska to Baja California
Locally abundant

>
Dentalium vulgare
Common Tusk

5 cm (2 in.)
British Isles
to Mediterranean
Common

>
Engina mendicaria
Striped Engina

2 cm (¾ in.)
Indo-Pacific
Common

>
Fusinus colus
Distaff Spindle

15 cm (6 in.)
Tropical Indo-Pacific
Common

<
Galeodea echinophora
Spiny Bonnet

6.5 cm (2½ in.)
Mediterranean
Uncommon

<
Haliotis asinina
Donkey's Ear
Abalone

6 cm (2⅜ in.)
Southwest Pacific
Abundant

<
Haliotis diversicolor
Variously Coloured
Abalone

8 cm (3⅛ in.)
Southwest Pacific
Common

>
Haliotis fulgens
Green Abalone

20 cm (8 in.)
Southern California to
Baja California
Common

>
Haliotis glabra
Glistening Abalone

5 cm (2 in.)
Philippines to
northern Australia
Common

>
Haliotis iris
Rainbow Abalone
or Paua

14 cm (5½ in.)
New Zealand
Common

<
Haliotis rufescens
Red Abalone

30 cm (12 in.)
Oregon to
Baja California
Common

<
Harpa amouretta
Minor Harp

5 cm (2 in.)
Entire Indo-Pacific
Common

<
Helix pomatia
French Escargot or
Roman Snail

Land snail
3.5 cm (1½ in.)
Central Europe
Common

<
Hexaplex duplex
Duplex Murex

9 cm (3½ in.)
Western Africa
Common

<
Hexaplex trunculus
Trunculus Murex

7.5 cm (3 in.)
Mediterranean
Common

<
Hippopus hippopus
Bear Paw Clam

20 cm (8 in.)
Southwest Pacific
Common

>
Lambis chiragra
Chiragra Spider
Conch

15 cm (6 in.)
Eastern Indian Ocean
to Polynesia
Common

>
Lambis lambis
Common Spider
Conch

18 cm (7 in.)
Indo-Pacific
Common

>
Lampsilis teres
Yellow Sandshell

Freshwater shell
15 cm (6 in.)
United States and
northern Mexico
Locally common;
endangered in
some states

<
Liguus virgineus
Virgin Liguus

Land snail
5 cm (2 in.)
United States, Haiti and
Santo Domingo
Abundant

<
Lopha cristagalli
Cock's-comb Oyster

9 cm (3½ in.)
Indo-Pacific
Locally common

<
Lyropecten nodosa
Lion's Paw

11 cm (4½ in.)
Southeast United
States to Brazil,
Ascension Islands
Locally common

>
Melo melo
Indian Volute

23 cm (9 in.)
Malaysia, South
China Sea
Uncommon

>
Melo umbilicatus
Heavy Baler

30 cm (12 in.)
Australia to
New Guinea
Uncommon

>
*Mercenaria
mercenaria*
Northern Quahog

9 cm (3½ in.)
Eastern Canada to
Georgia
Common

<
Mitra mitra
Episcopal Mitre

10 cm (4 in.)
Indo-Pacific,
Galapagos Islands
Common

<
Mitra papalis
Papal Mitre

8 cm (3⅛ in.)
Entire Indo-Pacific
Uncommon

<
Mitra stictica
Pontifical Mitre

6.5 cm (2½ in.)
Indo-Pacific
Common

<
Murex haustellum
Snipe's Bill Murex

12.5 cm (5 in.)
Indo-Pacific
Locally common

<
Mytilus edulis
Common Blue
Mussel

7.5 cm (3 in.)
Worldwide subarctic
seas, United States
Abundant

<
Nassarius camelus
Camel Mud Nassa

1 cm (⅖ in.)
Tropical Indo-West
Pacific
Uncommon

Nassarius distortus
Distorted Nassa

3 cm (1½ in.)
Tropical Pacific
Moderately common
>

Nautilus pompilius
Chambered
Nautilus

15 cm (6 in.)
Philippines and
Palau Islands
Common
>

*Neotrigonia
margaritacea*
Australian Brooch
Clam

5 cm (2 in.)
Southern Australia
Common
>

<
Neritina turrita
Turreted Nerite

1.8 cm (¾ in.)
Southwest Pacific
Common

<
Oliva porphyria
Tent Olive

9 cm (3½ in.)
Gulf of California
to Panama
Moderately common

<
Ostrea edulis
Common European
Oyster

8 cm (3⅛ in.)
Western Europe,
Mediterranean
Common

Ovula ovum
Common Egg Cowrie

7.5 cm (3 in.)
Indo-Pacific
Common
>

Patella vulgata
Common European
Limpet

6 cm (2½ in.)
Norway to Spain
Abundant
>

Patelloida saccharina
Pacific Sugar
Limpet

4 cm (1½ in.)
Southwest Pacific,
Melanesia
Abundant
>

<
Pecten maximus
Great Scallop

12 cm (5 in.)
Northwest Europe
to Madeira
Common

<
*Pecten maximus
jacobaeus*
St James's Scallop

12 cm (5 in.)
Mediterranean,
Canary Isles
Common

<
Phasianella australis
Australian Pheasant

5 cm (2 in.)
Southern Australia
and Tasmania
Common

<
Pinctada fucata
Akoya Oyster

9 cm (3½ in.)
Tropical West Pacific
Locally common

<
Pinctada imbricata
Atlantic Pearl Oyster

7.5 cm (3 in.)
Southeast United States
to Brazil
Common

<
Pinctada margaritifera
Black-lipped Pearl
Oyster

15 cm (6 in.)
Indo-Pacific
Locally common

>
Pinctada maxima
Gold-lip Pearl
Oyster

20 cm (8 in.)
Western Pacific
Common

>
Pinctada mazatlanica
La Paz Oyster

10 cm (4 in.)
Baja California through
Gulf of California,
south to Peru
Locally common

>
Pinna nobilis
Noble Pen Shell

60 cm (24 in.)
Mediterranean
Common

<
Pleuroploca gigantea
Florida Horse
Conch

60 cm (24 in.)
Southeast United States
and northeast Mexico
Common

<
Pugilina morio
Giant Hairy
Melongena

15 cm (6 in.)
Trinidad to Brazil,
West Africa
Common

<
Puperita pupa
Zebra Nerite

1.8 cm (¼ in.)
Southeast Florida, West
Indies and Bermuda
Abundant

>
Purpura columellaris
Columella Purpura

5 cm (2 in.)
Southwest Mexico to
Chile
Uncommon

>
Purpura patula pansa
Wide-mouthed
Purpura

7.5 cm (3 in.)
Southeast Florida,
Mexico, West Indies
Common

>
Pyrene ocellata
Lightning
Dove-shell

2 cm (3/4 in.)
Indo-Pacific
Common

<
Smaragdia viridis
Emerald Nerite

0.7 cm (¼ in.)
Southeast Florida, West
Indies, Bermuda
Common

<
Spondylus princeps
Pacific Thorny
Oyster

13 cm (5 in.)
Gulf of California to
northwest Peru
Common

<
Strigilla pisiformis
Pea Strigilla

0.5 cm (¼ in.)
Bahamas to Brazil
Abundant

< *Strombus canarium*
Dog Conch

6.5 cm (2½ in.)
Southwest Pacific
Common

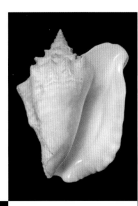

< *Strombus gigas*
Queen Conch or
Pink Conch

20 cm (8 in.)
Southeast Florida,
Bermuda, West Indies
Common

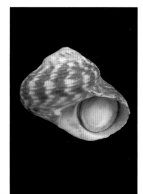

< *Subninella undulata*
Lightning Moon
Turban

6 cm (2.4 in.)
South Australia
Common

> *Swiftopecten swiftii*
Swift's Scallop

8 cm (3⅛ in.)
Japan
Locally common

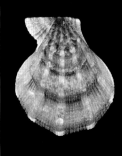

> *Tectus pyramis*
Pyramid Top

7 cm (2¾ in.)
Indo-Pacific
Locally abundant

> *Tellina tenuis*
Thin Tellin

1.8 cm (¾ in.)
Norway to
Northwest Africa
Abundant; scarce in
Mediterranean

< *Thais haemastoma*
Hays's Rock-shell

7.5 cm (3 in.)
Northwest Gulf
of Mexico
Common

< *Thatcheria mirabilis*
Japanese Wonder
Shell

9 cm (3½ in.)
Japan to Philippines
Common

< *Tivela stultorum*
Pismo Clam

12 cm (5 in.)
California and
Baja California
Common

> *Tonna dolium*
Spotted Tun

10 cm (4 in.)
Indo-Pacific,
New Zealand
Uncommon

> *Tonna galea*
Giant Tun

15 cm (6 in.)
Caribbean, Atlantic,
Mediterranean,
Indo-Pacific
Uncommon

> *Tridacna gigas*
Giant Clam

1.2 m (4 ft)
Southwest Pacific
Locally common
(protected)

< *Tridacna squamosa*
Fluted Giant Clam

30 cm (12 in.)
Indo-Pacific,
except Hawaii
Locally common

< *Tritogonia verrucosa*
Pistolgrip

Freshwater Mussel
18 cm (7 in.)
Central and southeast
United States
Widespread but
endangered in some states

< *Trochus niloticus*
Commercial Trochus

13 cm (5 in.)
Indo-Pacific
Abundant

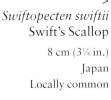
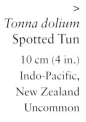

<
Turbinella pyrum
Indian Chank

10 cm (4 in.)
Southeast India and
Sri Lanka
Abundant

<
Turbo marmoratus
Great Green Turban

20 cm (8 in.)
Indo-Pacific, west
of Fiji
Locally abundant

<
Turbo sarmaticus
South African
Turban

7 cm (2¾ in.)
South Africa
Abundant

>
Turritella duplicata
Duplicate Turritella

12 cm (5 in.)
Southeast Asia,
Indian Ocean
Common

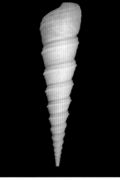

>
Turritella terebra
Screw Turritella

16 cm (6 in.)
Southwest Pacific
Abundant

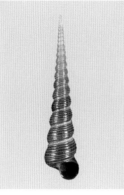

>
Umbonium costatum
Button Top

2.5 cm (1 in.)
Sea of Japan, East
China Sea, Philippines
Locally common

<
*Umbonium
giganteum*
Giant Button Top

4 cm (1½ in.)
Japan, West Pacific
Common

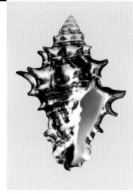

<
Vasum ceramicum
Ceramic Vase

10 cm (4 in.)
Entire Indo-Pacific,
except Red Sea
Moderately common

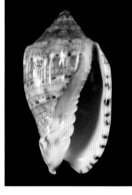

<
Voluta musica
Common Music
Volute

7.5 cm (3 in.)
Caribbean
Locally common

SEE MORE, READ MORE, FIND OUT MORE

SEE MORE: PUBLIC COLLECTIONS OF SHELLS

This list was compiled with the generous assistance of staff at the Natural History Museum, London. For information about access to collections not on permanent public display contact museums directly, or consult their websites.

UNITED KINGDOM

ENGLAND
Natural History Museum, Cromwell Road, London SW7 5BD
Cambridge University Museum of Zoology, Downing Street, Cambridge CB2 3EJ
Oxford University Museum, Parks Road, Oxford OX1 3PW
Royal Albert Memorial Museum, Queen Street, Exeter, Devon EX4 3RX
Plymouth City Museum & Art Gallery, Drake Circus, Plymouth, Devon PL4 8AJ
Nottingham Natural History Museum, Wollaton Hall, Wollaton Park, Nottingham NG8 2AE
Leeds City Museum, Calverley Street, Leeds, LS1 3A
Manchester Museum, University of Manchester, Oxford Road, Manchester M13 9PL
Liverpool Museum, William Brown Street, Liverpool L3 8EN
Hancock Museum, Barras Bridge, Newcastle-upon-Tyne, NE2 4PT

WALES
National Museum of Wales, Cathays Park, Cardiff CF1 3NP

SCOTLAND
Glasgow Art Gallery & Museum, Kelvingrove, Glasgow G3 8AG
Hunterian Museum, University of Glasgow, Glasgow G12 8QQ
Royal Museum of Scotland, Chambers Street, Edinburgh EH1 1JF

NORTHERN IRELAND
Ulster Museum, Botanic Gardens, Belfast BT9 5AB

EIRE
National Museum of Ireland, Natural History Division, Merrion Street, Dublin 2, Ireland

ISLE OF MAN
Manx Museum, Douglas, Isle of Man

AUSTRIA
Haus der Natur, Museumsplatz 5, A-5020 Salzburg

BELGIUM
Royal Belgian Institute of Natural Sciences, Vautierstraat 29, Brussels B-1000, Belgium

DENMARK
Zoological Museum, University of Copenhagen, Universitetsparken 15, Copenhagen, DK-2100

FRANCE
Musée National d'Histoire Naturelle, 55 Rue Buffon, Paris 75005

GERMANY
Haus der Natur, Baederstrasse 26, D-23743 Groemitz-Cismar
Senckenberg Forschungsinstitut und Naturmuseum, Senckenberganlage 25, 60325 Frankfurt am Main
Staatliches Museum für Naturkunde, Rosenstein 1, 70191 Stuttgart
Geological-Paleontological Institute and Museum, Hamburg University, Bundesstrasse 55, 20146 Hamburg
Zoologische Staatssammlung, Muenchhausenstr. 21, Munich D-85221
Zoological Museum, Martin Luther King Platz 3, Hamburg 20146

LUXEMBOURG
Musée National d'Histoire Naturelle, 25 rue Munster, L-2160, Luxembourg

NETHERLANDS
Naturalis: Nationaal Natuurhistorisch Museum, Darwinweg 2, 2333 CR, Leiden

POLAND
Institute of Systematics and Evolution of Animals, Polish Academy of Sciences, Sw. Sebastiana 9, Crakow
Museum of Natural History, Wroclaw University, Sienkiewicza 21, Wroclaw 50-335

RUSSIA
Zoological Institute and Museum, Universitetskaya Embankment 1, St Petersburg 199034
Paleontological Institute of the Russian Academy of Sciences, Profsoyuznaya 123, Moscow 117647

SPAIN
Museo Nacional de Ciencias Naturales de Madrid, Jose Gutierrez Abascal, 2, 28006 Madrid

SWEDEN
The Swedish Museum of Natural History, Frescativagen 40, Stockholm
Goteborg Natural History Museum, P.O. Box 7283, Gothenburg 40235

SWITZERLAND
Museum d'Histoire Naturelle de la Ville de Genève, 1 route de Malagnou, CH-1208 Geneva
Naturhistorisches Museum der Burgergemeinde Bern, Helvetiaplatz, Bern.

UNITED STATES

ATLANTIC STATES
National Museum of Natural History, Smithsonian Institution, MRC:NHB 118, Washington DC 20560
The Academy of Natural Sciences of Philadelphia, 19th and The Parkway, Philadelphia, PA 19103
Delaware Museum of Natural History, P.O.Box 3937, Wilmington, Delaware 19807-0937
Georgia Museum of Natural History, Natural History Building, University of Georgia, Athens, GA 30602-1882
American Museum of Natural History, Central Park West at 79th Street, New York, NY 10024
Harvard Museum of Natural History, Harvard University, 26 Oxford Street, Cambridge, Mass. 02138
Florida Museum of Natural History, University of Florida, Gainsville, FL 32611-7800
Bailey-Matthews Shell Museum, 3075 Sanibel-Captiva Road, Sanibel, FL 33957

MIDDLE WESTERN STATES
Field Museum of Natural History, Roosevelt Road at Lake Shore Drive, Chicago Ill. 60605
University of Michigan, 1109 Geddes Avenue, Ann Arbor, MI 48109
Carnegie Museum of Natural History, Carnegie Institute, 4400 Forbes Avenue, Pittsburgh, PA 15213

PACIFIC STATES AND HAWAIIAN ISLANDS
Berkeley Natural History Museums, 1190 Valley Life Sciences Building, Berkeley CA 94720-3070

California Academy of Sciences, Golden Gate Park, San Francisco, CA 94118

Santa Barbara Museum of Natural History, 2559 Puesta del Sol Road, Santa Barbara, CA 93105

San Diego Natural History Museum, 1788 El Prado, Balboa Park, San Diego CA 92112-1390

Natural History Museum, P.O. Box 1390, San Diego, CA 92112

Natural History Museum of Los Angeles County, 900 Exposition Blvd, Los Angeles, CA 90007

Bernice P. Bishop Museum, P.O.Box 19000-A, Honolulu, HI 96817

CANADA

Canadian Museum of Nature, Victoria Memorial Museum Building, 240 McLeod Street, Ottawa, Ontario.

Redpath Museum, McGill University, 859 Sherbrooke Street, West Montreal, Quebec, H3A 2K6

The Royal British Columbia Museum, 675 Belleville Street, Victoria, BC V8W 9W2

The Royal Ontario Museum (ROM), 100 Queen's Park, Toronto, M5S 2C6

Museum of Natural History, 1747 Summer Street, Nova Scotia, B3H 3A6

AUSTRALIA

Australian Museum, 6 College Street, Sydney 2010, NSW

Museum of Victoria, Carlton Gardens, Melbourne 3001, Victoria

Queen Victoria Museum & Art Gallery, 2 Wellington Street, Launceston, Tasmania 7250

Queensland Museum, South Brisbane, QLD 4101

Western Australian Museum, 3 Francis Street, Perth, WA 6000

NEW ZEALAND

Auckland War Memorial Museum, Domain Drive, The Domain, Parnell, Auckland

Te Papa Museum, Cable Street, Wellington

JAPAN

National Science Museum, 4-1-1 Amakubo, Tsukuba Ibaraki 305-0005, Tokyo

SOUTH AFRICA

Natal Museum, Pietermaritzburg 3200

SEE MORE: SHELL HOUSES AND GROTTOES OPEN TO THE PUBLIC

The following list is not intended to be comprehensive. It provides information about some of the most important shell houses and grottoes open to the public in Europe. Additional information for shell grottoes in the United Kingdom (excluding Ireland) can be obtained from the excellent book *Shell Houses and Grottoes* by Hazelle Jackson, published by Shire Publications, 2001.

ENGLAND

Skipton Castle, Skipton, North Yorkshire, BD23 1AW. Tel: 00 44 (0) 1756 792442. One of only two early 17th-century shell rooms surviving in Britain.

The Grotto, Woburn Abbey, Bedfordshire. Tel: 00 44 (0) 1525 290666. www.woburnabbey.co.uk. A 17th-century room in the main house, one of the oldest shell houses in Great Britain.

Basildon Park, Lower Basildon, Reading RG8 9NR. Tel: 00 44 (0) 118 984 3040. Interior 18th-century shell decoration.

The Shell Grotto, Grotto Hill, Margate, Kent CT9 2BU. Tel: 00 44 (0) 1843 220008. Discovered in 1835, this shell grotto's history is shrouded in mystery. Differing theories date it as an ancient Mithraic temple, or simply as an 18th-century cavern.

The Shell House, Goodwood House, Chichester, West Sussex. Tel: 00 44 (0) 1243 755048. A superb pavilion, probably the finest example of a shell house in Britain, created by the Duchess of Richmond and her daughters in the 18th century. Open to the public on certain days by written appointment with the Curator.

Leeds Castle Grotto, near Maidstone, Kent. Tel: 00 44 (0) 1622 765400. www.leeds-castle.com. Newly restored, with modern design, this is a grotto well worth a visit.

Goldney Hall Grotto, Bristol. Tel: 00 44 (0) 1179 034880. Belonging to Bristol University, this shell grotto is open to the public on certain days, by written appointment.

Scott's Grotto, Ware, Hertfordshire. Tel: 00 44 (0) 1920 464131. www.scotts-grotto.org. 18th-century grotto made up of a series of interconnected chambers extending into the hillside. Decorated with shells, coloured glass and flint.

The Grotto, Hampton Court House, Richmond, Surrey. A recently restored shell grotto in the garden of an 18th-century mansion, now an independent school. Open on one day each year, by written appointment from the Assistant Curator, Orleans House Gallery, Riverside, Twickenham, Middlesex.

WALES

Bro Meigan Gardens, Eglwyswrw, Boncath, Pembrokeshire SA37 0JE. Tel: 00 44 (0) 1239 841232. Shell grotto.

Pontypool Grotto, Pontypool Park, Pontypool, Torfaen. Tel: 00 44 (0) 1495 750236. 19th-century shell house in grounds of leisure centre.

Portmeirion, Penrhyndeudraeth, Gwynedd LL48 6ET. Tel: 00 44 (0) 1766 770000. 20th-century shell grotto.

Cilwendeg, Boncath, Pembrokeshire. Contact The Temple Trust Tel. 00 44 (0) 207 482 6171 Early 19th-century shell house in grounds of an estate restored by artist Blott Kerr-Wilson. Open for visits every Thursday during summer and early autumn.

IRELAND

Ballymaloe Cookery School, Shanagarry, Co. Cork. Tel: 00 353 (0) 21 4646785. A 20th-century shell room created by Blott Kerr-Wilson. Open all year round.

Curraghmore House, Portland, Co. Waterford. Tel: 00 353 (0) 51 387102. 18th-century shell house in garden.

SCOTLAND

Dunnottar Shell House, Dunnottar Woods, Stonehaven, Aberdeenshire. Tel: 00 44 (0) 1569 764444. 18th-century shell house.

Newhailes House, Newhailes Estate, Musselburgh, East Lothian EH21 6RY. Tel: 00 44 (0) 131 665 1546. Late 18th-century shell grotto.

CHANNEL ISLANDS

The Shell Garden, Mount les Vaux, St Aubin, Jersey JE3 8LS. Tel: 00 44 (0) 1534 743561. A garden created from millions of locally collected shells.

The Little Chapel, St Andrew, Guernsey. Dubbed 'the smallest chapel in the world', this is a tiny, unusual monument covered entirely in shells, pebbles and broken crockery. For opening times, ring the Tourist Office tel: 00 44 (0) 1481 723552.

FRANCE

Château de Rambouillet, 78120 Rambouillet (51 km southwest of Paris). Tel: 00 33 (0) 1 34 83 29 09 or 00 33 (0) 1 34 83 00 25. The 'Chaumière aux coquillages' is an exceptionally beautiful shell house in the garden of the chateau, built in the 18th century, and one of the most celebrated follies of the time.

Seminaire de Saint-Sulpice, 33 rue Général Leclerc, 92130 Issy-les-Moulineaux. Issy Tourist Office tel: 00 331 (0) 41 23 87 00. Email: touristoffice@ville-issy.fr. Shell house ('Le Nymphée') situated next to the Chapel in the seminary grounds. Individual and group guided tours on request from Tourist Office. Open all year.

Château de Gerbéviller, 54830 Gerbéviller (40 km from Nancy). Tel./fax: 00 33 (0) 3 8342 7157. Email: chateau.gerbeviller@free.fr. 'Le Nymphée', a 17th-century shell grotto in the park of a chateau.

Domaine du Piédefer, 21 rue Maurice Sabatier, 91170 Viry-Châtillon. Tel. 00 33 (0) 1 6912 6112. 17th-century vaulted grotto ('Le Nymphée') decorated with shells in Italian Baroque style.

Nymphée de Chatou, 78400 Chatou. Tourist Office tel: 00 33 (0) 1 3071 3089. 18th-century grotto facing the Seine river.

Bastie d'Urfé, 42130 Saint Etienne de Molard. Tel: 00 33 (0) 4 77 97 54 68. 16th-century 'Salle des rocailles', containing mythological subjects created out of pebbles, shells and sand of various colours.

Jardins de Kerdalo, 22220 Trédarzec, Brittany. Tel: 00 33 (0) 2 9692 3594. Beautiful grotto created by Peter Wolkonsky in 1965, set in superb gardens.

Château d'Auvers-sur-Oise, rue de Léry, 95430 Auvers-sur-Oise. Tel: 00 33 (0) 1 34 48 48 50. Dome-shaped grotto entirely covered in shells, stone and glass fragments.

Château de Vendeuvre, 14170 Vendeuvre, Normandy. Tel: 00 33 (0)2 31 40 93 83. 18th-century chateau with grotto in gardens, covered with 200,000 shells, viewed from pavilion above.

GERMANY

Grottenhof, Residenz München, Residenzstrasse 1, München. Tel: 00 49 (0) 892 90671. www.residenz-meunchen.de. Late 16th-century grotto built for Duke William V. Bombed in World War II, now rebuilt, decorated with shells, minerals and crystals.

Magdalenenklause, Schloss und Gartenverwaltung Nymphenburg, Schloss Nymphenburg, Eingang 19, 80638 München. Tel: 00 49 (0) 891 79080. www.schloesser.bayern.de. The court equivalent of a hermitage. Built as an artificial ruin in the early 18th century, it has a chapel designed as a grotto and a living room. Shells decorate both rooms.

Muschelkapelle, Jagdschloss Falkenlust, Schloss-strasse 6, D 50321, Bruhl. Tel: 00 49 (0) 223 244000. www.schlossbruehl.de. A beautiful 18th-century chapel built in the style of a hermit's grotto. The walls and ceiling are covered with shells, minerals and crystals.

Muschel Saal, Neues Palais, Park Sanssouci, Potsdam, near Berlin. Tel: 00 49 (0) 331 96 94 255. Fabulous mineral and shell-encrusted 'Shell Hall' in this 18th-century Baroque palace built by Frederick II.

Schloss Wilhelmsthal, Calden, near Kassel. Tel: 00 49 (0) 5674 6898. Fax: 00 49 (0) 5674 4053.

18th-century shell grotto in garden of summer residence of Landgraves of Hesse-Kassel.

Schloss Veitshochheim, Erwin-Vornberger-Platz, D-97209 Veitshochheim, near Würzburg. 18th-century shell grotto in public park adjoining summer palace of Prince-Bishops of Würzburg.

Altes Schloss Ermitage, Bayreuth, Bavaria. Tel: 00 49 (0) 921 759690. 18th-century pleasure palace of the Margraves of Bayreuth, containing a room with 'giochi d'acqua' and shellwork.

AUSTRIA

Muschelgrotte, Schloss Hellbrunn, Furstenweg 37, A-5020 Salzburg. Tel: 00 49 (0) 662 820 3720. www.hellbrunn.at. Early 17th-century shell grotto, built by Santino Solari.

HOLLAND

Kasteel Rosendael, Kerklaan, Rosendael (5 km northeast of Arnhem). Tel. 00 31 (0) 26 355 25 30. An exceptionally beautiful 18th-century shell gallery in the grounds of this castle, as well as an 18th-century shell grotto, with trick fountains.

Shell House, Hof van Heeckeren, Zutphen. Seen through a gate, recently restored house covered in 15,000 shells.

Rijtuigmuseum (Carriage Museum), Nienoord, 9351 AC Leek, Groningen. Tel: 00 31 (0) 594 512 260. 18th-century shell room in garden pavilion.

ITALY

Cupid's Grotto, Parco Demidoff, Pratolino, Tuscany (12 km north of Florence on S65). Tel: 00 39 (0) 55 409155. One of the few elements to survive from what was the most celebrated garden in Europe, now a public park.

Villa Medici at Castello (Villa Reale), Castello, Tuscany (6 km from Florence). Tel: 00 39 055 454791. Grotto of animals in the

garden of the villa owned by the Medici, dating from 1477.

Villa Contarini, Piazzola sul Brenta, Padova. Tel: 00 39 049 5590238. A large, late 17th-century shell-decorated room in the basement.

Villa d'Este, Piazza Prento 1, Tivoli 00018. Tel: 00 39 077 4312070. www.villadestetivoli.info. A 16th–17th century villa containing several rooms-decorated with shellwork, as well as famous shell-shaped fountains in the gardens.

Giardino di Boboli, Piazza Pitte 1, Firenze. Tel: 00 39 055 218741. www.firenzemusei.it. 16th-century gardens include the famous Grotta Grande, designed by Bernardo Buontalenti.

Villa Garzoni, Piazza della Vittoria 1, Collodi, Tuscany (17km north of Lucca). Tel: 00 39 057 2429590. 17th-century gardens containing grottoes, 'giochi d'acqua', fountains and statues.

PORTUGAL

Palacio dos Marqueses de Fronteira, Largo de S. Domingos de Benfica, Fronteira, near. Lison. Grotto of the Sunken Garden in the grounds of this 17th-century palace.

RUSSIA

The Lower (Great) Grotto, the Peterhof State Museum Reserve, 198516, St Petersburg, ul. Razvodnaya 2. Early 18th-century grotto with shell-encrusted walls in the palace park.

The Grotto, Catherine Park, Tzarskoje Selo State Museum, 7 Sadovaya St., Tzarskoje Selo (25 km from St Petersburg). Fax: 00 7 812 465 2196. Email: tzar@spb.cityline.ru. 18th-century grotto in palace garden, with sculpted shells on the exterior, and natural shell-encrusted walls inside.

READ MORE: ACCESSIBLE BOOKS ABOUT SHELLS

This is a selection of non-specialist books for the newcomer to shell collecting and the natural history of molluscs. A number of the titles are out of print, but good libraries may be able to obtain copies, and second-hand copies are often available from book dealers or via the Internet.

Several shell collecting guides listed here were written before conservation became the subject of international concern. The advice they give regarding collection of live specimens, therefore, may no longer be appropriate.

Abbott, R. Tucker & Dance, S. Peter, *Compendium of Seashells: A Colour Guide to More than 4,200 of the World's Marine Shells*, California, 2000. (The book widely regarded as the 'bible' by amateurs and professionals alike for the identification of shells.)

Arthur, Alex, *Eyewitness Guide: Shells*, 1989

Dance, S. Peter, *The Collector's Encyclopedia of Shells*, New York, 1974

Dance, S. Peter, *A History of Shell Collecting*, Leiden, 1986

Dance, S. Peter, *Eyewitness Handbooks: Shells*, London and New York, 1992

Dance, S. Peter, *Seashells*, London, 1971

Dance, S. Peter, *Shells and Shell Collecting*, London, 1972

Dance, S. Peter, *The Shell Collector's Guide*, Newton Abbott, 1976

Dance, S. Peter, *Out of My Shell*, Florida, 2005

Eisenberg, Jerome M., *A Collector's Guide to Seashells of the World*, New York, 1989

Florian, Douglas, *Discovering Seashells*, New York, 1986

Frost, Wendy, *Neptune's Garden: Shells A to Z*, Boston, 1992

Gabbi, Giorgio, *Shells: Guide to the Jewels of the Sea*, New York, 2000

Hook, Patrick, *The World of Seashells*, New York, 1998

Morris, Solene, *The Concise Illustrated Book of Seashells*, New York, 1990

Newell, Peter and Patricia, *Seashells, a Naturalist's and Collector's Guide*, Oxford, c. 1979

Oliver, A.P.H., *The Larousse Guide to Shells of the World*, New York, 1980

Rosenberg, Gary, *The Encyclopedia of Seashells*, New York, 1992

Sabelli, Bruno, *Simon & Schuster's Guide to Shells*, New York, 1980

Saul, Mary, *Shells: An Illustrated Guide to a Timeless and Fascinating World*, New York, 1974

Stix, Hugh, Marguerite Stix, and R. Tucker Abbott, *The Shell: Five Hundred Million Years of Inspired Design*, New York, 1988

Vermeij, Geerat J., *A Natural History of Shells*, New Jersey, 1993

Whybrow, Solene, *The Life of Animals with Shells*, London, 1975

Winner, Beatrice E., *Life Styles of the Seashells*, Florida, 1993

Wye, Kenneth R., *The Illustrated Encyclopedia of Shells*, London, 1991

Wye, Kenneth R., *The Shell Handbook*, Bideford, 2003

Wye, Kenneth R., *Mitchell Beazley Pocket Guide to Shells of the World*, London, 1989

Yonge, C.M., and Thompson, T.E., *Living Marine Molluscs*, London, 1976

FIND OUT MORE: USEFUL WEBSITES

This list of websites is an introduction to information online about shell collecting and the study of molluscs. It is not comprehensive, but includes many of the largest non-commercial websites on the subject at the present time.

NB The words 'Malacology' and 'Conchology' can both be used to describe the study of molluscs and their shells. Most commonly, 'conchology' refers to the study of shells only, and 'malacology' to the study of molluscs and their shells.

http://data.acnatsci.org/wasp/
The Academy of Natural Sciences, Philadelphia, 'Malacolog' (database of Western Atlantic molluscs)

www.malacological.org
American Malacological Society

www.shellmuseum.org
Bailey Matthews Shell Museum, Florida, USA

www.britishshellclub.org.uk
The British Shell Collector's Club

www.cites.org

www.ukcites.gov.uk
CITES (Convention on International Trade in Endangered Species)

www.conchsoc.org
The Conchological Society of Great Britain and Ireland

www.conchologistsofamerica.org
Conchologists of America

www.spirula.nl
Dutch Malacological Society

www.hausdernatur.de
Haus der Natur, Cismar, Germany

http://home.att.net/~w.thorsson/index.html
Hawaiian Shell News

www.sim-online.it
Italian Malacology Society

www.jaxshells.org
Jacksonville Shells, USA

www.malsocaus.org
The Malacological Society of Australasia

www.malacsoc.org.uk
The Malacological Society of London

www.manandmollusc.net
Man and Mollusc

www.sydneyshellclub.net
The Sydney Shell Club

www.enature.com
US National Wildlife Federation

http://home.wxs.nl/~spirula
Vita Marina & Spirula

www.worldwideconchology.com
Worldwide Conchology

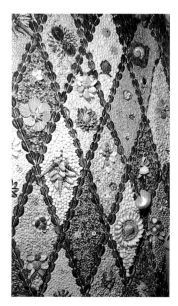

Images on pages 250–56 are details of shell artworks by Blott Kerr-Wilson.

BIBLIOGRAPHY

This book is underpinned by the original scholarship of numerous others across a wide range of fields. All such sources are acknowledged with gratitude. Place of publication is London or New York, unless otherwise stated.

Abbott, R. Tucker and Dance, S. Peter *Compendium of Seashells* El Cajon, California 1998

Abbott, R. Tucker *Compendium of Landshells* Melbourne, Florida 1989

Abbott, R. Tucker *Kingdom of the Seashell* 1973

Abbott, R. Tucker *The Best of the Nautilus* Greenville, Delaware 1976

Ackley, Clifford S. *Rembrandt's Journey* Boston 2003

Akin, David and Robbins, Joel (Eds) *Money and Modernity* Pittsburgh, 1999

Amico, Leonard N. *Bernard Palissy: In Search of Earthly Paradise* 1996

Bell, R.C. *Board and Table Games from Many Civilizations* Vol. II Oxford 1969

Bizot, Chantal, De Gary, Marie-Noël, and Possémé, Evelyne *The Jewels of Jean Schlumberger* 2001

Boekelman, Henry J. 'Ethno- and Archeo-Conchological Notes on Four Middle American Shells' *Maya Research* Vol. II, No 3, July 1935

Cameron, Roderick *Shells* 1972

Caygill, Marjorie *Treasures of the British Museum* 1992

Classen, Cheryl *Shells* Cambridge 1998

Cole, Alison *Virtue and Magnificence: Art of the Italian Renaissance Courts* New Jersey, 1995

Cook, Theodore A. *Spirals in Nature and Art* 1903

Cook, Theodore A. *The Curves of Life Etc.* 1979

Cooke, the Rev. A.H., Shipley, A.E., and Reed, F.R.C. *Molluscs and Brachiopods* 1895

Cooper, Emmanuel *Ten Thousand Years of Pottery* 2002

Corbett, Patricia *Verdura: The Life and Work of a Master Jeweler* 2002

Cox, Ian (Ed.) *The Scallop: Studies of a Shell and its Influences on Humankind* 1957

Cox, James A. *Shells: Treasures from the Sea* Leicester 1979

Currie, P.M. *The Shrine and Cult of Mu'in Al-Din Chisti of Ajmer* Delhi 1989

Da Costa, Emanuel Mendes *Elements of Conchology* 1776

Dance, S. Peter 'Ruskin the Reluctant Conchologist' *Journal of the History of Collections* Vol. 16, No. 1, 2004, pp. 35–46

Dance, S. Peter *A History of Shell Collecting* Leiden 1986

Dance, S. Peter and Heppell, David *Classic Natural History Prints: Shells* 1991

Dance, S. Peter *Out of My Shell* Sanibel Island, Florida, 2005

Dance, S. Peter *Rare Shells* 1969

Dance, S. Peter *The Shell Collector's Guide* Newton Abbot, Devon 1976

Davenport, Cyril *Cameos* 1900

De Waal, Edmund *Ceramics: Design Sourcebook* 2003

Die Muschel in Der Kunst Museum Bellerive, Zurich, Catalogue 1985

Dolan, Brian *Josiah Wedgwood* 2004

Dubin, Lois Sherr *The History of Beads, from 30,000 BC to the Present* 1987

Dunbabin, Katherine *Mosaics of the Greek and Roman World* Cambridge 1999

Edmonds, John *Tyrian or Imperial Purple Dye* 2002

Einzig, Paul *Primitive Money in its Ethnological, Historical and Economic Aspects* (2nd ed.) 1966

Emerson, William K. *Shells* 1972

Epstein, Diana and Safro, Millicent *Buttons* 1991

Fearn, Jacqueline *Discovering Heraldry* Aylesbury, Buckinghamshire 1980

Finlay, Victoria *Color: A Natural History of the Palette* 2004

Fish, J.D. and S. *A Student's Guide to the Seashore* (2nd ed.) Cambridge 1996

Fisher, Angela *Africa Adorned* 1996

Gabbi, Giorgio *Shells, Guide to the Jewels of the Sea* 2000

Godan, Dora *Molluscs: Their Significance for Science, Medicine, Commerce and Culture* Berlin 1999

Gombrich, E.H. *The Story of Art* (16th ed.) 2002

Habe, T. *Shells of Japan* Osaka 1971

Haeckel, Ernst *Art Forms in Nature* 1904

Hartt, Frederick and Wilkins, David G. *History of Italian Renaissance Art* (5th ed.) 2003

Hayden, Ruth *Mrs Delany, her Life and her Flowers* 1980

Hill, Leonard *Shells, Treasures of the Sea* Cologne 1997

Hornell, J. *Indian Molluscs* Bombay 1951

Hornell, James *The Sacred Chank of India: A monograph of the Indian Conch* Madras 1914

Howey, James *The Follies and Garden Buildings of Ireland* 1993

Impey, Oliver and Macgregor, Arthur *The Origins of Museums: The Cabinet of Curiosities in Sixteenth- and Seventeenth-Century Europe* 2001

Jackson, Hazelle *Shell Houses and Grottoes* Princes Risborough, Buckinghamshire 2001

Jackson, J. Wilfrid *Shells as Evidence of the Migrations of Early Culture* Manchester 1917

Jeffreys, John Gwyn *British Conchology*, Vol. 5 *Marine Shells* 1869

Jessup, R.F., Cook, N.C., and Toynbee, J.M.C. 'Excavation of a Roman Barrow at Holborough, Snodland' *Archaeologia Cantiana* Ashford, Kent 1955 pp. 34–37

Johnstone, Kathleen Yerger *Sea Treasure* Boston 1957

Jones, Barbara *Follies and Grottoes* (2nd ed.) 1989

Kaufmann, Edgar (Ed.) *An American Architecture: Frank Lloyd Wright* 1955

Kimball, Fiske *Creation of the Rococo Decorative Style* 1980

Konkylien: Snäcken och musslan in manniskans värld Kulturen Lund, 1984

Landman, N.H., Mikkelsen, P.M., and Bieler, R., Bronson, B. *Pearls: A Natural History* 2001

Lamprell, K. and Whitehead, T. *Bivalves of Australia*, Vol. 1 1992

Law, G. 'Regional Variation in Maori Greenstone Pendants of the Kuru Style' *Records of the Auckland Institute and Museum* 16:63–75, 1980

Layton, Rachel and Schroder, Timothy *The Gilbert Collection at Somerset House* 2000

Lindbergh, Anne Morrow *Gift from the Sea* 1955

Locard, Arnaud *Histoire des Mollusques dans l'Antiquité* Lyon 1884

Logan, Elizabeth D. *Shell Crafts* 1976

Mack, John (Ed.) *Africa: Arts and Cultures* 2000

Mack, John (Ed.) *Ethnic Jewellery* 1994

Maguire, Mary *Shells* 1997

Major, Alan *Collecting World Seashells* Edinburgh 1974

Marsh, John B. *Cameo Cutting* c. 1890

Marshall, Marlene Hurley *Shell Chic* North Adams, Massachusetts 2002

Massinelli, Anna Maria *The Gilbert Collection: Hardstones* 2000

Mauriès, Patrick *Cabinets of Curiosities* 2002

Mauriès, Patrick *Shell Shock* 1994

Meinhardt, Hans *The Algorithmic Beauty of Sea Shells* (3rd ed.) 2003

Meyer, Anthony J.P. *Oceanic Art* 1995

Meyer, Laure *Black Africa* Paris 2001

Miller, Anna M. *Cameos Old and New* 1998

Miller, Mary Ellen *Maya Art and Architecture* 1999

Miller, Naomi *Heavenly Caves* 1982

Morton, J.E. *Molluscs* 1963

Neild, Robert *The English, The French and the Oyster* 1995

Neptun's Cabinet – Shells and Conchs in Nature, Art and Symbolism Catalogue to a symposium-cum-exhibition at Kulturen, Lund 1985

Newell, Peter and Patricia *Seashells* Oxford 1979

Nuytten, Phil 'Money from the Sea' *National Geographic* Vol. 183, No. 1, January 1993

Ommanney, F.D. *Collecting Seashells* 1968

Opitz, Charles J. *An Ethnographic Study of Traditional Money* Ocala, Florida 2000

Osborne, Harold (Ed.) *The Oxford Companion to the Decorative Arts* Oxford 1985

Ostermann, Matthias *The Ceramic Surface* 2002

Paine, Sheila *Amulets* 2004

Pfeiffer, Dr Ludwig *Die Steinzeitliche Muscheltechnik* Jena 1914

Phillips, Tom (Ed.) *Africa: The Art of a Continent* Exhibition catalogue, Royal Academy of Arts, London 1995

Pin, Fred *Sea Snails of Pondicherry* Pondicherry 1990

Powell, A.W.B. *New Zealand Mollusca* 1979

Quiggin, A. Hingston *A Survey of Primitive Money* Ocala, Florida 1992

Raoul Dufy; Paintings, Watercolours and Drawings Exhibition catalogue, J.P.L. Fine Arts, London 1992

Racine, Michel *Jardins 'au naturel'* 2001

Riley, Terence (Introduction), Greham, Farrell (Photographs) *Visions of Wright* 1997

Ritchie, Carson I.A. *Carving Shells and Cameos* 1970

Ritchie, Carson I.A. *Shell Carving: History and Techniques* 1974

Rowan, Michele *Nineteenth Century Cameos* Woodbridge, Suffolk 2004

Rumphius, G.E. (Translated by Beekman, E.M.) *The Amboinese Curiosity Cabinet* 1992

Safer, J.F. and Gill, F.M. *Spirals from the Sea* 1982

Saul, Mary *Shells: An Illustrated Guide to a Timeless and Fascinating World* 1974

Schnack, Friedrich *Das Kleine Buch der Meereswunder: Kolorierte Stiche von Franz Michael Regenfuss* Leipzig (no date)

Seba, Albertus *Shells and Corals* 2004

Smith, Judith G. (Ed.) *Arts of Korea* 1998

Solem, A. Alan *The Shell Makers: Introducing Molluscs* 1974

Sowerby, G.B. *Shells of the World* 1996

Sprake, Austin *Opal of the Sea* Guernsey 1978

Sprake, Austin *Pearls and Mother-of-Pearl* Guernsey 1978

Sprake, Austin *The Cameo Story* Guernsey 1977

Springsteen, F.J. and Leobrera, F.M. *Shells of the Philippines* Manila 1986

Strong, Donald and Brown, David (Eds.) *Roman Crafts* 1976

Swainson, William *Exotic Conchology* 1834

Syndram, Dirk and Scherner, Antje (Eds.) *Princely Splendor: The Dresden Court 1580–1620* 2004

Tait, Hugh (Ed.) *Jewelry 7000 Years* 1986

Taxay, Don *Money of the American Indians, and other Primitive Currencies of the Americas* 1970

The Colin Harper Collection of Shells in Pottery and Porcelain, Auction sale catalogue, Phillips, Son & Neale, London 24–25 January 1990

The Splendor of Dresden: Five Centuries of Art Collecting The State Art Collections of Dresden, German Democratic Republic 1978

The Travel Sale, Natural History and Maps Sotheby's Sale Catalogue 15 November 2001

Thesaurus Librorum Conchyliorum ('A treasury of books about molluscs and their shells') Cat. 278, Antiquariaat Junk B.V., Amsterdam 1999

Travers, Louise Allderdice *The Romance of Shells in Nature and Art* 1962

Triossi, Amanda and Mascetti, Daniela *The Necklace from Antiquity to the Present* 1997

Untracht, Oppi *Traditional Jewelry of India* 1997

Valéry, Paul *L'Homme et la Coquille* Paris 1937

Van Cutsem, Anne *A World of Earrings: Africa, Asia, America from the Ghysels Collection* Milan 2001

Various: Grove Art Online, Oxford University Press, 2006 http://www.groveart.com/

Vermeij, Geerat *A Natural History of Shells* Princeton, New Jersey 1995

Warmus, William *The Essential René Lalique* 2003

Webb, Walter Freeman *Handbook for Shell Collectors* Wellesley Hill, Massachusetts 1959

Wilmot, R.H. *Discovering Heraldry* 1964

Woodcock, Thomas and Robinson, John Martin *The Oxford Guide to Heraldry* Oxford 1988

Woodward, S.P. *A Manual of the Mollusca* 1851

Wye, Kenneth R. *The Illustrated Encyclopaedia of Shells* 1991

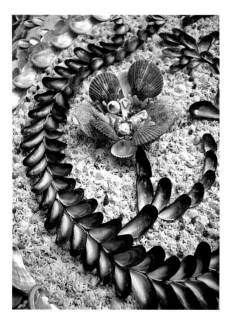

PICTURE CREDITS

l=left, c=centre, r=right, t=top, b=bottom

akg-images London: p.103 t Nimatallah.
Museo Archaeologico Nacional, Naples,
p.177 Erich Lessing
Alaska State Museums: p.67
Biblioteca Ambrosiana, Milan: p.143
Manfredo Settala Collection
American Museum of Natural History, New
York: p.10 br, p.11 t, p.14 cr, p.17 t, p.19
tl, tr, p.23 tc, p.25 t, p.31 tl, bl, p.46 Lynton
Gardiner, p.66, p.72 tl, p.73 tr, p.85 tl
© abm – Archives Barbier-Mueller – Studio
Ferrazzini – Bouchet: p.73 br, p.82 l, p.174
Musée des Arts Décoratifs, Paris: p.95 b
Ashmolean Museum, University of Oxford:
p.120 b, p.124 t
Australian Museum, Sydney: p.48 tl
Badisches Landesmuseum, Germany: p.188
Bailey Matthews Shell Museum: p.38
Bonhams, London: p.218 bl
© Thomas Boog: p.156 l, r, p.157, p.158
The Bridgeman Art Library: p.1 Private
Collection, p.24 b © Freud Museum
London, p.51 Mallett Antiques, London,
p.97 Fitzwilliam Museum University of
Cambridge, p.100 Palazzo Vecchio
(Palazzo della Signoria) Florence, p.111
Galleria dell'Accademia Venice, p.112
Nationalgalerie Berlin, p.114–15 Wallraf-
Richartz Museum Cologne, p.123 t Musée
d'Orsay Paris, p.126 Manchester Art
Gallery, p.128–29 Private Collection,
p.146 l Private Collection, p.176 l
Museum of Fine Arts Budapest, p.193 t
Private Collection, Christie's Images
Trustees of The British Museum, London:
p.12 tl, p.15 cr, bl, p.16 b, p.30 tr, p.34 t,
b, p.39 b, p.43 t, p.49 c, cr, p.64 bl, p.65 tr,
p.71 br, p.72 c, p.76 tl, p.77 t, p.116,
p.124 b, p.200 r
© Kitty Cloo Collection: p.169 Koos
Dansen, p.181 bl Koos Dansen
College of Arms: p.21
Philippe Poppe, Conchology Inc: p.6–7,
p.35 cl, p.35 bc, p.35 br
Christie's Images, London: p.50 bl, p.62,
p.63, p.75 cl, p.91, p.93 bl, p.94, p.95 t,
p.96 t, b, p.193 br, p.194 b, p.197 t, cl, b,
p.202 r, p.203 tr, p.205 b, p.210 t, cl, cr, b,
p.212 t, br, p.213 t, p.215 t, p.218 cr,
p.219 tl, cr, br, p.220 tr, p.221 tl
© Jane Churchill: p.224 tl
© Colefax & Fowler: p.224 tr
Collection of S. Peter Dance: p.31 tr Chris
Walker
Courtesy S. Peter Dance: p.175
Country Life Picture Library: p.171 b Tim
Imrie
Corbis: p.162 t Roger Wood, p.165 Richard
T Nowitz, p.171 t Arthur Thevenart,
p.172 b Francesco Venturi
© Belinda Eade: p.134, p.153 Angelo

Plantemara, p.160, p.185 tl, tr Photo Guy
Hilles
Musée d'Orsay, Paris: p.109
The Fan Museum, London: p.60–61
Villa Farnesia, Rome: p.113
The Field Museum, Chicago: p.71 bl, p.78,
p.79, p.80
Fine Arts Museums of San Francisco: p.22 bl
The Fitzwilliam Museum, Cambridge: p.204
Werner Forman Archive: p.77 bl Index
Firenze
© Peter Fraser Beard: p.225
The J. Paul Getty Museum, Los Angeles: p.131
The Gilbert Collection Trust, London: p.33,
p.57 t, p.89, p.192 bl
Library of Congress Prints and Photographs
Division Washington, D.C.: p.28 b
© Maggi Hambling: p.130 Unicorn Press
Hunterian Museum and Art Gallery,
University of Glasgow: p.127 Mackintosh
Collection
Israel Museum, Jerusalem: p.64 c
Department of Antiquities
Carole Jolly, The Pearly King and Queen
Society, London: p.14 t
Courtesy of Kentshire Galleries, New York:
p.58, p.144
© Blott Kerr-Wilson: endpapers, p.6,
p.185 b, p.186–87, p.250–56 Ben Krebs
© Peter Coke: p.155 t, b Chris Walker
Kunsthistorisches Museum, Vienna: p.105,
p.190 br
The Landmark Trust: p.136 Ian Sumner
Musée du Louvre, Paris: p.191
Marianne Majerus: p.183 © George Carter
Mallett Antiques, London: p.145, p.154
The Manchester Museum, The University of
Manchester: p.56
Collection of Roberto Maramba; Photos by
M. Yokoyama from *Form & Splendour* by
Roberto Maramba: p.70, p.78 inset, p.79
inset, p.80 inset, p.81 c, p.83 tl
Collection of Stephen & Louisa Maybury:
p.99
Frances McLaughlin-Gill/The Staley-Wise
Gallery, New York, Artifacts from the
collection of The American Museum of
Natural History: p.10 bl, p.11 bl, bc, br,
p.16 t, p.17 bl, br, p.18 b, p.22 c, p.23 tl,
p.27, p.29 t, p.30 tl, bl, p.83 br, p.85 r
Collection of Mrs Paul Mellon, United
States: p.74 Arch: D. inv. 994.30.1.4.79
Metropolitan Museum of Art, New York:
p.20 tl Anonymous Gift 1949 (49.32.79)
Photo 1986 Metropolitan Museum of Art,
p.39 tl Arthur M. Bullowa Bequest 1995
(1995.489a.b) Photo Metropolitan
Museum of Art, p.47 Gift of Jane Costello
Goldberg from the collection of Arnold I
Goldberg 1980 (1980.563.18) Photo 1981
Metropolitan Museum of Art, p.49 cl
Fletcher Fund, 1925 (25.215.41.ab) Photo
1985 Metropolitan Museum of Art, p.65 tl

Gift & Bequest of Alice K Bache 1966
1977 (66.196.40. 66.196.41) Photo 1995
Metropolitan Museum of Art, p.65 br
Purchase Rogers Fund and Gifts in honour
of Carol R Meyer 1985 (1985.260) Photo
Metropolitan Museum of Art, p.73 tl The
Michael C Rockefeller Memorial
Collection Bequest of Nelson A
Rockefeller 1979 (1979.206.1540), p.122
Wrightsman Fund 2002 (2002.68) Photo
2002 Metropolitan Museum of Art, p.203
b Gift of Mrs Russell Sage 1909
(10.125.83) Photo 1909 Metropolitan
Museum of Art, p.224 bl Gift of Muriel
Kallis Newman 2003 (2003.79.16) Photo
Metropolitan Museum of Art
Ministry of Information and Broadcasting,
Govt of India, New Delhi, Press
Information Bureau: p.19 tc
Moravske Museum, Brno, Czech Republic:
p.64 tl
© Tess Morley: p.152, p.159
National Gallery of Art, Washington, D.C.:
p.108 t Gift of the Adele R. Levy Fund, Inc
National Museum of the American Indian,
New York: p.48 b
Natural History Museum, London: p.12 b
© Brian W. Ogilvie 2004, p.182
Otago Museum, Dunedin, New Zealand:
p.48 tr
Pallant House Gallery, Chichester, England:
p.184 l, r Photo © Susie MacMurray
Collection Linda Pastorino, New York: p.86
br, p.87 br
Photokunst: p.84 Angela Fisher
Private Collection: p.39 tr
Rijksmuseum, Amsterdam: p.32, p.101
Réunion des Musées Nationaux, Paris:
p.57 b Photo Michele Bellot, p.123 b
Photo Gerard Blot
Romisch-Germanisches Museum der Stadt,
Cologne: Mario Carrieri p.190 l
The Royal Collection © Her Majesty Queen
Elizabeth II, 2007: p.214, p.215
Courtesy of Ruzzetti and Gow, New York:
p.212 bl
Saffron Walden Museum: p.31 c Beddoes
Collection 1925.28A
The Shell Museum, Norfolk: p.135 Chris
Walker, p.150 Chris Walker
Collection of Edward Shofstall & Frank
Maresca: p.224 br
Smithsonian Office of Anthropology, Bureau
of American Ethnology Collection: p.68,
p.81 br, p.87, p.211
Sotheby's Images, London: p.52–53, p.117,
p.120 t, p.121, p.189, p.192 br, p.194 t,
p.195 t, p.213 b, p.220 bl, p.221 b
Staatliche Kunstlammungen Dresden,
Grunes Gewolbe: p.36 r, p.54, p.192 c,
p.198, p.199 bl, p.200 l, p.201 tr, p.220 br
State Hermitage Museum, St Petersburg:
p.42 t, c, p.203 c

253

© Stiftung Preussische Schlosser und Garten Berlin-Brandenburg: p.173
Strong-National Museum of Play®, Rochester, New York 2006: p.140–41
Tate Images: p.132-33 © the artist, Courtesy Jay Jopling/White Cube, London
Collection of Tony Thomson: p.98 Alexander Mcintyre
Courtesy of Tiffany & Co Archives: p.90 tr Jan Van Pak Photography, p.90 b
Courtesy Mr & Mrs Denis Tinsley: p.160–61 Diana Reynell
The National Trust Photo Library: p.118 John Hammond, p.139 b Derrick E. Witty, p.146-47 Nadia Mackenzie, p.162 Nick Meers, p.172 t Andreas von Einsiedel, p.178 Bill Batten
Uffizi Gallery, Florence: p.103 b

V&A Picture Library: p.26 t, cl, p.37, p.43 cr, p.44–45, p.50 tl, p.53 cr, p.55 l, r, p.59, p.69 t, p.88 Liberty & Co Ltd, p.138, p.148, p.149, p.151, p.193 cl, p.196 l, r, p.201 b, p.202 l, p.205 t, p.207, p.209 bl, p.216 b, p.217, p.219 bl
Fulco di Verdura: p.75 br, p.92, p.93 t Photos by David Behl / © Verdura, p.93 bl © Verdura
Verulamium Museum, St Albans, Herts: p.163
Wartski, London: p.199 c
Courtesy of The Wedgwood Museum Trust, Barlaston, Staffordshire England: p.195 b, p.208, p.209 c
West Norway Museum of Decorative Art, Bergen: p.36 l Egil Korsnes
Courtesy of The Worcester Porcelain Museum: p.206 tl, b

All images in the Illustrated Glossary of Shells p.238–46 are © Philippe Poppe, Conchology Inc. With the exception of: © Amgueddfa Cymru – National Museum Wales: *Busycon canaliculatum; Busycon carica; Dentalium pretiosum; Haliotis fulgens; Lopha cristagalli; Melo umbilicatus; Neotrigonia margaritacea; Pecten maximus jacobaeus; Pinctada fucata; Pinctada mazatlanica; Pleuroploca gigantea; Purpura columellaris; Strigilla pisiformis; Strombus gigas; Subninella undulata; Tectus pyramis; Tivela stultorum; Turritella duplicata; Umbonium costatum; Umbonium giganteum.*

ACKNOWLEDGMENTS

This book was written with information and help from many people. My warmest thanks go to: Simon Aiken, Regine Aldington, Marco Badini, Maggie Black, Anne Blight, Rita Boogaart, George Carter, Susan Cerezo, Wendy Cook, Mark Currie, Julia de Roeper, Gina Douglas, Stephanie Fawcett, The Garter King of Arms, the Somerset Herald and Robert Yorke at the College of Arms, Angelica Goodden, Rachel and Nabil Hamdi, Ursula Harrison, Ruth Hayden, Dr Martin Henig, John Hoole, Barbara Huelin, Mia Jackson, Carole Jolly, Blott Kerr-Wilson, Camilla Knight, Tim Knox, Annette Kobak, Brinny Lyster, Stan and Angela Marsland, Ian Maskell, Lorna Maskell, Louisa and Stephen Maybury, Ruth McAulay, Wim Meulenkamp, Kate Meynell, Lynn Miller, Colm Murray, Anne-Joëlle Nardin, Katherine Oakes, Deborah Owen, Helen Peacocke, Diana Reynell, Edward Saunders, Dr Mary Seddon, Glenys Stace, Ruth Stockland, Cozette Swickard, Michael Symes, Briana Tarantino, Annike Thierry, Tony Thomson and Diana Naumann, Gabrielle Townsend, Tom Walker, Lalla Ward Dawkins, Kathy Way, Terry Wimbleton, Harriet Wood.

And then there are particular thanks:

To Nicola and Teddy, for throwing the first pebble into the pond.

To Ian and Tei Willox, for getting married.

To Mandy, for solving the biggest problem in one simple sentence.

To my agent Sheila Ableman, for believing in the book from the start.

To S.H., for being my sheet-anchor.

To Peter Dance, conchologist supremo, for many gestures of generosity.

To Mary Saul, for encouraging me to draw from her fascinating book.

To Chris, for all that long-distance, high-resolution photography.

To Lizzie, for flying to the UK solely to upgrade my technology.

To Kezia, for always tuning into my frequency.

To Vanessa, for cycling merrily around London in search of elusive illustrations.

To Kevin Brown, irreplaceable ally, for masterly expertise in shell identification, and for countless problems solved.

To Ali, for skilfully improving the text, and for the elephant's toenail.

To John, for gently holding me up and guiding me through the maze of self- doubt. And ever wise and tactful, for suggesting changes to the text.

To Finn, for long-range encouragement, as only he knows how.

To my editor Amanda Vinnicombe, designer Niki Medlik, and picture researcher Amanda Russell, for the privilege of working with true professionals, and for heart-warming teamwork.

And finally, crucially, to Miranda, a deep well of gratitude for quietly opening the door, allowing me to pursue my passion and to write this book.

Wendy Gay, senior picture researcher at Thames & Hudson, was an inspiration to work with, and a tower of strength during the early stages of the book's development. I offer heartfelt thanks to her, but sadly they are in absentia, because tragically she died before the book was finished.

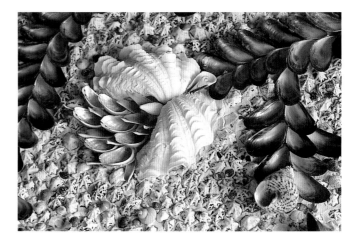

INDEX

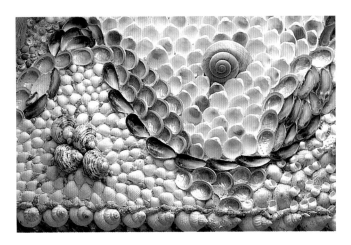

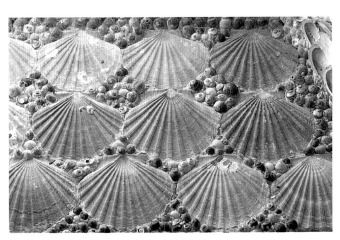